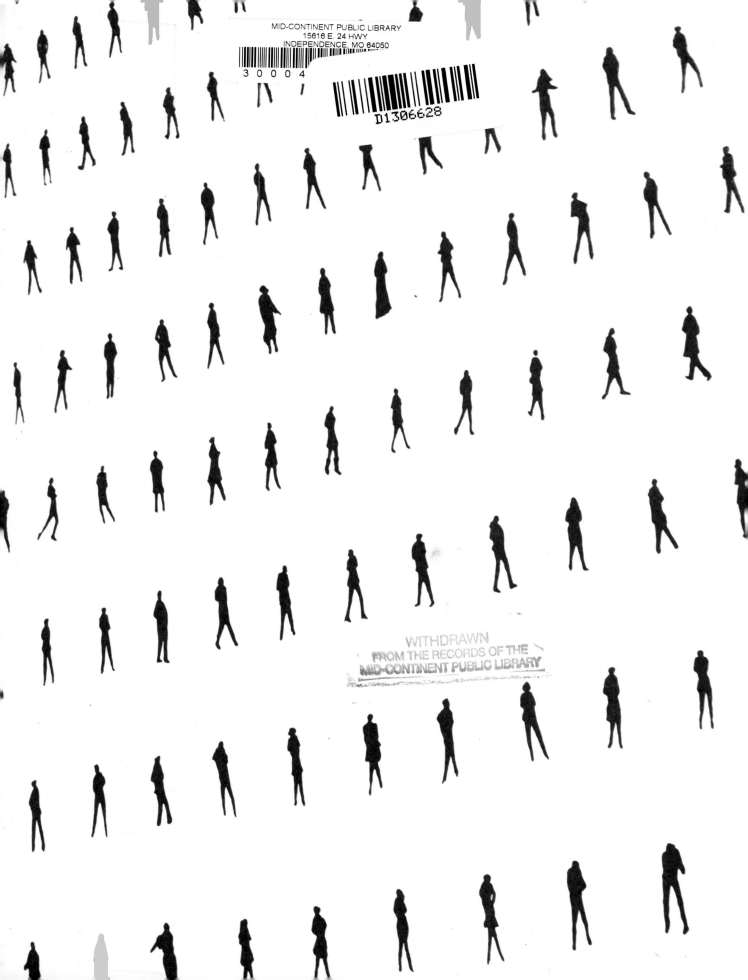

14th Street

13th Street

Arnhold Hall
Sol LeWitt
Brian Tolle
Kara Walker

University Center
Agnes Denes
Alfredo Jaar
Glenn Ligon
Rita McBride

12th Street

Sixth Avenue

Fifth Avenue

Alvin Johnson/J. M. Kaplan Hall
Thomas Hart Benton*
Camilo Egas
Gonzalo Fonseca
Dave Muller
José Clemente Orozco
Martin Puryear + Michael Van Valkenburgh

*Now in the collection of The Metropolitan Museum of Art, New York

I Stand in My Place with My Own Day Here

I St

in My

witl

Own

He

and Place My Day re

Site-Specific Art at The New School

Conceived and produced by
Silvia Rocciolo, Lydia Matthews, and Eric Stark

Edited by
Frances Richard

A collaboration between
The New School Art Collection and
Parsons Curatorial Design Research Lab

Published on the occasion of
The New School Centennial

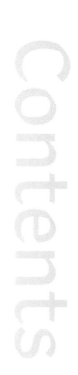

Foreword: Co-Designing a Kaleidoscope
Lydia Matthews

WHAT YOU HOLD IN YOUR HANDS is the culmination of an expansive, multiyear partnership between two entities within The New School: The New School Art Collection and the Parsons Curatorial Design Research Lab (CDRL). Composed of faculty, curators, and students from across the university who investigate and design innovative curatorial platforms, the CDRL works both on The New School's campus in New York City and beyond the institution's borders. The Lab's underlying purpose has been consistent since its founding in 2012: to open globally oriented conversations about the critical functions of visual and material culture in contemporary daily life.

In 2016, The New School Art Collection's curators and active CDRL members Silvia Rocciolo and Eric Stark brought the idea of this publication to the Lab. They put forth a challenge: How might we call attention to the thirteen extraordinary site-specific works on campus? Permanent, yet all-too-often overlooked, these holdings ranged from the epic cycle of murals produced by José Clemente Orozco in the early 1930s to Agnes Denes's monumental wall drawing composed of thousands of miniature human figures, which was about to be installed in the University Center cafeteria. How could we heighten the visibility of these exceptional works and inspire viewers to reconsider their value?

Consistently across its one-hundred-year history, The New School has commissioned works by artists important to their times. These commissions announce the institution's commitment to fostering radical creative practice and advocating

for art's power to manifest progressive political values. With this in mind, we at the Lab asked ourselves what kind of curatorial platforms we could co-design to enable audiences to think more deeply about the layered narratives embedded in these unique works. How could we motivate members of our educational community and campus visitors to slow down and look more closely? What kinds of urgent messages are harbored in plain sight within these wall works and objects—which rank among the finest large-scale site-specific pieces in New York?

In response to this lively set of provocations, we began to develop this publication. As a first step, we asked Pablo Helguera, an internationally celebrated artist who is also the director of adult and academic programs at The Museum of Modern Art, to visit our Lab and offer a workshop to help us better imagine the sorts of strategies we might deploy. Subsequently, we invited nearly fifty internationally renowned critics, poets, visual artists, art historians, and scholars from multiple fields to contribute short essays, each discussing one of the commissioned works and reflecting the writer's unique vantage point. The response to our invitation was overwhelmingly enthusiastic, and marvelous polyvocal texts began to pour in, offering us a kaleidoscopic view onto the thirteen artworks. We decided, moreover, that these short texts would be complemented by three longer essays and one roundtable discussion that provide insights into the institutional, architectural, art-historical, and pedagogical contexts in which our baker's dozen of site-specific

works exist. Looking through this variety of lenses, we can better understand how art functions as an ever-morphing teaching tool, a source of cultural meaning-making, critical debate, and aesthetic pleasure.

A complex undertaking like this would never have succeeded without the generous contributions of many individuals who deserve our acknowledgment and thanks. First and foremost, we feel enormous gratitude for the rich contributions of all the invited writers, as well as those of our brilliant editor, Frances Richard, whose poetic sensibility and professional grace shaped all aspects of this book. Her stellar editorial team included editorial assistant Elisa Taber and copy editor John Haffner Layden, whose insider knowledge of the university is incomparable. Ryan Newbanks and Cathy Hannabach of Eyes on Fire served as the book's proofreader and indexer, respectively, and we have greatly appreciated the support and wise counsel of our book distributors, Courtney Berger and Michael McCullough at Duke University Press.

Several of the CDRL's esteemed Graduate Student Fellows were responsible for art-historical background research and for synthesizing this information for use by the book's contributors; we extend our thanks to Fernando do Campo, Sinead Petrasek, Macushla Robinson, Utsa Hazarika, Josephine Lee, Logan Magee, and Luke McCusker as well as to Agnes Szanyi, whose keen archival skills proved essential. We also deeply value the efforts of Wendy Scheir, CDRL member and director of The New School Archives and Special Collections, and Jeanne Swadosh, associate archivist, who have worked in tandem to develop an exceptionally rich university archive that has informed the efforts of everyone involved. In developing a Web-based component for the project, we sought the guidance of MFA Creative Writing program professor John Reed and his graduate assistant Samantha Kirby. We then hired CHIPS, the talented Web design team composed of Dan Shields and Adam Squires, to launch a site (thenewschoolart collection.org) that will promote the publication and allow its investigation of the artworks to expand over time.

Of course, this is a project in which text and image must be treated with equal sensitivity. The sumptuous photographs that adorn these pages are the handiwork of Nicholas Calcott, Fernanda

Kock (Galo Studios), Daniela Merino, Tom Moore, and Martin Seck. In the earliest stages of the project, we had the pleasure of working with Lucille Tenazas, Henry Wolf Professor of Communication Design, who also serves as Associate Dean of Parsons' School of Art, Media, and Technology. Lucille brilliantly guided the students in her Collab communication design course (particularly Gabriela Carnabuci) to produce elegant promotional materials that initiated fund-raising efforts for the publication. Later, as the essays began to accumulate, we enlisted Barbara Glauber of Heavy Meta studio to be the book's designer. With her patient professionalism, good humor, and astute design solutions, Barbara has been a joy to work with.

We have benefited from the support of The New School's top-level administrators and unsung heroes alike. We thank Tim Marshall, Provost; Bryna Mary Sanger, Deputy Provost and Senior Vice President of Academic Affairs; Pat Baxter, Vice Provost; Mark Gibbel, Chief Development Officer; Steve Stabile, Treasurer and Vice President for Finance and Business; and the entire New School Development and Alumni Relations team, not to mention University President David E. Van Zandt, for their ongoing assistance in securing funding for the book. We are indebted to Joel Towers, Executive Dean of Parsons School of Design, and Anne Gaines, Dean of the School of Art, Media, and Technology at Parsons, who have promoted the CDRL from its inception and were among the first to encourage us to realize the present project. Similarly, The New School Art Collection Advisory Group—counting among its members Laura Auricchio, Beth Rudin DeWoody, Andrea Geyer, William B. Havemeyer, Carin Kuoni, Tim Marshall, Christiane Paul, Silvia Rocciolo, Eric Stark, and Radhika Subramaniam—have consistently encouraged our efforts. Thanks also to Jed Crocker, Director of Academic Planning in the Provost's Office, and Anna Thibeault, Operations Manager for Academic Planning, as well as to Alexandra Lederman, Digital Asset Manager, and Susan Sawyer, Associate General Counsel, each of whom contributed expertise as an advocate for the project. Lia Gartner, Vice President of Buildings, and Thomas Whalen, Assistant Vice President for Facilities Management, have provided indispensable help, as have five exceptional historians of New School activity:

building superintendents Ray Battista, Gene Evans, Ernesto Golfo, Phil Mattos, and George Park, who collectively have overseen Alvin Johnson/ J. M. Kaplan Hall, Arnhold Hall, and the University Center for many years.

This ambitious labor of love would never have gotten off the ground had it not been for our generous patrons, whose financial support has been invaluable. These remarkable individuals include Joshua Sapan and Ann Foley, whose substantial donation provided the seed money to begin our project, and Beth Rudin DeWoody and the May and Samuel Rudin Family Foundation, Inc., William B. Havemeyer and Elizabeth Dickey, who each helped nourish the book's progression. We have also relied on several Cross-School Grants from the Parsons Deans Council and the Provost's Office's Mutual Mentoring Grants to sustain our efforts. We are grateful for each of these contributions.

Finally, I want to acknowledge the CDRL members whose ideas, efforts, and warm collegiality have made this venture possible: Margot Bouman, Assistant Professor of Visual Culture at Parsons; Julia Foulkes, Professor of History at the Schools of Public Engagement; Carin Kuoni, Director and Chief Curator of the Vera List Center for Art and Politics; Sarah E. Lawrence, Dean of the School of Art and Design History and Theory at Parsons; Sarah A. Lichtman, Director of Parsons' master's program in History of Design and Curatorial Studies; Christiane Paul, Director and Curator of the Sheila C. Johnson Design Center and Professor of Media Studies; Radhika Subramaniam, Associate Professor of Art and Design History and Theory at Parsons; Soyoung Yoon, Program Director and Assistant Professor of Art History and Visual Studies at Eugene Lang College of Liberal Arts; and of course Silvia Rocciolo and Eric Stark, who have contributed the lion's share of insight and labor to this publication. I consider myself fortunate to have such intellectually gifted and delightful colleagues to collaborate with and I look forward to our future projects.

Introduction

Silvia Rocciolo and Eric Stark

THE TITLE OF THIS BOOK, *I Stand in My Place with My Own Day Here*, is drawn from Walt Whitman's biographical poem "Starting from Paumanok," which introduces the 1867 edition of *Leaves of Grass*. The phrase comes to us by way of the artist Glenn Ligon, who included it in his site-specific work *For Comrades and Lovers* (2015), a neon frieze wrapping the interior of the Event Café in The New School's University Center. Paumanok is the Native American name for Long Island, Whitman's birthplace. The direct translation of *Paumanok* is "land of tribute."

For Whitman, paying tribute meant implicitly acknowledging our collective histories, legacies that he sought to express through his use of the Algonquin name. The poet openly rebelled against the class hierarchies and social conformity that undergirded nineteenth-century American culture, even as he embraced that culture's entrepreneurialism and its privileging of newness. Whitman claimed license for his unique social and artistic vision by looking toward the future even as he sought to honor the past, and such paradoxes open in his work a great array of possibilities—many of which he could not have foreseen.

The same could be said for each of the artists whose site-specific works are the focus of this book: Thomas Hart Benton, José Clemente Orozco, Camilo Egas, Gonzalo Fonseca, Martin Puryear and Michael Van Valkenburgh, Dave Muller, Sol LeWitt, Kara Walker, Brian Tolle, Rita McBride, Alfredo Jaar, Glenn Ligon, and Agnes Denes. The thirteen works commissioned from these artists over nine decades represent storied episodes in the remarkable life of an inspired, lively, contentious, and mutable happening called The New School.

For us, marking the university's centennial by paying tribute to these artworks likewise means acknowledging histories, invoking presence, and honoring space and place. We take Whitman's seemingly simple statement as a summing up of The New School's ethos—affirming the intrinsic right to freedom of expression and activating that freedom in an implicit call for social engagement.

In *The Scent of Time: A Philosophical Essay on the Art of Lingering* (2009), philosopher Byung-Chul Han speaks to a temporal crisis in human experience. He portrays a society in which many of us have lost our capacity to linger. Life has no fixed coordinates; we are transient, living in an ever-shrinking present shaped by a centrifugal phenomenon Han calls dyschronicity: "Time is running off because it cannot find an end or conclusion, because it is not restrained by any temporal gravitational forces. There are no longer any dams that regulate, articulate or give a rhythm to the flow of time. There are no dams to hold or halt time by giving it something to hold on to—'hold' in its exquisite double meaning."[1]

The site-specific works in The New School Art Collection act as these dams, channeling the flow of a vast body of knowledge that shapes and informs who we are as an institution, as a community, as individuals—offering us *something to hold on to*. These works give rhythm to time past, even as they pull us gravitationally into the present. While each offers an entry point into the landscape of a specific historical moment, each

Auditorium at 66 West 12th Street, 2019.

also speaks to us across decades, serving as a sentinel and storyteller, a witness to the myriad individuals and communities that have passed through these spaces. Each work holds within it a regenerative capacity to invite engagement; each puts forth a call to embrace our varied inheritances.

———————

In 1931, Alvin Johnson, the first New School president, set the school on a unique path by issuing invitations to Thomas Hart Benton, José Clemente Orozco, and Camilo Egas to create murals for a nascent institution whose mission was to stimulate new ways of thinking and learning. Johnson's challenge to each artist was to create a work of art that would resonate in a hundred years, and this established a blueprint for the university's aspirations in art, culture, and politics. Eighty-five years later, McKenzie Wark, professor of culture and media studies at Eugene Lang College of Liberal Arts and The New School for Social Research, offered his own challenge in a convocation speech to an incoming class of students. Reflecting on The New School's twin legacies of intellectual liberty and political commitment, Wark told his audience:

> The founders of The New School were not dogmatists. They had no program to impose on anyone. As one of our founders, James Harvey Robinson, put it, "I have no reforms to recommend, except the liberation of intelligence.". . . The aim of education is the liberation of intelligence—from dogma, prejudice, superstition, sophistry, slogans, fear mongering, naïveté, spin, trivia, pedantry, wishful thinking, and the rest. The aim of education is to negate the given, and in so doing, throw into sharp relief both what is right and what is wrong with the social order. Education is not outside of the incessant struggle to make the world. It is one of the essential moments of that struggle. The aim of education is to be a provocation to thought; the aim of thought is the renovation of the world.[2]

Robinson's recommendation for liberation and Wark's renovation of the world—like Johnson's lofty request to Benton, Orozco, and Egas—are tall orders for an institution to fulfill. In asking for a century (and more) of relevance, Johnson sought something that the artists could not have guaranteed. Yet they delivered exactly what he was looking for: microcosms of the world as they saw it in moments of inspiration. Their distinct visions, blends of their personal, artistic, cultural, and global histories,

left us with three sustaining works—three provocations for thought, three renovations of the world.

One could argue that creative agency and The New School became inseparable in that first era of the institution's life. But it was not until 1960 that this integration of art with the university manifested formally with the launching of the List Art Purchase Fund and, in the same year, The New School Art Center. Under the directorship of Paul Mocsanyi, the grant from Albert and Vera List established a purchasing program for contemporary works of art and an ambitious exhibition program introducing "noteworthy expressions" of art on an international scale to a Greenwich Village community in the throes of the Beat Generation.

The New School at that time had not formed a permanent collection; in an organization challenged by constraints on space and financial resources alike, any works acquired were meant to be returned eventually to the marketplace to facilitate additional purchases of art. By the early 1960s, however, expansions to the built space of the campus were creating new opportunities for place making. In 1961, Gonzalo Fonseca, who had been a student of Joaquín Torres-García, followed up on the contributions of Orozco and Egas by introducing into The New School yet another modernist idiom from the Global South when he created a large-scale mosaic for the lobby of the recently built extension at 66 West 12th Street (now Johnson/Kaplan Hall). Several decades later, New School Art Collection curator Kathleen Goncharov (who served from 1987 to 2000) realized *Vera List Courtyard*, a collaboration between artist Martin Puryear and landscape architect Michael Van Valkenburgh, sited in the atrium and courtyard that conjoin the Johnson/Kaplan building with the Eugene Lang building at 65 West 11th Street.

Goncharov had inherited 200 works when Mocsanyi retired. Supported by the active patronage of Vera List and Agnes Gund, chair of the university art committee, Goncharov expanded the holdings to 1,100 works, transforming a grouping of objects into a formal body. The New School Art Collection, with a guiding mission, governing protocols, and a supportive advisory group, focused on acquiring works with a strong political bent by emerging and underrepresented artists—women, people of color, and members of the LGBTQ community.

Stefano Basilico, the next curator (2000–04), continued to grow the Collection to approximately

1,800 works. He added four new site-specific commissions, extending the muralist program founded by Alvin Johnson into the twenty-first century. A multipart work by Dave Muller was introduced into the 66 West 12th Street extension, and Sol LeWitt, Kara Walker, and Brian Tolle were commissioned to create site-specific pieces for the newly established Arnhold Hall at 55 West 13th Street.

During our own tenure as curators, we have presided over the selection and installation of site-specific projects by Rita McBride (2014), Alfredo Jaar (2014), Glenn Ligon (2015), and Agnes Denes (2016). How are decisions made in commissioning such works? Many competing considerations—political, aesthetic, intellectual, and financial—come into play and in the end no single force wins. Our experience has been collaborative both within our department and more broadly across the institution. We owe a debt of gratitude to all who have helped make these commissions possible, most notably the commissioned artists whose generosity and trust in the process have given rise to unexpected and beautiful results.

The New School Art Collection's lack of dedicated exhibition space has never deterred its growth. Rather, we as curators have foregrounded this dispersal as one of our distinguishing features. Now numbering approximately 2,500 works, the Collection is installed in public spaces across the campus in offices, corridors, and classrooms. Artworks are lived with, encountered unpretentiously and intimately by the school community on a daily basis. They are a presence, charged in their content and materiality. Deep acts of generosity have sustained the Collection, as stalwart supporters and wise counselors including List, Gund, Gabriella De Ferrari, and Beth Rudin DeWoody have championed it with conviction and creativity.

Nevertheless, there are times when this unique collection feels precarious, tangential, risking disappearance as it hides in plain sight. At the time of this writing, as movements like Black Lives Matter, Decolonize This Place, Me Too, and Time's Up have gained momentum across a fraught national terrain, students of color at The New School have demanded and received their own dedicated meeting and event space, and graduate students have occupied the dining hall, striking in solidarity with cafeteria workers for better wages and benefits.[3] All are asserting their right to occupy, to stand in their place, to resist. It's another day at The New School—

another day experiencing the fully lived reality of an institution grappling with the complexities of an unsettled world.

In Agnes Denes's mural *Pascal's Perfect Probability Pyramid & the People Paradox—The Predicament (PPPPPPP)* (1980/2016), thousands of figures forming a perfect pyramid stand quietly behind the students in the dining hall. Have the students read the wall text? we wonder. Denes dedicates the work to them. Has she, the artist, in some sense prefigured the agitations of our moment? Does her audience at The New School know about her many creative interventions into public space, her decades of committed activism? "Read the figures, they are you," she urges.

And in fact, such readings do regularly occur. Recently, a student read a set of figures in just this intimate way. An MFA Transdisciplinary Design class was taking place in the Orozco Room, and the presenter introduced himself as a first-generation Mexican American. Pointing to one of the mural panels, he announced, "These are my grandparents." The student's project—a pilot program for decolonized design-thinking workshops offered to day laborers in support of community mobilization—resonated uniquely in the setting. Distances collapsed, and the histories shared between student and artist were interwoven in a moment of connection and recognition. A new history began to unfold.[4]

One could argue that, ultimately, each of these works embodies a radical act—not of monument building but of community building. At their best, they serve as sanctuaries, engendering inclusivity, conviviality, and tolerance, offering moments of blessed pause. These installations invite the liberation of our thinking—within and outside ourselves, our tribes, our classrooms, and our boardrooms. They offer up a common ground, a space and place from which to assert, to occupy, to welcome, or simply to be.

Now, during The New School's centennial and at a critical moment in our nation's history, when competing political and cultural forces are vying to shift our focus away from Robinson's "liberations," can we continue to find such spaces of discovery? Vera List, the generative force behind The New School Art Collection, liked to say that art is a way for us to "become humans all." At its core, our collective project has been precisely this: a project for human liberation in all its messiness, contentiousness, and coming-together. And art—as a

self-sufficient medium that is also a vector for empathy, a methodology for building knowledge and culture, an agent of activism—has always been an elemental part of the university's pedagogy, an integral part of an overarching vision.

The essays that follow are a convocation of voices from a community at large. They embody, in their capacious embrace of these site-specific works, the larger meaning of Byung-Chul Han's verb "to hold." Liberations and renovations of our world begin when the seeds of transformation are given ground on which to thrive. So, linger here. Stand in your place. Live your day.

1 Byung-Chul Han, *The Scent of Time: A Philosophical Essay on the Art of Lingering* (2009), trans. Daniel Steuer (Cambridge, UK and Medford, MA: Polity Press, 2017), 2.

2 McKenzie Wark, "The Aims of Education" (New York, NY, September 2, 2010), https://intertheory.org/wark.htm (accessed May 31, 2019).

3 The student strike was one of a series of actions that resulted in a landmark first contract with SENS-UAW, the union representing academic student workers at The New School.

4 Jeanne Swadosh, Associate Archivist in The New School Archives and Special Collections, recounted this anecdote to Silvia Rocciolo in an email on May 10, 2018. The student was Ángel López, MFA Transdisciplinary Design, Parsons, 2018.

José Clemente Orozco and Camilo Egas with *Call to Revolution and Table of Universal Brotherhood (Science, Labor, and Art)*, 1930–31 (detail).

Various, Humane,
Political

THE NEW SCHOOL

Holland Cotter

IN TERMS OF PUBLIC ART, my college years were an experience of starvation, though this wasn't for lack of images. At the venerable school I attended, a large outdoor bronze statue of the founder stood, a sleek Edwardian omphalos, at the center of campus. Painted portraits of past school presidents and donors lined dining hall walls. Murals commemorating—celebrating?—the lives of students lost in wars framed the entrance to the main library.

All of this—I'll call it art—was part of the school's educational argument, one that asserted, environmentally, the earned power of institutional tradition, the justice of selective history. When I arrived, a hazy adolescent with little training in history and none at all in irony, I barely took in the bland visual diet. When I eventually did, I found it indigestible, acid on the tongue.

I was in school in the 1960s. The world was exploding. Some of us were waking up to the fact that the founder's statue was a victory banner planted on colonized soil. We were beginning to learn that presidents—of anything—were, by definition, a problem. We emphatically understood that the only thing standing between us and a present-day imperialist war was graduation day.

And how, I wondered even then, had I not noticed that to be nonwhite, nonmale, nonstraight (I was gay), and economically nonthriving was to be unrepresented in the public images around me? It's an interesting moment when you first fully register that the official version of reality you've been told to trust is not on your side.

Half a century earlier, a handful of New York teachers, some at Columbia University, came to a similar conclusion from a different direction—that is, from the instructional side. In the immediate aftermath of World War I, an event that shattered Western ethical certainties and divided global epochs, they concluded that the education they had been giving their students was useless for progressive life and thought in 1919.

Judging major American universities to be, at least in the short term, unreformable, the splinter group established a school of its own on a new model. They exchanged the old Western classical curriculum for a focus on the still-new fields of political science and sociology. They de-emphasized grades and degrees in favor of making learning "for mature men and women" an end in itself. They located their New School for Social Research downtown, in Greenwich Village, a refuge for politically minded intellectuals, writers, and artists.

Given this location, it only made sense for The New School to eventually introduce the arts—approached, in a way familiar to us now, as a form of social practice—into the curriculum. And it made further sense that, in 1931, when the school opened its Joseph Urban–designed headquarters at 66 West 12th Street, contemporary art would be integral to the design, an aspect of the educational project that signified not earned tradition but its active overturning.

To that end, two painters—**Thomas Hart Benton** of the United States, and the Mexican-born **José Clemente Orozco**—were invited to create mural cycles within the building, the founding works in a series that has extended to the present. What do we learn, then, from the juxtapositions of

Facade, 66 West 12th Street, 2019.

these thirteen school-commissioned public art-works? To put it simply: We are reminded that politics changes history, and history changes art.

Actually, the Benton mural cycle *America Today* (1930–31) was originally only semipublic: It was installed in a boardroom, later repurposed as a classroom. (It's now in The Metropolitan Museum of Art.) In style, it's vividly theatrical. Politically, it's liberal-ordinary, an interlocking group of symbolic vignettes that project an image of the United States as a giant market-feeding machine. The take is pro-populist but also pro-capitalist, seeming to suggest that if, in the grand frenzy of production, some people—African Americans, say—lose out, well, that's just how it goes.

Orozco's mural project differs not only in its dour palette and uningratiatingly spiky style, but also in its contents. The cycle is in two parts, *Call to Revolution* and *Table of Universal Broth-erhood* (1930–31), both still installed in their original settings, a former student cafeteria and adjoining lounge—though the rooms are used for different purposes now. Orozco doesn't pull any punches with his themes. He includes portraits of Vladimir Lenin and Joseph Stalin. His *Table of Universal Brotherhood* depicts a proto–United Nations of ethnicities—African, Chinese, European, Indian, Mexican, Native American—sitting down together with an African American man at the head.

The muscular, can-do spirit of *America Today* felt mildly progressive in the upbeat 1920s and radically misguided once the Depression hit. Now, in the MAGA age, the cycle's vision of a nearly all-white, immigrant-free, largely rural nation could probably find an appreciative new audience, conservative beyond anything Benton might have imagined.

As for Orozco's paintings, during the red-baiting 1950s, right-wing voices called for the murals to be destroyed, as if their call to revolu-tion might pass like a virus into the population. Even for sympathetic viewers, the work is flawed by its insistence on overt lessons: Some of Orozco's heroes proved to be villains; the ideology he advertised has, in some cases, triggered catastro-phe. Yet the global consciousness of this art, and its unseating of white supremacy, aligns it with much that is positive in the American present, and with far more recent commissions of public art that likewise seek to render history into something viscerally, visually accessible.

Kara **Walker**'s 2005 black-and-white mural, *Event Horizon*, painted on a high staircase wall between floors in the school's Arnhold Hall, is an evocation of the transatlantic slave trade and its aftermaths, with figures tumbling in free-fall into a pit like an intestinal tract. On the seventh floor of the University Center, in the library, stands **Alfredo Jaar**'s *Searching for Africa in* LIFE (1996/2014), a photographic indictment, based on reproductions of more than 2,000 *LIFE* magazine covers, of racism through erasure. These twenty-first-century pieces are, in different ways, half-hidden. They don't ask that you seek them out. Rather, they find you as you pass from here to there. Both are about long-suppressed histories: Slavery was the nightmare behind the American dream; Africa was the continent the West tried to bury in darkness. In art, both histories push their way to the surface—in Walker's work as a visual explosion; in Jaar's work as a conceptual whisper.

Other earlier site-specific works in the Collection approach political import in comparably complex ways. The painter **Camilo Egas**, who found-ed and led the school's art program and hired star teachers—Stuart Davis, Lisette Model—contributed a mural-size oil painting in 1932. Titled *Ecuador-ian Festival*, it depicts a folk celebration in the art-ist's home country. Far from being merely pleasur-able, however, it's an agitated image, charged with compositional tensions that undercut an easily exoticized reading of its subject.

That a painting devoted to indigenous South American customs should appear at The New School in the early thirties was remarkable in itself—though this too spoke to the progressive aspira-tions of the Depression-era institution. It is all the more noteworthy that, in the very different political climate of 1961, another South American artist would come to work in the lobby of the Joseph Urban building. There the Uruguayan sculptor **Gonzalo Fonseca** completed a large-scale mosaic composed of symbols drawn from archaeological sources, primarily pre-Columbian, rendered in a geometric style by then familiar from modern abstract art. Not depicting scenes as Egas does, and lacking the explicit didacticism of Orozco or Benton, Fonseca's visual language is open-endedly transcultural.

Indeed, abstraction has consciousness-raising capacities of its own. Three benchlike geometric sculptures by **Martin Puryear**, installed in 1997 in

close proximity to the Fonseca mosaic, turn the courtyard between two New School buildings into a communal gathering space. Two highly colored wall paintings by **Sol LeWitt** destabilize the heights and depths of the spaces they occupy in Arnhold Hall. **Rita McBride**'s extraordinary architectural sculpture *Bells and Whistles* (2009–14), a network of brass ducts, twists its way through five floors of the University Center. It feels vaguely sinister—are the ducts conveying some hidden matter, some essence, from floor to floor?—but also lends the building a sense of organic life.

Such mysterious architectural vitality appears in a different and even spookier way in **Brian Tolle**'s 2006 installation *Threshold*. It consists of two fiberglass panels placed on a stretch of wall in Arnhold Hall. Illusionistically molded and painted, they suggest membranes gently rising and falling, as if the wall were breathing.

Does any of these abstract pieces qualify as "political" art? Technically, topically, no. Do they heighten our perception of our immediate surroundings, which happen to be public spaces in an institution of learning—an institution dedicated, from the start, to learning how to live in the political condition that is the Now? Yes.

And it is this Now, in all its multiplicity, that one might understand as the subject of a few more public pieces, all thoroughly planted in the present. **Glenn Ligon**'s 2015 commission, *For Comrades and Lovers*, is installed in the University Center. A wrap-around environment of phrases spelled out in lavender neon tubing, the work centers on language excerpted from Walt Whitman's poetry—nineteenth-century verse that speaks of radical democracy, social equality, and same-sex love. In two time-spanning lines, the poet states that there will "never be any more perfection than there is now. Nor any more heaven or hell than there is now." In a third, he promises to send "a few carols vibrating through the air" when he leaves this earth. The neon vibrates ever so slightly.

One might say that there is poetry without verse in a 2016 mural-size print by **Agnes Denes**, a New York artist now in her late eighties. It has a long title—*Pascal's Perfect Probability Pyramid & the People Paradox—The Predicament (PPPPPPP)*—and takes the form of a curving pyramid composed of thousands of small, silhouetted humanlike figures. In an accompanying statement, the artist gives this composite image both positive and negative spins: Without the cooperation of all the figures, the pyramid would fall; the fact that it hasn't implies that escape from its structure is impossible. In that paradox, one might see the double bind of democracy.

The placement of this mural in a university dining room means that at least some alert eyes will be returning to it and to the ideas it poses again and again. Denes addresses herself to these viewers, dedicating the work to "the refugees of the world, the homeless, misplaced and unwanted whose well-being depends on kindness and compassion. It is also a gift to the students. Read the figures, they are you."

Who knows, maybe the public art I was seeing on my college campus all those years ago was beneficently intended too—though it struck me then, and strikes me now, that there was a different dynamic at work. I was being urged to subsume my identity into that of the school. Few institutions are entirely free of such presumptions—and indeed a sly, easy-to-miss work of institutional critique by the California-based artist **Dave Muller** nails the narcissism at the root of even the most humane academy. For the target under fire is The New School itself. In a series of modestly sized acrylic-on-paper paintings titled *Interpolations and Extrapolations*—created between 2002 and 2003 and expanded in 2008—the artist records the school's adventures in self-branding. This began with a change of name. "The New School for Social Research" was streamlined to "The New School," period, and then to "The New School University." These changes coincided with a number of logo redesigns intended to project various institutional personalities: formal or casual, tough or soft. Does this search for a marketable look imply insecurity or flexibility? Neurosis or health?

I'd say health. The school I attended had for centuries branded itself visually with the same faux-aristocratic crests and Latin moral maxims, with the result that learning felt like a marmoreal enterprise. The New School's collection of public art—various, humane, political—generates a very different atmosphere. Politics change history; history changes art. And art—if it's alert and alive and tuned in to whatever present produced it—changes people. Isn't change what education is for?

Schooled in the New: The Arts as Social Research

Julia L. Foulkes

WITH ITS ODD NAME, it's hard to know exactly what The New School stands for except "the new." Now, in the face of its centenary, even its stance as new is questionable; while not old—in the life span of established universities, the school may have reached puberty—it has acquired traditions, histories, and institutional gravity. How do these legacies inflect its claims to innovation? The original full name of the school, The New School for Social Research, only adds to the confusion. What does social research mean? Such questions offer interesting vantage points from which to look at the school's past. What reveals itself is a collaboration between newness and social research, a fusion that is distinct in producing a mission bound to addressing contemporary societal problems. From its inception, the school dedicated itself to providing education that matched the moment, embracing responsiveness and empiricism as its hallmarks.

When The New School was established in 1919, it was part of a movement of the new: the political platforms of Woodrow Wilson's New Freedom and Teddy Roosevelt's New Nationalism in the 1912 election; the dawning of more public roles and possibilities for the New Woman; and the flowering of artistic talent in the Harlem Renaissance of the New Negro. Two other forms of the new proved still more crucial. The New History was a school of historiography led by James Harvey Robinson and Charles Beard, both of whom were critical to the founding of The New School. In their books, articles, and lectures of the 1910s, Robinson and Beard argued against the idea of the past as a stable chronology of heroic events, an idea that

formed the basis for the classical education championed by Nicholas Murray Butler, president of Columbia University, on whose faculty they served. Instead, they argued that the past should be used. The past was less an inheritance or a value than a material to be critiqued and molded, a spur toward change. History was a platform for action.

This call to action resonated in another forum for the new that contextualized the founding of the school: the *New Republic*, the bimonthly magazine of politics and culture that began in 1914. As contributing writers, Robinson and Beard were in conversation with Herbert Croly, the *New Republic*'s editor, as well as other intellectuals featured in the young magazine, such as John Dewey and Randolph Bourne. Out of those conversations—and encouraged by a rancorous battle with Butler and the trustees of Columbia over faculty governance—Croly first formulated "a school of social research" in the *New Republic*'s issue of June 8, 1918. This school would dedicate itself "exclusively to the study of the subject matter of modern society." Curriculum would derive from the emerging social sciences, including anthropology, economics, and international relations. Faculty would "enjoy full control" over educational policy and the hiring and firing of professors. These ideas crystallized into "A Proposal for an Independent School of Social Science for Men and Women," whose aim would be to educate those interested in taking action in the world—not in obtaining a degree, which the founders saw as a bureaucratic and corrupting influence on learning. Social research at this moment thus meant applying scientific investigation to human-

Lobby, 66 West 12th Street, 1930s.

made institutions, policies, and relations. Mission named, the new school opened its doors at 465–469 West 23rd Street in Chelsea, just down the block from the offices of the *New Republic*.

Here, then, are the bases for much of what we still herald about The New School: attention to issues of the current day; focus on problem-solving; academic research in service to the public; a fostering of active citizenry. But nowhere in these early statements is there any mention of the arts. In fact, the arts are specifically excluded, to focus instead on the unique role of the social sciences in educating an empirically informed and practically effective "new" public in the twentieth-century city. The arts had no place at this New School for Social Research.

And, then, somewhat abruptly, they did. In the fall course catalog for 1922, Social Forces in Modern Literature, The Art of Theatre, and a philosophy course on Beauty and Use appeared. Lewis Mumford added a course on architecture, and Waldo Frank established one on Modern Art—all sandwiched among courses in policy, labor, politics, and psychology. In a few short years, the school became a home for modernism, a status instantiated in architectural form at 66 West 12th Street, where the operation moved in January 1931. Ezra Pound's modernist injunction to "make it new" now fit The New School's mission, for being new did not guarantee to the arts an audience or appreciation, and these are what the school helped to supply. People might encounter the experimental piano-playing of Henry Cowell, who made sound with the entire instrument, not just the keys, and then take his course on world music. John Martin, the first dance critic of the *New York Times*, offered lecture-demonstrations with modern dancers such as Martha Graham and Doris Humphrey. Berenice Abbott established a photography program. The new building by Joseph Urban and the murals commissioned from Thomas Hart Benton and José Clemente Orozco made concrete, visible, and spatial the idea that the arts occasioned insight.

It was Director Alvin Johnson who articulated the role of the arts in the school and in society—the arts as social research—that steadily took hold at The New School. By 1923, the realities of producing curricula, paying electricity bills, and responding to student demands had hobbled the early idealism of a faculty-led, research institute–cum–lecture bureau, and the board picked Johnson to lead the struggling institution. He turned the school more clearly toward students, heeding their requests by expanding course offerings in the arts and psychology. This did not mean turning against the social sciences, however. During his term as director, Johnson became managing editor of the *Encyclopedia of Social Sciences*, whose first edition of fifteen volumes was published in 1930. The wide world of the encyclopedia replicated the breadth of Johnson's vision—one that reached to the arts. In the encyclopedia's foreword, written by the economist Edwin Seligman, the arts were framed as a "creative activity…in contrast with science." "But," Seligman went on, "artistic creation is dominated by values and these are, at least in part, of social origin. No one who wishes to understand the operation of social laws in the modern world can afford to overlook the evidence offered by the arts." John Dewey's pragmatist treatise, *Art as Experience* (1934), reinforced this view of the functional role of the arts as a way to understand how the world worked; the arts were dependent on individual creativity and response, but also capable of articulating what bound people together in a particular moment. The arts were inherently modern and social because they were an active way of knowing and doing. They were research too.

By the 1930s, the arts at The New School had become an immersive experience, guiding its architecture, courses, and programming. Count Basie played the piano backdropped by Benton's mural *America Today*; students and faculty dined surrounded by Orozco's visions of revolutionary struggle and universal brotherhood; Camilo Egas's *Ecuadorian Festival* marked the entry to the dance studio.[1] Prominent and seemingly permanent, these artworks were the focus of the visual arts at the school for decades, even as smaller works were shown in exhibits and Gonzalo Fonseca's mosaic mural was commissioned for the new J. M. Kaplan lobby, an extension of the Urban building, in 1961. At the same time, the school consolidated its interests in the visual arts with dedicated funds from the philanthropist Vera List (who took classes at the school) to formalize an Art Center for exhibitions, along with an Art Collection whose express purpose was to collect transiently available as opposed to permanently sited works of art, and a shorter-lived Collectors Institute that trained people in the valuation and trade of art. Directed by Paul Mocsanyi, the Art Center hosted

exhibitions and public programs, often on contemporary political and social issues; *Hiroshima Panels* (1970), an exhibition of painted panels by Iri and Toshi Maruki, depicted the ongoing consequences of the American bombing of Japan, and other events protested U.S. involvement in Vietnam. Mocsanyi was also curator of the Art Collection, where he implemented List's vision of purchasing contemporary works to be displayed throughout the school's buildings, rather than remaining confined to the space of a gallery or the moment of an exhibition. These smaller, movable pieces could come and go; the modern ceded to the contemporary, and the Collection was intended to feature artwork that was "educationally important." The arts were made ever-present as provocation throughout the spaces of the school, in hallways, offices, and classrooms.

Such portable acquisitions did not make the declarative statement that the murals of the 1930s did. Yet, in some ways, by 1960, the school no longer needed to be so bold. It was now a well-known institution in the cultural landscape of New York. It enrolled over ten thousand people in its classes and included graduate and undergraduate degree programs. The smaller works acquired with List's funds made particular sense, too, in a rapidly changing art world where performance was intervening in the dominance of painting and sculpture, and lofts and outdoor spaces were becoming more appealing venues for art experiments than museums and universities. John Cage's celebrated courses taught at The New School in the late 1950s sparked a generation of students to move outside the classroom—and every other kind of institutional frame as well.

The New School, furthermore, had suffered from its political associations during the McCarthy era, and a particular artwork had emerged as an emblem of that struggle. Orozco's murals, and the hopeful view of revolution they espoused, had been embroiled in the broader debate over Communism in the U.S. Hoping to forestall unwelcome questioning by students, the public, and the media, in 1953 administrators hung a yellow curtain over the portion of the mural that depicted Stalin and Lenin. School officials worried about an outright attack on the piece, and looked into trying to sell it. Ultimately, the function of the room was changed, so that it became a meeting room for staff rather than a cafeteria and lounge. By the early 1960s, the curtain was removed with barely a notice—in part because students and the public no longer

frequented the space in which the mural is installed.

Contemporary arts came in to The New School, then, on a rotating basis, with a knowing appreciation for the offense art could provoke. In 1977, spurred again by the action of Vera List, The New School lent an office and small gallery space to Marcia Tucker, the founder of the New Museum, with its mission to exhibit recent works by living artists. The Art Collection continued its displays in the school's now-multiple buildings, as well as its program of buying and selling—even deaccessioning its most famous item, Benton's *America Today*, in 1984. (Not only had the mural cycle come to require more protection and conservation than the institution could provide, but it was at the time among the Collection's most valuable holdings, and the sale helped stabilize the school's finances.) Despite this loss, the merger with Parsons School of Design in 1970 intensified institutional commitment to arts education, a project further expanded with the formation of a contemporary jazz program in 1986, the joining of Mannes College of Music in 1989, and the addition of a drama school in 1994.[2] The school in this era operated largely as a federation of constituents rather than a university per se, and it was rare that the different parts met.

A university gallery show of the Japanese graphic designer Shin Matsunaga in 1989, in fact, summed up the difficulties in bringing such disparate parts together. On display among 350 other works in Matsunaga's exhibition was an advertisement for a milky soft drink that utilized a racist image once common in the U.S. The school erupted. Students and faculty from liberal arts and management programs asked the president to take the piece down; a professor—the artist and activist Sekou Sundiata—drew an X over the image, declaimed it as racist, and signed his name. Design students defended Matsunaga's work on the grounds of freedom of expression.

The Matsunaga Affair, as it became known, laid bare the politics of the arts, and that which constituted social research, in a new era. Protestors against Matsunaga's design asked, "Is racist art 'freedom of expression'?" President Jonathan Fanton's address to Parsons graduates in May 1990 tried to parse the controversy, pleading, "let us not frame the issue as if freedom of expression and freedom from intolerance are incompatible or are enemies." He believed that the university should have a critical function as a neutral

platform for disagreement, while remaining fierce in its advocacy against censorship of any kind. Others at the university insisted that the institution could not maintain such temporizing distance: the urgent issue demanded a specific position. Fanton resisted any action—the image and scrawled statements of protest over it remained in the show until its closing—and he defended inaction by claiming that censorship in this instance would only allow censorship in others. But the protest—and perhaps a new recognition of the depth and persistence of the challenge of systemic racism—made an impact. In the same speech, Fanton also demanded that artists and designers interrogate themselves regarding the use of content and imagery that might insult others.

This was a fine line to walk, and, increasingly, the national arguments of the culture wars—most heated in the policies of the National Endowment for the Arts (NEA)—arrived on campus. Just before the Matsunaga Affair erupted, the curator of the Art Collection, Kathleen Goncharov, initiated a commission for an artwork in a public space of the university, the first in almost sixty years. The NEA support for this commission, the Martin Puryear and Michael Van Valkenburgh courtyard installation (1997), then afforded an opportunity for the university to further decry, and refuse to sign, the federal agency's newly legislated anti-obscenity rider. This was a way for the university to take another stand against censorship, but unlike the defense of neutrality in the Matsunaga Affair, this action affirmed the political rights of women, minorities, gay men, and lesbians.

In the twenty years since the NEA contretemps, nine site-specific commissions have been added, reinvigorating commitment to the permanency and visibility of art at the school. This is surely due to the dedication of the curators of the Art Collection, from Goncharov to Stefano Basilico, Eric Stark, and Silvia Rocciolo. But it may also be due to broader moves by the university to integrate its different parts, hire and tenure more full-time faculty, offer more degrees: that is, to become a university in more recognizably conventional ways. New buildings and the artwork in them reflect the updated vision of the university as an ongoing institution that offers degrees and training, but also a tradition. The upstart school that began as a provocative rebuke to universities has become one of them.

The recent flourishing of site-specific commissions can thus recall earlier moments in the school's history, while also marking changes in the state of higher education and the contemporary understanding of arts as forms of social research. Women, African Americans, and Latinos are now among the artists featured. Kara Walker's *Event Horizon* (2005); Glenn Ligon's *For Comrades and Lovers* (2015); Alfredo Jaar's *Searching for Africa in* LIFE (1996/2014); and Agnes Denes's *Pascal's Perfect Probability Pyramid* (1980/2016) are notably political works that have been added to the Collection, while wall works by Sol LeWitt (*Wall Drawing #1073, Bars of Color [New School]*, 2003) and Brian Tolle (*Threshold*, 2006), along with Rita McBride's sculptural installation *Bells and Whistles* (2009–14), highlight abstraction and design, rather than protest as such, as media for stimulating social responsiveness. Dave Muller's *Interpolations and Extrapolations* (2002–03) and *Extensions* (2008) explore the evolution of the school's self-branding. These projects instantiate the contradiction of the school's legacy: an institution committed to responsiveness and change now bound self-consciously to a 100-year history as a "legendary progressive university."[3]

1 It is a common misconception that émigrés from The Frankfurt School of the Institute for Social Research in Germany were concentrated at The New School in the 1930s. The Frankfurt School, instead, was officially aligned with Columbia University; only one member, Erich Fromm, was affiliated with The New School, teaching there from 1941 to 1959. The University-in-Exile émigrés who did teach at The New School were collectively designated the Graduate Faculty in Political and Social Science and focused primarily on the social sciences rather than the arts. One exception (for a short time) was Brecht's collaborator, the Austrian composer Hanns Eisler, who was blacklisted by the House Un-American Activities Committee, and has not been much celebrated in New School history—although his professional influence, especially in regard to film scores, was considerable.

2 This was the Actors Studio, which remained affiliated with The New School until 2005, when the two institutions parted ways; subsequently the university's theater school was known as The New School for Drama; it was later renamed the School of Drama. An earlier theater program, the Dramatic Workshop, existed from 1940 to 1949, directed by another German émigré, Erwin Piscator.

3 This phrase appears in the first sentence of the description at the bottom of the university's homepage; a brief video introduction on the website is titled *The New School: A Progressive University in NYC.*

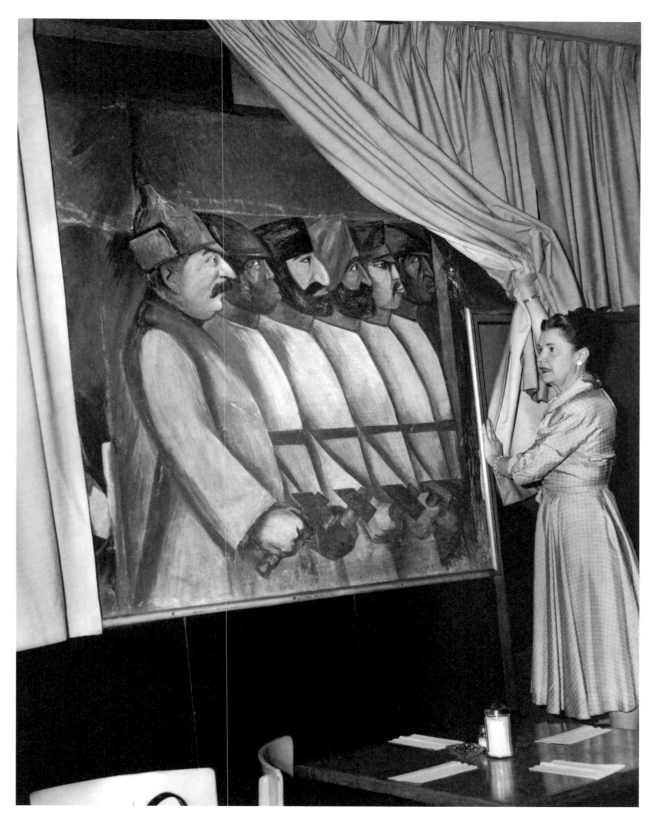

Unidentified New School administrator in a photograph from "New School Keeps
Red Mural Hidden," *New York Times*, May 22, 1953.

Living and Learning from the University Center to 66 West 12th Street; or, Arendt in Mar-a-Lago

Reinhold Martin

THE NEW SCHOOL'S UNIVERSITY CENTER, a "vertical campus" designed by Roger Duffy of Skidmore, Owings & Merrill, opened in 2014. Bookending the better part of a century's growth, the building invites comparison to its eminent forebear, 66 West 12th Street, the university's first purpose-built structure, which was designed by Joseph Urban and opened in 1931. The University Center responds to educational principles that have long contributed to The New School's uniqueness. But it does so at the very moment when those principles, unevenly applied, have become virtually ubiquitous in academia and beyond. Architecturally and institutionally, the building is therefore more of an enigma than it may initially seem. The New School has, by virtue of its singular institutional project and urban location, never been bound to a "campus" marked by traditional distinctions between inside and outside, or academic buildings and "social" ones. Nonetheless, its rededication to such mixture derives from and reflects the ever-increasing value placed today on knowledge gained through social interaction, with contradictory implications. Moreover, as a defining characteristic of The New School's institutional and architectural history, this combination of living and learning offers an unusual glimpse backstage, into today's salons of power.

Like other New School buildings, the University Center is filled with artworks from the school's extraordinary collection. But unlike those buildings, which were originally designed for uses very different from education, the University Center joins 66 West 12th Street in addressing its publics as a work of art in its own right.[1] The parallels begin on the facade, where Duffy's stark horizontal bands of outsized brass shingles echo Urban's horizontal brick stripes in larger form. On the inside, the new building includes a dormitory (Kerrey Hall), classrooms, a library, large and small lecture halls, and a cafeteria. The multipurpose center effectively bundles an entire campus into sixteen stories and realigns what was once necessity—a single, all-in-one building was all the still-new New School could afford in the 1930s—with a theory of education.

That theory, often tacit but widely applied in academic buildings around the world, goes like this: Knowledge is social, and learning is a social activity that extends beyond the classroom; hence, the entire campus is a learning environment, an extension of society rather than a space apart. Aspects of this idea can be traced to one of The New School's founding figures, the philosopher and educator John Dewey. But over the past century, the context for the idea has changed significantly. Design features originally aimed at throwing off the shackles of rigid teacher-student hierarchies, rote learning, and antidemocratic pedagogy have shifted toward training students and teachers alike in the governing norms of neoliberal sociability. Today efforts to nurture active, quasi-Deweyan learning are as likely to be found in the business world, especially the technology sector, as they are in educational institutions; paradigmatically, the nurturing of critical citizens has been replaced by the nurturing of gregarious entrepreneurs. Social competence and "imagination" have been

Twin staircase in the library, 66 West 12th Street, 1930s.

commoditized. In short, the tables have turned to such an extent that Silicon Valley office complexes routinely mimic college campuses by constructing an entire life-world of eating, playing, and socializing.

Colleges and universities, in the meantime, have responded by introducing social activities previously limited to "student centers" or "student unions" into academic spaces, and vice versa. The result deepens or exaggerates the resemblance of campuses to city-states responsible for across-the-board care of their constituents. Accompanying this change is the dissolution of spatial and social boundaries that, to some extent, had differentiated sites of learning from sites of "living." It is easy to compare this state of affairs, favorably or not, to the alleged rigors of the old-fashioned classroom—which was usually presided over by a white man who was authorized by social processes to expect the deference accorded a God-anointed patriarch. It is equally easy to understand the new sociability as an extension of the earlier collegiate tutelary function known as in loco parentis.

In contrast to the traditional hierarchical order, much of today's campus architecture emphasizes openness or transparency. Below 14th Street in Manhattan, no academic building does this as dramatically as does the University Center. But the conventions are notable as well in two sequential renovations to The New School's Arnhold Hall, a midblock, multifunctional loft building on West 13th Street that was once an R. H. Macy department store. The first renovation, by FXFowle in 2003, opened up the lobby and added a central stair leading to flexible teaching spaces on the second floor, surrounded by a gallery and space for informal gathering.[2] The second, by Deborah Berke Partners in 2015, reorganized the interior to accommodate the College of the Performing Arts and inserted a visually transparent "process lab" adjacent to the lobby. There, careful lighting and built-in seating combine to balance mingling and lingering against the classic quietude of scholarly or artistic concentration. Step into any academic building built or renovated in the past twenty years and you are likely to find some version of this balance, which is especially difficult to achieve in The New School's busy downtown setting.

Back at the University Center, the most visible expression of this learning-and-living mixture is not the interlocking functional spaces of the

interior. It is rather the faceted glass form that winds up and around the facade, interrupting the volume's shingled horizontality. Architecturally, the relative shapelessness of this transparent zone is no accident. It does not register the presence of a distinct space behind the glazed area. Rather, it acknowledges the up-and-down, in-and-out process that architects call circulation, which, in turn, reenacts the theory of education as social interaction. As in the flexible spaces at Arnhold Hall, the idea is this: Stairs, landings, and corridors are spaces of encounter. As such, they are to be celebrated, and should be afforded sufficient spaciousness and graciousness to give students, faculty, and their guests an occasion to pause, and perhaps to interact in ways that they might not in the classroom or, for that matter, the street. Failing that, such spaces should at least give students, faculty, and guests an occasion to *imagine* that they might have enjoyed such encounters, had their busy schedules or Instagram feeds permitted.

This is not to say that the University Center's serpentine stairs, or the lobby spaces at Arnhold Hall, fail to deliver the social frisson they promise; only that their main purpose is to stage its possibility. These zones are indicative of the designs' contemporaneity, their belonging to the learning-as-living story.

―――――――

"To dwell means to leave traces," wrote Hannah Arendt's friend Walter Benjamin in 1935.[3] The German Jewish Arendt escaped her French internment camp in 1940 and found safety in New York. (Benjamin, who sought similar sanctuary, did not.) Arendt would join the faculty at The New School only in 1967. But during the 1930s, the school offered refuge to dozens of German and Austrian intellectuals fleeing Nazi persecution in what became known as the University in Exile.[4]

Writing years later, the school's first president, Alvin Johnson, recalls that it was the needs of this University in Exile that prompted one of the most significant alterations to 66 West 12th Street. Now known as Alvin Johnson/J. M. Kaplan Hall, the building was designed by the émigré Viennese architect and stage designer Joseph Urban. Trim and nattily attired on the outside, 66 West 12th Street reveals its secrets on the inside. A sectional drawing in the school's archives shows it to be its own "vertical campus": a collage of functions with

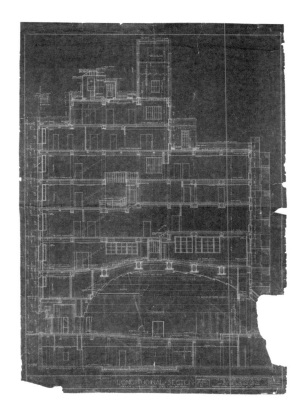

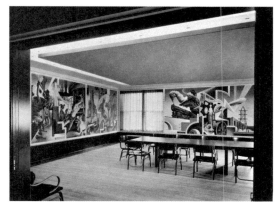

an ovoid auditorium on the ground floor, a dance studio in the basement, classrooms and offices throughout, and, originally, a double-height lounge/library on the fourth and fifth floors. Twin staircases supported by walls of books descended dramatically from the lounge to a reading room which, Johnson hoped, "would draw lounging students down the stairs to magazines and new books when conversation ran thin."[5] This arrangement was altered in the mid-1940s to meet the needs of the new Graduate Faculty, made up mostly of the exiled Europeans. Not for the last time, one phase in The New School's life was overwritten by another.[6]

Conceived by a group of dissident academics, the school was centered on the principle of intellectual exchange; in addition to Dewey, its founders included the economist Thorstein Veblen and the historians Charles Beard and James Harvey Robinson. Their coming together was partly occasioned by the decision, in 1917, by Columbia University's president, Nicholas Murray Butler, to fire two faculty members, the literary scholar Henry W. L. Dana and the psychologist James McKeen Cattell, for expressing opposition to U.S. participation in World War I. Beard and Robinson resigned their positions at Columbia in protest and joined their colleagues Dewey (who remained at Columbia) and Veblen (then a freelance writer) to establish a "New School for Social Research" dedicated to adult education, which opened its doors in 1919.[7]

By 1929, when Urban was hired, the institution had outgrown its original quarters, in a row of six townhouses on West 23rd Street. Johnson had narrowed his list of architects to the incongruous pair of Urban and Frank Lloyd Wright but, apparently fearing Wright's imperiousness, opted for Urban— who had emigrated in 1912 to become artistic director of the Boston Opera. In 1915, Urban moved to New York to serve as stage designer for the Ziegfeld Follies and from there to design a new home for the Metropolitan Opera. Although that project fell through with the onset of the Great Depression, he completed extravagant designs for the opera and was well connected to New York society. Urban designed the Atlantic Beach Club in Long Island and the opulent roof garden at New York's St. Regis Hotel, in which his ties to the Vienna Secession are especially evident; in addition, he produced not only the International Magazine Building on Eighth Avenue but also a series of film sets for the building's owner, William Randolph Hearst.

"I expected to be struck dumb," Johnson writes, "when face to face with the great man. But with all his visible power, he was so understanding, so charming, that I found myself almost eloquent in describing the New School, its character, its aspirations, its meaning for education and for society."[8] Thus began a partnership that attended to every detail of the new building, including the distribution of ninety-odd colors throughout the interior, which Urban orchestrated in spatial and perceptual sequences.[9] In his memoir, Johnson recounts the process: He would identify the likely use of a room, based on which Urban would develop a scheme on the principle that walls ought not to be all of the same color. Why? Because that color would shift subtly as a result of variable lighting, distracting what Johnson called the "eyes of the audience" with too much nuance, whereas, as he put it, "if the eyes flit from one strong color to another the audience is wakeful to the lecture."[10]

Johnson had his own theories about the psychology of academic space, arguing that large rectilinear halls distract shy lecturers ("and most lecturers who have anything to say are shy") with their high ceilings and embarrassingly small audiences. To address this problem, Johnson proposed an ovoid space for the auditorium, a "half-eggshell" which "tends to draw the audience together."[11] Urban obliged with a theatrical crescendo of concentric, contoured gray surfaces emanating from the ceiling, perforated to reduce reverberation and separated by reddish orange recesses intercut with bands of electric light.

The effect was a sort of starburst, and many luminaries, including Arendt and Wright, lectured there.[12] Indeed, there is a scene in Margarethe von Trotta's 2012 film *Hannah Arendt* in which Arendt is shown leaving her lecture class, book and briefcase in hand, and accompanied by students as she goes down the stairwell of a modernist academic building with bright yellow interior walls, on which metal lettering reads, "James A. Newman Auditorium"— a fictionalized version of the actual Bernhard Mayer Auditorium in Urban's building.[13] The camera follows Arendt as she walks past a horizontal window with a metal grille similar to those on the front doors at 66 West 12th Street; it then cuts to her smoking on the sidewalk in front of the New School building. Later in the film, a student approaches Arendt's longtime colleague Hans Jonas in the same stairwell, to ask about Arendt's recently

published report (in a series of five articles for the *New Yorker*) on the war crimes trial of Adolf Eichmann.[14] These scenes conflate several periods. But in addition to depicting just the sort of productive stairway encounter that design regimes like that of the University Center seek to promote—and, not incidentally, displacing the image of the professor as patriarch—von Trotta's scenarios point to the symbolic importance of the auditorium and its lobby in New York intellectual life.

Sixty-six West 12th Street is a quintessentially modern building; with its streamlined profile, striped-brick facade, and horizontal bands of windows, it was sufficiently restrained for Philip Johnson to recognize Urban as "having produced the illusion of a building in the International Style."[15] However, unlike Johnson, whose politics were reactionary, as progressive modernists the faculty in the 1930s was uncompromisingly opposed to the propaganda that had arisen in both Germany and the Soviet Union and, well before Arendt's study of the topic, had dedicated itself to studying totalitarianism and its origins and consequences.[16] In fact, the Graduate Faculty stipulated in its founding charter (1933) that "no member of the faculty shall be a member of any political party or group which asserts the right to dictate in matters of science or scientific opinion."[17]

But modernism, of course, has many sides. Urban's Mayer Auditorium is often cited as the main source for Edward Durell Stone and Donald Deskey's Radio City Music Hall, designed in 1940 for the impresario Samuel "Roxy" Rothafel. While still in Vienna, Urban himself staged elaborate exoticisms for Abbas II, khedive of Egypt. What to make, then, of the fact that an architect accustomed to designing lavish princely fantasies should come to build a home for the rationalist, left-leaning University in Exile? How could Alvin Johnson, who had traveled across Europe to rescue a group of austere social democrats skeptical of capitalist excess, work intimately with an architect only too prepared to indulge modernity's stage-managed cults of capital and of power?

Hearst and the Egyptian khedive were not the only incongruous clients on Urban's list. Just prior to receiving the New School commission, he had accepted an invitation from Anthony Drexel Biddle, Jr., scion of the Philadelphia banking family and an investor in the St. Regis Hotel, to design the Bath and Tennis Club in Palm Beach, for which the

architect earned an honorary membership along with his fee. The club was immediately adjacent to Mar-a-Lago, the residence of Marjorie Merriweather Post of the Post cereals fortune, and it threatened to block her ocean views. Anticipating conflict, Biddle brokered a meeting between Urban and Post, who was sufficiently taken by the same charm Alvin Johnson had reported that she invited the architect to transform Mar-a-Lago's first floor into a Gatsbyesque theater of new money, the gilded ceiling in its grand salon copied from the fifteenth-century original in the Gallerie dell'Accademia in Venice.[18]

A vivid sense of history's sarcastic twists is offered by the *New York Evening Post*, describing Urban's decorations for (of all things) a St. Patrick's Day dance in 1927:

> Under the magical artistry of Mr. Joseph Urban the club was transformed into a dazzling scene of splendor, depicting scenes from "A Thousand and One Nights," a street scene from Bagdad [*sic*], and colorful and beautiful vistas of the orient. The patio represented a harem with guests seated on large satin cushions of brilliant colors. At one side was the golden throne of the prince.[19]

"Arendt in Mar-a-Lago" would be one name for the contradictory truth wherein the "origins of totalitarianism" lie not only in the suspension of the rights of citizenship, as the exiled philosopher argued, but socially, in backstage dinners and members-only clubs festooned with the convivial trappings of capital. Even now, in The New School's friendly new stairways, Arendt's voice echoes:

> Never has our future been more unpredictable, never have we depended so much on political forces that cannot be trusted to follow the rules of common sense and self-interest—forces that look like sheer insanity, if judged by the standards of other centuries.[20]

These are the contexts into which the new University Center, like the rest of The New School and like all other institutions of higher learning in the United States, has been thrust. It is neither too early nor too late to learn the lessons such histories have to teach.

Note: I would like to thank Agnes Szanyi for her assistance with research related to this text.

1 Examples of buildings so adapted are the Albert and Vera List Academic Center, at 6 East 16th Street, and Fanton Hall, at 72 Fifth Avenue.

2 In 2018, FXFowle became FXCollaborative.

3 Walter Benjamin, "Paris, the Capital of the Nineteenth Century" (1935), trans. Howard Eiland, in *Walter Benjamin: Selected Writings*, vol. 3, 1935–1938, ed. Howard Eiland and Michael W. Jennings (Cambridge, MA: Belknap Press of Harvard University, 2002), 39.

4 For a list of exiled scholars who taught at The New School between 1933 and 1945, see The New School History Project: "University in Exile," http://newschoolhistories.org/hstrs/university-in-exile/ (accessed June 26, 2018).

5 Alvin Johnson, *Pioneer's Progress: An Autobiography* (New York: Viking Press, 1952), 322.

6 Between 1956 and 1959, a campus extension project razed brownstones on West 11th and West 12th Streets in order to erect two interconnected buildings for the school. On West 12th Street, the Urban building was linked by a new lobby to the J. M. Kaplan addition, and the paired structures were renamed Alvin Johnson/J. M. Kaplan Hall. A midblock courtyard led from the new lobby to the new Albert List Building at 65 West 11th Street (now Eugene Lang College of Liberal Arts). The architects of the multipart extension were Mayer, Whittlesey & Glass.

7 Peter M. Rutkoff and William B. Scott, *New School: A History of the New School for Social Research* (New York: Free Press, 1986), 84–106.

8 Johnson, *Pioneer's Progress*, 320.

9 Randolph Carter and Robert Reed Cole, *Joseph Urban: Architecture, Theatre, Opera, Film* (New York: Abbeville Press, 1992), 204. See also John Loring, *Joseph Urban* (New York: Abrams, 2010).

10 Johnson, *Pioneer's Progress*, 322.

11 Ibid., 323.

12 Although there is no definitive list of speakers in the Mayer Auditorium, weekly announcements appear in the *New School Bulletin*. For example, a new course offered by Arendt, The Great Tradition and the Nature of Totalitarianism, is announced for Wednesday evenings (most likely in 8the auditorium) in March and April 1953, in the *New School Bulletin* 10, no. 28 (March 1953): 2. The *Bulletins* are available online at The New School Digital Archives and Special Collections Digital Archive, http://digitalarchives. library.newschool.edu/index.php/ Detail/collections/NS030102 (accessed September 21, 2018). Wright is also frequently cited as a New School lecturer.

13 Originally dedicated as the Bernhard Mayer Auditorium, the hall was renamed Tishman Auditorium in 1993. It is now known simply as the Auditorium at 66 West 12th Street. Bernhard Mayer was the father of Albert Mayer, a New School trustee and principal (with his brother Charles) of the firm Mayer, Whittlesey & Glass. Their sister Clara Mayer, a key fund-raiser for the 66 West 12th Street building project, served as dean of the School of Philosophy and Liberal Arts (1943–61) and vice president of the New School for Social Research (1950–61).

14 Arendt's articles, collectively titled "Eichmann in Jerusalem—I–V," appeared in the *New Yorker* from February 16 to March 16, 1963, and are available online at https://www.newyorker.com/search/q/Eichmann%20in%20Jerusalem (accessed May 31, 2019). They were collected as *Eichmann in Jerusalem: A Report on the Banality of Evil* (New York: Viking Press, 1963).

15 Philip Johnson, "The Architecture of the New School," *Arts*, March 1931, 393, quoted in Carter and Cole, *Joseph Urban*, 209.

16 Rutkoff and Scott, *New School*, 107–27. On Philip Johnson's involvements with National Socialism, see Franz Schulze, *Philip Johnson: Life and Work* (New York: Albert A. Knopf, 1994), 132–43.

17 Charter of the Graduate Faculty (1933), quoted in The New School for Social Research Curriculum, 1940–41 (circa 1940). The New School Archives and Special Collections Digital Archive, http://digitalarchives.library. newschool.edu/index.php/Detail/ objects/NS050101_ns1940ye [New School course catalogs; Schools of Public Engagement; General course catalogs] (accessed June 26, 2018).

18 Carter and Cole, *Joseph Urban*, 173–74.

19 "Annual St. Patrick's Day Dance...," *New York Evening Post*, March 5, 1927, quoted in Carter and Cole, *Joseph Urban*, 176.

20 Hannah Arendt, "Preface to the First Edition," *The Origins of Totalitarianism*, 2nd ed. (New York: Harcourt Brace Jovanovich, [1951] 1973), vii.

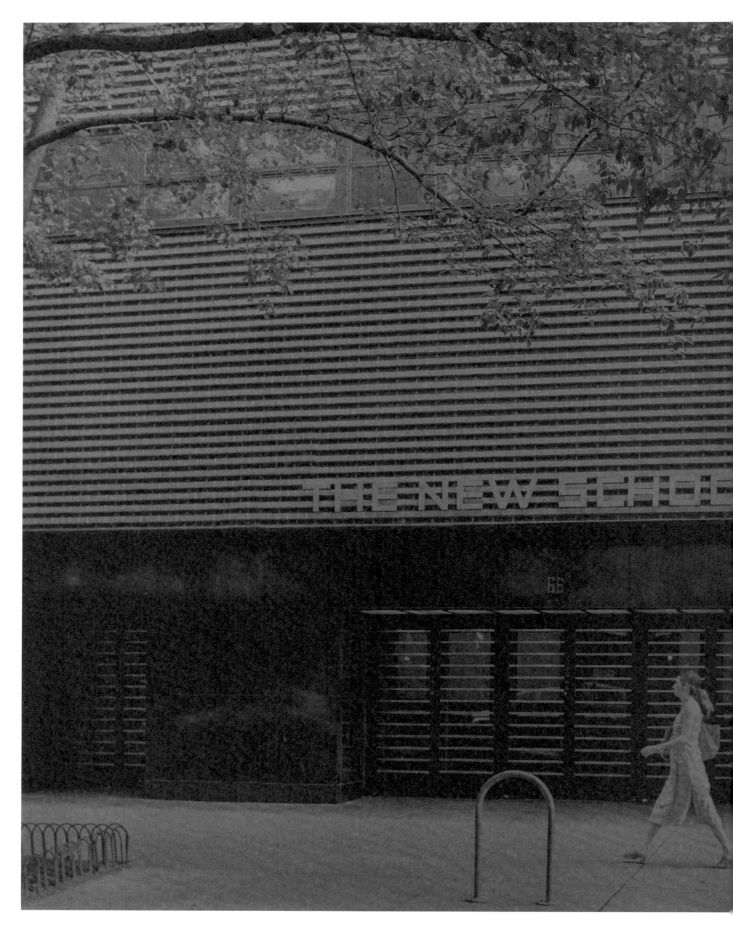

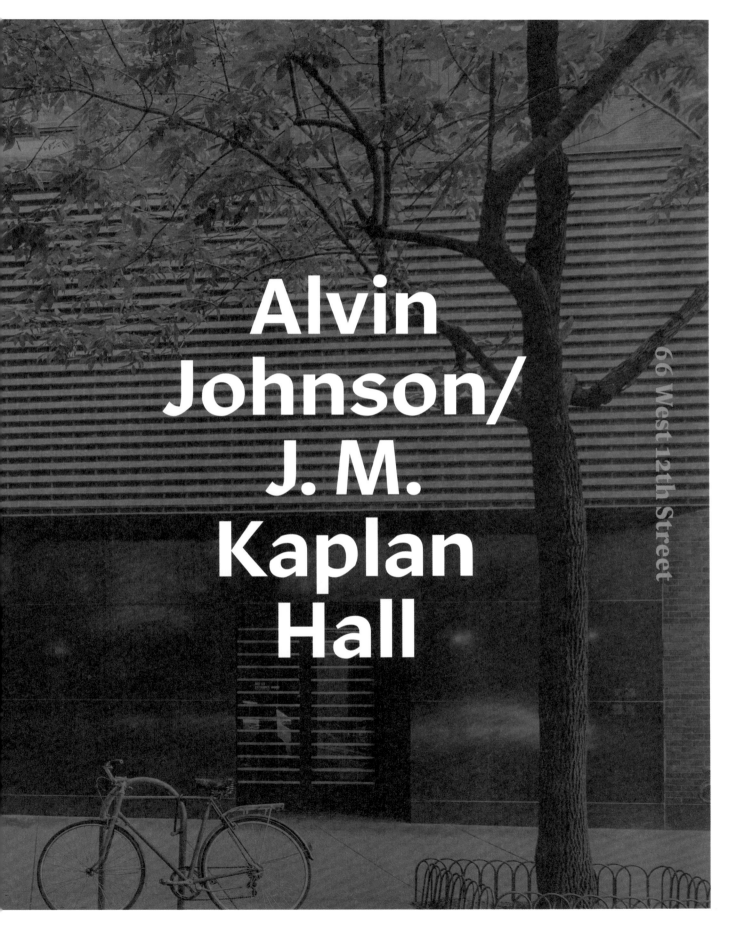

Alvin Johnson/ J. M. Kaplan Hall

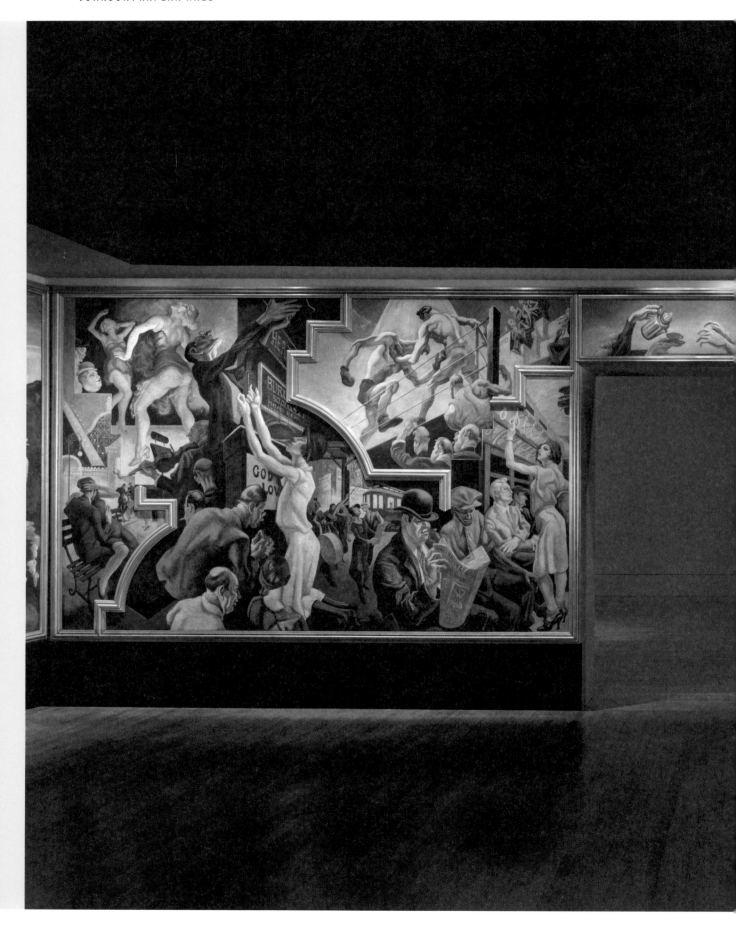

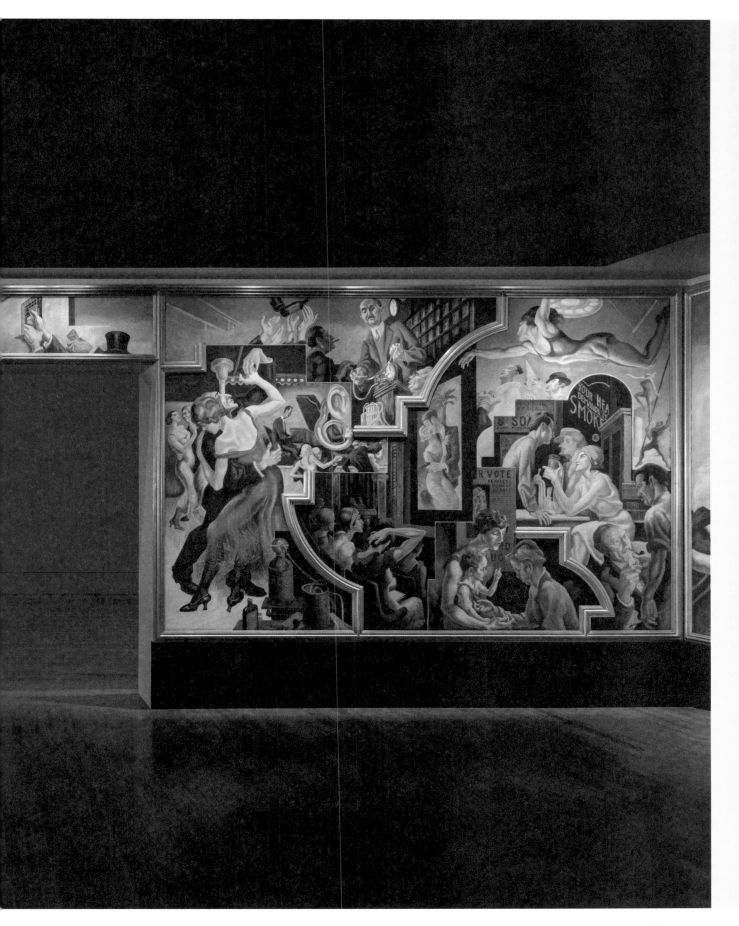

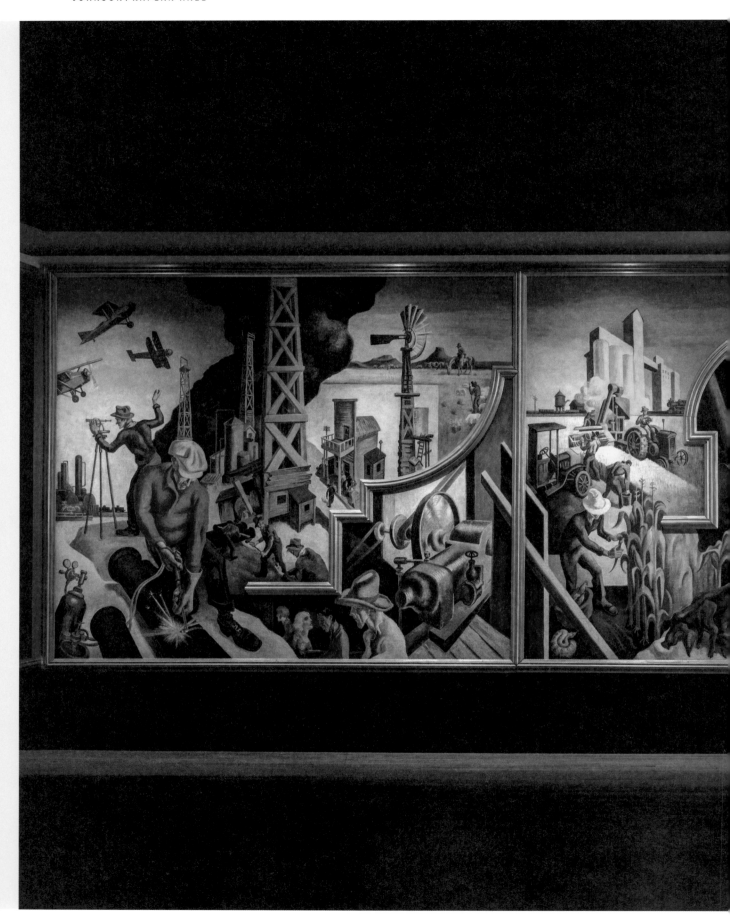

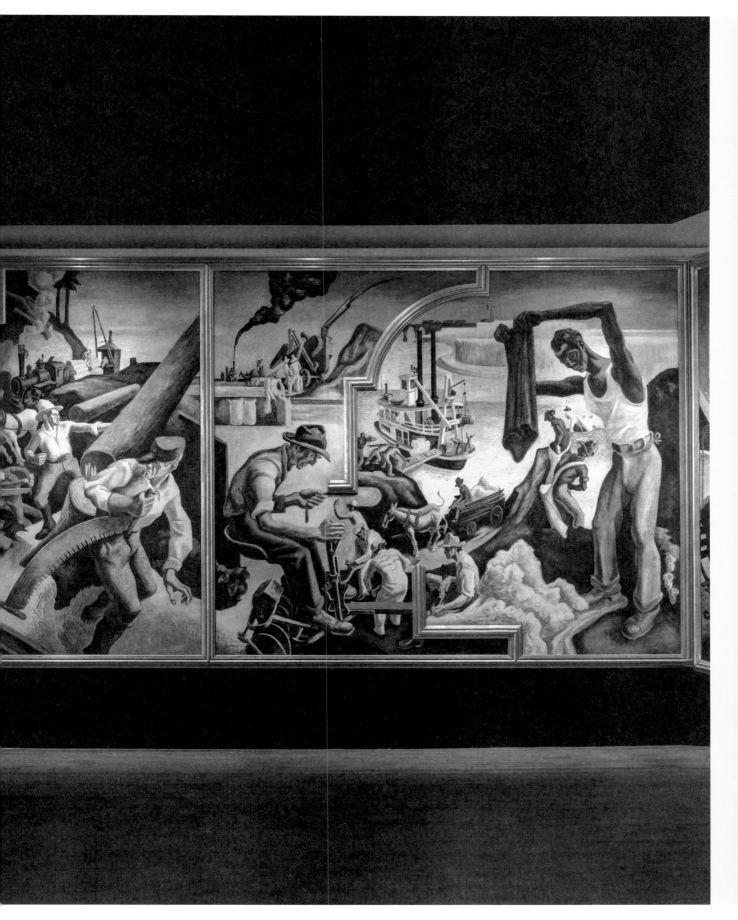

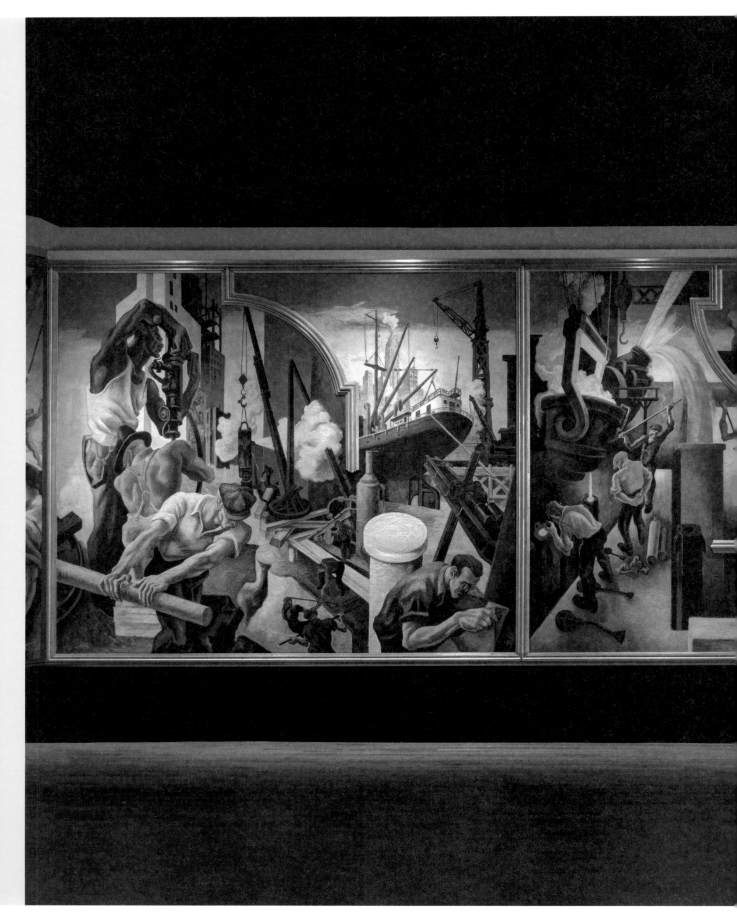

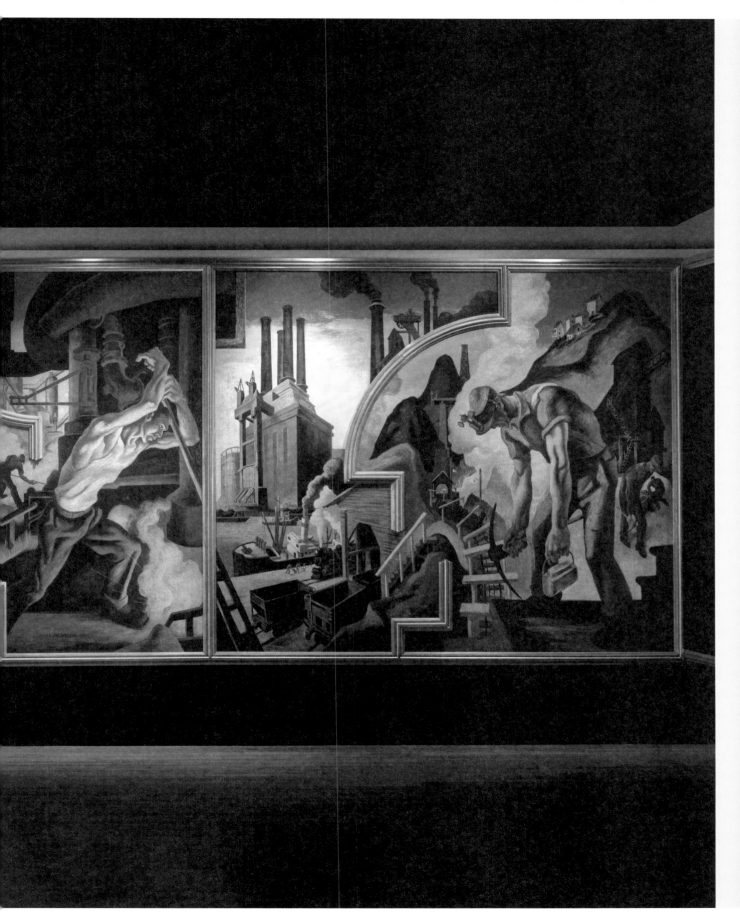

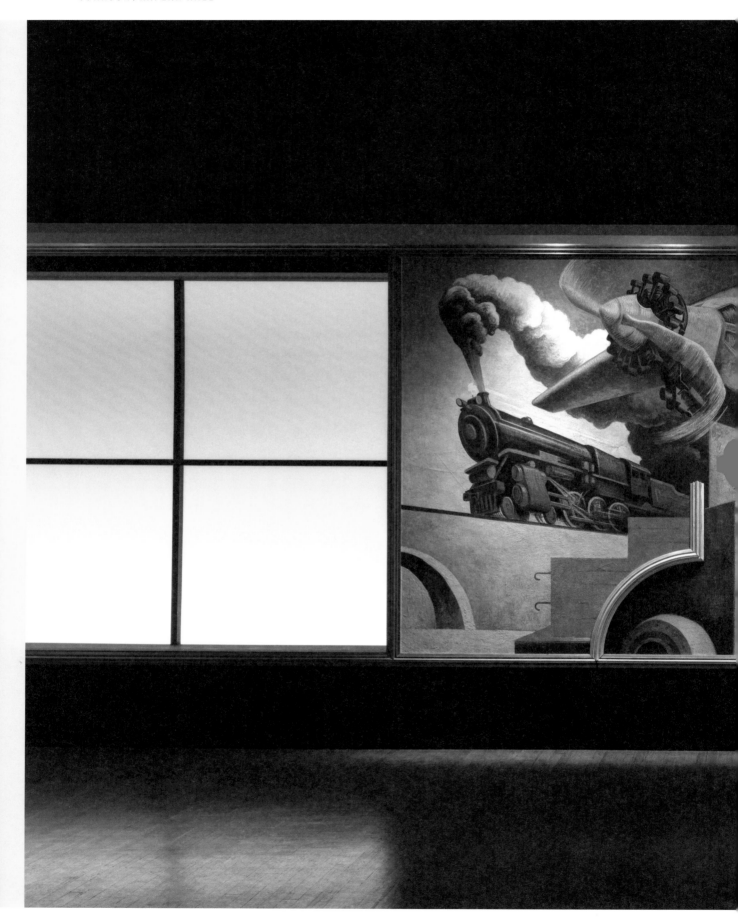

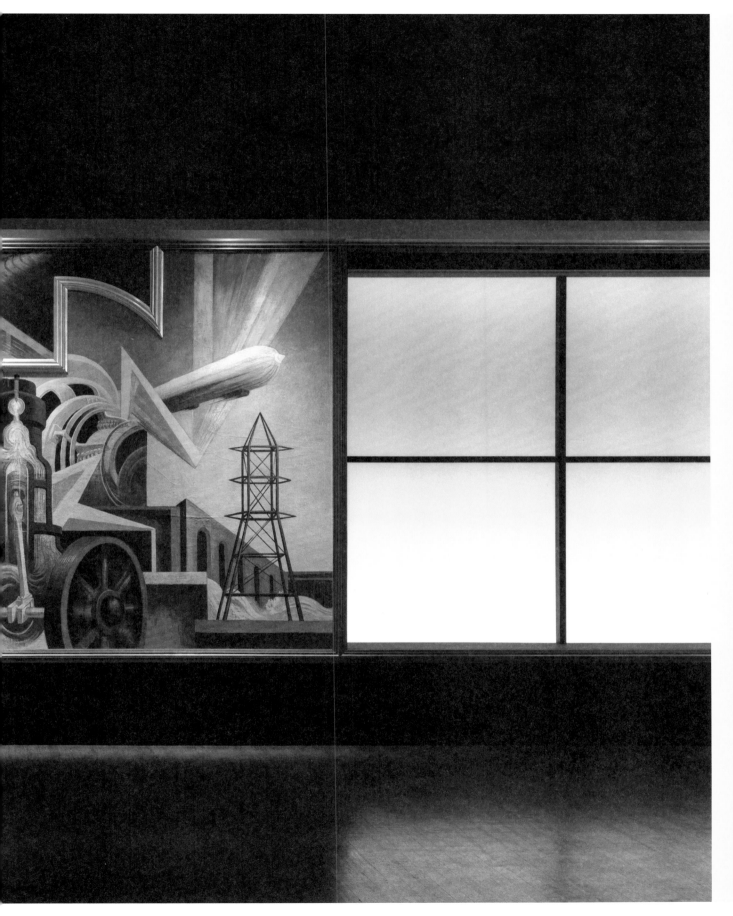

Thomas Hart Benton

America Today
1930–31
Egg tempera on linen
(Now in the collection of
The Metropolitan
Museum of Art, New York)

From The New School to The Metropolitan Museum of Art: The Odyssey of Thomas Hart Benton's *America Today*

Randall Griffey

IN APRIL 1930, NEW SCHOOL DIRECTOR Alvin Johnson extended to Thomas Hart Benton a career-changing opportunity to complete a mural for the boardroom in the institution's new building designed by Joseph Urban. After nine months of work in his Greenwich Village studio, Benton—who for years had longed for such a public commission—delivered an ambitious ten-panel series he called *America Today*, which debuted to considerable acclaim when the building opened in January 1931. Over time, however, the panels endured damage and benign neglect, conditions that led to the university's sale of Benton's series in 1982. Today, the mural, a veritable time capsule of American culture at the onset of the Great Depression, appears reassembled in The Metropolitan Museum of Art. The mural's rather harrowing odyssey—from an institution of higher learning to a corporate collection to a preeminent museum—highlights the degree to which *America Today* became an index of the shifting tastes and biases that followed World War II.

Offering a panorama of American life in the 1920s, *America Today* promotes an idea of "progress" predicated on modern technology and heroic labor even as it calls attention to the country's economic crisis. The largest of the panels, *Instruments of Power,* includes a rushing train at left, a monoplane, and a cross section of a combustion engine; a hydroelectric dam and tower at right evoke the production and distribution of electricity,

PAGES 34–41: Details from Thomas Hart Benton, *America Today*, 1930–31.
PAGES 34–35: *City Activities with Subway, Outreaching Hands,* and *City Activities with Dance Hall.*
PAGES 36–37: *Changing West, Midwest,* and *Deep South.*
PAGES 38–39: *City Building, Steel,* and *Coal.*
PAGES 40–41: *Instruments of Power.*

demand for which had skyrocketed throughout the decade preceding Benton's work. The grain silos in the panel *Midwest* echo the skyscrapers in *City Building*, while the downtrodden African American cotton worker in *Deep South* and the muscular construction worker in *City Building* serve as historically symbolic bookends to the series. The two panels that originally flanked the boardroom's doorway present leisure activities during Prohibition: enjoying jazz in dance halls, socializing in soda shops, imbibing (illegal) alcohol in speakeasies. Nevertheless, elsewhere, signs for businesses closing and a stock-market monitor worriedly studying a ticker tape remind the viewer of the crash. The smallest panel—which Benton reportedly added after he came to realize the severity of the national situation—shows only hands reaching for bread and other hands holding money adjacent to a top hat, an indirect but unmistakable reference to robber barons in the mold of J. P. Morgan. This marks the artist's most explicit indictment of the capitalist greed that he and many others believed had precipitated the collapse.

Benton painted *America Today* in a dynamic, restlessly figurative style that reflects his study of Italian Mannerism. His figures' pantomimed gestures likewise recall early film. Yet the artist worked from life sketches he had made while traveling in the regions he depicted, and people he knew were included in his emblematic scenes. Jackson Pollock, Benton's student at the time at the Art Students League, modeled for several figures, in particular a lean steelworker in the *Coal* panel. In the panel known as *City Activities with Dance Hall*, Benton's wife, Rita, looks on as their son, Thomas Jr. (T. P.), receives instruction from the progressive educator Caroline Pratt. Nearby, Alvin Johnson appears beside Benton himself, the two clinking glasses.

Among the mural's most distinctive features are the original aluminum-leaf wooden moldings, which not only frame the panels but create inventive spatial breaks within every composition. An architectural rendering of the boardroom discovered in a storage room by Facilities staff and Collection curators at The New School in 2009 provides a bird's-eye view of the plan, including individual elevations of each wall (opposite). The drawing shows the moldings as they appear in Benton's final design,

suggesting that the architect (rather than the artist) developed this unique element; the moldings harmonized with streamlined architectural details throughout Urban's building.

Third-floor boardroom of Johnson/Kaplan Hall (66 West 12th Street), 1930. Drawing by Joseph Urban.

America Today was praised by critics from its inception; after seeing it in progress in the artist's studio, Edward Alden Jewell wrote in the *New York Times*, "Thomas Hart Benton is really speaking out with the full force of his spiritual bellows."[1] Benton soon thereafter gained influential patrons, such as Gertrude Vanderbilt Whitney, and was offered further commissions, among them a mural about the history of the State of Indiana for the 1933 Chicago World's Fair. On December 24, 1934, his self-portrait graced the cover of *TIME* magazine, making him the first artist to appear in this context. For the remainder of his life, Benton recognized

1 Edward Alden Jewell, "Orozco and Benton Paint Murals for New York. Gesso and True Fresco: Artists Produce Work in the Modern Spirit for the New School for Social Research," *New York Times*, November 23, 1930, 120.

that his success owed much to the opportunity the commission had afforded him; he reflected in a letter to then New School President John Everett in December 1972: "As you know, I have an attachment to the New School Murals because they are the first I executed for a public place—and a remembered attachment for the man who made them possible."[2] (Johnson had died in June 1971).

In 1982, The New School announced that it would sell *America Today*, which had proved difficult and costly to maintain, particularly after the boardroom was co-opted for use as a classroom because of an influx of students following World War II. In the intervening years, Benton's artistic reputation had declined precipitously in the context of a larger cultural tendency to dismiss art of the Depression era as kitsch. In addition, Benton, who corresponded with New School officials over many years in efforts to determine effective means of protecting the panels in their original context, died in 1975, so he could not oppose the school's decision. However, help came from another quarter; spurred by his special aide Herbert Rickman, New York Mayor Ed Koch became convinced of the work's cultural significance and spearheaded a campaign to keep the panels from being dispersed when sold (which would, in effect, destroy the mural). AXA, the global insurance company, bought the complete work in 1984, underwrote its full conservation, and displayed the panels—albeit out of the order that the artist intended—in two successive corporate headquarters in Manhattan.

In 2011, AXA gave *America Today* to The Metropolitan Museum of Art. Installed since 2014 in the American Wing, *America Today* not only bolsters the artist's posthumous reputation, but encourages a resurgent appreciation of American art of the 1930s. Indeed, the cycle has seemed relevant again in the wake of the global recession in 2008 and the prolonged recovery that followed, with its heated debates regarding the privilege of the so-called One Percent. Benton's over-door panel showing the top hat and money-grubbing hands once again resonates as profoundly prescient.

2 Thomas Hart Benton to John R. Everett, December 22, 1972, New School mural collection, NS.03.05.01, box 1, folder 5, The New School Archives and Special Collections, The New School, New York.

The Ghost of Progress Past

Luc Sante

THOMAS HART BENTON'S SERPENTINE BODIES, lean and gnarled, twisting diagonally across the picture plane in a display of musculature and will and, occasionally, torment, are the ghosts of an idea of progress that still walks among us, dragging its chains. *America Today*, the mural he completed for The New School in 1931, is an artifact from the height of that idea: the pre-Depression United States, where industry and agriculture and entertainment and even art were joined in a mighty upward struggle that was sure to result in the ideal society envisioned, if dimly, by the nation's founders. Progress required strong arms and backs; the country was hiring; workers could see and measure the products of their labor. For a while nobody was complaining too much about the injustices of wealth distribution—pretty much everybody was housed and fed.

"The release of energy was terrific and, even to those who like myself did not share much in the benefits, inspiring," Benton later wrote. "What person, sensitive to human drama, could have helped being stirred by this 'devil take the hindmost' race, this display of power, immense greed, and superhuman confidence?"[1] Benton, a native of Missouri, was educated in art schools in Chicago and Paris. In 1912, he moved to New York City. Twenty-three years later, alienated by left-wing cosmopolitanism, he reverted to form and moved back to Kansas City, but in the meantime he had absorbed modernism by osmosis, perhaps despite himself. *America Today* shows that he had at least been looking at the works of José Clemente Orozco and Diego Rivera; Orozco, who was painting his own mural at The New School at the same time, was a particular influence. The fluid rhythms and epic sweep of the Mexican artists made their way into Benton's work, helping choreograph his Regionalist imagery, ostensibly all-American, if

1 Thomas Hart Benton, "American Regionalism: A Personal History of the Movement" (1951), quoted in Emily Braun and Thomas Branchick, *Thomas Hart Benton: The America Today Murals* (Williamstown, MA and New York: Williams College and Equitable Life Assurance Society, 1985), 19.

with muscle memory from El Greco and more than a hint of Social Realism from the Soviets. Benton was paid for his work in eggs—he made egg tempera, the traditional mural medium, in the traditional way.

The ten panels of *America Today*, which originally ran around a boardroom, accommodating themselves to its doors and windows, are individually framed by molding which also runs into the panels themselves, in darting segments of curves and right angles. For all the influence of the Mexicans and Soviets, the present-day viewer (conditioned by such later things as WPA murals in rural post offices, themselves strongly influenced by Benton's work, which succeeded in setting the terms of socially engaged art in the U.S. for a generation) may well be reminded mostly of the decorous civic boosterism of the past, of world-conquering brochures issued by doomed industries or the endpapers of defunct encyclopedias.

The series begins with *Instruments of Power*: a steam engine that leans forward in its haste; an airplane revving up its propeller; a zeppelin flying dangerously near a transmission tower (seven years before the *Hindenburg* disaster); assorted wheels and dynamos—the pulse of the growing nation. This is followed by *Deep South* (riverboats and cotton; a black man dumping out his sack, his trousers held up by a rope); *Midwest* (sawyers and corn farmers, with a titanic grain elevator looming in the distance); and *Changing West* (oil derricks, boomtowns, a sky filled with airplanes, while at upper right, the cowboy and the shepherd continue their lonely watch). In *City Building*, men of all races haul and heave, drill and plane, surrounded by billowing steam, partly constructed high-rises, assorted engines, cranes, and a boat in dry dock. *Steel* features white men poking long rods into the flames and tipping buckets of red-hot ore as dawn or dusk gathers beyond. In *Coal*, two white men bent double stagger through, clutching their pickaxes against a backdrop of coal face, slag heap, chimneys, boxcars, a freighter.

City Activities with Dance Hall follows, lifting the exhausted and dutiful mood with a muscular fox-trotter in a semitransparent red

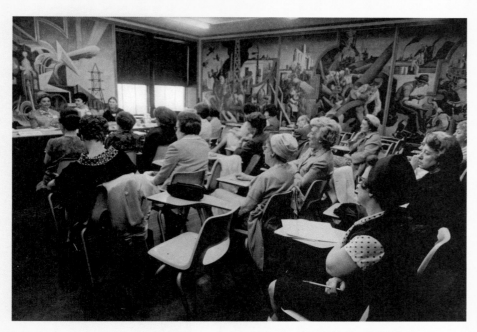

Peter Moore. Thomas Hart Benton, *America Today*, 1930-31, installed in a boardroom
repurposed as a classroom at 66 West 12th Street. 1950s.

dress; a trapeze artist; a woman in a cloche hat in earnest conversation
with a soda jerk; a row of women in cloche hats taking in a sultry Holly-
wood picture, and also—reminding us of the world's gravity—a stockbro-
ker inspecting a ticker tape and a teacher or doctor inspecting a child. *City
Activities with Subway* continues with burlesque dancers, a boxing match,
an evangelist, a couple necking on a bench, a rollercoaster, a straphanger.
Finally a thin panel called *Hands*, originally situated over a doorway, shows
hands pouring a cup of coffee, others clutching for it, yet others clutching
greenbacks, the top of a top hat, against what might be a jail. And that is
the one and only time in the series that discontent is suggested, however
obliquely. *America Today*, with its soft colors and obligatory optimism, is
antique in its mood, its message, its moral. It is a mighty achievement, but
it has not aged well.

Paid in Eggs

Mira Schor

THE HISTORY OF *America Today*, Thomas Hart Benton's 1931 mural for The New School, is complex: The paintings have been restored four times, twice by the artist; the work has been moved at least four times; and of all the works examined in this volume, only Benton's has been deaccessioned.

When the latest episode of this history was made public through the 2014 acquisition and installation of the piece by The Metropolitan Museum of Art, I went to see it, intrigued in particular by its relation to The New School—where I have been an adjunct professor since 1989 (the mural cycle had been sold in 1982 to the first in a series of new owners). I have to admit that I was most interested in the charming information offered by The Met's wall text: Benton was paid in eggs, to mix the egg tempera he chose as his medium. Here, then, I consider the meanings I read into this story.

With the advent of pure abstraction in Western painting, figuration was problematized: If representation was now optional, how was one to approach it? Abstraction itself offered a number of directions, from geometric to biomorphic, and often the result was a twentieth-century mannerism. Artists in the United States between the wars had to deal with the lure of the modern and the dominance of European aesthetic ideologies, the cultural conservatism of the general American population, and a responsibility to address social issues as the Depression set in. The stylizations that resulted can age badly; in terms attributed by Barnett Newman to Meyer Schapiro, the subject matter (a gestalt encompassing the handling of paint and the articulation of space and human scale) can overtake the object matter (the objects represented in the painting, and by extension the ideological program of the work).[1]

1 Barnett Newman, "Interview with Emile de Antonio," in *Barnett Newman: Selected Writings and Interviews*, ed. John P. O'Neill (New York: Alfred A. Knopf, 1990), 303.

Thomas Hart Benton, *America Today* (*City Activities with Subway, Outreaching Hands,* and *City Activities with Dance Hall*), 1930–31 (detail). Portrait of Rita Piacenza Benton (in red blouse) with the Bentons' son Thomas Jr.; Alvin Johnson with pipe, and Thomas Hart Benton with drink (far right).

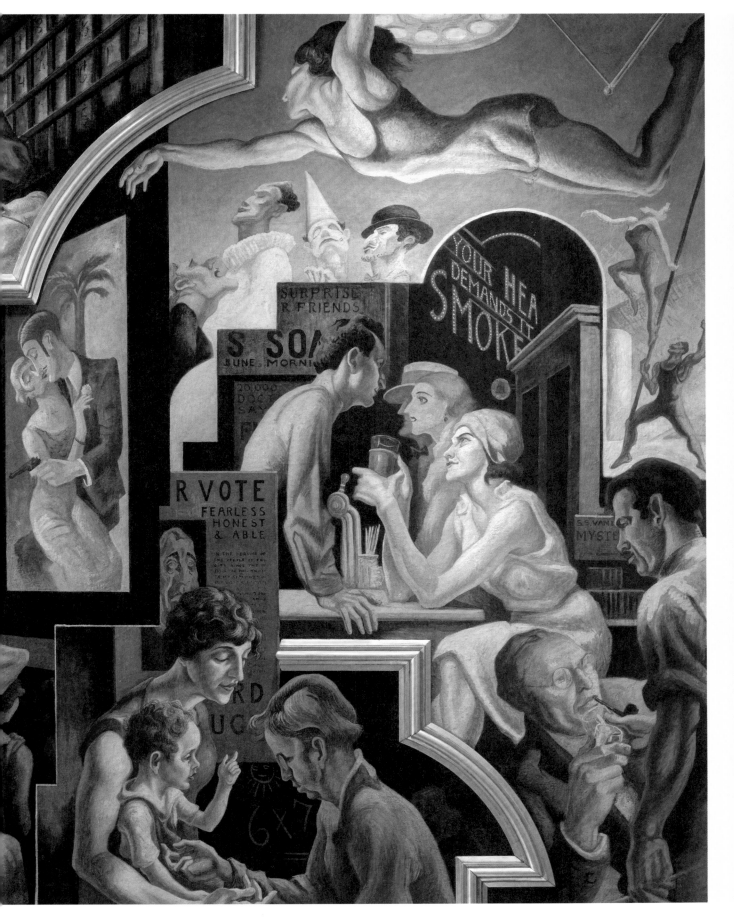

America Today embodies the dilemma of this moment. Benton is not my favorite artist, in part because of his mannered style, and yet I admire the labor of the piece, am compelled by its ambition; I am critical of the heroic, heavily muscled figures working in the foreground, but I don't mind what he does to trains and factories, and I really like how he depicts electric towers and coffeepots. Research reveals that my response is consistent with a polarization in the mural's reception over the decades. So, is the problem the hyperbolic figuration? Or is the datedness more reflective of Benton's political position in the early thirties, as a Marxist turned anti-Stalinist; a Midwesterner caught between the conservatism of his roots and the intellectual ferment of the cities? Whose side was he on? The industrialist's or the worker's? The mural does not establish a clear position.

The theme of *America Today* is the shift from an agrarian economy to an industrialized one, represented in a positivist way—workers here are triumphal, rather than downtrodden like the masses in *Metropolis* (1927), or driven mad by mechanization, like Charlie Chaplin's character in *Modern Times* (1936). Which brings me to the eggs: Once I learned about Benton's "payment," it was hard to think about the mural other than as a parable of exploitation of artistic talent. In 1932, a dozen eggs cost eighteen cents. If I knew how many dozens Benton used, I could extrapolate the university's outlay and relate it to my own salary. I have a feeling we'd still be at the low end of recompense for labor versus cost of living.

To be fair, New School President Alvin Johnson also paid for a studio near the school, which he visited every day, and Benton gave lectures for extra payment.[2] Nevertheless, both Benton and Johnson often referred to the eggs. It makes for a funny story, but it also highlights for me the degree to which institutions, like people, have personalities from their inception—and the degree to which institutions that present themselves as free-thinking outposts of critique eventually must deal with money. The New School's initial goal was to be modern, progressive. The institution that commissioned *America Today* offered no degrees and had no endowment.

2 Justin Wolff, *Thomas Hart Benton: A Life* (New York: Farrar, Straus and Giroux, 2012), 202. Also cited in Emily Braun and Thomas Branchick, *Thomas Hart Benton: The America Today Murals* (Williamstown, MA and New York: Williams College and Equitable Life Assurance Society, 1985), 15.

Yet, it was able to raise funds to build the Joseph Urban–designed building at 66 West 12th Street. In recent years, a great deal of money was found to build the University Center on Fifth Avenue, even as part-time faculty were fighting to unionize and negotiating contracts that, although they have improved certain aspects of employment security, still do not provide a living wage. The legacy of The New School's educational philosophy, which allowed great personal freedom for the faculty, has remained central to the institution's rhetorical position. But in reality the school has yielded to the imperatives of the corporate university, dominated by widening tiers of administrators, enforcing a model of student/customer satisfaction.

In winter 2017, it was revealed that The Metropolitan Museum itself was in financial straits. There were buyouts, retirements, layoffs. In the weeks that followed coverage of the managerial misconduct that had led one of the world's greatest museums to this difficulty, I attempted several times to see the Benton again, only to find the gallery roped off. In one case, a discussion with a guard revealed that it was closed because of "manpower issues"—that is, not enough money to pay guards. Even paying in "eggs" is too much, apparently.

At The Met, the installation of *America Today* replicates details of its original site, albeit with crepuscular lighting. I was curious to see what its original room had looked like. A photograph of the third-floor boardroom offers a partial view into a simple modern interior with a pale wood floor, the painting's panels interrupted by large windows: an open, simple space where these intensely rendered images of America as a big country with powerful engines could operate in counterpoint to the idealism posited by the space itself. It must have been incredible to work in that room.

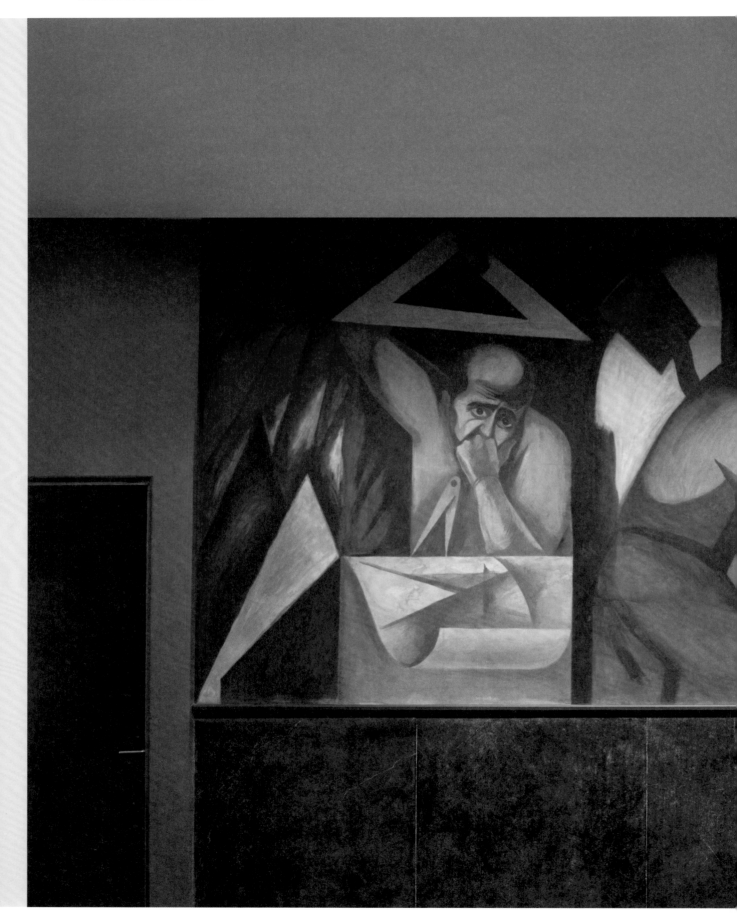

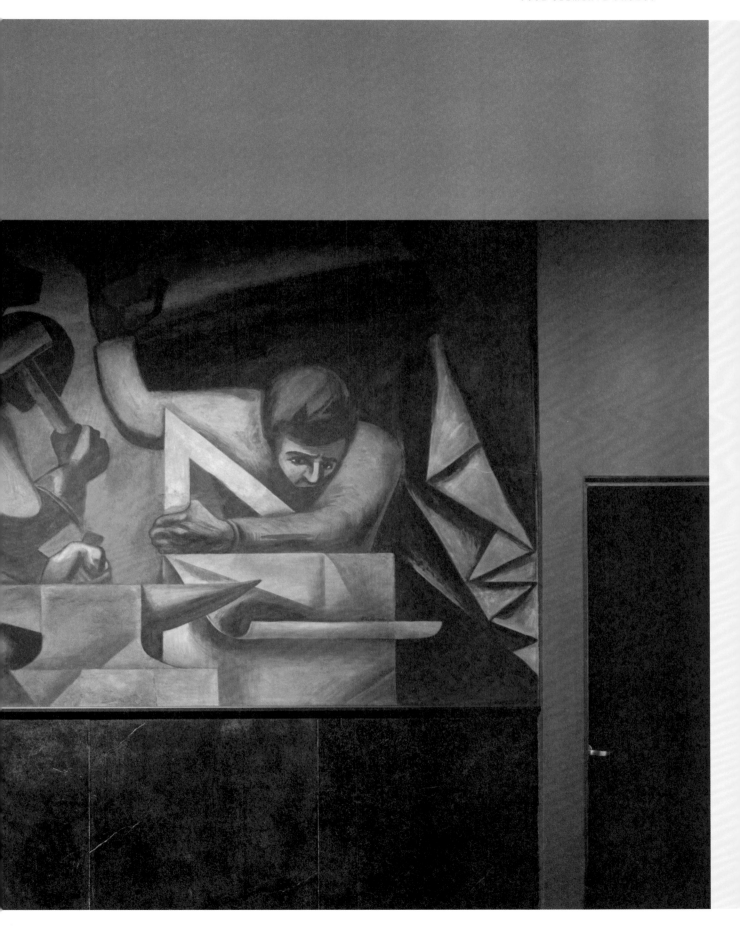

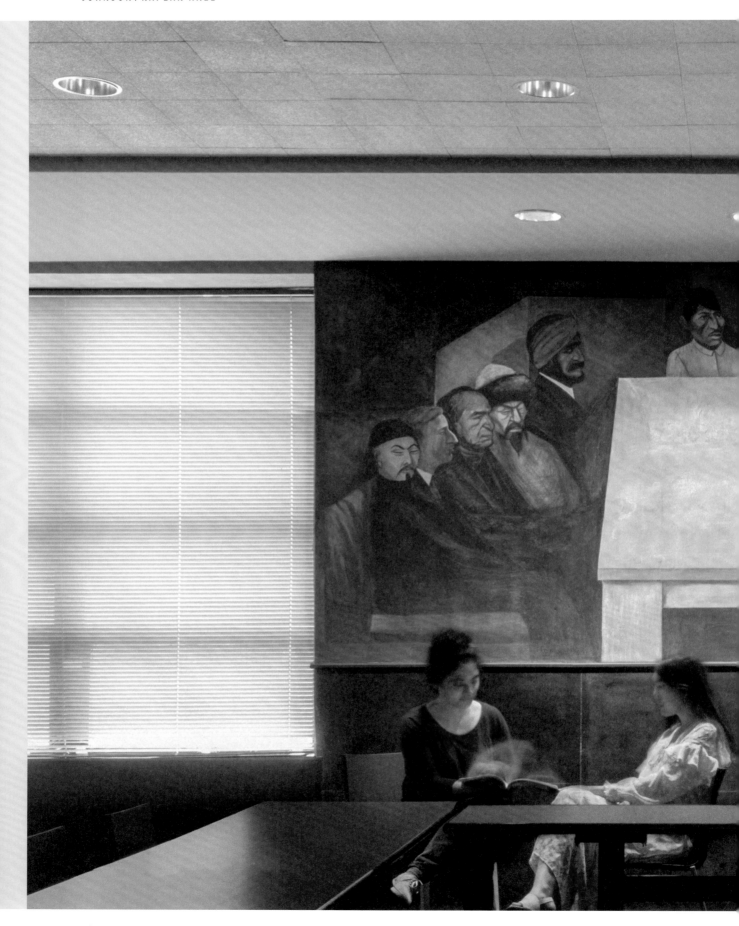

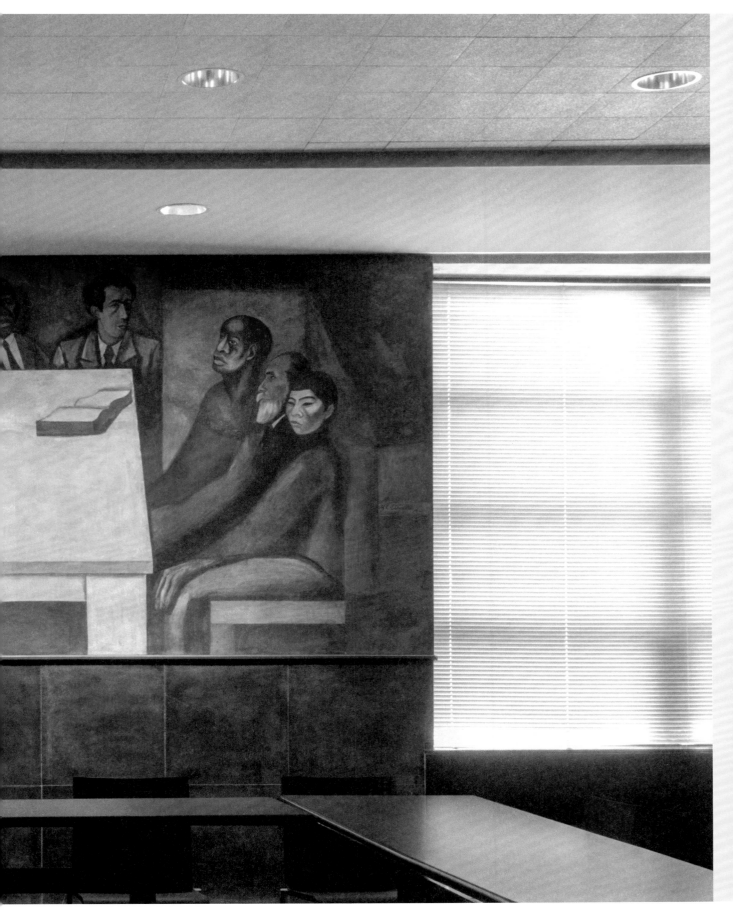

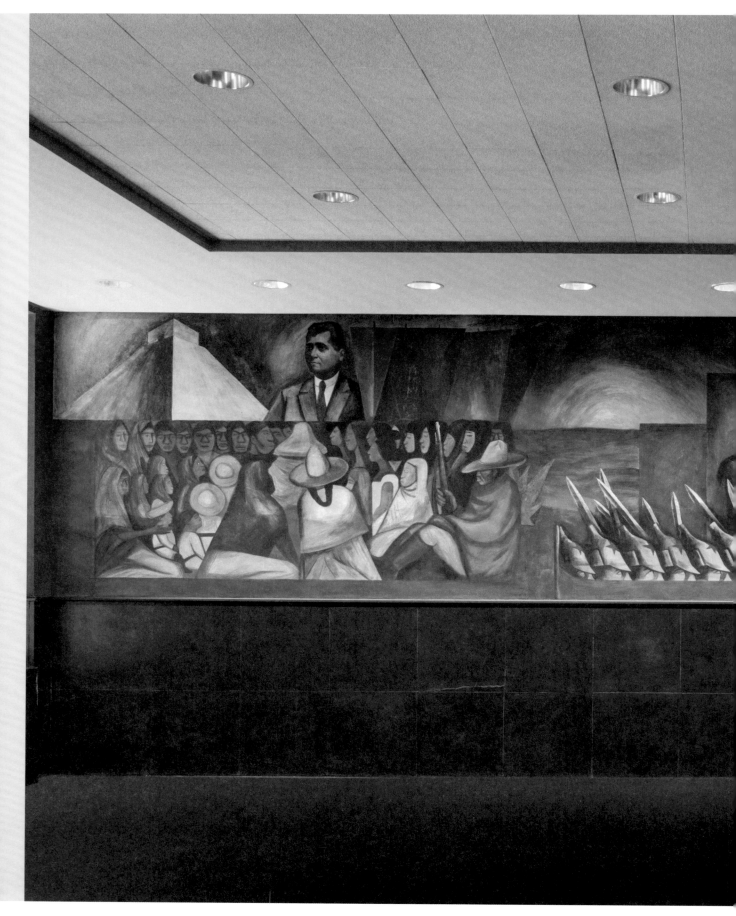

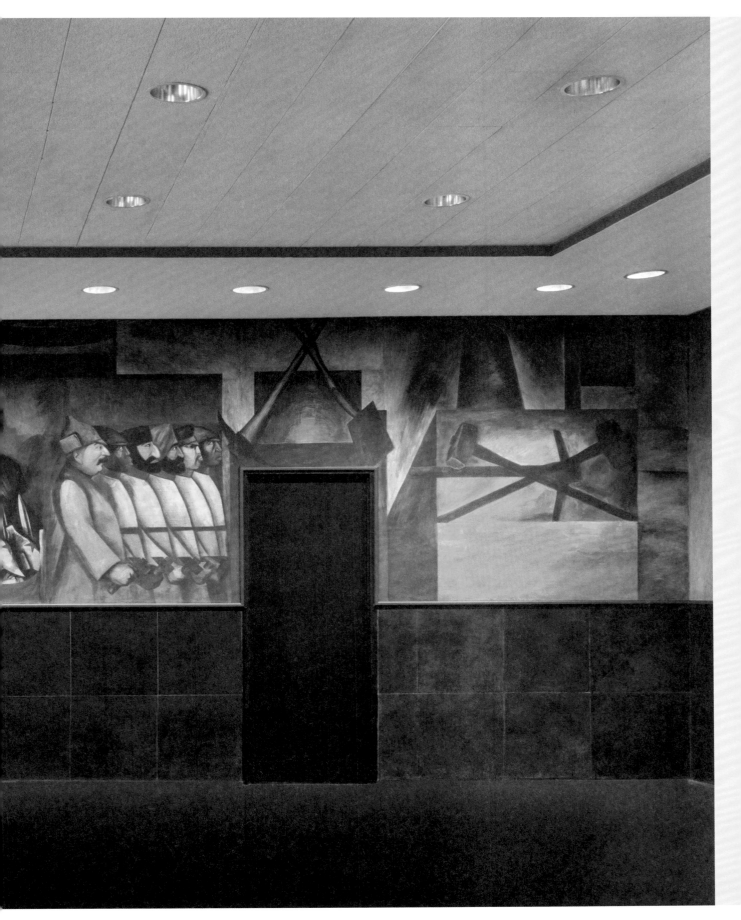

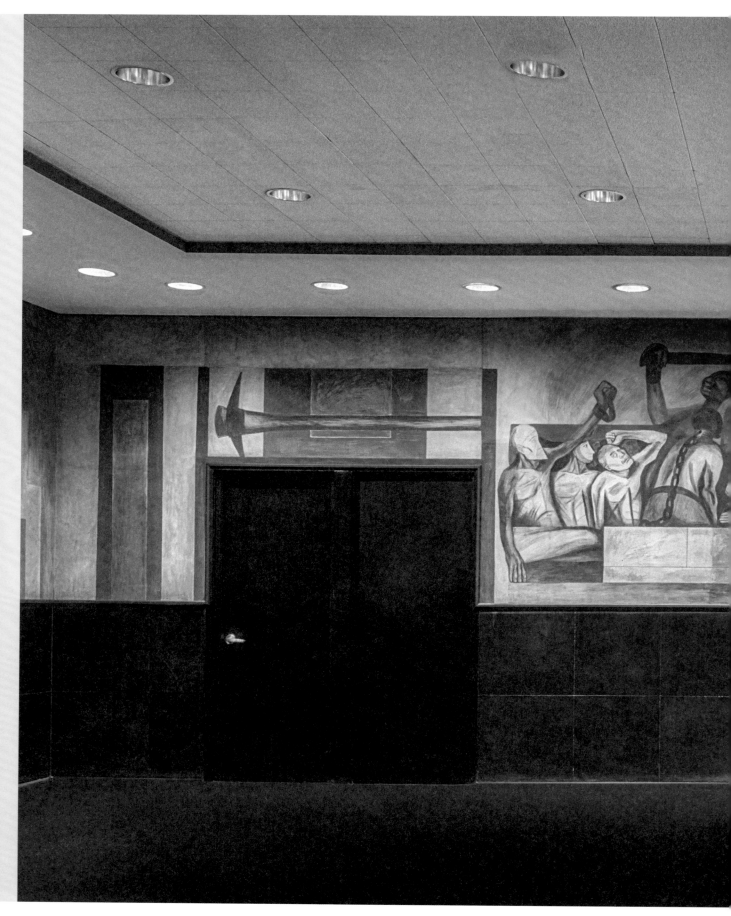

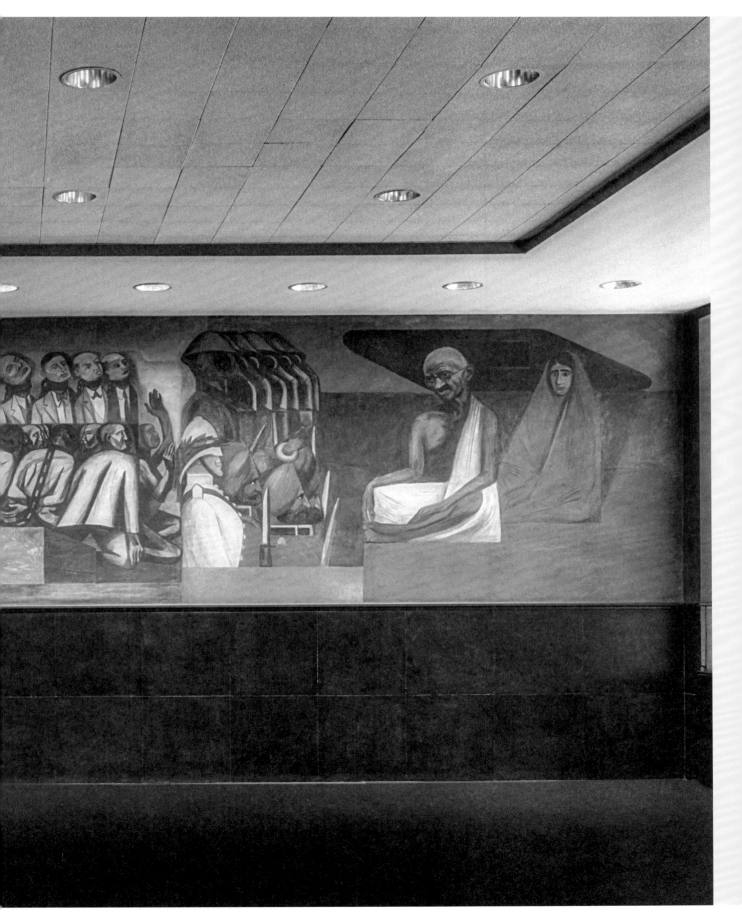

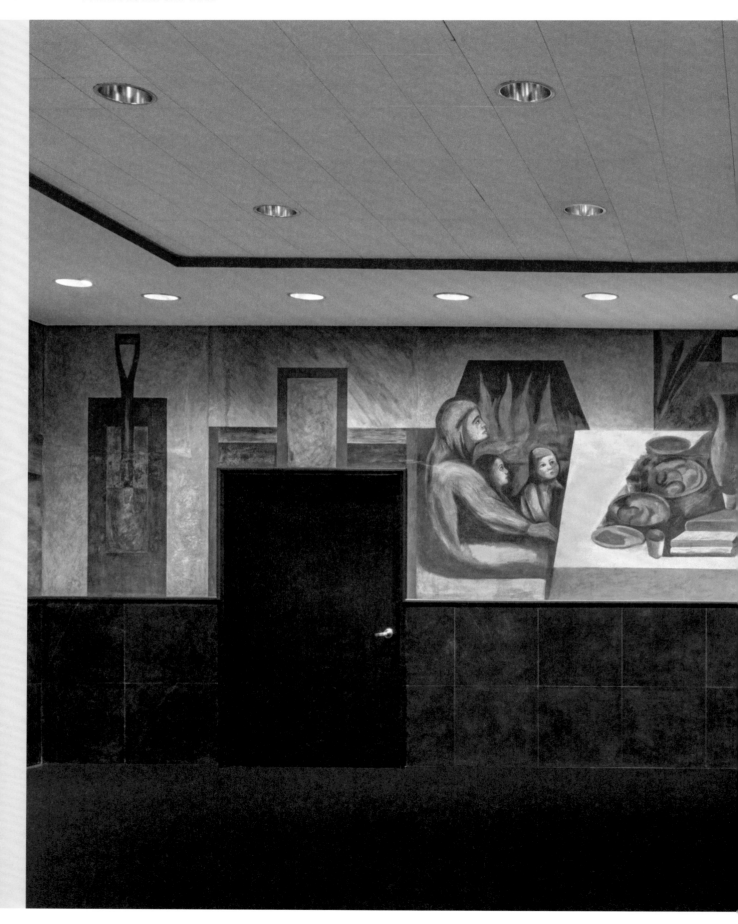

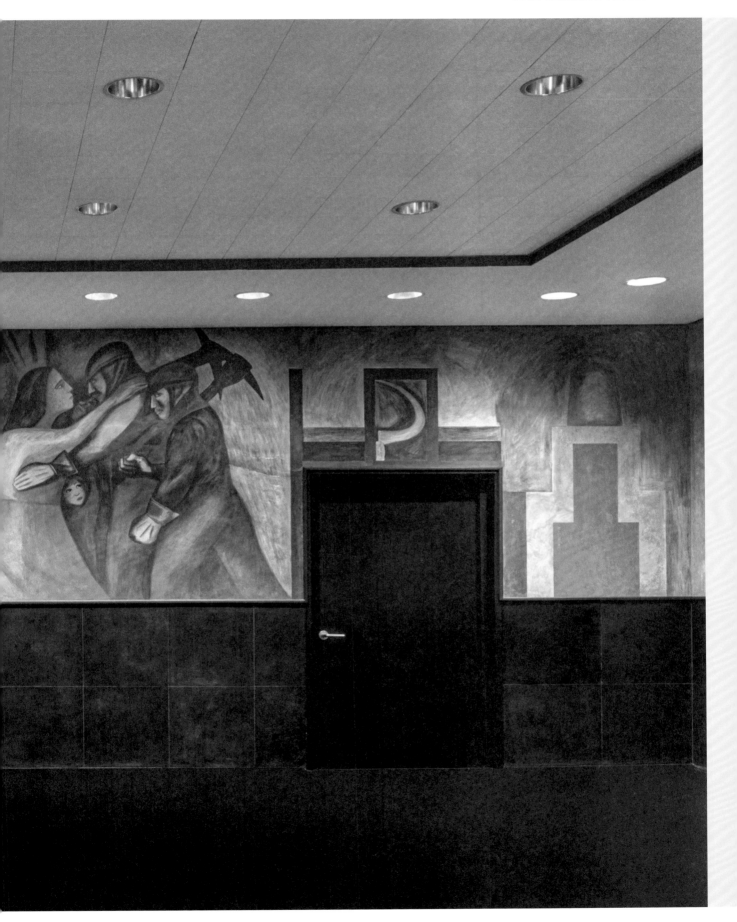

José Clemente Orozco

Call to Revolution and Table of Universal Brotherhood (The New School Mural Cycle)
1930–31
Fresco

Orozco's New School Murals: Activating Revolutionary Thought

Anna Indych-López and Lynda Klich

INSTALLED IN AN INTIMATE ROOM on an upper floor of the Joseph Urban building,[1] José Clemente Orozco's New School mural sits above a soapstone wainscoting, whose smooth black surface resembles a chalkboard—an apt metaphor for the intellectual engagement this work demands.[2] The chalkboard's synechdochic implication of writing and rewriting relates to the broader vision of history that Orozco expressed in many of his murals, which are marked by the interactions of heroes and masses. In Orozco's vision, the viewer is positioned not as a passive recipient of historical narratives, but as an active producer of meaning, encouraged to connect the mural to burning issues of personal import and contemporary relevance.

Walking into the Orozco Room with a group of eager art and art-history students serves as a vivid reminder of this summons to participation, demonstrating that modern public art, as practiced by the Mexican muralists, primarily sought to promote discursive exchange and social action. Students may first react viscerally to the tactility of fresco (after having seen the mural only in digital form), or be dazzled by its sparkling surface (a result of silicate added as a bulking agent by the artist) and "warm furnacelike glow."[3] But they soon recognize that engaging with the mural depends significantly on their own physical relationships to the work and its site as spurs to active thought.

Not for quiet meditation, muralism necessitates spatial engagement on the part of the viewer. Such engagement not only requires attentive interpretation of dense iconography and themes, but also

PAGES 54–63: Details from José Clemente Orozco, *Call to Revolution and Table of Universal Brotherhood,* 1930–31.
PAGES 54–55: *Science, Labor, and Art.*
PAGES 56–57: *Table of Universal Brotherhood.*
PAGES 58–59: *Struggle in the Occident.*
PAGES 60–61: *Struggle in the Orient.*
PAGES 62–63: *Homecoming of the Worker of the New Day.*

1 The Orozco Room was originally situated on what was then the building's fifth floor; a renovation in the 1950s removed a library, which spanned two floors, with the result that the room is now on the seventh floor.
2 In a letter to his wife (November 16, 1930), Orozco notes that "the room is going to be something extraordinary as interior decoration, the wainscoting and the floor are going to be of a single material, slate [sic], the same that is used for blackboards in schools, only in large blocks." ["el salón va a ser algo extraordinario como decoración, el 'guardapolvo' y el piso van a ser de un solo material, pizarra, la misma que sirve para las pizarras de las escuelas, sólo que en grandes bloques."] José Clemente Orozco, *Cartas a Margarita* (Mexico: Ediciones Era, 1987), 230. Cited by Miliotes, 131 n. 60. (Authors' translation.)
3 Authors' email communication with Thomas J. Branchick, Williamstown Conservation Lab, January 6, 2017; Roberta Smith, "New School Unveils Its Restored Orozco Murals," *New York Times,* October 11, 1988, C15.

demands awareness of the ways in which artists such as Orozco, Diego Rivera, and David Alfaro Siqueiros carefully calibrated how the viewer would move through and utilize space, creating relationships between the works and their surroundings that amplified viewers' associations with the wider world of intellect, ideas, and ideals.

Enveloped in the modest room that houses the Orozco mural, the viewer cannot escape the work's revolutionary proposals, which the artist wanted to be contemporary but also to endure. In studying *Call to Revolution and Table of Universal Brotherhood*, viewers gain a fundamental understanding of Orozco's role in visualizing historical struggle as consequential and connected to daily experience. Absorbing the ways in which muralism in the Americas sought to harness the tensions between individual subjectivities and historical currents, visitors to this, the first—and only surviving—mural by a Mexican artist in New York, receive anew the enduring lesson of muralism: the ever-urgent necessity of using art to put forth a call for action.

Anyone teaching the New School murals relies on Diane Miliotes's foundational text, which established an understanding of the work in the contexts of Orozco's intellectual milieu; in one of the first modernist buildings in New York; and in the progressive educational model of The New School.[4] Tracing the mural's themes—international forms of social revolution and the transformative possibilities of cooperation among scientists, laborers, artists, and thinkers—Miliotes situates the work within the political aspirations of the Delphic Circle, a New York salon that strove for international peace and brotherhood. She likewise establishes the five-panel cycle, which earlier generations of scholars had seen as anomalous in Orozco's oeuvre, as an avant-garde intervention. Using compositional devices (such as color blocks) and style (such as geometrized form), Orozco engaged with Urban's International Style structure, which emphasizes each room's function and palette. Yet the artist also met the mandate from New School Director Alvin Johnson that the mural challenge the viewer and not just blend into the architec-

4 Diane Miliotes, "The Murals at the New School for Social Research (1930–31)," in *José Clemente Orozco in the United States, 1927–1934*, ed. Renato González Mello and Miliotes (Hanover, NH: Hood Museum of Art/Dartmouth College, 2002), 118–41.

ture. Miliotes hence posits the mural as an intellectual space that resists facile narrative readings and inspires debate among viewers forced to reckon with its ideological pushes and pulls; her analysis demonstrates the ways in which the work furthered The New School's mission to create "informed and active citizens."[5] This interpretation revolves around the mural's original audience of 1930s progressives or "New World elite," who would have encountered the work in what was then a dining room, a setting generating spontaneous conversation. The Orozco Room now houses special events, i.e., conversations of a more structured kind. But the exhortation toward engagement remains valid for contemporary audiences—such as our CUNY students, who often come from social sectors underrepresented in the academy.

As Orozco stated the year prior to executing the New School commission, "Although the art of all races and of all times has a common value—human, universal—each new cycle must work for itself, must create, must yield its own production—its individual share to the common good." Considering the "unavoidable duty to produce a *New Art* in a new spiritual and physical medium," he claimed the mural as "the highest, the most logical, the purest and strongest form of painting."[6] The New School work, and other U.S. commissions that this group of artists received, enabled them to carry the form beyond the specificity of the Mexican Revolution, to nuance pictorial strategies, and to empower the visual mode on a wider stage within the worldwide current of leftist artistic engagement.

Framed in the discourses of 1930s progressivism, Orozco's mural reverberated in the 1950s with McCarthy-era politics, and in the 1960s with civil rights movements. For students today, it conjures up discussions of income inequality, Occupy Wall Street, Black Lives Matter, the enduring legacies of colonialism and imperialism, worker's rights, and institutionalized misogyny. In a 1950 letter addressing the Red Scare censorship of the Soviet panel on the west wall of the room (*Struggle in the Occident*), Johnson predicted that the mural would "be more valuable at a future date when politics will let art alone. But now politics is in the saddle."[7] On the

5 Ibid., 129.
6 Orozco, "New World, New Races, and New Art," *Creative Art* 4, no. 1 (1929): 24–25.

7 Alvin Johnson to Dr. Hans Simons (president of The New School 1950–60), December 11, 1950, The New School Archives and Special Collections, The New School, New York.

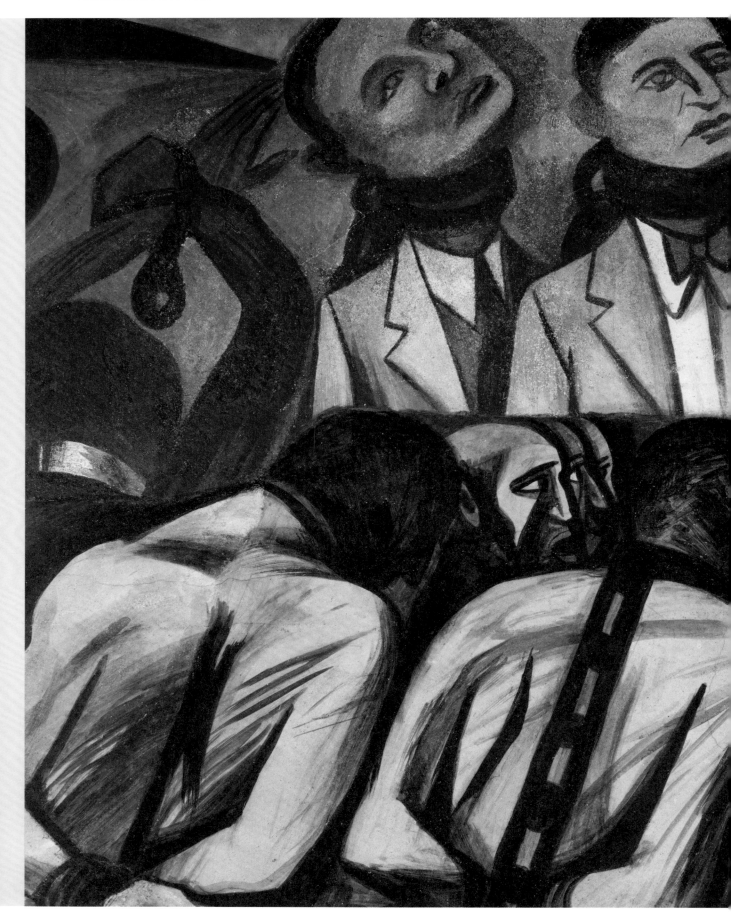

contrary, the lasting ability of Orozco's mural to galvanize audiences who are committed to progressive education testifies to the work's resonance with continued fights for social justice.

The Chains in Orozco's Murals

Otto von Busch

WHEN JOSÉ CLEMENTE OROZCO finished his murals for The New School in the first days of 1931, director Alvin Johnson immediately recognized them as a success. Much more than visually pleasing, they served a "civic purpose," as they were to "provoke thoughts and feelings about contemporary society and culture."[1] Orozco himself argued that the mural was made in a "school for investigation, not for submission."[2]

Yet from their moment of creation, the murals were also considered provocative and potentially dangerous. Johnson describes the evolution of the debate in a 1950 letter to New School President Dr. Hans Simons, in which he discusses controversies from the 1930s, including that provoked by the *Table of Universal Brotherhood*, which is presided over by a black man, and the outrage among "Anglophile friends" over Orozco's image of Britain yielding to Gandhi and a figure whom Johnson called "Mother India."[3] Johnson notices, however, that few conservatives protested against the portraits of Soviet heroes, as Trotsky was not included (though Lenin and Stalin were), and thus the mural did not suggest the threat of world revolution. Instead, as Johnson posits, at the time of the work's completion, the Soviet Union was considered a possible American business partner, as Yugoslavia became under Tito in the fifties.[4] Indeed, the fiercest early opposition to the

José Clemente Orozco, *Call to Revolution and Table of Universal Brotherhood (Struggle in the Orient)*, 1930–31 (detail).

1 Alvin Johnson quoted in Maurice Berger, "Patrons of Progress: The New School University Art Collection" (New York: Vera List Center for Art and Politics/New School University, 2003), 18.

2 José Clemente Orozco quoted in Julia Foulkes, Mark Larrimore, and Radhika Subramaniam, "Offense and Dissent: Image, Conflict, Belonging: Red Scare, Yellow Curtain," http://sjdcparsons.org/tpp/od/offensedissent.php (accessed May 31, 2019).

3 The figure whom Johnson designates as "Mother India" is Sarojini Naidu, a stateswoman, feminist, and poet who was known as the "Nightingale of India." She was also a member of the Delphic Circle.

4 Alvin Johnson to Dr. Hans Simons, memorandum regarding public reception of the murals by José Clemente Orozco, December 11, 1950, New School Publicity Office records, General subjects and administrative records, The New School Archives and Special Collections Digital Archive (accessed September 18, 2017).

mural came from Trotskyites, who saw it as an affirmation of Stalin's national policies and "the revolution betrayed." Nevertheless, after World War II, the Soviet panel (*Struggle in the Occident*) became so bitterly contested that, in 1953, the school placed a curtain over the images of the Russian revolutionaries. The sparsely clad Gandhi was left out in the icy winds of the cold war.

If I am to approach the murals today, the Soviet part of the murals indeed appears exotic. But it is the depiction of India—the panel that Orozco calls *Struggle in the Orient*—that I find more intriguing. It is here that I sense we may unlock ideas to bring into the realm of fashion design.

In his notes on the murals, Johnson highlights how the depiction of India makes the many aspects of domination and subordination explicit in the primordial slavery of chained prisoners. But he also discusses the white-collar functionaries whom Orozco portrays, the business beneficiaries of British imperialism in their suits. It is noteworthy to see the white-collar worker likewise unchained, yet still on his knees, in a depiction of the well-fed slavery of usurer and contractor, their hands tied behind their fat backs; the snobbish slavery of the Eurasian civil service, with chains around their refined necks, all defended by a squad of European soldiers in gas masks.[5]

In 1931, when Orozco was examining the many layers of collaborationism in imperial India, Gandhi had just successfully organized the Salt March and forced the British to the negotiation table through civil disobedience. By distinguishing the various valences of power operating in the colonial project—from literal slaves to white-collar collaborators, bankers, and military officers—Orozco points to colonial power as a participatory subordination that corrupts society across its layers. Thus, when we see the oppressed breaking their chains, it is their obedience to the British that is broken. Their chains are cultural and psychological; the material weapons, the bayonets and gas masks, are left untouched. Indeed, the tank passing behind the heads of Gandhi and Mother India seems to show that physical violence cannot crush the truth-power of disobedience, and instead suggests that peace making, as a fostering of freedom, can be more powerful than acts of violence.

5 Alvin Johnson, *Notes on the New School Murals* (New York: New School for Social Research, 1943), 9.

The curtain veiled the contagion of revolutionary struggle, but, as a student mentioned when the covering was installed, the mural had never "corrupted anyone."[6] Furthermore, the *Table of Universal Brotherhood* remained visible, still headed by a black man, assembling people of all colors to cooperate "in the enterprise of writing reality upon the blank pages of the book of peace."[7] While McCarthy led inquisitions against socialists across the United States and the official strategy was to contain the expansion of Communism across the world, the methods of disobedience prototyped by Gandhi were spreading through the civil rights movement.

Today, looking at the Orozco murals from the perspective of fashion—now one of the most popular disciplines across The New School— Gandhi's legacies can teach us a lot. I see the suffering caused by colonialism and the struggle for independence, but also the everyday conflict between conformity and disobedience; the ways in which "snobbish slavery" and collaborationism are still the greatest obstacles to a more equitable and sustainable world. Indeed, in consumerist societies, most design affirms the status quo. Perhaps we can imagine another type of fashion design, a

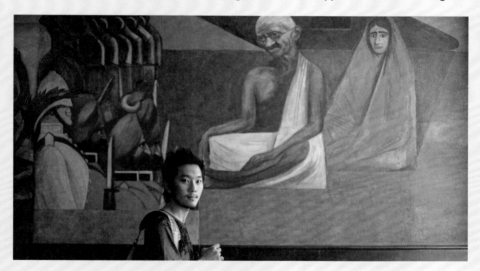

Struggle in the Orient, 1930–31 (detail).

6 "The New School Student Committee Against the Curtaining of Murals." "Student Mural Committee Disbands, Urges Freedom Forum." Dec. 10, 1953, New School Publicity Office records; General subjects and administrative records, The New School Archives and Special Collections Digital Archive, http://digitalarchives. library.newschool.edu/index.php/Detail/objects/ NS030105_000016 (accessed May 23, 2018).

7 Johnson, *Notes on the New School Murals*, 11.

fashion design taught by Orozco. I guess it would resemble what Johnson saw in the murals: not so much "pleasing" as "honest, and beyond that significant."[8] We would be asked to find the civic purpose of fashion, and to draw our figures not in the spirit of competition but in "the book of peace." In our classes, around the Table of Universal Comradeship, we need to address fashion as a global issue, a matter of justice, in order to find nonviolent ways to produce and express dressed identity. Could Orozco's revolutionary struggle even inform fashion designers cosseted in plenty and vanity, and help us position our work in the larger scope of things? Even in the most banal way, could we break our chains of status anxiety, and imagine fashion liberated from chain stores? Fashion can never be autonomous; it is always social. But could it become a matter "for investigation, not for submission"?

Center of Gravity: Orozco

Roberto Tejada

Center of gravity: proportion
Center of gravity: form
Center of gravity: color
Center of gravity: tone
Center of gravity: character
Center of gravity: meaning
　　　—José Clemente Orozco, *Notebooks*, 1931–34[1]

CENTRAL TO THE MURAL CYCLE OROZCO completed by mid-January 1931—swiftly, in "forty-six and a half days"[2]—is the measured rendering of human assembly in circular or semicircular formations. The facing tableaux synchronize and stagger meanings in this immersive work, designed for a place of interaction, once a modestly sized dining hall, now a lecture room. Energizing

8　Johnson, *Notes on the New School Murals*, 13. For further reference, see Roberta Smith, "New School Unveils Its Restored Orozco Murals," *New York Times*, October 11, 1988, C15.

1　José Clemente Orozco, *Cuadernos*, ed. Raquel Tibol (Mexico City: Secretaría de Educación Pública, 1983), 147. Author's translation.
2　Edward Alden Jewell, "The Frescoes by Orozco," *New York Times*, January 25, 1931, X12.

José Clemente Orozco, *Call to Revolution and Table of Universal Brotherhood (Struggle in the Occident)*, 1930–31 (detail).

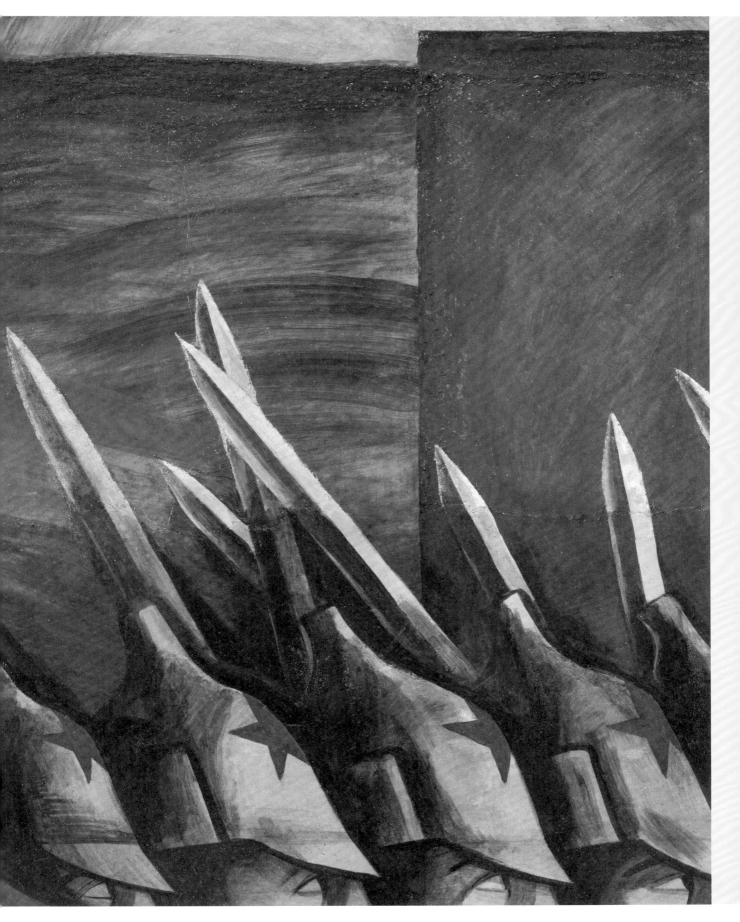

the sleek geometries of Joseph Urban's interior, the overall effects derive from a jolting choreography of cadmium yellows and reds, tawny orange, and a grim sienna that predominates, as though to suggest a sober optimism. Elements of green imply an exit—across a threshold, through a window, along a proscenium floor behind a red stage curtain—when in fact there can be no leave taking from this web of world events.

Nestled between the room's south-facing windows, a rectangular surface commands attention, an unwieldy volume in hues of natural wood. In order for the men around this *Table of Universal Brotherhood* to be distinct, their faces racially and psychologically legible, Orozco elongates their bodies and sets them aslant in formal and tonal relation to the center of gravity. Each conveys indeterminate degrees of solemnity, weariness, displeasure, or expectation, yet all are contemplative in their presumed authority as agents of social change.[3] Orozco's style spans from the naturalistic to the jaggedly distorted.[4] A kind of folk figuration is invoked in his depiction of women, notably in *Homecoming of the Worker of the New Day* and an adjacent scene in *Struggle in the Occident*: except for a single man bearing a rifle, here sits a governance of women with children in their charge, heads covered in blue or black veils; one or two wear revolutionary *sombreros*. This alliance of *campesinas*, expectant, as though waiting to care for the wounded or plot an insurrection, correlates to the administrative fraternity at the table. In the plane above the women is a portrait of Mexican revolutionary leader Felipe Carrillo Puerto, with a Mayan temple from his native Yucatán in the background, his eyes cast toward a future that includes our knowledge of his execution by firing squad at the hands of rebel forces aligned with Adolfo de la Huerta. A spectacle of crimson pennants leads the eye to a portrait of Vladimir Lenin towering over the rank and file. A throng of combatants outfitted with helmets bear red stars into the day, the stabbing blades of their bayonets an advancing menace. They form a rear guard to Red Army officials, international, multi-ethnic, with hammers in hand. Stalin serves as just another affiliate in what amounts to a composite image alternately depicting the

3 Alvin Johnson, inaugural director of The New School, observed, "You see the Nordic, the Chinese, the Jew, the American Indian, the East Indian, the African Negro and American Negro cooperating in the enterprise of writing reality upon the blank pages of the book of peace." Alvin Johnson, *Notes on the New School Murals* (1943), Alvin Saunders Johnson collection, The New School Archives and Special Collections Digital Archive (accessed January 19, 2017).

4 "Though he spoke slightingly of folk art," relates fellow artist Jean Charlot, Orozco captured the tragic mood of Mexico's "many *bultos* and *santos*—statues carved out of a beam by the local carpenter." José Clemente Orozco and Jean Charlot, *The Artist in New York: Letters to Jean Charlot and Unpublished Writings, 1925–1929* (Austin: University of Texas Press, 1974), 13.

power of assembly, the seductions of doctrine, the cult of personality, and the dehumanizing servitude of militarism.

Orozco was concerned with questions of the common good, universal values promised in art and industry, and the dubious prospects for world heritage in light of the existence of social organizations built on slavery or the oppression of peasants and laborers.[5] This intellectual appetite had found in New York a counterpart to Mexico City *veladas*, artistic salons, in the Delphic Circle that gathered at the lower Fifth Avenue apartment shared by Eva Palmer-Sikelianos (wife of the Greek poet Angelos Sikelianos) and American journalist Alma Reed. Fellow attendees included followers of Mahatma Gandhi, such as the poet Sarojini Naidu—two of the figures depicted on the east wall of the mural cycle. It was such commitments that obliged Orozco to reckon with exploitative labor even when it is elided by nation-state design, and to explore the conditions that require us to obey the laws of universal kinship. Thus, the mural's corner elements—cruciform mallets and pickaxe, a triangle formed by shovel and pick intersecting at the handles—are not merely ornamental. They are proxies for those other tools that mediate between violence and justice—language, science, art.

Orozco the ironist....Disinclined to identify with one belief or another, or to flatten historical processes into a palliative storyline, he gave free rein to human passion in monumental form; a web of contingent relations, not obligatory ones. *Call to Revolution* gestures, in this circle of interrelated attitudes, to a homecoming: a hearth, a mother, two children, a kitchen table; a temporal leap; then another woman, or a future version of the same figure, welcoming two workers—or are they her offspring, now laboring adults? Orozco the dramatist....Like Nietzsche, for whom history is the spectacle by which to think "all things in relation to all others,"[6] Orozco mistrusted a "unity of plan" as much as the mechanistic life. He favored instead distancing effects that make bearable certain shocks of the here and now, especially when brutal intrusions beyond the law threaten to evict us from our homes. You can hear his demand: Do you want humanity at the service of justice, or justice at the service of humanity?[7]

5 Orozco's assistant on the murals, Lois Wilcox, described the "great rhythms" that emanate from the scenes of slavery; the figuration "stylized for the purpose of forcing the eyes of the beholder to feel the abstract beauty of design." Cited in Edward Alden Jewell, "About Orozco's New Frescoes," *New York Times*, February 1, 1931, 119.

6 Friedrich W. Nietzsche, *Untimely Meditations*, trans. R. J. Hollingdale (Cambridge: Cambridge University Press, 1983), 91.

7 The remark is a paraphrase from Tzvetan Todorov, "No somos ni buenos ni malos, pero tiene sentido luchar: entrevista con Tzvetan Todorov (trad. del francés de Aloma Rodríguez)," *Letras Libres*, March 13, 2017, http://www.letraslibres.com/espana-mexico/revista/no-somos-ni-buenos-ni-malos-pero-tiene-sentido-luchar-entrevista-tzvetan-todorov (accessed May 22, 2018). Todorov (1939–2017), like Orozco, was concerned with the role of artists and intellectuals in civic life and with cultural encounter and conflict.

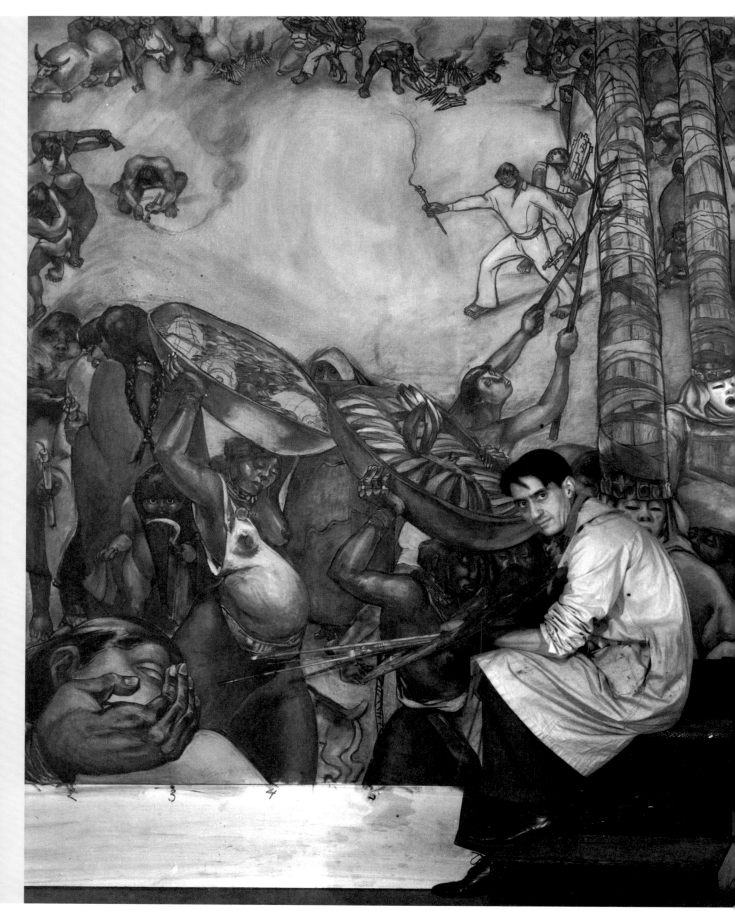

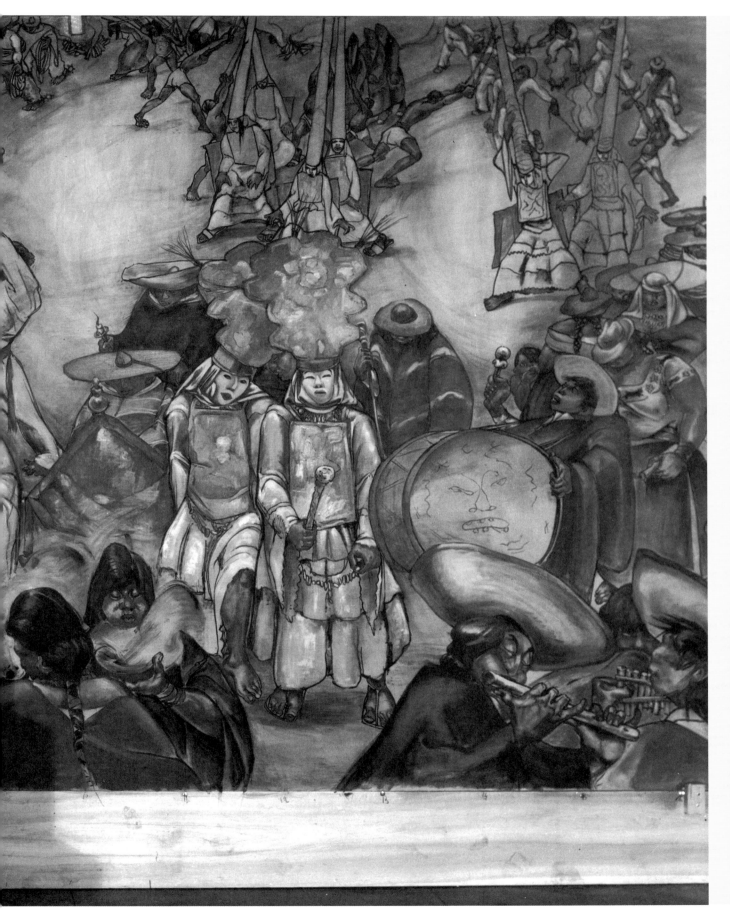

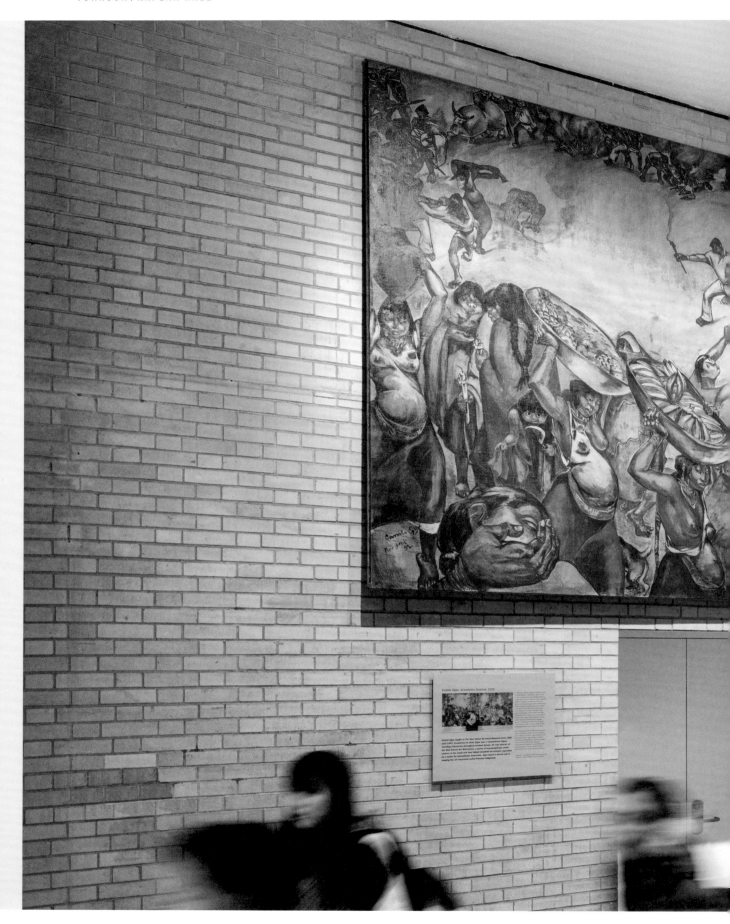

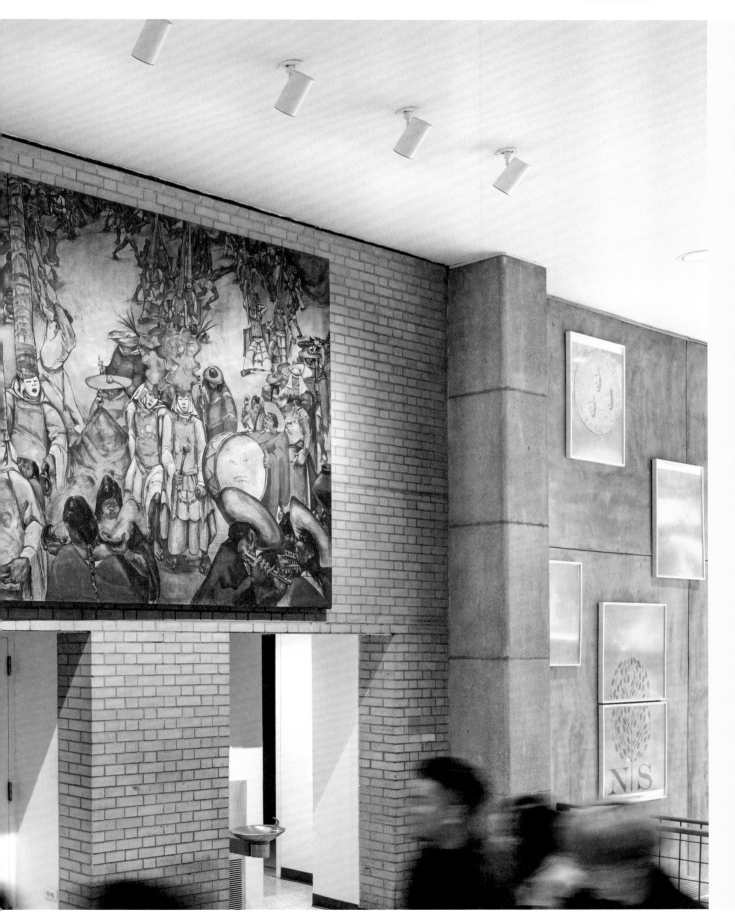

Camilo Egas

**Ecuadorian
Festival**
1932
Oil on canvas

A Celebration of Dance

Michele Greet

ECUADORIAN ARTIST CAMILO EGAS began teaching at The New School for Social Research in 1929 and soon after became director of the Art Workshops, "a series of interdisciplinary studio courses in the visual arts." He would direct the Art Workshops until his death in 1962, hiring numerous talented teachers— Berenice Abbott, Stuart Davis, Yasuo Kuniyoshi, and Lisette Model, among others—and establishing The New School's reputation as a center for international modernism. This focus extended to the discipline of dance, and in 1931, Director Alvin Johnson invited Egas to paint a mural for the anteroom of the dance studio on the building's lower level, where contemporary choreographers Martha Graham and Doris Humphrey would soon collaborate. The commission was part of Johnson's initiative to integrate contemporary art into the school's International Style building, designed by Joseph Urban. Bringing together dancers in native costumes, musicians playing traditional instruments, and scantily clad tropical-fruit vendors from various regions of his country of origin, Egas structured his *Ecuadorian Festival* as a kind of cultural sampler, a palimpsest of traditions and perspectives that emulates the modernist project of collage.

Egas had received his own education at the School of Fine Arts in Quito; he traveled to Rome, Madrid, and Paris, where he first came in contact with European avant-gardes, before arriving in New York in the mid-twenties. Over the course of his career, he experimented with various stylistic tendencies, including *modernismo*, *indigenismo*, Surrealism, and abstraction. Yet he consistently painted indigenous subjects, adapting the theme according to his many stylistic shifts—and, at the time of *Ecuadorian Festival*, was most influenced by American Scene Painting, with its emphasis on capturing the essence of national identity in the United States. He

PAGES 76-77: Camilo Egas at work on *Ecuadorian Festival*, 1932. Photo by Peter A. Juley, 1932.
PAGES 78-79: Camilo Egas, *Ecuadorian Festival*, 1932.

thus created a synthetic vision of Ecuadorian culture for a North American audience by combining traditions from various regions of his country.

Ecuadorian Festival complemented wall works already completed by José Clemente Orozco and Thomas Hart Benton, and Egas seems to have gleaned ideas from both. The energy and movement of his figures owe something to Benton, while his use of earth tones—which Egas claimed invoked ancient Incan art—is closer to Orozco's palette. These muted tones also serve as a sort of antidote to stereotypes of the folkloric so often evoked by vibrant colors and patterns, and instead position the theme of indigenous dancers as a serious subject. Rather than attempting to document a specific festival, the work depicts a generic celebration, a multifigural composition of nearly life-size ceremonial dancers representing tribal groups from across Ecuador.

Ecuadorian Festival is in fact not a mural in the traditional sense, but rather a nearly eight-by-seventeen-foot detachable wall panel, painted in oil on canvas. (It now hangs in the lobby of Alvin Johnson/J. M. Kaplan Hall.) By introducing a vision of indigenous dances into a space specifically assigned to the creation of modern choreography, Egas established a dialogue between the traditional and the experimental. He was not alone in this impulse; both visual and performing artists of the period often looked to so-called primitive forms as a means to invigorate the modern. In the same year that *Ecuadorian Festival* was commissioned, for example, Graham choreographed *Primitive Mysteries,* drawing on the sacred practices of the Penitente Indians of New Mexico and attempting to tap into what she—like many of her contemporaries—perceived as the primordial impulse behind indigenous ritual.[1]

Egas may, therefore, have envisioned his mural as providing inspiration for the creative processes of modern dance. Moreover, his use of modernist spatial strategies—the dancers' elongated bodies and the sharply tilting space in which they appear—situate the work in dialogue with the sleek modern architecture for which it was created. The composition presents a flurry of movement, with figures swirling around three open

1 Ramsay Burt, *Alien Bodies: Representations of*
 Modernity, "Race" and Nation in Early Modern Dance
 (New York: Routledge, 1998), 137.

central areas, as if expelled by an invisible force; the open areas between festival participants give the impression that performers will explode from the crowd at any moment, generating dramatic tension. This configuration calls to mind the circular floor of Urban's design for the dance studio, as well as the circular rhythms of much traditional choreography. Egas further divides the composition with two extraordinarily tall ceremonial hats, or *cucuruchos*, balanced on the heads of masked dancers known as *almas santas* by attendants bearing long forked sticks. In indigenous Ecuadorian culture, this headgear—derived from the cone-shaped hats worn in Spanish Holy Week processions—had assumed a form of its own by extending to extreme heights.

To a New York audience, the scene would have been breathtakingly exotic, and *Ecuadorian Festival* was favorably reviewed in the *American Magazine of Art, ArtNews,* the *New York Times,* the *New York Sun,* and the *New York Evening Post.* Perhaps because of The New School's progressive orientation, Johnson made the painting's emphasis on cultural identity into a specifically political issue, asserting in a pamphlet discussing the Benton, Orozco, and Egas commissions that the hand in the lower-left corner of Egas's image is "the hand of Spain suppressing the Indo-American spirit."[2] This interpretation seems a bit implausible, given Egas's own description of the scene as "something that reflects the moments of happiness into which the natives of Ecuador immerse themselves, so colorful and simultaneously so solid; strong in body yet anxious to enjoy their festivals."[3] The work was not intended as a form of social protest, but rather as a celebration, a moment of escape and enjoyment, and a stimulus to dancers entering the studio. While he incorporated instances of ethnographic specificity, Egas's *Ecuadorian Festival* is a collaged account of indigenous culture assembled for the edification of a North American audience alert to the syncretic practices of modernism, but unfamiliar with the unique traditions of Ecuador.

2 Alvin Johnson, *Notes on the New School Murals* (New York: New School for Social Research, 1943), 17–18.

3 "[A]lgo que refleja los instantes de alegría a que se alzan los nativos del Ecuador, tan llenos de colorido y tan sólidos a la vez; fuertes de figura y ansiosos de gozar en sus festivales," in Henry Laville, "Algo sobre arte," *El Comercio* (Lima), January 1933.

Celebration as Resistance

Heather Reyes

THROUGHOUT THE COURSE OF HIS more-than-forty-year career, Camilo Egas's approach to Indigenism and the indigenous figure encompassed a variety of artistic movements, including Surrealism and Abstract Expressionism. Most significant to this development was the artist's move from Ecuador to New York in 1927. In the face of myriad effects of the Great Depression, along with the rise of socially engaged modernism in the city during the inter-war period, Egas pursued a new representation of the indigenous body that deviated from the stoic academicism he had used in Europe and Quito in the late 1910s and early 1920s. Egas's employment at The New School put him in close contact with the Social Realist techniques of his fellow mural-ists Thomas Hart Benton and José Clemente Orozco, and exposed him to the progressive and internationalist ideals upon which the institution was founded. Yet even before Egas began work on the mural *Ecuadorian Festival*, in 1932, he already conceived of his artistic practice as part of a larger con-versation centered on cultural diplomacy. As he told an unknown reporter in 1931, one of his priorities was to "definitively unite the two Americas in artistic matters."[1] Understanding Egas as a transnational figure with the de-sire to culturally link the continents while foregrounding a South American perspective is critical to the modernist and political themes of the mural.

 Ecuadorian Festival presents, at first glance, coastal and high-land indigenous groups gathered in a seemingly generic celebratory proces-sion. A closer inspection, however, reveals the mural's activities as an amal-gamation of pre-Colombian and Spanish traditions that continue to serve important roles in Ecuadorian culture to this day. Specifically, Egas empha-sized the concept of the festival as a site of religious and cultural syncre-tization. New School Director Alvin Johnson also reinforced this view in the

1 Quoted in "Un aspecto de Greenwich Village, desde el estudio del pintor Camilo Egas," January 1931, Archives of Eric Egas.

Camilo Egas, *Ecuadorian Festival*, 1932 (detail).

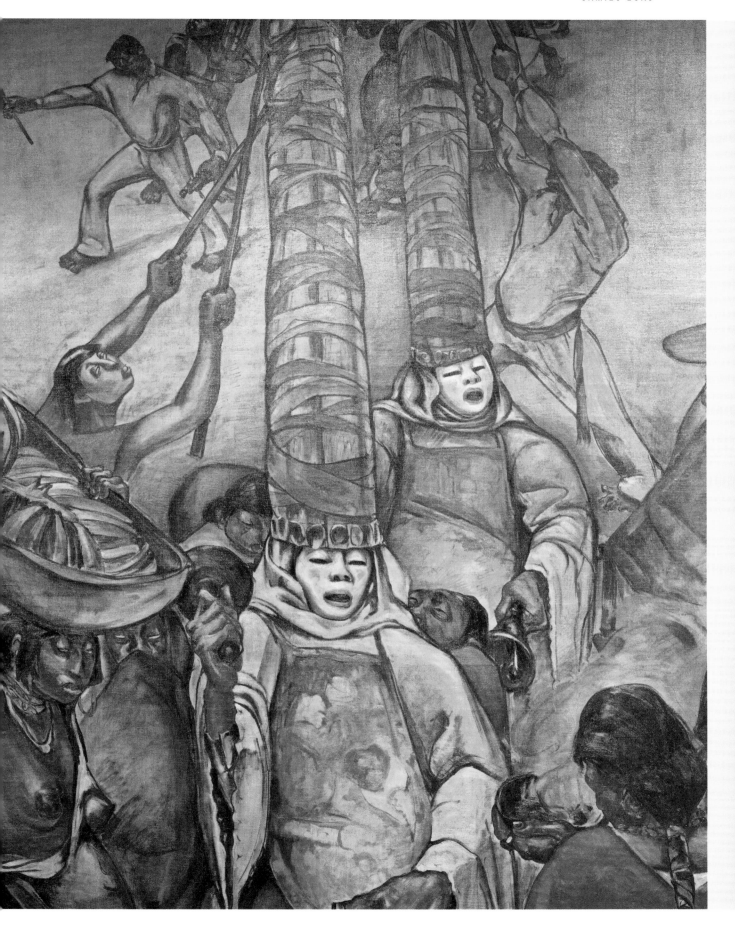

mural's caption, "Mixed pagan and Christian ceremonies," from the 1943 publication *Notes on the New School Murals*.[2] I argue that *Ecuadorian Festival* must be understood in light of the central function Catholic festival processions play in Ecuadorian culture, as well as bringing to the fore the indigenous communities' ability to formulate distinct customs to adapt and celebrate these religious events. The mural, therefore, not only represents the "moments of happiness into which the natives of Ecuador immerse themselves," as Egas stated, but also suggests indigenous resistance.[3] Nowhere is this more evident than in the half-naked boy crouching quietly on the far left of the mural, his left hand wrapped tightly around a sharp scythe—a forceful embodiment of the tumultuous history of colonialism in Ecuador.

Egas references the fusion of Catholic and pre-Columbian traditions in the figures of *almas santas*, the participants who wear tall conical headdresses and have been central to Holy Week processions in Quito for over four hundred years. Other figures in the mural, who don smaller, square crowns, are known throughout Ecuador as Sun Dancers and are popular in the highland province of Cotopaxi. These dancers featured prominently in pre-Columbian festivals that celebrated Inti (the Incan sun god), the summer solstice, and the harvest; with the arrival of the Spanish, the native agricultural rite was incorporated into the Catholic celebration of Corpus Christi. Finally, the two swaying figures in the upper-left corner of the mural, along with the areas of empty space, evoke the circular movements of the *sanjuanito*, a dance (and musical genre) that originated in festivals also dedicated to Inti, performed throughout Ecuador's Imbabura province during the summer season. After the Spanish conquest, the *sanjuanito* and its associated sacrificial celebrations became linked to the June 24 festival of Saint John the Baptist, although present-day incarnations of the festival retain its pre-Columbian associations with violence and agricultural fertility.

Egas further enhanced the simmering tensions underlying these celebrations in *Ecuadorian Festival* through his composition. With the pockets of empty ground at the upper reaches of the canvas pushing participants downward into the viewer's space, tight compression of the

2 Alvin Johnson, *Notes on the New School Murals* (New York: New School for Social Research, 1943), 17–18.

3 Quoted in Henry Laville, "Algo sobre arte," *El Comercio* (Lima), January 1933, as cited in Michele Greet, *Beyond National Identity: Pictorial Indigenism as a Modernist Strategy in Andean Art, 1920–1960* (University Park: Pennsylvania State University Press, 2009), 95.

group against the painting's picture plane, and tilt of the conical head-dresses at the center, Egas suggests an uncontainable movement of people. This carefully constructed instability, coupled with the artist's subtle melding of *almas santas*, Sun Dancers, and the performance of the *sanjuanito*, highlights the resourcefulness of Ecuador's native communities in keeping centuries-old celebrations alive under colonialism through the integration of indigenous rituals with Catholic feast days. Moreover, Egas's engagement with Social Realist themes inspired him to present a strong and able-bodied indigenous population, eschewing the narrative of oppression and subjection typical of his earlier paintings. *Ecuadorian Festival*, in short, provided Egas with the opportunity to present a politicized Indigenism within the context of The New School's progressivism, engendering a form of international dialogue that would further his project of cultural diplomacy and Pan-American exchange.

New School Desires: "Poised Precisely Between Fantasy and Reality"

Jasmine Rault

THIS PAINTING HAS ALWAYS made me uncomfortable; it hits all my orientalism-exoticization-primitivism-patriarchy gag reflexes. Above the door frames and milling students waiting for elevators at 66 West 12th Street, the first thing that catches my eye are the breasts. Brown female bodies that seem conflated with fecundity and food dominate the lower-left section of the painting, foregrounded against a crowded scene of masks and headdresses,

instruments, laborers, costumes, smoke. Faces are caricatured or obscured, eyes closed or downcast—except for one short, mostly nude figure, looking right at us with a red flag in one hand and a raised scythe in the other. In my years of teaching at Eugene Lang College of Liberal Arts, I saw versions of this fighter everywhere: students who felt and furied against the contours by which they were painted into racial, sexual, gender, and economic scenes of the university and its self-fashioning.

Camilo Egas was the last of three artists commissioned by Alvin Johnson to paint murals in The New School's first rebranding exercise, the construction of a new building in the modern style to announce the institution as a center for the modern arts as well as social sciences. For this flagship, Johnson hired Joseph Urban, renowned set designer for the Ziegfeld Follies, one of the architects of Florida's then-most-extravagant mansion, Mar-a-Lago, and also its interior designer.[1] As the *New York Times* has noted, Urban's work created "a world poised precisely between fantasy and reality."[2] The fact that The New School's first dream home was created by the same architect as (what became) Donald Trump's reminds us to contextualize Egas's mural in the long modern-colonial American project that vacillates between bombastic utopian fantasy and disastrously violent reality.

Around 1931, when Egas was asked to produce a mural for the basement dance studio, he had already been teaching at The New School for three years; he would go on to direct the Art Workshops until 1962. Yet when Johnson published his *Notes on the New School Murals* in the 1940s, Egas was introduced as an afterthought. After discussing Benton's and Orozco's contributions at length (for fourteen pages, to be exact), Johnson seems suddenly to remember Egas: "But these are not the only murals in the New School." He then spends two paragraphs on Egas—who, we are told, "combined in himself the blood and the spirit of the Inca and the Spaniard."[3] Johnson's commentary extends a story that he seems to hope is already being told by Egas's biography: "He is alive as none of us are to the great problem of Latin America….Egas represents the creative, artistic, indignantly pietistic native American culture in its

1 Urban collaborated on Mar-a-Lago with the architect Marion Sims Wyeth.

2 Paul Goldberger, "At the Cooper-Hewitt, Designs of Joseph Urban," *New York Times*, December 20, 1987, https://www.nytimes.com/1987/12/20/arts/at-the-cooper-hewitt-designs-of-joseph-urban.html?searchResultPosition=3 (accessed May 31, 2019).

3 Alvin Johnson, *Notes on the New School Murals* (New York: New School for Social Research, 1943), 15.

struggle against the suppressive hand of Spanish white race arrogance."[4]

Looking at the painting now, it might be difficult to see how Johnson comes to this impassioned interpretation of anticolonial struggle. Egas himself described the scene as "something that reflects the moments of happiness into which the natives of Ecuador immerse themselves, so colorful and simultaneously so solid; strong in body yet anxious to enjoy their festivals."[5] Yet, to my eye, the mural seems neither particularly colorful nor joyous. Indeed, as Anna Indych-López puts it, "rather than depicting a bucolic scene, Egas' image conveys instability, disruption, and anxiety."[6] We are left with neither the decolonial joy that Egas intended, nor the revolutionary Social Realism that Johnson expected, but instead the uneasy weight of unresolved tension. While Egas was certainly influenced by Mexican muralists, Michele Greet argues that, in the reception of Egas in the United States, "[e]xpectations of cultural authenticity, social criticism, and an affinity with other Latin American artists often led critics to read his work in a way that reflected their own prejudices more than the artist's intent."[7]

New York in the 1930s had developed a taste for Latin American Indigenism combined with politically critical Social Realism, and an expectation that these new aesthetic movements somehow authentically emerged from the blood of artists born anywhere in Latin America.

Egas had studied at the recently founded School of the Fine Arts in Quito, and on scholarships to Italy and France throughout the 1910s and twenties, and was thus trained in European traditions of romantic orientalism, primitivism, and *costumbrismo*. His version of Indigenism is negotiated through this long tradition.[8] We may share Johnson's desire to see this painting as a celebration of indigenous survivance in the rejection of "white race arrogance." But this shared desire might be fueled by the same structure that produced Johnson's "expectations of cultural authenticity." That is, *Ecuadorian Festival* strikes me as a haunting reminder of The New School's unresolved tensions, its deep investments in the logics of colonial modernity, and its struggle to find poise between spectacular fantasy and unbearable reality.

4 Ibid., 15, 17–18.

5 Quoted in Michele Greet, *Beyond National Identity: Pictorial Indigenism as a Modernist Strategy in Andean Art, 1920–1960* (University Park: Pennsylvania State University Press, 2009), 95.

6 Anna Indych-López, "Making Nueva York Moderna: Latin American Art, the International Avant-Gardes and the New School," in *Nueva York, 1613–1945*, ed. Edward J. Sullivan (London: Scala, 2010), 242.

7 Greet, *Beyond National Identity*, 87.

8 See Trinidad Pérez, "Exoticism, Alterity, and the Ecuadorean Elite: The Work of Camilo Egas," in *Images of Power: Iconography, Culture and the State in Latin America*, ed. Jens Andermann and William Rowe, trans. Philip Derbyshire (New York: Berghahn Books, 2005).

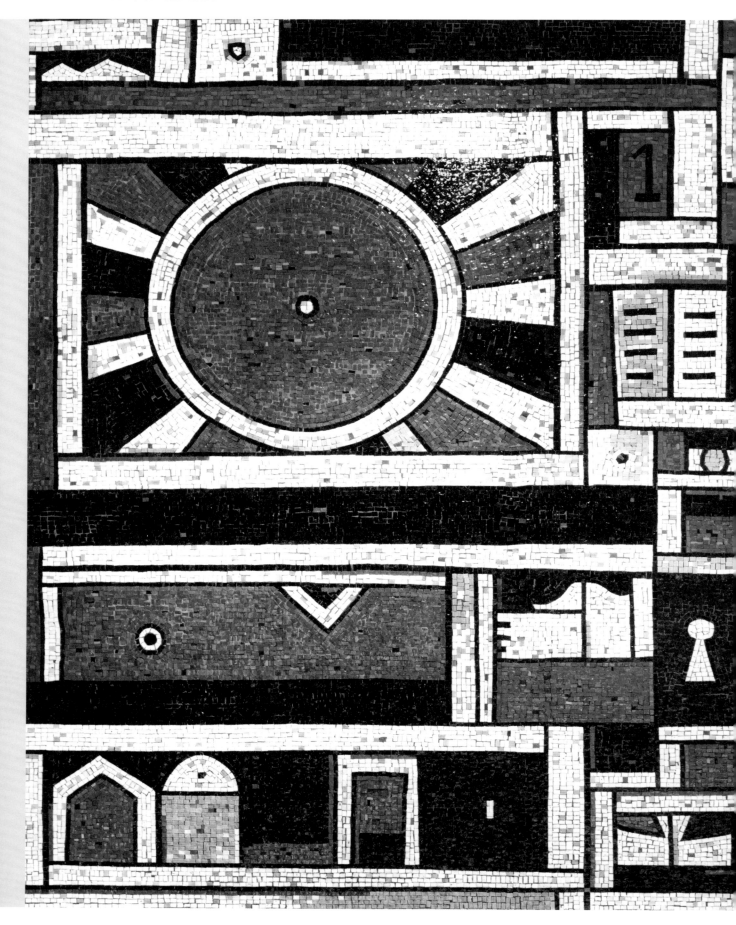

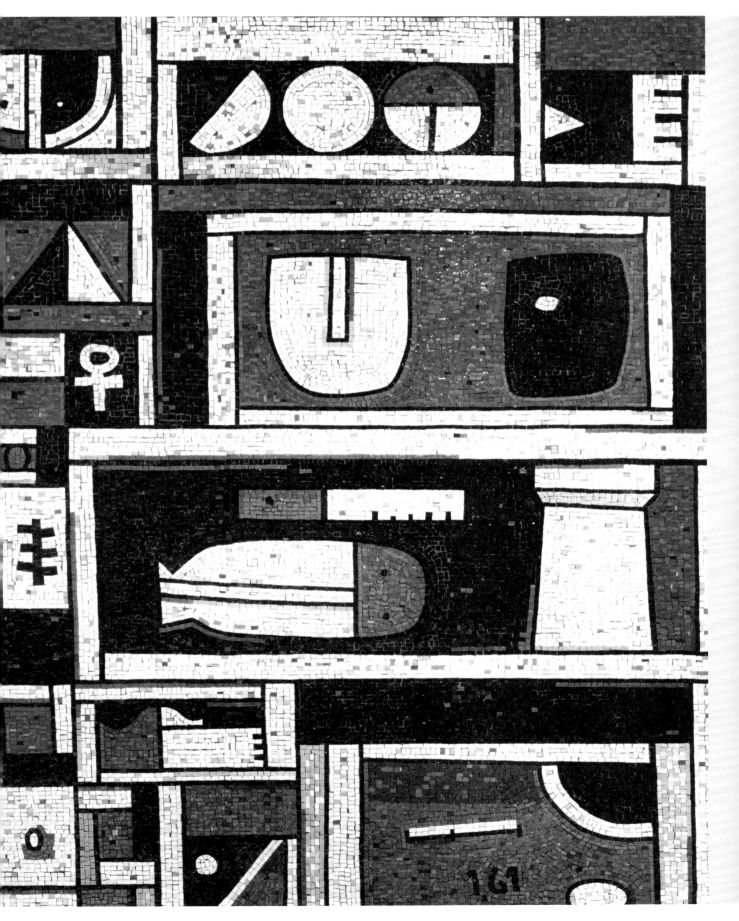

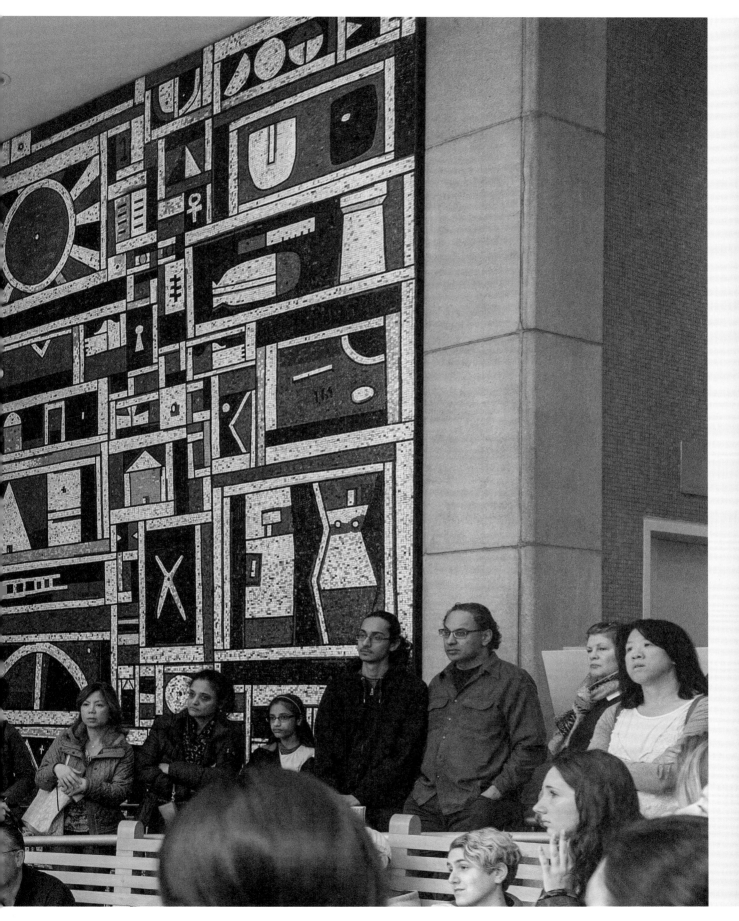

Gonzalo Fonseca

Untitled
1961
Glass mosaic

Gonzalo Fonseca and Universalist Modernism

Edward J. Sullivan

SURPRISING VISITORS OR STUDENTS at The New School as they turn a corner of the main lobby in Alvin Johnson/J. M. Kaplan Hall on West 12th Street is an imposing glass mosaic by Uruguayan artist Gonzalo Fonseca (1922–1997). Approximately eighteen by eleven feet, this image is created with thousands of individual tesserae (small glass tiles of Italian manufacture) in sober tones of muted red, brown, black, gray, and white, suggesting the substance of the earth and nature in its most austere state. The artist divides the area into a multitude of individual spaces, creating a veritable warren of trompe l'oeil cubes, shelves, and indentations to suggest a vast grid. Within this pattern Fonseca places a broad variety of simple shapes, among them such emblematic forms as a house, a fish, a key, and a pyramid, as well as circles and half-moons. In addition, we observe the inclusion of culturally specific shapes such as the ancient Egyptian ankh and a reference in the form of a half circle to the Inca sun god, Inti, in the upper left. The overall impression is of an encyclopedic web of interlaced and interrelated archetypal and transcendent symbols, which derive from the collective consciousness of the inhabitants of the earth. This work not only evinces significant power as a site-specific piece within a setting—the distinguished collection of one of the country's most renowned institutions of higher learning—but also partakes of an art-historical genealogy that links it to some of the most important manifestations of visual creativity in the twentieth century.

Gonzalo Fonseca's mosaic is, in fact, the largest and perhaps the only example in the United States of a monumental work that represents the artistic movement called El Taller Torres-García (The Torres-García

PAGES 90–91: Gonzalo Fonseca, *Untitled*, 1961 (detail).
PAGES 92–93: Vera List Atrium, with Gonzalo Fonseca, *Untitled*, 1961, and works by Martin Puryear and Dave Muller.

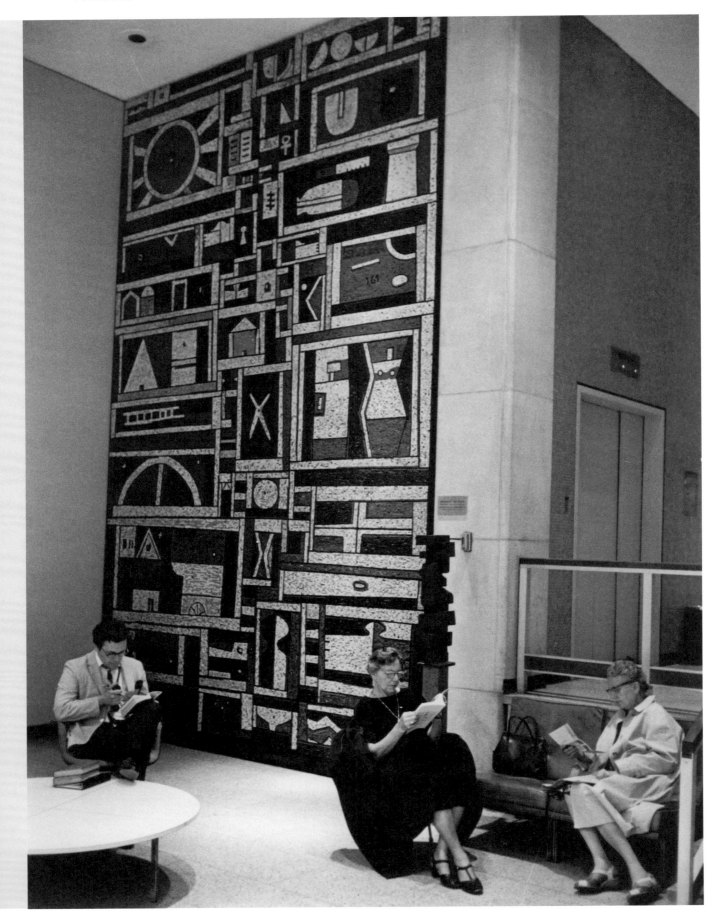

Workshop), named for the Uruguayan painter Joaquín Torres-García (1874–1949). Torres founded this organization in Montevideo in 1943, with himself at its head and his many disciples (including Fonseca, Julio Alpuy, Héctor Ragni, José Gurvich, Rosa Acle, and Torres's sons, Augusto and Horacio, among others) as participants in a series of artistic experiments that included painting, sculpture (principally in wood), ceramics, furniture, stained glass, and textiles. El Taller existed into the early 1960s, by which time many of its members had left Uruguay for travels in South America, Europe, and the Middle East, and in some cases (as in that of Fonseca), long periods of residence in New York. While El Taller had its greatest impact in South America (especially in Uruguay and Argentina), its members worked in collaboration with artists in a wide variety of venues throughout the world. El Taller Torres-García and its highly experimental orientation reached far beyond the conventional limits of "fine arts" to embrace architecture, interior decoration, and furnishings, in order to create comprehensive aesthetic environments. In its idealism, it is directly connected to such utopian endeavors as William Morris's late-nineteenth-century Arts and Crafts Movement, as well as the Bauhaus in pre–World War II Germany and the United States.

Fonseca's New School work evokes the theoretical viewpoints of Torres-García, his teacher and mentor, who conceived the philosophy he called Constructive Universalism, a mode of thought and art making that encapsulated his desires to evoke the primal concerns of humankind—from love and the need for shelter to faith and the impulse to worship a deity of one type or another—and to create art forms that would speak to all persons, no matter their ethnicity, cultural background, or religion. The mosaic could be described as what Torres-García called a Grid-Pattern-Sign, in which a surface (a canvas or, in this case, a wall) is divided into segments to house individual signs for or references to specific ideas. In this sense, Fonseca's work becomes, as well, a perfect reflection of the goals of The New School itself, in its desire to provide a socially engaged and relevant educational experience for students from all personal and geographical contexts, as well as creating an atmosphere of acceptance for intellectuals from all branches of inquiry.

Peter Moore. Lobby lounge with Gonzalo Fonseca's *Untitled*, 1961. 1965.

Fonseca had a personal relationship with The New School—which, in 1960, as the mosaic was in progress, presented an exhibition of the works of Taller Torres-García members. The artist lived in an apartment on West 11th Street into which he moved after receiving a Guggenheim Fellowship in 1957; his wife, Elizabeth Kaplan Fonseca, was the daughter of a university trustee and great financial supporter, Jacob M. Kaplan—for whom the building in which the mosaic is located is named. The New School's president at the time, Dr. Hans Simons, was instrumental in commissioning the work for the lobby of the structure that served as an extension of the historic 1931 Joseph Urban–designed building. And other Latin Americans, including Cuban painter Mario Carreño, Mexican photographer Emilio Amero, and Argentinean printmaker Antonio Frasconi, were active as teachers throughout the years in The New School's art program, making the school a model of excellence and a magnet for artists from south of the U.S. border. Fonseca's work is a jewel of the collection and an outstanding example of the impact of the collective artistic experience embodied by the renowned Taller Torres-García.

There are two more reasons why this mosaic represents a remarkable achievement. Although it was one of a number of large-scale decorative projects done by Fonseca in South America and the United States, most of these are now lost. Moreover, it was one of the last of its genre. From the late 1960s until the time of his death, Fonseca became much better known for his stone sculptures, to which he dedicated attention both in his New York studio and his atelier in Seravezza, Italy, where he would often spend six months of the year. These works, usually depicting architectonic structures, preserve the monumental and iconic qualities of his two-dimensional art. But the mosaic recalls the artist's early formation and, as an important example of mid-twentieth-century muralism, represents the concluding chapter in more than one history. Not only does it cap the first phase of mural making at The New School, earlier exemplified by Thomas Hart Benton, José Clemente Orozco, and Camilo Egas, it also stands as an end point to the idealistic projects that typified El Taller Torres-García. Fonseca's work was created on the cusp of the ascendancy of such decidedly non-utopian

modes of art as Conceptualism and Minimalism. It remains, therefore, a unique manifestation in a Manhattan context of a sensibility often associated with pre–World War II projects, a heroic and universalizing modernism.

Solve et Coagula

Hugh Raffles

THERE IS A PHOTOGRAPH OF Gonzalo Fonseca from 1957, the year before he moves to New York and begins work on the New School mosaic (page 101).[1] He is barefoot and from his neck, covering his body, hang objects of all shapes and sizes—a mass of mysterious objects that he has made himself, mostly, it appears, from wood: flat rectangles, square boxes, balls, paddles, half-moons, circles, sheets perhaps of woven reed, geometrical cases with carved interiors that look like *retablos* or schematic models of buildings, others that might be toys; recondite objects that hang from Fonseca like the tools of a shaman or a *curandero* or a *brujo* (an impression reinforced by the thin cane that he holds lightly in his right hand like a wizard's wand); objects that bring to mind Sir James Frazer's descriptions of ritual and magic in *The Golden Bough* (1890), one of the great anthropological compendia which Fonseca knew intimately, a companion to the hermetic collection of ancient and indigenous objects that would animate his new studio on 11th Street, behind doors on which he would write *NUTRISCO ET EXTINGUO* ("I nourish [the good] and extinguish [the bad]," the motto that the Renaissance king Francis I of France engraved on his personal emblem of crowned salamanders), and *SOLVE ET COAGULA* ("Dissolve and Recombine," the methodological axiom of the alchemists).[2] It is hard to read Fonseca's expression in the photo. A lock of dark hair strays over one eye. He is thirty-five, but looks older. He has traveled

1 The photograph is reproduced in Kosme de Barañano, "Gonzalo Fonseca: Arqueología de la Memoria," in *Gonzalo Fonseca, Kosme de Barañano, Brian Nissen, and Karen Wilkin* (Valencia: IVAM, 2002).

2 See Cecilia de Torres, "Gonzalo Fonseca, Graneros III," in *Blanton Museum of Art: Latin American Collection*, ed. Gabriel Pérez-Barreiro (Austin: University of Texas Press, 2006). My sincere thanks to Cecilia de Torres for her generous help with this essay.

widely in Europe, the Americas, and the Arab world, staying in a Shipibo village in the Amazon and visiting the pre-Columbian monuments of Bolivia and Peru (where, like so many people, he was overwhelmed at Machu Picchu), as well as the ancient sites of Egypt, Syria, Turkey, and the Mediterranean. He has recently worked at Jericho with the British archaeologist Kathleen Kenyon, who excavated the 9,500-year-old Jericho Skull—a skull packed with soil, its eyes two shells, its face filled out and modeled in plaster.

In leaving Uruguay, Fonseca is ending his long association with El Taller Torres-García, the pioneering painters' and sculptors' workshop in which he had incubated his ideas, his method, and his art. The indigenous people of Uruguay—the Charrúa, the Chaná, the Yaro, the Minuane, the Bohán, and many others—were all but eliminated by the mid-nineteenth century, and their architecture had been overlooked, ignored, or built over.[3] The future would be created from a past transfigured, by the reworking of its cosmic essence, its religious and ceremonial dimensions, its aesthetic and structural geometries, by the renewing of its spirit, by the South American artist making South American art—no matter where he was located. ("Our north is the South," Joaquín Torres-García wrote of his famous upside-down map of the continent. "There should be no North for us except in opposition to our South. That is why we now put the map upside-down, to have the right idea as to our position.")[4] "To see a rock in a field is nothing—but a rock on which there's a human trace—that moves me," Fonseca told a reporter when his first U.S. solo show, at the Jewish Museum, opened in New York in 1970.[5]

The New School mosaic, Fonseca's first commission in New York, was his final work for El Taller (he prominently positioned the group's fish symbol and signed the piece "TTG"). In his new studio—and at his house in Seravezza, Italy, next to a Carrara marble quarry—Fonseca began to produce the sculptures for which he is best known: mysterious stone landscapes and architectural models from times and places (and at scales) impossible to identify, densely erudite topographies that are also welcoming, inviting touch and immersion, humorously cryptic and puzzling, and

3 Gustavo Verdesio, "From the Erasure to the Rewriting of Indigenous Pasts: The Troubled Life of Archaeology in Uruguay," in *Handbook of South American Archaeology*, ed. Helaine Silverman and William Isbell (New York: Springer, 2008), 1,115–26.

4 Joaquín Torres-García, "The School of the South" (1935), reprinted in *Constructive Universalism and the School of the South*, ed. Ana María Escallón and Cecilia de Torres (Washington, DC: Art Museum of the Americas/ Organization of American States, 1996), 41.

5 Quoted in Grace Glueck, Art Notes, *New York Times*, November 29, 1970, 142.

Gonzalo Fonseca, 1957. Photo by Elizabeth Kaplan Fonseca.

strikingly beautiful in their textures and tactility. His work became an extended meditation, an encyclopedic universe of symbols and of references to what the critic Marianne V. Manley recognized as "an imagined antiquity," a magical and mysterious field, enigmatic but meaningful, meanings just beyond our grasp.[6] Some of this is already there in the mosaic, a wall of signs and spells now partially hidden behind Martin Puryear and Michael Van Valkenburgh's ramp but still pulsing with a vitality of its own, a deeply personal curtain of incantations and knowledge, arcane and inscrutable; of histories and geographies that, even as we snatch a glimpse of something familiar, still elude us, leaving the promise of worlds elsewhere that we don't yet, and perhaps never will, completely understand.

When a Mural Is a Blueprint

Mónica de la Torre

A WALL IS A WALL, UNLESS it is a mural. A mural is often a window, or a door. Gonzalo Fonseca's untitled mosaic mural in the lobby of Alvin Johnson/J. M. Kaplan Hall refuses trompe l'oeil in its resolute frontality, yet it imagines itself a portal to the realm of pure forms. Through its gridlike arrangement of red, black, and white glass tiles, it depicts architectural motifs and symbols from ancient civilizations: the ankh representing life, aqueducts, dwellings, granaries, masks, pottery, pyramids, silos, silhouettes, sundials, temples, towers, and—central to the composition—a variety of keyholes. A wall is stationary, but a mural can appear to be moving. In Fonseca's case, the shifting scale of the grid's panels gives the work a dynamism that seems as interested in defying flatness as in traversing time, pointing uncannily to early agrarian societies as much as to the urban grid underpinning the actual site.

6 Marianne V. Manley, "Gonzalo Fonseca," *Latin American Art*, Spring 1990, 25; cited in Kosme de Barañano, "Arqueología de la Memoria," 28, 30.

Liminal in more ways than one, *Untitled* was among Fonseca's first public commissions in the United States, and his first glass mosaic. But it was also one of his last pieces to utilize the pictographic idiom of the workshop of which he was a prominent member: El Taller Torres-García, founded by Joaquín Torres-García upon his return to Montevideo in 1934, after residing in Europe nearly four decades. Fonseca abandoned walls to focus on free-standing sculptures suggestive of miniature buildings, cave dwellings, or pueblos shortly after completion of the mosaic in 1961. These are built forms that nevertheless subvert function, turning on its head the architectural vocabulary of his previous wall works.

The mosaic's pictograms don't tell the story of Fonseca's move toward fantastical architecture, yet they do articulate other narratives. One of these speaks to abstraction as the condition of possibility for the cultural commons of the Americas, as posited in Torres-García's doctrine of Constructive Universalism. If the political turmoil of the era—with the Vietnam War and the 1968 movements across the world—amply demonstrates the pitfalls of universalist ideals, colonialism's ideological supports, then the contributions of Torres-García's School of the South (another designation for El Taller) reside in the *specificity* of geographical and historical context. Consider the following quotation, from Torres-García's "The New Art of America" (1942): "[W]e had already inverted the map, indicating that the South was our aim, and in a way severing our ties to the spiritual tyranny of Europe. Let us, then, reintegrate into the great Native American family." This reintegration "with archaic man" manifests in the appearance of the "geometric principle," which has a cosmic dimension and prevents the twentieth-century artist from falling into "the archeological, into making South American pastiches."[1]

Although such advocacy of pictograms as terms through which to articulate a cohesive cultural legacy had begun to falter after Torres-García's death in 1949, the School of the South's utopian aims remained very much in vogue in the sixties. The nonhierarchical structures of both the grid and the collective, in which notions of genius are invalidated;

1 Reprinted in Mari Carmen Ramírez and Héctor Olea, *Inverted Utopias: Avant-Garde Art in Latin America* (New Haven: Yale University Press, 2004), 474.

Cagean belief in the interpenetration of arts like architecture and fine art; emphasis on experimental processes as opposed to individual expression; construction of a common lexicon: What could correlate more effectively to ideals of the university?

And yet symbols can be ciphers. The pictographic elements of *Untitled* bestow on it an enigmatic quality. Do students passing through the lobby sit on Martin Puryear's nearby bench in order to decode the mosaic? That I cannot say, although I am reminded of the first piece by Fonseca that I ever encountered, in Mexico City. Each day, thousands of vehicles pass *La Torre de los Vientos* (*The Tower of the Winds*, 1968), his habitable cast-concrete structure alongside an exit of the Periférico highway. Drivers might imagine it to be a futuristic bunker, a set for a film taking place in the Tower of Babel, or a pre-Columbian silo associated with the archaeological ruins of Cuicuilco about a mile away, which remain partially buried by volcanic rock. Although the ruins are nearly three thousand years old, we owe their discovery to the same event for which Fonseca's sculpture was commissioned. The 1968 Olympics prompted construction of multiple facilities in a then-underdeveloped part of the city, attendant archaeological excavations, and the creation of nineteen public sculptures along the route between venues. This road was named the Ruta de la Amistad ("Route of Friendship"), although the country's political climate was rife with social tensions and tragically far from amicable. Only ten days before the games' opening ceremony, hundreds of students at a peaceful rally had been massacred by the state in the name of safeguarding the peace—students whose chants included *"¡No queremos Olimpiadas, queremos revolución!"* ("We don't want Olympic games, we want revolution!") In its abstraction, *La Torre de los Vientos* made no direct address to these concerns. But, then as now, it marks the last era in which large-scale public projects could be propelled by ideals of the avant-garde. Like the mosaic mural in New York, the tower in Mexico City stoically endures. Each defies function and commerce, and stands as a temple to the imagination and ritual. They remind us that architecture is shelter, and that at its foundation is a universal "will to construct,"[2] as Torres-García would have it.

Gonzalo Fonseca, *Untitled*, 1961 (detail).

2 Ibid., 488.

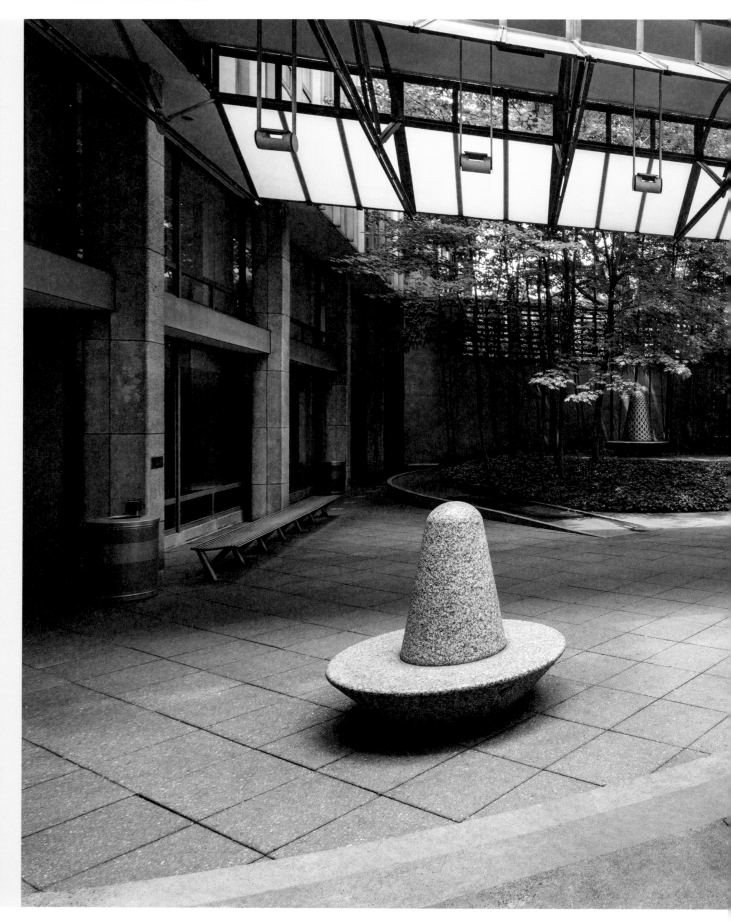

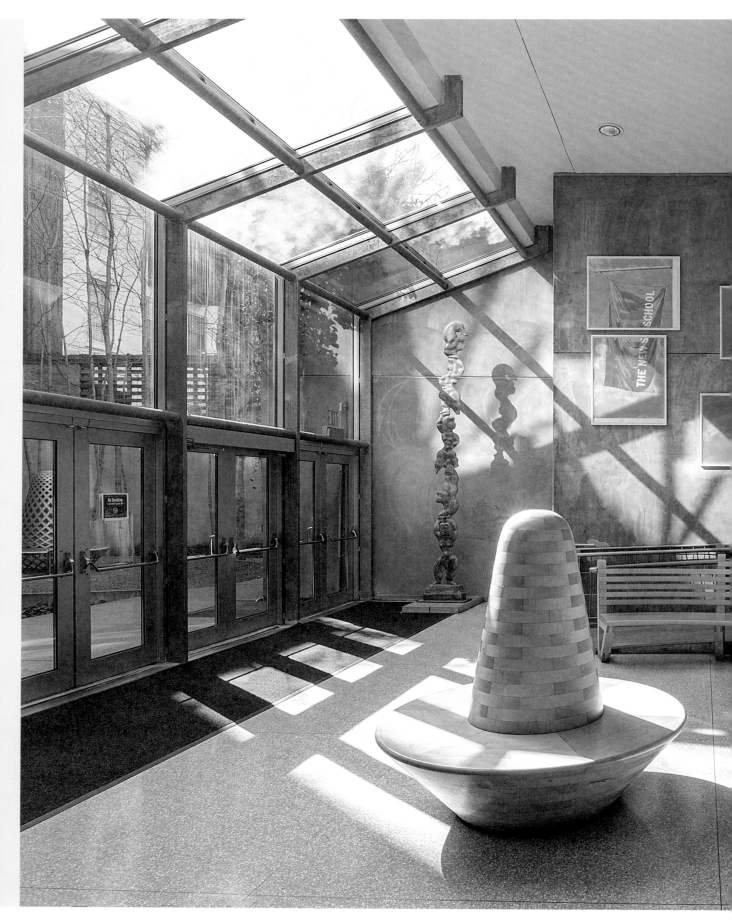

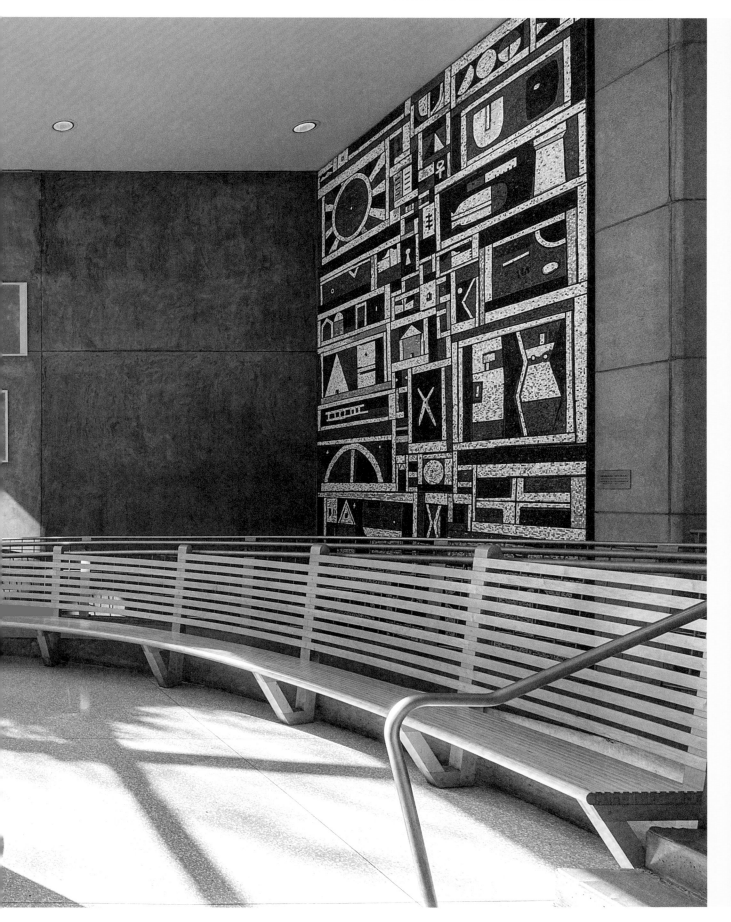

Martin Puryear + Michael Van Valkenburgh

Vera List Courtyard
1997
Courtyard and atrium design; benches in granite, stainless steel, and maple

Vera List Courtyard: A Brief History

Kathleen Goncharov

I MET VERA LIST IN 1987, soon after I assumed my position as curator of the university's Art Collection. Vera was a member of the newly formed Art Committee, and we became regular gallery-going companions. Vera was famous for spontaneously calling departments at the university and offering to fund new programs or scholarships—usually related to social justice—and if she thought an artwork would spark controversy or spur conversation, or if I led her to a piece that I felt suited the culture and politics of The New School, she often bought it for us whether or not it reflected her personal taste. The Graduate Faculty Building, also known as the List Center, had been named for her husband, Albert List, though she was the impetus behind his philanthropy to The New School. Vera came to the university as a student of sculptor Chaim Gross in the 1950s, eventually became a Life Trustee, and throughout the years was a major donor to The New School in her own right. She took her own generosity for granted and never asked that anything be named especially for her.[1] But I believed that this oversight should be corrected.

My purview as curator included the sculpture courtyard of Alvin Johnson/J. M. Kaplan Hall, which was outdated and under-used—and in early 1989, I learned that the Art in Public Places program of the National Endowment for the Arts (NEA) had begun to offer special grants for collaborations between artists and architects. This was an idea much in the air at the time as an antidote to what was derisively called "Plop Art." The Percent for Art program of the New York City Department of Cultural Affairs legally required that funds for art be included in the budgets of many new buildings, and the NEA wanted to stimulate artist-architect collaborations from a project's beginning to its end.

PAGES 106–07: Martin Puryear + Michael Van Valkenburgh, *Vera List Courtyard,* 1997 (exterior). PAGES 108–09: Martin Puryear + Michael Van Valkenburgh, *Vera List Courtyard,* 1997 (interior). Also visible are (far left) *Family of Five Acrobats* (1951), by Chaim Gross; (middle) *Extensions (Interpolations and Extrapolations)* (2008), by Dave Muller (detail); and (right) *Untitled* (1961), by Gonzalo Fonseca.

1 The Lists donated money to help build the 11th Street building in 1959, now the location of Eugene Lang College of Liberal Arts. In 1967, they also helped to purchase and renovate the building at 65 Fifth Avenue that became the Graduate Faculty Building. Both buildings carried Albert A. List's name for many years. In 2010, the building at 65 Fifth Avenue was demolished to be replaced by the University Center, and today 6 East 16th Street is known as the Albert and Vera List Academic Center.

Because Vera was a sculptor herself, I thought that a permanent work by Martin Puryear, her favorite living sculptor—and an artist whose work was particularly amenable to the purposes of public space— would be the perfect way to honor her. At a meeting with NEA officials, I raised the possibility of Puryear and an architect collaborating on a design for our courtyard. Puryear wanted to work with a landscape architect and proposed Michael Van Valkenburgh—a choice subsequently ratified by a committee including New School faculty and outside experts, as well as Puryear himself.[2]

The so-called culture wars were raging. Andres Serrano's *Piss Christ* (1987) and Robert Mapplethorpe's homoerotic photographs were in the news, and Congressional Republicans, led by Jesse Helms, were trying to defund the NEA. (Around the same time, The New School acquired Hans Haacke's silkscreen-and-photocollage diptych *Helmsboro Country (unfolded), 1990* (1990), a work pointing to Helms's deep ties to the tobacco industry; I was likewise concerned as a curator to augment the school's investment in artists of color, adding works by David Hammons, Glenn Ligon, Adrian Piper, Lorna Simpson, Carrie Mae Weems, and many others to the collection.) Eventually, The New School received an NEA award of forty-five thousand dollars for the Puryear–Van Valkenburgh commission. But an anti-obscenity clause, a sign of the times, had been attached. University president Jonathan Fanton was appalled. The institution had been founded on principles of free speech by intellectuals who had been censored elsewhere. It was clear to Fanton and the trustees that signing any clause restricting artistic expression would go against everything for which the university stood.

A lawsuit was filed by The New School against the NEA in June 1990, and settled out of court in February 1991. The obscenity clause was dropped. Just a month before, that clause had been declared unconstitutional in another suit won by California-based nonprofits. The final suit in the culture wars would be won in 1993 by "The NEA Four" (John Fleck, Karen Finley, Holly Hughes, and Tim Miller), performance artists whose peer panel–awarded grants had been unilaterally revoked for obscenity by the NEA chairperson. This last victory was short-lived, however, because in

2 The New School's architect, Rolf Ohlhausen, was brought into the project later, when it was decided that the 11th Street courtyard entrance and the cafeteria needed a redesign as well, and that the lower portion of the 12th Street lobby should be made ADA compliant.

retaliation all NEA funding for individual artists was eliminated.

Meanwhile, another controversy was brewing at The New School. Many institutions with financial troubles were selling artworks, and the university was considering deaccessioning its Isamu Noguchi sculpture, which stood in the courtyard. Agnes Gund, then president of The Museum of Modern Art and a member of The New School's Art Committee—who considered Vera something of a role model—was vehemently opposed to sales other than for the purchase of art. A compromise was reached in which Gund agreed to make a donation for the renovation of the courtyard if a portion of the funds from the sale of the Noguchi were also dedicated to the project. As unfortunate as it was to lose the Noguchi, Puryear and Van Valkenburgh's garden design, which integrates sculptural presence and practical function to create a contemplative meeting space in the midst of a busy urban institution, has been a particularly apt way in which to honor Vera's legacy. *Vera List Courtyard* was dedicated on November 2, 1997.

Inside Out: Outside In

Sarah E. Lawrence

IN THE LATE 1950S, as part of an expansion that marked the fortieth anniversary of The New School for Social Research, the Jacob M. Kaplan building was built alongside the 1931 landmark designed by Joseph Urban, which faces onto West 12th Street. A second edifice, opening onto West 11th Street and now known as the Eugene Lang College of Liberal Arts building, was erected a few years later.[1] The two buildings were connected midblock by a small courtyard featuring a sculpture by Isamu Noguchi. This courtyard was intended to be a central gathering place, but instead was used primarily as a mere

1 The Kaplan building was completed in 1956, and the Lang building (originally called the Albert List Building) in 1959.

passageway; its purpose as an "intellectual-artistic-social center for the community" was never realized.[2] Then in 1990, The New School received a grant from the National Endowment for the Arts to transform the courtyard into a site-specific work of art in itself, an environment for social interaction rather than an open-air patio used to display stand-alone artworks.

The project, later named the *Vera List Courtyard*, was to be a true collaboration between artist and architect. The commission was awarded to Martin Puryear, who sought out as his collaborator Michael Van Valkenburgh, a landscape architect whose work had already received numerous awards.[3] The successful collaboration is evident in that, in the courtyard, no meaningful distinction can be made between landscape and sculpture—it is the entirety of the space to which the visitor responds.

Having taken on the renovation of several urban plazas in the 1980s, Puryear differentiated between his sculpture and what he called his "amenities," sculptural furnishings for an urban setting: "Although I am primarily a sculptor, when I design something for use, I don't insist that it be called sculpture. If I am asked to design a bench, I'm happy having it called a bench. I think that responding to function is a very high calling."[4] The seating in *Vera List Courtyard* is more than a trio of benches, however, just as the articulation of space here is more than a courtyard. Puryear and Van Valkenburgh expanded the scope of their project to include the lobby lounge of Alvin Johnson/J. M. Kaplan Hall. The interior and exterior spaces are subtly linked by equidistantly placed benches that interrupt swift passage between buildings and instead invite passersby to pause. The three benches have an imposing sculptural presence. A central parabolic cone provides a backrest for the circular bench created by a second inverted cone. Puryear presents a form that appears familiar but cannot readily be named. In the courtyard, one bench is rendered in granite and the other in molded steel lattice; the third bench, in the lobby interior, is made of strips of laminated maple. Each of these materials finds its echo in the adjacent architecture: in the concrete basin of the courtyard, the steel grid of the facades on both buildings, and the encircling maple bench in the lobby.

Martin Puryear + Michael Van Valkenburgh, *Vera List Courtyard*, 1997 (exterior).

2 "Campus in a city back yard," *Architectural Forum* 113, no. 3 (September 1960): 106.

3 "New School for Social Research Sculpture Courtyard Prospectus" (1990), The New School Art Collection Files.

4 Martin Puryear quoted in Jan Garden Castro, "Martin Puryear: The Call of History," *Sculpture* 17, no. 10 (December 1998); 21. See also John Elderfield, *Martin Puryear* (New York: Museum of Modern Art, 2007), 177.

These sculptural forms in varied materials, so characteristic of Puryear's art, are designed to carefully orchestrate the passage from interior to exterior. The spiral ramps inside and out, which provide wheelchair access to the installation's changing levels, establish curves that repeat in the maple bench inside and in the stone and steel benches, ovoid terrace, pool, and plantings outside. The overhead walkway linking the two buildings is visually buffered by a glass canopy that frames the volume of space contained within. The rounded contours of the canopy shape the negative space overhead in sync with curved forms throughout the installation. Puryear has said, "I think that all my work has an element of escape, call it what you want: fantasy, escape, imagination, retreat."[5] *Vera List Courtyard* provides an urban haven in this way, an environment to which one can escape for imaginative reflection that fulfills the courtyard's original purpose as an intellectual-artistic-social center for the university.

Seats of Tension: Collaboration, Access, Security, Expression

Laura Y. Liu

VERA LIST COURTYARD (1997), by sculptor Martin Puryear and landscape architect Michael Van Valkenburgh, is a collaborative program for a public space that bridges indoor and outdoor use, creating adjoining spaces that serve as both transit areas and gathering places. Taken as a whole, the work raises questions about function-driven collaboration, the power of design to privilege subaltern users, the privatization of public space, and the politicization of federal arts funding.[1]

5 Martin Puryear quoted in Alan G. Artner, "A Sculptor's Two Sides: Martin Puryear in His Public and Private Art," *Chicago Tribune*, February 1, 1987, sec. 13. p. 14. Cited in John Elderfield, "Martin Puryear: Ideas of Otherness," in *Martin Puryear*, 48.

1 "Subaltern" here is drawn from the work of the Marxist theorist Antonio Gramsci (1891–1937), who used the term to designate a subordinated social group that nevertheless retains the immanent power to challenge hegemonic structures.

The courtyard and lobby feature three sculptural seats by Puryear, sharing a distinctive shape but realized in granite, stainless steel, and maple, as well as a curving maple bench that rings the indoor cone-shaped structure. Puryear is known for his mastery of materials and his virtuosity with abstract form. Yet of his functional pieces, he says, "I don't like to have these things confused with my sculpture. These are somewhere between sculpture, architecture, and design."[2] The distinction is suggestive; perhaps, like utilitarian objects, good public space requires aiming for "somewhere between." These remarks by the artist illuminate the dynamic interplay between the aesthetics and the functionality of the work's form.

One wonders how the demands of function shaped the collaboration. How was the "somewhere between" arrived at for the sculptor and the landscape architect? A New School press release announcing the dedication of *Vera List Courtyard* in 1997 notes, "The design is a total collaboration between Mr. Puryear and Mr. Van Valkenburgh, but Mr. Puryear was responsible for the sculptural seating and for the canopy that covers a visually problematic skyway."[3] Neither Puryear nor Van Valkenburgh has said much about their process—its delineations, shared contours, divisions of labor. Perhaps this ambiguity underscores the unknowability of collaboration for those outside it, leaving us to look for its traces in the echoes between the forms themselves. The curved seats and benches, for example, are mirrored in other elements shared between courtyard and lobby, notably the curving accessibility ramp at the center of each space—a larger one encircling the steel seat outdoors, and a smaller one wrapping around the maple seat inside. The functional and focal prominence of these ramps expresses a subtle power. By situating them as literal and aesthetic central features, Puryear and Van Valkenburgh present accessibility as the norm, rather than an awkward accommodation in compliance with the federal Americans with Disabilities Act (1990). This is an effective and elegant challenge to ableism in public space, reorienting our sense of who the privileged user is, and in effect, *renorming* the spaces.

2 Martin Puryear quoted in Jan Garden Castro, "Martin Puryear: The Call of History," *Sculpture* 17, no. 10 (December 1998): 16–21.

3 New School for Social Research, "New School Dedicates the Vera List Courtyard," news release (with images), November 2, 1997, New School Communications Office, records of George Calderaro, NS.03.01.03, unprocessed collection, The New School Archives and Special Collections, The New School, New York.

Yet we see a countervailing trend in terms of access for those outside of the school. Puryear and Van Valkenburgh's public space is institutional, of course, primarily serving the university. At the time of its renovation, however, the space was also envisioned as a benefit to the neighborhood, meant to "draw the larger community of Greenwich Village and New York City."[4] The renovated site would symbolize "openness" and would be "open to the public six days a week";[5] the 1997 press release describes it as a "small neighborhood park."[6] These visions stand in stark contrast to what exists today: a post-9/11 securitized institution where admittance is regulated by guards and identification cards, and visitors must have an explicit reason for entering. This deviation from The New School's original plan reflects the degree to which privatization has claimed institutional "public" space; the regulation of access compromises the porousness of the university to its neighborhood. Without romanticizing public space as a mythic agora, we should lament the distance between a vision of unplanned contact, social interaction, and intellectual exchange, and the institutional segregation produced by restricting *Vera List Courtyard* to those who already belong.

It appears that access, like publicness itself, entails conflict and negotiation over belonging. Public funding, too, exposes these tensions. Puryear and Van Valkenburgh's collaboration came at a moment of cultural dissent and state censorship in the United States. In 1989, The New School applied to the National Endowment for the Arts (NEA) to fund the renovation. The infamous effort led by Jesse Helms and the religious right was underway, seeking to defund the NEA on the grounds that the agency supported obscene and "anti-Christian" artwork. The New School, claiming violation of its First and Fifth Amendment rights, refused to sign the anti-obscenity pledge attached to its award and sued the NEA. In 1991, the parties reached an agreement to remove the condition, and the university dropped the lawsuit. The courtyard's design reminds us to be attentive to the ways in which art remains subject to political uses, including distortion. During the 1989 controversies surrounding the work of Andres Serrano and Robert Mapplethorpe, I was an undergraduate studying architecture,

4 "New School for Social Research Sculpture Courtyard Prospectus" (1990), The New School Art Collection Files.

5 Ibid., 2.

6 "New School Dedicates the Vera List Courtyard."

newly alert to art's capacity as both a powerful expression of cultural dissent and a tool for fomenting moral panic. In 1990, I saw a performance by Karen Finley, one of the "NEA Four" who were denied funding, and was deeply impressed by the visceral power of artistic risk-taking.

Today it is clear to me that, although Puryear and Van Valkenburgh's serene and abstract space seems to share little aesthetically with the provocatively sexualized work of Finley, Serrano, and Mapplethorpe, all these projects have intervened against morality-based censorship. Proposals to defund or restrict the NEA have resurfaced and will continue to arise, and the tightening of control over the right of entry into institutions will likely go on as well. The disjuncture between the expansion of non-ableist access achieved by Puryear and Van Valkenburgh's design and the narrowing of neighborhood access brought about by the tightening of university access rules encapsulates the complicated trajectories of social progress in the design of institutional public space as well as in wider society in the decades since Vera List Courtyard was installed. Yet the value of federally funded art and design, like that of public space, remains: to provide a public good in the service of democratizing access—in all its forms.

Vera List Courtyard and the Culture Wars

Olu Oguibe

MARTIN PURYEAR AND MICHAEL VAN VALKENBURGH'S collaborative commission for the midblock courtyard between 66 West 12th and 65 West 11th Streets at The New School began with an unlikely controversy, one that

makes it unique in The New School Art Collection as well as in the careers of the artist and architect. It is hard to imagine this conflict now when undergraduates slip into the court on a spring afternoon to chat with their mates or catch up on social media; after all, usually, obscenity or decency controversies emerge around art in public space only after a work has been installed—and such debates almost always focus on content or location. Neither of these was at issue with the Puryear + Van Valkenburgh commission. Instead, the controversy centered on the parameters of civic patronage or, more plainly, the use and abuse of public funding to regulate art.

Michael Van Valkenburgh's work is typically no more contentious than that of any other visionary landscape architect. Martin Puryear's sculpture, with its ascetic, East Asian religious inclinations and traditional West African formal and philosophical references, certainly has its sensual qualities. It could, in fact, be argued that although Puryear's work is deeply and inscrutably formal, his often fastidiously polished surfaces and curvilinear shapes evoke more than a touch of eroticism. This sensual element is probably most obvious in the two upright mortar-and-pestle forms that Puryear placed in *Vera List Courtyard*, one in granite and the other in a woven steel mesh that transforms it almost completely into basketry. The steel form is illuminated from within, so that it doubles as a lamp at night. The two forms also function as circular benches. (A third bench, in which the same shape is rendered in maple, occupies the lobby atrium of 66 West 12th Street.)

These elements are anchors in the plan that Puryear and Van Valkenburgh executed, but they are hardly the most striking features in an ingenious design that also includes a prominent central mound; a wide, low flight of stairs extending from indoors into the court, forming a kind of amphitheater; a smooth-paved accessibility ramp opposite the stairs; and large swaths of plantings, combining deciduous trees, bamboo, and climbers with hardy, evergreen ground cover. Surrounded by the full foliage, the mortar-and-pestle sculptures become almost utilitarian, and it takes a creative imagination to read them as erotic, or to connect them to the earth mound and thence to fertility totems.

However, in 1990, these formal considerations were beside the point, for The New School had been awarded a planning grant by the National Endowment for the Arts (NEA). The university could implement the grant only by complying with a clause introduced by Republican Senator Jesse Helms requiring that all NEA grantee projects clear a decency or anti-obscenity bar, as determined by the agency. It gave the agency new authority to use federal funding—"taxpayer dollars," as conservatives like to say—to regulate cultural practice in the United States. The New School felt that the clause breached its First and Fifth Amendment rights, and therefore was unconstitutional. The university took the NEA to court.

In a statement issued on July 10, 1990, Jonathan Fanton, then president of The New School, argued, "We believe the obscenity condition, even as now interpreted, will continue to cause grant recipients to avoid producing controversial art for fear it will be seen as coming too close to the line that defines prohibited speech." On February 20, 1991, the case was settled out of court with an agreement that the NEA could not enforce the Helms clause. The New School saw the settlement as a victory against emboldened right-wing encroachment on artistic freedom and constitutional protections.

The battles that took place throughout the 1990s between artists and cultural institutions on one hand, and conservative forces and right-wing politicians on the other, came to be known as the culture wars. The annals of these years are filled with public confrontations and marquee moments, and seldom is mention made of the New School court case or the Puryear–Van Valkenburgh project. Although Martin Puryear is far from an overtly political artist and the *List Courtyard* commission was not in itself provocative, it nonetheless stands as a landmark in the struggle to protect freedom of speech and freedom of expression in the United States.

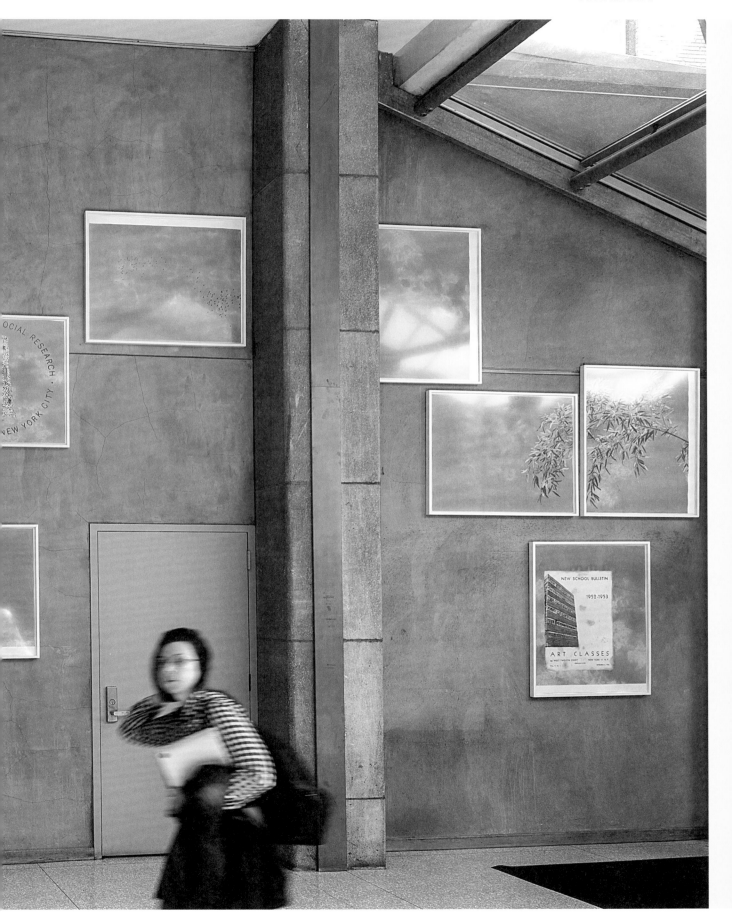

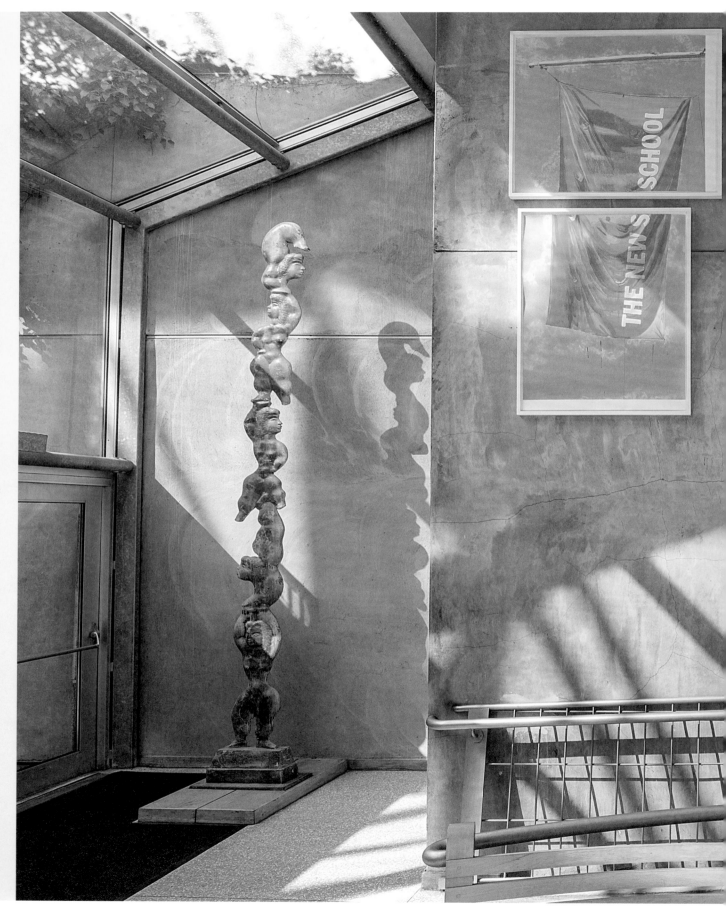

Dave Muller

**Interpolations
and Extrapolations**
2002–03
**Extensions
(Interpolations and
Extrapolations)**
2008
Acrylic on paper

Interpolating and Extrapolating

Stefano Basilico

TIMES CHANGE AND MEANINGS CHANGE. So do branding exercises. If brands are what we believe in, what do we believe when the brand changes repeatedly?
Dave Muller's *Interpolations and Extrapolations* was commissioned in 2002. It consists of fifteen individually framed drawings, depicting blue skies and various logos that had at that point been used by The New School, along with birds and bamboo leaves. What was originally called The New School for Social Research had been in existence since 1919 and had gone through many changes: from a small continuing education school that became an important refuge for European dissidents in the era of World War II to a full-fledged university, providing undergraduate and graduate degrees as well as continuing education classes. This eclectic amalgam had been knit together from a group of smaller independent schools and institutes, including Mannes College of Music, Parsons School of Design, the Milano Graduate School of Management and Urban Policy (now Milano School of Policy, Management and Environment), and the Institute for Retired Professionals, among others. In the years between the institution's founding and the creation of Muller's installation, The New School had grown, its mission had evolved, its student population had exploded, and its name had been altered. The result of this dynamism was that the school's identity seemed unstable—even to itself. Muller's work—which frequently deals with self-selecting social groups (such as the art world) and these groups' self-presentations through ephemera—provided an ideal lens through which the institution could reflect on itself and communicate a reunified identity. At the same time, Muller's subtle

PAGES 122–23: Dave Muller, *Interpolations and Extrapolations*, 2002–03.
PAGES 124–25: Dave Muller, *Extensions (Interpolations and Extrapolations)*, 2008. Also visible on page 124 is *Family of Five Acrobats* (1951), by Chaim Gross.

intervention suggests that the ongoing effort to select a brand identity was a major focus for the university, possibly as important to its self-definition as the substance of its pedagogy.

"What's in a name? That which we call a rose / By any other name would smell as sweet." This may have been true in Shakespeare's time, but today, even for things originally made by nature, a name purports to be everything. Even the rose is simple no longer. Instead we have, for instance, David Austin® English Roses, which have a "superb fragrance with many petals." So if trademarked roses have a sweeter smell, then the branding of an institution is key to its success, or thus we have been led to believe. A name and design iconography become substitutes for meaning, stand-ins for experience. The power of brand identity was of course well understood before we entered the digital age, at least by marketers and advertising professionals. But our digital culture has stimulated in us a desire to present a unified and positive face not only to the world at large but to our most intimate audience—ourselves. The exceedingly cheery and interesting lives we seem to lead on social media are only possible because we perform those lives—or at least curate the photographic proof and written synopses of our existence—with a brand marketer's clear-eyed view that the appearance of reality is paramount.

The New School's grasp of the ways in which design and visual presentation shape the world is exemplified by the fact that in 2008, The Art Collection recommissioned Muller to update his existing work to respond to the school's newest branding makeover. The effect is to render Muller's project an inverse of *The Picture of Dorian Gray*. Unlike the protagonist's portrait in the Oscar Wilde novel, Muller's series is prominently displayed, serving not to hide the truth or the past, but to make it knowable as an object lesson whereby the institution's historical evolution—and even struggles—are conveyed. Muller's two-part work also serves as a cautionary tale about the valorization of brands in contemporary culture. While The New School's transparency and self-awareness regarding the power of design and the visual domain are manifest in its commitment to Muller's

evolving work, the university's expanded invitation to the artist also reminds us that such transparency is not necessarily common outside its doors. There are too many recent instances to list, but suffice it to say that real-world examples of the complete separation of substance from image are all too prevalent. In his own sly way, Muller gives us a paradigm by which to critically understand all institutions: Consider his title. Interpolation and extrapolation, in mathematical terms, are means by which we can estimate what we don't or can't know on the basis of what we do know. Interpolation allows us to guess at what may be found between two known sets of facts or points. Extrapolation allows us to imagine what the future of a thing or person may be from what we know about that entity's past. These two strata-gems are useful not only to aspiring mathematicians but to any citizen who wishes to reconstruct or to predict otherwise hidden aspects of the world around them. For, ultimately, the world and knowledge of it are what interest Muller most. Branding and design may determine political, social, and institutional realities to a great extent. But look through the plate-glass wall separating The New School's lobby from its interior courtyard, and real bamboo and sunshine—not their graphic representations—are what you will see.

Brand New

Jeffrey Kastner

THE EFFECTS OF INSTITUTIONAL IDENTITY are difficult to quantify. But the ways in which a given organization distills what it considers its signal qualities into a public image—figured through carefully calibrated symbols, colors, typographic strategies, and the like—are almost universally agreed to play a critical role in how an enterprise is received. Branding is a multi-million-

dollar industry, and critics like Naomi Klein have argued that the insidious complex of lifestyle marketing produces an estranging sense of our lives as "sponsored." The situation is perhaps less cut-and-dried for a university—especially one like The New School, with its unique origin story and composite institutional (and physical) structure. For an educational institution, public image can be understood as more than an enticement to potential customers/attendees. It's likewise a means of gathering a heterogeneous student body into a community, one at least notionally united under a visual rubric.

It's not unusual for organizations to undergo (sometimes repeated) "rebrandings"—not just to communicate an evolving operational focus or respond to shifting economic conditions within or beyond the institution, but also to contend with changing fashions in marketing, design, and/or technology. And despite being relatively young, The New School has undergone its fair share of such identity recastings, involving in some cases its very name. The challenge for organizations that alter their public personae in this way is to frame the modifications as a sign of flexibility and responsiveness rather than anxious attempts to court newness.

In 2002, the University Committee on The Art Collection commissioned a work for the atrium at 66 West 12th Street from the Los Angeles–based artist Dave Muller. Muller is known for his interest in social and institutional dynamics, and the ways in which such dynamics are made manifest in cultural imagery and activity. He responded to the invitation with *Interpolations and Extrapolations* (2002–03), a series of acrylic-on-paper paintings that consider the evolution of the space in which they sit and, more broadly, that of The New School's identity. In his practice, Muller has frequently attempted to locate affective potential in the taxonomic and the archival, and the conditions of a brand—a signifying complex expressly designed to conjure a kind of emotional affinity—provide a rich subject for this mode of inquiry. Muller's project suggests that, taken together, the repeated alterations of The New School's identity constitute a form of institutional memory, a means for understanding historical trajectories

both within and outside of the organization. His gathering of these traces produces what might be thought of as a meta-brand for the school—one that yields, via aggregation, a fuller sense of the university's nature than is available in any single one of its successive looks.

Interpolations and Extrapolations brings together a number of threads in Muller's art. Evocative of his interest in reportorial renderings of familiar cultural objects—notably the spines of rock-and-roll LP covers and cassette and CD cases—the New School images are also formally related to a series of multipanel paintings the artist was working on in the first decade of the 2000s that are similarly modular and dominated by expanses of sky. For The New School he produced a group of individual rectangular paintings that mix and match such skyscapes, using them in some images as moments of unadorned, punctuational stillness and in others as a background for deadpan representations of symbols and artifacts suggestive of the institution's history. These include a medallion from the 1960s that features the likenesses of Alvin Johnson, Charles Beard, and James Harvey Robinson, three founders of the original New School for Social Research; a stylized tree logo with the letters *NS*, in use in the 1960s and 1970s; and a green banner from the 1990s adorned with an abstracted, multicolored shield that served as the logo for what was then known as New School University. Other panels in the suite turn their attention to an artistic legacy: an art-class bulletin from 1952–53 with an image on its cover of the modernist facade at 66 West 12th Street; the top of the honeycombed steel seat by Martin Puryear placed in the courtyard; and a rendering of a sculpture by Isamu Noguchi, formerly owned by the school, that was deaccessioned in order to help fund design of the atrium and courtyard.

In 2005, just two years after Muller created *Interpolations and Extrapolations*, The New School was again rebranded. The new new identity introduced the school's refashioned name, "The New School"—with the phrase "A University" often appended to it—rendered in a stylized, stencil-like form, and in 2008, Muller was invited to add to his original work in order to include the amended logo. The quartet of new paintings, *Extensions*

(Interpolations and Extrapolations), has over time been hung in different configurations with others from the total group of nineteen. In the current iteration, the four most recent images are installed together on a wall opposite the larger group: two featuring the 2005 banner, and two filled only with sky and wispy clouds, here reading like a sly nod to the school's apparently limitless blue-sky optimism regarding the possibilities of the new. One wonders if the wall space left open around this quartet might give form to a presentiment of a third phase for Muller's project, given that in 2015, the school updated its branding once again, replacing its just-ten-year-old identity with yet another that was designed to wipe the slate clean once more and confidently tell a new story—but which, for the artist, provides an additional element to be added to his archive of the school's ever-shifting notions of itself.

Identity Interpolated and Extrapolated

Jamer Hunt

WHEN CORPORATIONS HAVE SOME of the same legal rights and standing as natural persons do, what does it mean to suggest that an institution has an identity? Identity is a funny thing. It seems to inhere in things the way that the human spirit inheres within the physical body or the way that carbon atoms inhere within all living things. And yet often, and especially for institutions and organizations, identity comes from without—as an external imposition of order and meaning upon an otherwise sprawling agglomeration of things material and immaterial.

Dave Muller, *Interpolations and Extrapolations*, 2002–03 (detail).

Identity, as a communication designer might produce it, is the artifact of a cognitive sleight-of-hand: Insignificant marks—ink on paper or pixels onscreen—aim to invoke entire value systems, signaling outward through a swarm of competing signs and symbols. Now often called brand identities, these marks condense buildings and people and products and services and organizational culture and transportation systems and workers and boxes and retail stores and logos and mission statements and dreams into an impossibly slight form that strains to contain its multitudes—the part standing in for the whole.

At its most literal, identity is self-similarity: This thing *is* this thing and that thing *is* that thing. The word itself derives from the Latin *idem*, meaning "same." But to be the *same* presupposes likeness, and likeness presupposes an originary entity and the quality of being selfsame to it. In other words, identity is always split into two, existing in tension between its material substrate and an essential quality that almost, but not quite, inheres in it.

The psychoanalyst Jacques Lacan understood this dualistic tension. In his famous 1949 lecture "The Mirror Stage as Formative of the Function of the I as Revealed in Psychoanalytic Experience," Lacan suggested that identity—that solid sense of a unique self that we embody—comes to us as much from without as from within. The mirror stage represents a moment in the development of a child (between six and eighteen months) when, as Lacan suggests, she is "jubilant" to see herself for the first time as a unified being in the mirror's reflection. Until that point, the infant senses herself as a "body in fragments," a discordant jumble of drives and sensations that are not fully dissociable from the surrounding environment.[1] The mirror stage is formative of the *I* that emerges individuated, bounded, out of the chaotic sensations that precede it. The rub, for Lacan, is that that confirmatory mirror image haunts us thereafter. We long for, but can never attain, the fulsome unity the mirage promised: plenitude, completeness, and satisfaction.

If Dave Muller's 2002–03 work *Interpolations and Extrapolations* (as well as its 2008 update, *Extensions*) reflects upon The New School's

1 Jacques Lacan, "The Mirror Stage as Formative of the Function of the I as Revealed in Psychoanalytic Experience," in *Écrits: A Selection*, trans. Alan Sheridan (New York: W. W. Norton and Company Inc., 1977), 2.

history and identity, it does so in a way that visually echoes the dynamic tensions of the mirror stage. The work itself is a remarkable assemblage: fragments of The New School's manifold visual identities—its design histories—serenely float in a blue sky like splintered recollections from a dream. Meticulous in their painterly execution, yet oddly excised from any context except that blue sky, the solitary elements weave a web of associations that add up to something approximating a visual genealogy of The New School.

Muller's multipanel work (with nineteen panels in all) x-rays the institution's protean identity, revealing it to be a volatile mixture of solidity and flux, artifact and fantasy. Is this any surprise? An institution that embraces "the new" as a permanent condition is, in that sense, flouting the fixity of identity itself. By parading across his frames of view the material traces of The New School's past efforts to incorporate its own identity—via logotypes, insignias, banners, medallions, and catalogs—Muller dares us to consider their essential inadequacy. He does not align the fragments into some comfortable historical narrative of progress and unity. They are, instead, parts straining to signify a whole, and Muller's provocative juxtaposition across his dreamscape makes manifest their imposture.

The glimpses into these many windows are, indeed, *interpolations* and *extrapolations* of what The New School has been, is, and might well become. *Inter-* and *extra-*, between and beyond, they honor restlessness and fluidity. Most universities reach for signifiers of constancy. Muller's panels reveal instead an identity that resists misbegotten appeals to timelessness.

There is another class of elements in Muller's many panes: that blue sky, bamboo leaves, details of sculptural forms, flocking birds. These are strangely familiar to any New School regular, for they point toward the outdoor courtyard adjacent to the work itself—though on the other side of the glass. Hovering between inside and out, Muller's "windows" create an illusory threshold, a porous skin through which the interior and the exterior commingle. Just as the child's identity forms through the oscillation of inside and outside, Muller's windows reflect back to us the unsteady tension of stasis and flux at the heart of institutional identity.

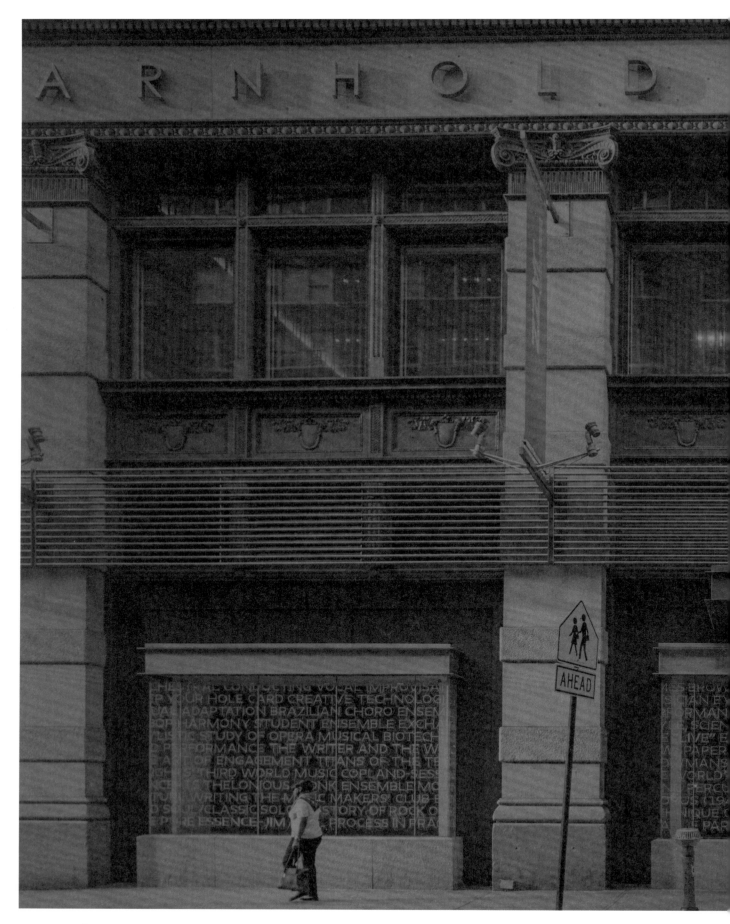

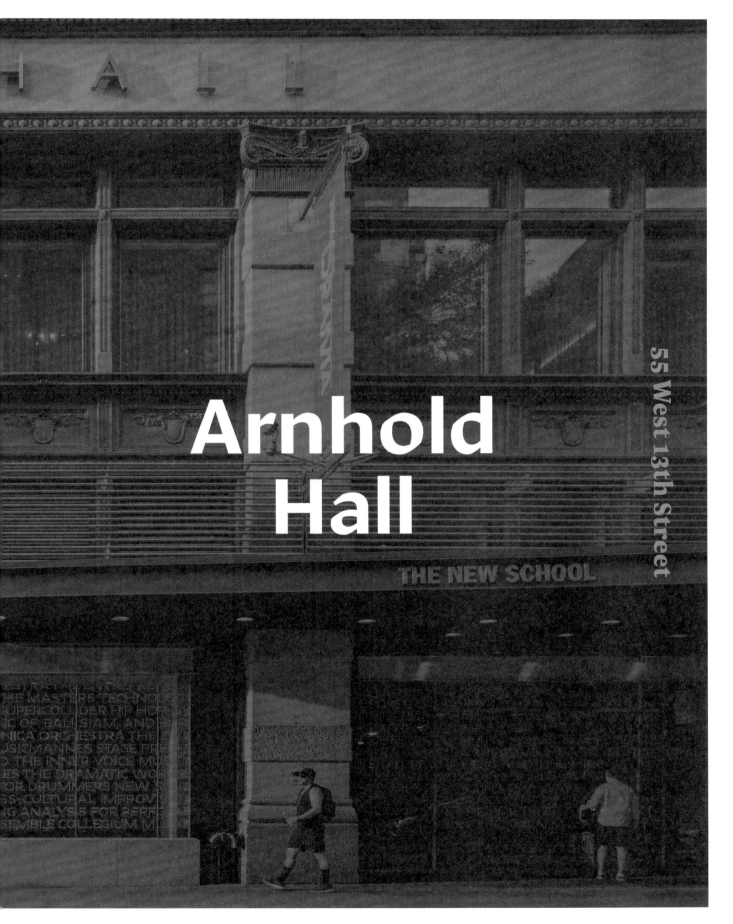

Arnhold Hall

THE NEW SCHOOL

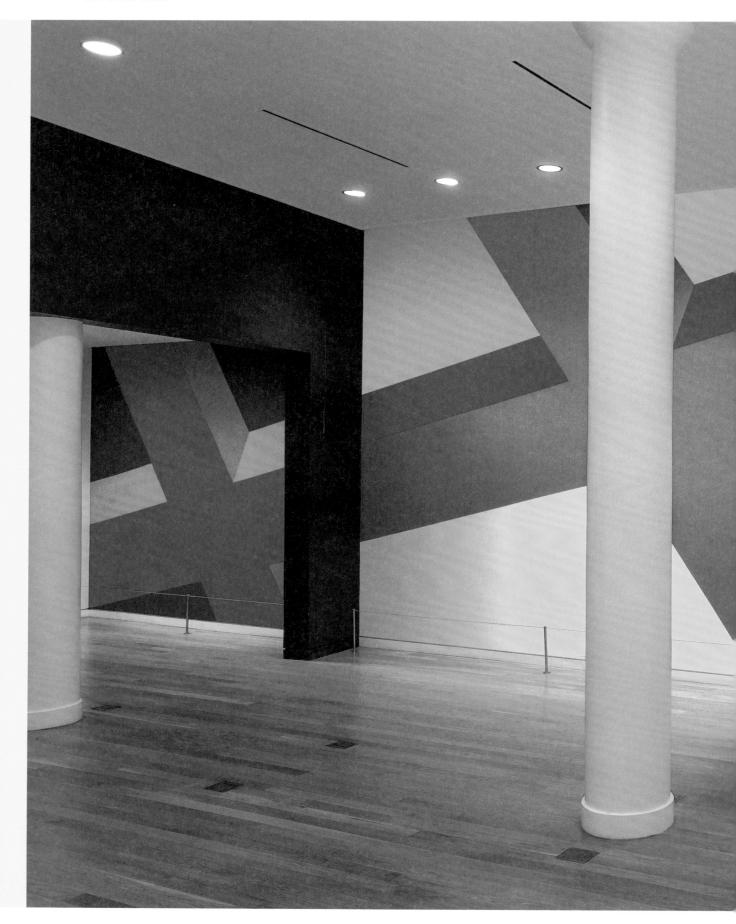

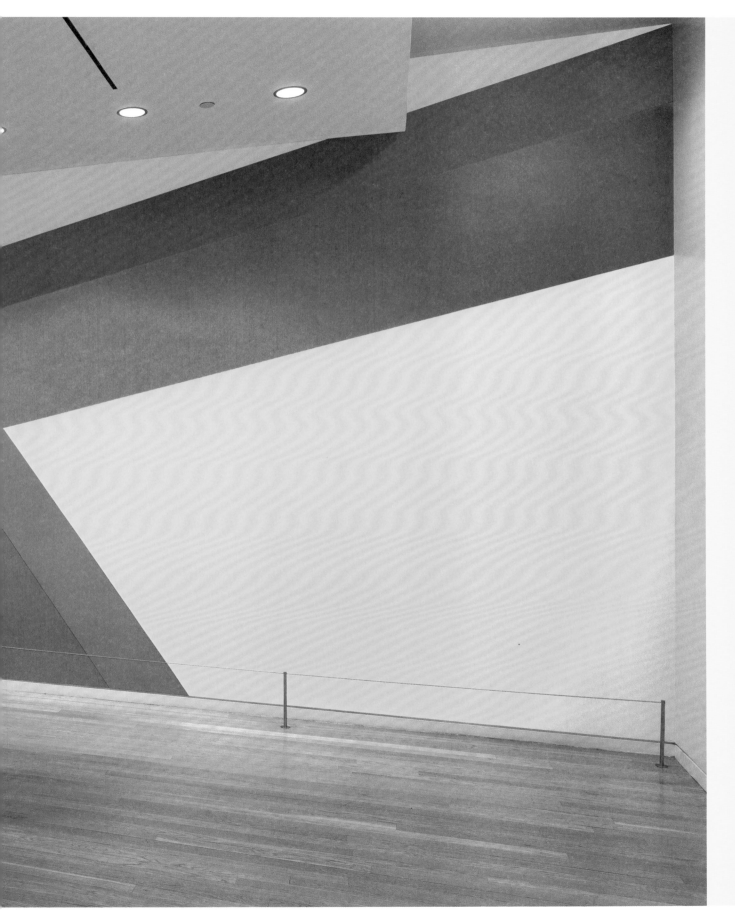

Sol LeWitt

**Wall Drawing
#1073, Bars
of Color (New
School)**
2003
Acrylic paint

#1073

Tan Lin

LIKE A DOOR, a wall is a serial operation performed on a spatial volume. And so it is with Sol LeWitt's *Wall Drawing #1073, Bars of Color (New School)* (2003). Zoning codes in the mid-sixties dictated the set-back, step-down structure of New York skyscrapers and the skyscraper-and-tenement rhythms of the city's skyline; likewise, LeWitt's mural establishes a series of cadences across four distinct architectural zones. LeWitt notes, "Serial compositions are multi-part pieces with regulated changes."[1] The mural is first visible near the main entrance of 55 West 13th Street, on the ground floor, along a western wall bisected in perpendicular fashion by a glass partition. On the second floor, the mural resumes along an eastern wall, where it is bisected by a gray-painted proscenium-style wall (not part of the artwork) near the elevator.

Traversing vertical and horizontal axes, the work creates a time-based image or calculus that resembles the photographer Eadweard Muybridge's stop-motion photographs, from which LeWitt claimed to have drawn inspiration. The western and eastern walls are not contiguous on the vertical axis; they are parallel but offset; the bright colors limn the left-hand lobby wall as one enters and the right-hand upstairs wall as one faces the back of Arnhold Hall. The mural's rhythmic composition meets the viewer as a series of perceptual experiences tuned to structural supports. As LeWitt has explained, "The physical properties of the wall: height, length, color, material, and architectural conditions and intrusions, are a necessary part of the drawings."[2] The regulated bars of color, like color more generally, punctuate the building and give it constancy; the color conforms to rather than adorns the architectural program, such that perception of the work is correlated to perception of the architecture as one moves through it.

PAGES 138–39: Sol LeWitt, *Wall Drawing #1073, Bars of Color (New School) (Part A)*, 2003, redrawn in 2015.
PAGES 140–41: Sol LeWitt, *Wall Drawing #1073, Bars of Color (New School) (Part B)*, 2003.

1 Sol LeWitt, "Serial Project No. 1," *Aspen Magazine*, nos. 5–6 (fall/winter 1967): n.p. Reprinted in Gary Garrels, ed., *Sol LeWitt: A Retrospective* (San Francisco Museum of Modern Art and New Haven: Yale University Press, 2000), 373.

2 Sol LeWitt, "Wall Drawings," *Arts Magazine* 44, no. 6 (April 1970): 45.

Because an inhabitant's sensory registration of space is subject to movement and recalibration, use of space is time-sensitive, processual, inconstant. LeWitt's mural obeys this logic of the interval. Not unlike Steve Reich, who made what he termed "perceptible processes" audible by repeating a taped segment twice and looping the results—thereby creating an effect known as phase shifting—LeWitt orchestrates phase shifts between upstairs and downstairs and left and right. Such a project involving the calculus of the sensorial might be termed an architectural plan of feelings stimulated by the physical surround and the three-dimensional apparatuses that undergird them. What are perceptions but the mental and psychological administering of procedural conditions? And what of the feelings themselves, subject to arbitrary incompleteness? LeWitt's genius was to suggest that feelings are serial operations of life, out of sync with themselves and thus capable of generating microtonal timbres lodged in the intervals between the things we thought and the things we thought we saw.

LeWitt's Problem(s)

Jennifer Wilson

IN MY OPINIONATED YOUNGER DAYS, I held a secret disdain for Conceptual art. Mathematics, I said to myself, is the real Conceptual art; what we call Conceptual art is merely bad mathematics.

At the time, I was responding to the vague terms and lack of analysis I perceived in the practices of artists such as Joseph Kosuth and Lawrence Weiner. Their self-referential works blur boundaries between language, abstraction, and visual artifact—a territory that mathematics

occupies with well-defined vocabulary and rigorous logic. But that was before I learned about the wall drawings of Sol LeWitt.

It is not an artist's business to illustrate mathematical concepts, but more than the works of other Conceptual artists, LeWitt's drawings have often been linked to mathematics. There is his reliance on geometric forms to explore ideas of dimension, scale, perspective, color, and permutation. There is also his formal language: the apparent order and economy of gesture, the reliance on notation and precise syntax to define an idea. Most crucially, however, from a mathematician's perspective, is the sense that each work seems to present the solution to a specific problem.

LeWitt's well-known *Variations of Incomplete Open Cubes* makes the case most strongly. The problem suggested in this work on paper (which served as the announcement for his 1974 show at the John Weber Gallery in New York) is as follows: Find all connected sets of edges of a cube that contains between three and eleven edges, where two sets

Sol LeWitt, *Variations of Incomplete Open Cubes*, announcement card for exhibition at John Weber Gallery, New York, 1974.

are considered equivalent if one can be rotated to coincide with the other. LeWitt uncovered the 122 variations by working with physical models, and then contacted physicist Erna Herrey to ensure that his list was complete.

The cubes in *Variations…* are organized by size, each row (or group of rows) in the grid corresponding to an increasing number of edges. Within the rows, however, the logic is less apparent. What is the organizing principle by which the individual versions are sequenced? Can we tell simply by looking that these are all the variations that exist? Should we even try to analyze this work like a puzzle, or should we respond directly to the confluence of two- and three-dimensional representations and the beauty of the geometry? A mathematical solution would not only contain the correct answer, but present it in such a way as to convince the reader/viewer of its truth. The explanation—whether verbal, symbolic, geometric, or a combination thereof—would be communicated through a logical progression of ideas.[1]

The ambiguity of LeWitt's intentions is still more apparent in *Wall Drawing #305: The location of one hundred random specific points. (The locations are determined by the drafters)* (1977). The language of the instructions—which, along with the lines and points, make up the drawing itself—echoes that of Euclid's *Geometry*. But as the sequence progresses,

Sol LeWitt, *Wall Drawing #305*, August 1977 (detail).

1 In 2011, for his master's thesis, "Analysis of Variations of Incomplete Open Cubes by Sol LeWitt," Michael Allan Reb completed a graph-theoretic proof that the 122 variations are complete. Kansas State University Archives (2004), http://krex.k-state.edu/dspace/handle/2097/15809 (accessed January 10, 2016).

the text becomes increasingly baroque. In "Paragraphs on Conceptual Art," LeWitt declares, "The idea becomes a machine that makes the art."[2] Here the machine is a geometry exercise from hell, a Euclidean construction taken to extremes. Mathematically, the problems of the "one hundred random specific points" are "well-posed": the descriptions of the locations are internally consistent; each one follows logically from the one previous, and the result is a unique solution. But to what end? What geometric truth has been revealed through these mental gymnastics?

Compare these works to the following "proof without words," demonstrating that the sum of consecutive odd numbers is equal to a square:

$$1 + 3 + 5 + \cdots + (2n - 1)^2 = n^2$$

Jennifer Wilson, "proof without words," 2018.

Here, symbols and image form a coherent and compact whole. The sentence expressed in the equation both summarizes the content of the picture and represents an abstract statement whose truth value the image makes manifestly clear. The purpose is to convey a specific idea and to convince the viewer of its correctness through the clarity of the logic represented in the image.

2 Sol LeWitt, "Paragraphs on Conceptual Art," first published in *Artforum* 5, no. 10 (June 1967): 79–83.

So what problem is being solved in The New School's work *Wall Drawing #1073, Bars of Color (New School)* (2003)? The description in the accompanying certificate is minimal, indicating the work's formal organization and colors. But the language of "front" and "side" in LeWitt's instructions suggests that the drawing represents a three-dimensional form. This sense is reinforced in the sketch, and even more so in the realized painting, where a dramatic tension exists between the convincingly rendered geometric solid (with a single vanishing point) and the flatness of its constituent planes.

The strength of the composition derives from the way in which the edges between planes meet at the drawing's corners: The edge between red and blue planes in *Part B* runs from bottom left to top right, while the edge between blue and yellow planes in *Part A* runs (or would, if extended) from bottom right to top left. These diagonals break the paintings into a small number of simple geometric shapes. John Hogan, installations director of the LeWitt estate and overseer of The New School's work, suggests that the drawings were motivated by a division of the plane, yet the constraints of the installation space make it difficult to identify a simple mathematical problem underlying the realized drawing.[3] One version might be: Find a representation of the given geometric solid such that the resulting planar regions contain the fewest number of edges. Another version might be reframed in terms of pairs of parallel lines. The ambiguity of the problem is underscored by the fact that in the terminology of mathematics, the problem is not well defined; that is, there is no unique solution.

In fact, another solution *is* visible in the current version of *Wall Drawing #1073, Bars of Color (New School)*. In 2015, remodeling at 55 West 13th Street resulted in the destruction and re-installation of *Part A*. The slightly altered proportions of the wall required a new configuration, one in which the planes still meet at the corners but the yellow plane has been adjusted to coincide with the right edge rather than the bottom one.

The power of mathematics stems from the precision of its language and the clarity of its goals. Sol LeWitt co-opts the language,

3 Private communication, July 19, 2016.

but not its goals. Early critical response to his work focused on his dual allegiances to mathematics and abstract thought,[4] to the irrational, the humorous, and the intuitive.[5] "Irrational thoughts should be followed absolutely and logically," he writes in "Sentences on Conceptual Art."[6] Rosalind Krauss called the need to depict *all* 122 variations of the cube obsessional—a judgment with which many mathematicians would disagree.[7] And there is a whimsicality in *Wall Drawing #305,* where the freedom given the drafters to choose the points they wish exists in tension with the need to define those points' exact location.

In the end, of course, what makes a good problem in mathematics is not the same as what makes a good problem in art. Both appeal equally to intuition, but where mathematicians move from "rational judgment" to "rational judgment," seeking the truth of one problem while searching for the next, LeWitt allows his problems to flourish briefly before starting afresh, allowing his "irrational judgments [to] lead to new experience[s]."[8]

Sol LeWitt, *Wall Drawing #1073, Bars of Color (New School) (Part A),* 2003, redrawn in 2015 (detail).

4 Donald Kuspit, "The Look of Thought," *Art in America,* September–October 1975, 42–49.

5 Rosalind Krauss, "The LeWitt Matrix," in *Sol LeWitt: Structures 1962–1993,* ed. Chrissie Iles (Oxford: Museum of Modern Art, 1993), 25–33.

6 Sol LeWitt, "Sentences on Conceptual Art," *0 to 9,* no. 5 (January 1969): 3–5.

7 Rosalind Krauss, "LeWitt in Progress," in *The Originality of the Avant-Garde and Other Modernist Myths* (Cambridge, MA: MIT Press, 1984), 252.

8 These are LeWitt's own terms in "Sentences on Conceptual Art."

One Sentence for Sol LeWitt

Saul Anton

WHEN YOU THINK ABOUT IT, the first of Sol LeWitt's famous "Paragraphs on Conceptual Art" (1967), "Conceptual art is not necessarily logical," is an easy idea to accept, at least at first sight, since what art or which artist would wish to walk under the banner of logic, that flinty word that brings to mind sharp-elbowed arguments by art critics, or the back-and-forth discussions of philosophers, or, worse, politicians, except that, if you think about it some more—or just reread the sentence—you can almost not help but trip over the word "necessarily," which sits there like a stutter, a hesitation, at the very least a qualifier that muddies what seemed initially to be a crystal clear claim, at least to my eyes, since it calls forth not only the regularity, elegance, and reasonableness of LeWitt's wall drawings, but also all that's surreptitiously off-color, out of whack, and ultimately unreasonable in his work—of which, of course, there's really quite a lot, once you start looking, and not just in the piece he did for The New School, to which I'll come shortly, but also works such as *Wall Drawing #462* (1986), at MASS MoCA, or *Wall Drawing #797* (1995), at the Blanton Museum, or *Wall Drawing #1131, Whirls and Twirls,* at the Wadsworth Atheneum, which he produced in 2004, or another from his late period at the Turner Contemporary, *Wall Drawing #1136* (2004; installed 2013), though all of these are, in fact, relatively conservative since they don't even do the two-part A/B thing he did at 55 West 13th Street in *Wall Drawing #1073, Bars of Color (New School)* (2003), realized on the western wall of the lobby and the eastern wall of the Tishman Gallery space on the second floor, though the New School piece does deploy the rectangular and triangular shapes in red, blue, yellow, and green that he used in *Wall Drawing #1005*, first produced in 2001

for the Fundación PROA in Buenos Aires, and even more so, recalls the bars of color that make up *Wall Drawing #1046* (2002) for the Fundación Pedro Barrié de la Maza in La Coruña, Spain, all of which somehow seem as if they put that stuttering "necessarily" that hinges his first sentence into play, performing it, bringing it to life, so that you begin to believe him when he says, in another of his famous pronouncements, this one in "Sentences on Conceptual Art" from 1969 (and it's somewhat incomprehensible when you first read this too), that "conceptual artists are mystics" and, therefore, their work really ought to be understood as the stuff of visions, which, in fact, you can readily see in *#1073, Part B* of which continues up through the ceiling to the second floor at 55 West 13th to serve as a backdrop to a space currently used as a student study and lounge, but not before it, the drawing, has already been bisected on the first floor into an upper and lower portion by a polished steel girder incorporated into the design (along with a ventilation grill near the entrance about which one could say a lot), so that the wall above this portion of the work has something of the quality of a tympanum, those semicircular or triangular carved decorative pieces set over church doorways and designed to get you to look up; so that maybe it's reasonable to think that someone wants to get your soul moving upward, vertically, as it follows your gaze and the tilt of your head, though it isn't hard to see that LeWitt's piece also works against that tradition and instead embraces the horizontality of landscape frescoes, a mode that is all about how we exist in our bodies on the earth, in our *finitude*, as continental philosophers might say, which isn't the same thing as our *materiality*, which is something else altogether—and, in fact, LeWitt gestures toward this idea as well, without in any way wrapping his arms around it—for the drawing accompanies visitors as they enter deeper into the building toward a bank of elevators on one side and a stairwell on the other, the latter of which offers those who walk up a beautiful silhouette piece by Kara Walker that extends to the second floor, where, once you, the visitor, realize that the LeWitt piece has followed you there, too, and that it's not simply a matter of a return to

horizontality in a piece with a simple A/B/A scheme, but rather of an uncompromising hard-edged drawing that is, at the same time, soft and playful, rendered in red, yellow, green, and blue, a composition that can be read as two large girders rising up through the floor at two different points and reaching to the ceiling with scale and power as diagonal rather than vertical or horizontal lines—almost like an x-ray, if you will—representing the shape and structure of what LeWitt claims, if we take him at his word, as a mystical experience, an elevation that embodies the life of the mind, a rising that aims not for transcendence but simply to rise, using human art (that is, girders), to construct and sustain the edifice of knowledge in its homely—though here also colorful—earthly forms, plain walls, lobbies, libraries, offices, and stairwells, all of which rest on the encounter of one line with another, one edge with another, one color with another, in order to construct the diagonal *framework*— understood, let us not mince words, metaphorically—of a university building, rather than the soaring verticalities of the cathedral, because it is art rather than architecture, and lacks the hardness of necessity, being necessarily more—and, I suppose, less—than logical.

Sol LeWitt, *Wall Drawing #1073, Bars of Color (New School) (Part B)*, 2003 (detail).

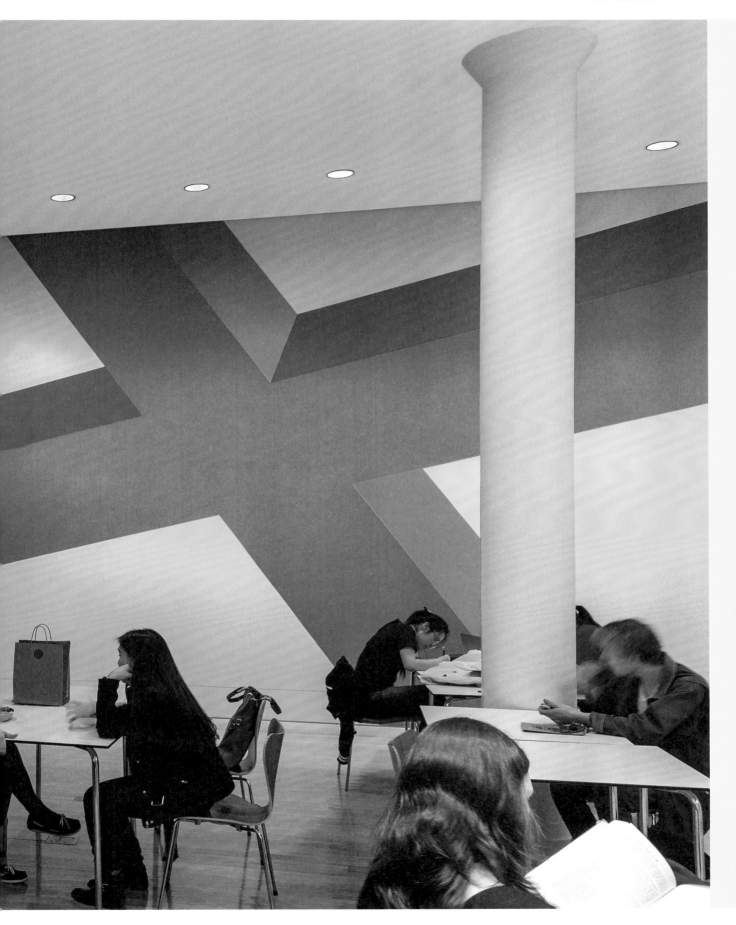

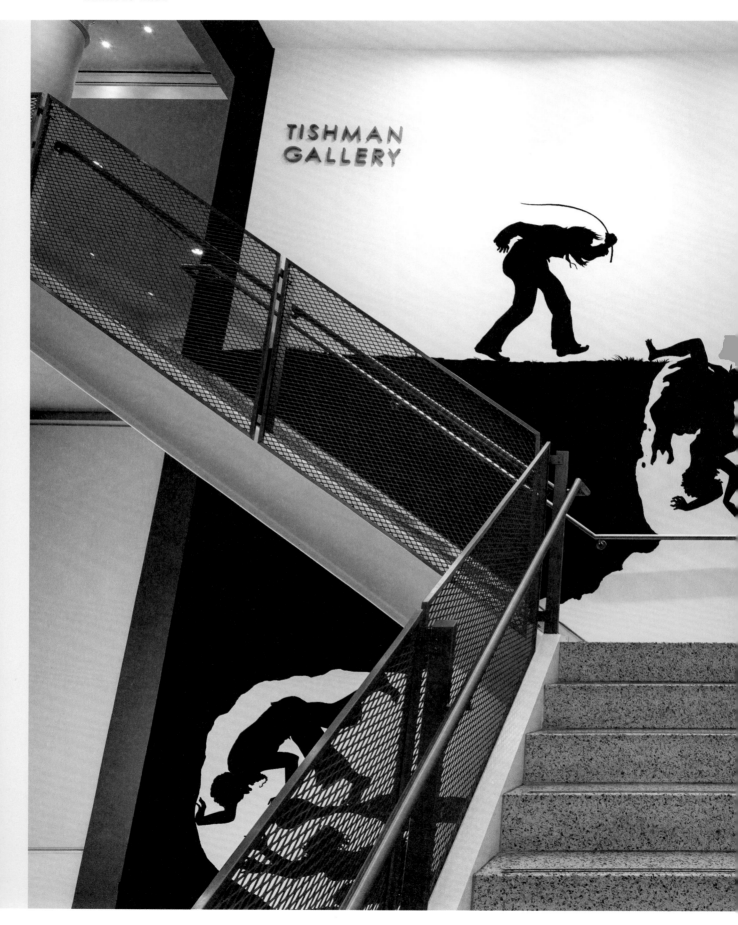

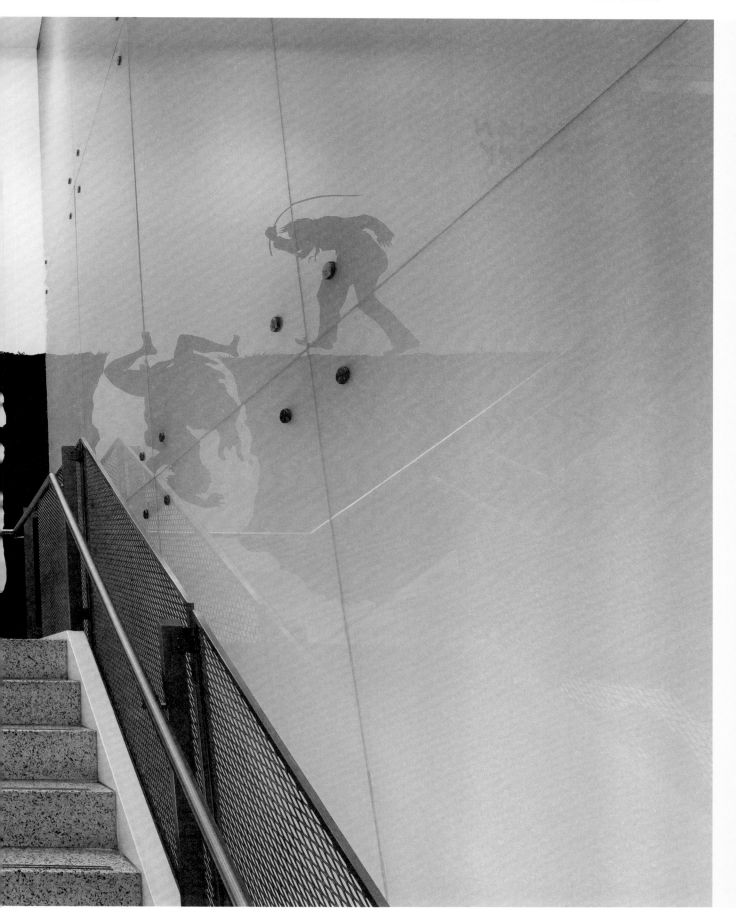

Kara Walker

Event Horizon
2005
Latex paint

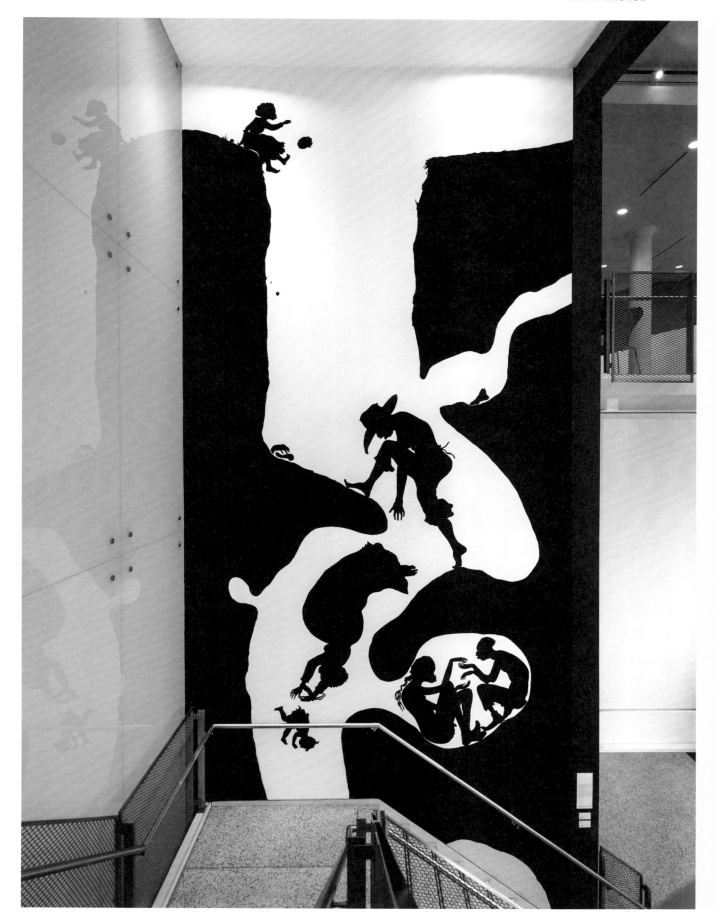

History's Worth of Fictions

Mabel O. Wilson

How else can this daughter of afro-suburbia (blind to her circumstances, faithful to her self-image as an a-historical non-entity…a black hole, if you will) reclaim her presence but by filling that space with a history's worth of fictions?
—Kara Walker, artist's statement[1]

STANDING IN THE LOBBY OF ARNHOLD HALL, I catch a glimpse of the lower reaches of Kara Walker's towering mural *Event Horizon* (2005), the artist's first permanent public-art piece. A conjurer of dark couplings that lurk in America's antebellum landscape of chattel slavery, Walker typically crafts her tableaux to unfold panoramically in front of and around the viewer. For this particular mural, however, she worked within a different configuration. Affixed to two facing walls, *Event Horizon* occupies the space of the building's stairway, connecting the lobby to the second-floor Theresa Lang Community and Student Center. I enter the work's vertiginous slice through the earth, where black bodies tumble and navigate through snaking passages. I begin ascending the stair and stop on the landings to more closely scrutinize the figures who animate Walker's scene—a diving woman whose bound wrists reach for a baby slipping from her hold or a young girl, doll in hand, whose shoulder and toe avert her fall into the abyss.

Along with its placement, *Event Horizon* departs in other ways from Walker's typical museum or gallery installations. Its orientation is vertical rather than horizontal. It is made from a permanent coat of black latex paint rather black photographic paper layered temporarily onto a white wall. Its placement within a rather nondescript stairway allows its narrative to unfold amid the bustling routines of students, faculty, staff, and visitors. Despite these differences in context and technique,

1 Kara Walker, unpublished artist's statement. See Darby English, *How to See a Work of Art in Total Darkness* (Cambridge, MA: MIT Press, 2007), 87.

Kara Walker, *Event Horizon*, 2005 (detail, east wall).

Walker continues to cast her fictional characters, stereotypes of blackness and (dis)figurations of black and white bodies, in scenarios that provoke fear and disgust, in positions and pairings that stir uncertainty and curiosity. As I stand between the two-story sections that split the black earth in two, I wonder where these winding passages lead. Are these underground routes to freedom or tunnels to death? Who are the enslaved men, women, and children who either pitch perilously downward or climb unsteadily up toward the mouth of the hole? Why have two figures sought refuge in one of the ancillary cavities, and why, engrossed in play, do they seem oblivious to the dangers nearby? Why has the white overseer, guarding the terrain aboveground—which aligns with the top landing—brandished his whip to chase a black woman headfirst down one of the holes? What has the girl perched unsteadily at the top of the other hole tossed into the orifice: Is it a clump of earth or is it more grotesque—a human brain? Whose dismembered body do a pair of hands, a foot, and perhaps the brain belong to?

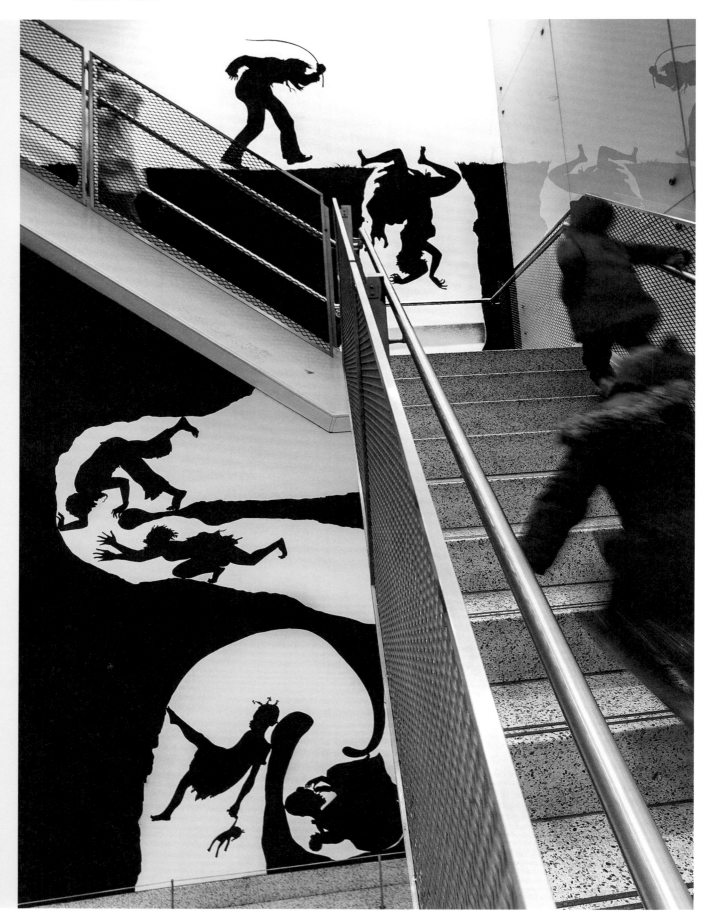

What truths or fictions does this lurid world seek to tell me?

When I was a student at the University of Virginia, I remember being transfixed by a mural in an auditorium where I took classes: a full-size reproduction of Raphael's sixteenth-century *The School of Athens*. The sprawling painting, the original fresco of which adorns a private apartment in the Vatican, depicts a fictitious gathering—as *Event Horizon* does. In the deep perspectival space of Italian Renaissance architecture, Raphael convenes the great antiquarian philosophers Aristotle, Pythagoras, Euclid, Ptolemy, Heraclitus, and others. To the eyes and mind of a first-year student, a young black woman, this convocation of great minds was there to elevate my knowledge about the origins of humanism. UVA's founder, the statesman and slave owner Thomas Jefferson, had enshrined these values of the quest for truth and freedom in the pursuit of knowledge in the Neoclassical design of the university's Lawn.

With her enigmatic figures stirring memories of my own educational experiences, it is as if Walker's *Event Horizon* had plumbed the submerged spaces hidden between the Lawn's white colonnades, within its ten columned pavilions, inside the Platonic geometry of the Rotunda, the university's original library. In the antebellum period of the university's early history, these invisible spaces, like Walker's deep passages, bustled with enslaved men, women, and children who dwelled in cramped confines below the pavilions and labored behind the graceful serpentine walls. They too endured, escaped, or succumbed to the violence inflicted by their white masters and mistresses, who kept them chained as property in perpetuity. Perhaps my costume as Sally Hemings, which I wore to the Beaux Arts Ball one year—an homage to Jefferson's enslaved concubine, who had lived nearby atop the mountain of Monticello, and with whom he fathered six children—was my way of performing, imagining, and understanding that repressed history. In the absence of a likeness of Hemings in the form of a painting or cameo, I had to imagine her dress and comportment. Perhaps it was an act in the spirit that Walker has described: "[B]eing in control of characters that represent the social manipulations that blacks have

Kara Walker, *Event Horizon*, 2005
(detail, west wall).

undergone in the country at least puts me in the position of being the controller or the puppet-master of imaginary black people."[2]

Who, then, are the imaginary black people in *Event Horizon*? Scientists speculate that an "event horizon" occurs in the zone where the time-space of the universe meets the distorting gravitational pull of a black hole. In her practice, Walker explains that she posits "her self-image as an a-historical non-entity…a black hole" in ways that allow her to "reclaim her presence…by filling that space with a history's worth of fictions." Thus, *Event Horizon* marks not only a threshold between the orderly, rational aboveground of modernity and the anarchic world of modernity's others below; the work also defines a threshold of perception, a limit between historical truths and all those events that have happened but cannot be seen, remembered, or known. If a university's mission is to seek truth and knowledge, the core values of Western humanist thought resplendent in Raphael's epic mural and on Jefferson's noble Lawn, then Walker has disgorged her visions to seep into liminal institutional spaces, to burrow below the foundations of the modern episteme and to ask us what truths cannot be known, but instead imagined through her haunting historical fictions.

On Kara Walker's
Event Horizon
Maggie Nelson

START UNDER THE STAIRS. I had thought that I might need special access—leave an ID at the counter, etc.—but the guard at the building just lets me in, points me toward what I'm looking for, and leaves me alone with it.

I start under the stairs. Face to face with the strangest scene

2 Lawrence Rinder, "An Interview with Kara Walker," in *Capp Street Project: Kara Walker* (San Francisco: CCAC Institute, 1999), quoted in Gwendolyn DuBois Shaw, *Seeing the Unspeakable: The Art of Kara Walker* (Durham, NC: Duke University Press, 2004), 18.

of all, so strange I have to draw it in my notebook to apprehend it. At the installation's base, a female figure (inflated butt, iconic head rag) appears to be fisting or stuffing a man's butt, her hand disappeared up to her forearm. The man appears legless, reaches up in agony. She is studious, patient in the face of his suffering. *Give me just a moment, I'm almost done.* A doctor's intervention; Princess Leia uploading into R2-D2 the plans for the Death Star. A preparation, an impregnation. Some kind of necessity. She seems all-powerful, but she also appears in danger of being crushed by a giant foot, which is also just the bulge of earth hovering over her, encasing her at the bottom.

 The title of the installation is *Event Horizon*, a term which, in astronomy, correlates to the edge of a black hole, "a celestial object so massive that no nearby matter or radiation can escape its gravitational field." The easiest interpretation is that the event at hand is American chattel slavery, a multicentury institution and atrocity which has arguably

Kara Walker, *Event Horizon*, 2005 (detail, east wall).

created the most powerful, virulent, and ongoing gravitational pull in American history and lived life.

But the title also draws our attention to a formal problem: Whatever horizontal boundary these players may have been sucked over (or, more exactly, lashed into: A master figure at one cliff top whips a female figure over the edge, seemingly driving this Dante-esque world into action), the momentum now is vertical. The operative metaphor here may be that of the Underground Railroad, but there is no forward motion, no visible means of escape. Instead, the figures play out scenes in womblike bulges, recalling the words of Saidiya Hartman: "*The slave ship is a womb/abyss*. The plantation is the belly of the world. *Partus sequitur ventrem*—the child follows the belly.… The mother's only claim—to transfer her dispossession to the child."[1]

Indeed, scenes of natal alienation and maternal distress abound. In the middle of one wall, a woman tumbles headfirst, reaching in vain after a baby inexorably falling; a well-meaning man crouched nearby reaches out, but is unable to help. Another woman with a baby affixed to her back sits curled in a cul-de-sac, hands to her head; the baby appears distraught, but the woman is too occupied by her suffering to attend to it. Directly across the stairwell from the master with the whip, a young girl sits atop another cliff, playing with a dirt clod that, upon closer inspection and in context, may be a severed head (dismembered body parts litter the tunnel). Elsewhere underground, a young girl holding a doll picks at the wall with her foot, loosening dirt and ignoring, for the moment, the various dramas of failed assistance and suffering around her. Two other adult figures, crouched inches from the woman falling headfirst after her baby, appear to be playing a clapping game.

The apparent boredom of the girl with the doll, the playfulness of the girl at the cliff top with the head-clod, the figures passing time with a hand game—this variety of affect is one of the most fascinating and disturbing aspects of Walker's work. It indicates how even the most one-dimensional, flattening forces of sadism and control (represented here by the man with the whip) produce scenes of diverse, unpredictable, complex behavior.

1 Saidiya Hartman, "The Belly of the World: A Note on Black Women's Labors," in *Souls: A Critical Journal of Black Politics, Culture, and Society* 18, no. 1 (January–March 2016): 166. Italics in the original.

Kara Walker, *Event Horizon*, 2005 (east wall). Also visible (upper right-hand corner) is *Untitled #587* (1988), by Petah Coyne (detail).

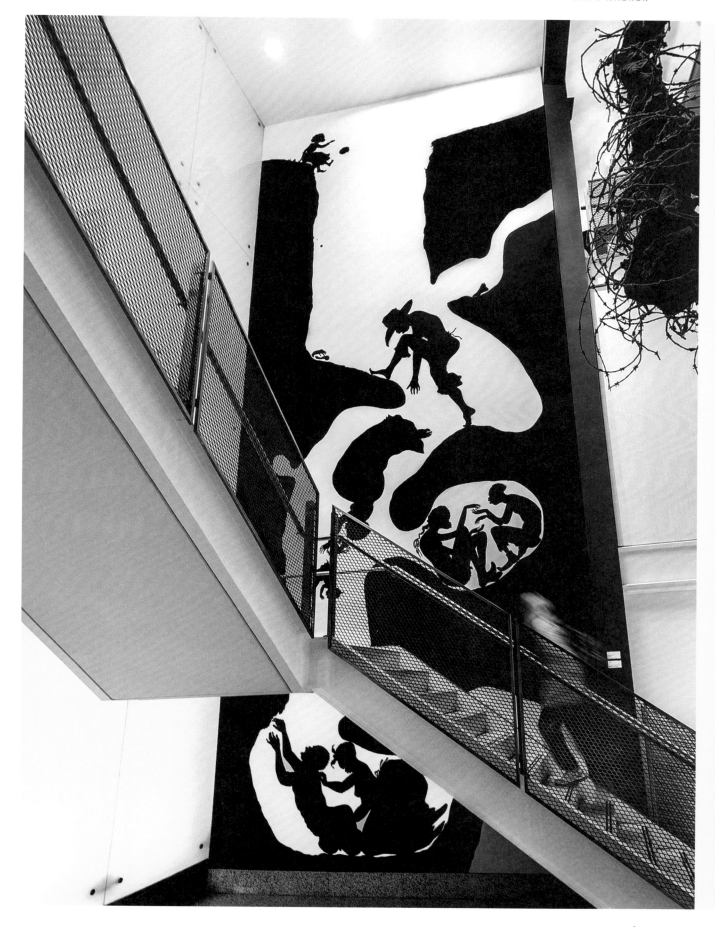

The whole time I'm visiting *Event Horizon*, an actual baby is crying at the top of the stairs. Eventually I ascend, to check it out. On my way up, I notice that the perfect black of Walker's installation is rippling in places, scuffed. I find this satisfying, after seeing Walker's work in museums for years, justly and amply guarded. No one is watching me here, so I reach out and touch the wall.

Later, I read the university's press release on *Event Horizon*, which characterizes the work's action as follows: "A slave driver in the left-hand corner of the work attempts to drive the characters down the tunnel, but they aspire to climb out to freedom and opportunity." The release then quotes New School President Bob Kerrey: "A metaphorical Underground Railroad, the piece can be seen not only as a commentary on the African American community's historical struggle for freedom, but education's role in today's society as a route to opportunity."[2] And just like that, with all good intentions, the complexity of the piece—all the despair, idleness, free fall, enigma, boredom, sadism, and loss—gets refigured as a struggle for "freedom and opportunity"—the default narrative which is so often the only one we are willing to promulgate, see, or make visible.

Thankfully, there's Kara Walker, who was seemingly put on this earth to complicate default narratives. As she once said in an interview, "I read somewhere about how Frederick Douglass's narrative, or variations on his narrative, have this very American rags-to-riches or boy-to-man construction, whereas—and maybe I just intuited this—women's narratives are confronted with silences: rape, child death, illegitimate childbirth."[3] With no crystal clear objective (thankfully), Walker keeps on addressing such silences with unyielding narrative and image.

At the top of the stairs, in an open reading room of sorts, I find the crying baby. It's strapped to the chest of a man, presumably its father, in an Ergo, facing outward. He bounces the baby, trying to calm it down, as he attempts to carry on a conversation with a woman in business attire. He's brown-skinned, perhaps of Middle Eastern descent; she's African American, has the vibe of someone who's in charge of things around

2 "New School Unveils 'Event Horizon,' the First Major Public Art Commission by Artist Kara Walker" (April 26, 2005), https://www.newschool.edu/pressroom/pressreleases/2005/042605_nsu_walkerk.html (accessed May 23, 2018).

3 "Kara Walker by Matthea Harvey," *BOMB*, no. 100 (summer 2007): 76.

here. I wonder if she's his boss, professor, or friend. I'm a white lady with a notebook, lurking under and on the stairs. Nothing about the scene correlates directly to the world of *Event Horizon,* but nonetheless, here we are, its inscrutable inheritors, arranged in our own complex tableaux of work, caretaking, power, and consolation.

Meanwhile, scholars such as Hartman continue to ask if or how insubordinate black women ("the sex drudge, recalcitrant domestic, broken mother, or sullen wet-nurse") can fit into more customary narratives of black liberation (such as Douglass's boy-to-man construction, or the worker-hero of the general strike). "What is the text of her insurgency and the genre of her refusal?" Hartman asks. "Or is she, as [Hortense] Spillers observes, a subject still awaiting her verb?" The glory and plenty of Walker's work lies in how many verbs she provides for her many subjects. In *Event Horizon*, they fall, hunker down, grieve, reach out, play, and—perhaps most crucially—protect their mysteries.

Black Atlantis

Naomi Beckwith

ENVELOPED BY THE WALLS of the central staircase of the Tishman Gallery in The New School's Arnhold Hall is a multistory mural of matte black figures against a stark white background. The figures are life-size, somewhat exaggerated, but remarkably natural in rendering. Though they are mere silhouettes, their contours establish the recognizable shapes of black and white bodies, acting out vignettes in a landscape of the nineteenth-century United States. Indeed, the lines are so precise that one senses the entire scenario takes place at night. Or, if this is not a nocturnal scene, it is certainly happening in the dark. From the top level of the staircase, which marks ground

level for the tableaux, figures careen down a tunnel toward the bottom of the stairwell, sometimes nestling into diverticula under the ground.

This installation, Kara Walker's *Event Horizon*, was her first painted mural (as opposed to those constructed with paper cutouts) and an early public work. The artist is, in many ways, an unnatural choice for a public commission. Long before her formidable installation at the decommissioned Domino Sugar factory in Williamsburg, Brooklyn, broke attendance records (*A Subtlety, or the Marvelous Sugar Baby*, 2014), to choose Walker for a public project meant to select an artist known for rendering casually nightmarish scenes where murder, fellatio, rampant sadism, and all manner of interracial, intergenerational, and intergender violations unfolded.

Walker's wall works tend to be narrative, in a left-to-right format, influenced by nineteenth-century cycloramas—the proto-cinematic entertainment in which a viewer entered a cylindrical room in order to get a 360-degree view of a narrative scene. *Event Horizon* dispenses with the "cycloramic" viewing condition and responds to its architectural site by taking advantage of the verticality of the stairwell. The action starts from the atrium's top floor, where white men savagely force living black figures—mostly terrified women, children, and the disabled, along with sundry excess body parts—down a chute, to be swallowed by the earth. Indeed, the shapes of the tunnels more closely resemble a bodily gullet or bowels than any geological hole. For some of Walker's characters, the place is a permanent tomb; for others, it is the belly of Hell, where they endure endless tortures from other castaways. For others still, the little caves become wombs where they pass the time with dolls or careless games of patty-cake. No one dies in the descent.

In African American folklore, specifically of an Afrofuturist bent, this subterranean world has an aquatic equivalent. It is called Drexciya—the underwater utopia where Africans who avoided slavery by leaping from slave ships into the Atlantic Ocean thrived rather than died. Drexciya is an Africanized image of Atlantis, an apocryphal haven that attempts to account for the massive loss of life and perhaps to reclaim

some agency from the horrific chattel transport of millions of Africans to the Americas. It's an invisible world that exists alongside the tangible, objective place that we all call "reality."

Walker's narratives, too, constitute a form of speculative fiction, though creating parallel universes of a more dystopian tinge. Still, her work is very much in conversation with that of other black cultural figures who, through a kind of paranormal narrative, constitute blackness as otherworldly. For instance, the musician Sun Ra declared that black people are extraterrestrials, claiming that his own heritage originated on Saturn. In *Event Horizon*, Walker creates another kind of otherworldly black site, giving us a cross-sectional view of the subterranean "secret place" where those black bodies jettisoned from the earth's surface now reside. Whereas Drexciya offers an escape from a harsh reality, Walker's earthly bowels promise more horrors, rather than solace. It is yet more disturbing, nevertheless, to see some figures acclimate to the underground world. Some characters seem to adapt to their fate with equanimity, displaying a strange, even playful behavior, and others inflict brutalities on their co-inhabitants.

Western societies have often romanticized characters and places that exist outside of a "natural" or legal regime—the underground, the otherworldly, and the rebel enclave. Walker's underground tales figure something closer to Hades than Atlantis and posit that any place, real or imagined, that harbors human beings also harbors the possibility of cruelty. Her bravest gesture is to imagine the sites where this persistent cruelty can unfold, and to give these cruel states physical representation. This is not the same as harboring a subconscious desire to do such things, nor is it a prophecy that all human behavior ends in the torture and devaluation of others. But there are moments, such as the days of the transatlantic slave trade, in which human cruelty frames history. For Walker, history possesses a subconscious where suppressed historical traumas still reside. So perhaps *Event Horizon* represents a psychological site, more than a particular physical or historical one. It's a place that hovers under the surface of our national narratives and one that, collectively, we'd much sooner forget.

Brian Tolle

Threshold
2006
Fiberglass and
acrylic paint

The Gentle Wind Doth Move Visibly

Shannon Mattern

TYPICALLY RESERVED FOR BOARD MEETINGS and small-scale, invitation-only gatherings, the Dorothy H. Hirshon Suite was not always a venue that The New School's faculty and students visited frequently. Yet I fortuitously found myself attending several meetings there in the spring and summer of 2007, when the Facilities crew seemed to be conducting some sort of drawn-out repair operation behind the room's west wall. A gauzy white scrim skimmed the steel studs and seemed to register, in its billows and ripples, a draft coursing through the building's cavities. Growing up in the hardware business, I'd seen plenty of Tyvek and construction shrink-wrap. But the scrim's protracted presence here, in this dignified conference room named after a glamorous socialite, made me wonder what could possibly be causing such intractable infrastructural maladies.

Then, after months of casual glances, I finally noted that this gossamer veil, which I had admired for so expressively registering the tiniest fluctuations in ventilation, was fixed in frozen undulation. I saw the wall label. My scrim was fiberglass—which made it no less dynamic and articulate. Brian Tolle's computationally modeled and fabricated panels transformed the Hirshon Suite's walls into a respiratory membrane, a *Threshold* between atmospheres, a medium for the exchange of breaths and voices and ideas.

Much of Tolle's work has inhabited the edges—between spaces, times, and materials. He has crafted floppy silicone models of mid-century suburban homes, and draped them over domestic props: ironing boards, chairs, basketball hoops, and wagons (*Levittown*, 2009). He has ornamented Cleveland's public park, Mall B, with classical urns, milled from

PAGES 170–71: Brian Tolle, *Threshold*, 2006.

high-density Styrofoam, that appear to be bending with the lake winds (*The Gentle Wind Doth Move Silently Invisibly*, 2005). Inside a Manhattan gallery, he has re-created a low-ceilinged Tudor hall, complete with rough-hewn beams, a formidable charred hearth, and diamond-paned windows that look out upon an idyllic nowhere (*Overmounted Interior*, 1996). He has re-created the twin allegorical figures by Daniel Chester French that once presided over the two ends of the Manhattan Bridge (*Miss Brooklyn* and *Miss Manhattan*, 2016); constructed twisted Styrofoam-brick chimneys (*Simnai Dirdro*, 2010, and *Witch Catcher*, 1997); and transported stones, soil, and flora from County Mayo to re-create a nineteenth-century Irish cottage in Lower Manhattan (*Irish Hunger Memorial*, 2002). Through its range of materials and locations, traversing edge conditions between artificial and organic, here and there, past and present, Tolle's work poses historical and ontological questions about the ways in which sites give objects value, about the material qualities that signal authenticity and locality, about the entanglements of time and place. What does it mean, for instance, to rely on man-made synthetic materials to "authentically" capture the texture and patina of historical building materials, or to "indexically" register environmental conditions—to "freeze" the winds on Lake Erie or the HVAC tremors in the Hirshon Suite?

By resolutely positioning themselves at such thresholds, Tolle's sculptures and installations make palpable, even inhabitable, various political-economic inequalities and infrastructural aberrations. Just as his *Irish Hunger Memorial* sits in the shadow of New York's financial giants in Lower Manhattan, contrasting utter lack with excess, *Threshold* installs a perpetual construction site in an exclusive domain of polished presentations and donor dinners. Just one block away, in another of The New School's *sancta sanctorum*, the walls are again perpetually unsettled; here, José Clemente Orozco's frescoes speak of oppression, revolution, and redemption. While Tolle's fiberglass panels might be less radical in their overt content, I have found them to be breezily provocative in their form.

In simulating the building's subcutaneous structural and ventilation systems, *Threshold* primes the room's inhabitants to be

mechanically and infrastructurally minded in our dinner discussions—to search for errant drafts, leaky pipes, load-bearing walls, and power sources. Tolle's forms introduce incongruities in ambience—disheveled irruptions amidst the room's modernist order—that remind us of the labor, skill, and professional intelligence required to allow our facilities to *facilitate* intellectual labor. Over the years I've joined colleagues and students in the Hirshon Suite to engage in countless discussions that have been shaped—or so I like to imagine—by *Threshold*'s environmental and intellectual scaffolding. Here, we've debated the politics of "making," the "right to be forgotten" in an age of Big Data, social justice in the arts, the sociocultural aspects of special economic zones, ethical considerations in cartography, and pedagogical strategies for engaging with social and environmental challenges—all concerns that necessitate the deployment of systematic sensibilities and infrastructural logic.

Rarely have we concluded such discussions with allegiances settled, questions answered, minds made up, consciences clear. Such topics of debate don't lend themselves to neat resolution, nor do they allow us to ignore our own messy complicity in perpetuating the world's injustices and absurdities, or our obligation to make things better. And in simulating "the gentle wind [that] doth move / Silently, invisibly" through the room (to quote William Blake), Tolle's billowing screens might also evoke the presence of other inciting voices: those of The New School's revolutionary founders, of Orozco's oppressed, of today's exploited and disenfranchised—all those who cannot speak audibly, whose passions and pleas register only in a silent ripple, and who depend on us to take up their causes, wave their banners. In that sense, we, too, are thresholds, mediums.

Yet the fixity of Tolle's panels—their arrested undulation—suggests that there is more to this mediating agency. It's not enough to make the silent winds audible. We must also serve as agents through which the breath of our dialogue and the spirit of our commitment are materialized into strong tools and stable scaffoldings for repairing our broken institutional and urban structures, and breathing new life into their frameworks.

Unsettled

Victoria Hattam

DID IT MOVE? Is it damaged? Is The New School short on cash? Brian Tolle's *Threshold* is a delightfully subtle installation that unsettles. Tolle's work quietly disrupts expectations and is thus deeply political. In the Dorothy H. Hirshon Suite on West 13th Street, where Tolle's work is located, the world is a little off-kilter. The materiality of the work puts walls in question. Stationary, predictable lines are replaced with variable forms. There are no narratives in place to reassure. The form is the thing. It asks the mind to shift.

A subtly pink-tinged whiteness and three-dimensionality animate the piece. Shadows move across the work as the light falls on the wall's uneven topography. The variability across such uniform paleness is startling, as the surface accentuates its ripples in ways that might have been obscured with stronger coloring. Less is more.

Site specificity is key. The Hirshon Suite is an intimate space measuring roughly twenty-two by twenty-six feet, with wooden tables and chairs usually arranged in a square. No lecture hall here. The décor is muted—maple wood furnishings and pale green walls. The room's scale ensures that anyone who enters will be but a short distance from *Threshold*, which sits up high, in two panels, on the western wall. The installation may go unnoticed, receding into the quiet aesthetics of the room. But wait a few minutes for the wall to speak—disruption creeps in. Is that a billowing fabric with struts beneath, a windswept landscape, or exhaled and inhaled breaths? The point is not to fix on a thematic. If one sits with the ambiguity, the room expands. Boundaries between animate and inanimate begin to dissipate. Animation through fixity is an amazing thing.

Brian Tolle, *Threshold,* 2006 (detail).

Of Two Minds

Carin Kuoni

SET IN A PORTION of built space that is usually passed over, *Threshold* by Brian Tolle occupies one upper wall of the Dorothy H. Hirshon Suite. At first sight— if it comes to that at all—the work blends in perfectly with the room's architecture and décor. When *Threshold* was commissioned in 2004, the invitation to Tolle insinuated that something quite different was expected: This room was the "brain of the university," the president told the artist, the place where trustees meet in order to make historic decisions that will be "broadcast everywhere from here" and forever affect the course of The New School. How would the artist like to represent such intellectual and material power?[1]

When asked about the deeper roots of *Threshold*, Tolle begins with a particular square in the Belgian city of Ghent, where a pub innocuously marks the location of the medieval town gallows, a site that, as he says, "you will never want to forget" (and which the artist had considered as place for a public art installation).[2] The contrast between the cheerful gathering place and its sinister history was not lost on Tolle. And not unlike the Ghent pub, the gentle, billowing undulations of the fiberglass relief in the Hirshon Suite both reveal and conceal a site of violence, in this case architectural rather than punitive: On seeing the freshly renovated room for the first time, Tolle requested that one of the walls be ripped open, the sheetrock removed, and the metal studs exposed. He proceeded to create his work: two different computer-simulated and -generated fiberglass relief prints capturing the effects that various degrees of air pressure in the room might have had on the sheetrock once covering the walls—that is, if sheetrock could billow.

Thus, the character of this room, of potential or actual historical significance, of hyperbole and speculation, is captured by a sly

1 All quotes are from an interview with the artist conducted in the Dorothy Hirshon H. Suite on March 28, 2017.

2 Eventually, Tolle chose another site for *Eureka*, commissioned by curator Jan Hoet as part of the outdoor exhibition *Over the Edge* in Ghent, Belgium, in 2000.

gesture—the barely noticeable impressions of simulated air on simulated walls. To what effect?

The two panels are distinct, and it is far from arbitrary how Tolle arrived at their shapes: For each, he reviewed a range of computer-modeled air-on-wall collisions before settling on these two particular scenarios, each with its own qualities. One bulges out, the other sucks in; one is crisply defined, the other sags; one seems to exhale, the other to inhale. Like a freeze-frame image, each panel captures the precise moment of a specific encounter between air and wall. Something dramatic has occurred, is occurring; but in context, at this institution of higher learning, what the collision actually portends and what will transpire from it, we cannot know. Certain interpretations offer themselves: If we consider the room an acoustic body, the panels are membranes of the inaudible instrument constituted by us as "users" or "players" of the Dorothy H. Hirshon Suite. But the panels also occupy a strange place between actual and imaginary space. Like a trompe l'oeil, the simulated metal studs take us inside the architectural structure. The softly billowing surfaces of the panels, however, evoke pictorial rather than physical space, landscape paintings rather than sculptural constructions. They owe more to Baroque ceiling paintings of the heavens than to the conceptual deconstruction of a building.

Regardless of how we approach *Threshold* (and despite the presidential charge to create a substantial work), something remains amiss. More than anything, the panels evoke sensations and sights that are no longer there or not yet articulated—sound, color, landscapes, bodies, breath, or, indeed, decisions. In this evocation of the absent, something unexpected happens: Because Tolle has so precisely tracked the impact of simulated air on the simulated walls—strictly adhering to the production logic of the conditions he has established—these stilled impressions read as specific historical and material occurrences, not just abstract imaginings; the ripples are forever tied to the moments of anticipated collision.[3]

This material evidence harbors numerous clues. The slightly pinkish hue hints at white skin, delicately oscillating against the ever-so-

3 The human body and its implied political positionalities have always provided a crucial subtext to Tolle's work. As an undergraduate at Parsons, he was a founder of The New School's first official student organization dedicated to gay and lesbian rights.

Brian Tolle, *Threshold*, 2006 (detail).

faint greenish tinge of the wall panels surrounding *Threshold*; the imprints look like bodily shapes pressed against the still-visible studs, which evoke prison bars as much as, yes, gallows; the vortexlike movement seems to swallow everything around it—or would, if the implied motion were to resume. All these elements suggest a vulnerability that is perhaps closer to the history of the Ghent town square than one might assume. As a threshold, the installation operates in two realms, employing the metaphors of invisibility and motion as subtle critique of the boardroom where solid power sees itself ensconced.

Quiet Possibilities of the Subjunctive

G. E. Patterson

I**N THE WORLD OF THE SUBJUNCTIVE**, assertions exist to make us wonder. Each would rather yield and claim by turns than insist on its own incontrovertibility. Brian Tolle's *Threshold* is part of that world and a portal to it. By its very title, *Threshold* announces itself as architecturally relational. In person the relational possibilities of the work multiply.

Threshold is stationed as a frieze in the Dorothy H. Hirshon Suite on the second floor of Arnhold Hall. Its siting in two bays or niches, its matte texture, its warm, neutral monochrome, its suggestions of draping in the undulations of fiberglass over (apparently) structural studs: These aspects might signal a classical reticence—a distance from the people and activities that occupy the space.

In its placement, *Threshold* is elevated—but marginal. It governs the upper periphery of my vision, except when I look up. When I do look up, its prominence is undeniable—but when my gaze dips, that perceived prominence recedes.

Given that mutability and restraint, the initial call for the viewer's attention may come from the smaller (not site-specific) artworks that are displayed in niches below *Threshold* and in the corresponding niches across the room. These works are more conventionally placed in the field of vision, and rhyme with the multiple (or nearly so) symmetries of the room's architecture, so that the viewer is visually engaged by repetition and distinction, and guided into acknowledging the fluidity of semantic possibility. The attention that *Threshold* receives subsequently is likely to follow the same pattern: a contrapuntal layering of initial impressions and later

acknowledgments of difference that quietly assert the subjectivity and provisionality of seeing.

There's a wry paradox in a piece that integrates into a room's architecture well above the universal-design standard for human reach, when the primary definition of "threshold" is a strip of material at the bottom of a doorway. An inviting playfulness courses through the word's secondary definitions: a minimum level of stimulus; a point of entry or beginning; the magnitude or intensity at which something comes into effect. These meanings are not hidden in the work; they are latent.

The adventure here is in looking and thinking and feeling. Although Tolle's panels are of equal size, they are neither identical nor book-matched (mirror images). The ripples in the painted fiberglass and the varied distribution and depth of the volumetric swellings activate the imagination, calling up familiarities not only of the classical but of the Baroque, architectonic or voluptuous as the case may be. One can make a diachronic (sequential) survey through the numinous gestures of abstraction to the materialist restraint of Minimalism, and continue toward the postmodern fascination with simulacrum. And one can see *Threshold*'s range of familiarities as compounded and specific to this present moment (simultaneous, synchronic).

Each person in the Hirshon Suite is likely to establish a distinct relationship to the piece, depending on the shape of her attentiveness, her height, and the shifting possibilities of perspective: The stimuli here are spatial, temporal, and textural. The color and volume of the work fluctuate in tandem with shifts in light both natural and electric. The perceiving and reasoning process allows so freely for addition and substitution and multiplication and exponentiation that the in-person experience is algebraic in its variability. For, while the transforming functions of observation and revision are key, any summary of the experience will necessarily be indeterminate.

Tolle's work refines the idea of a transitional state or space in order to better describe our cognitive and sensory awareness. The time-lapse drama of *Threshold* is the possibility that we are just beginning to see.

Brian Tolle, *Threshold*, 2006 (detail).

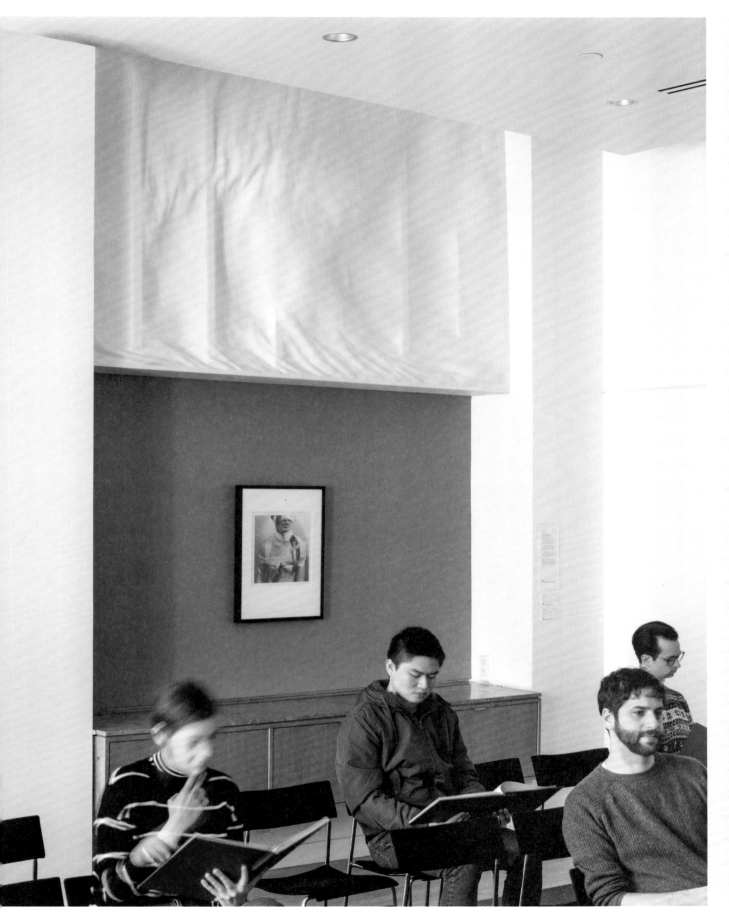

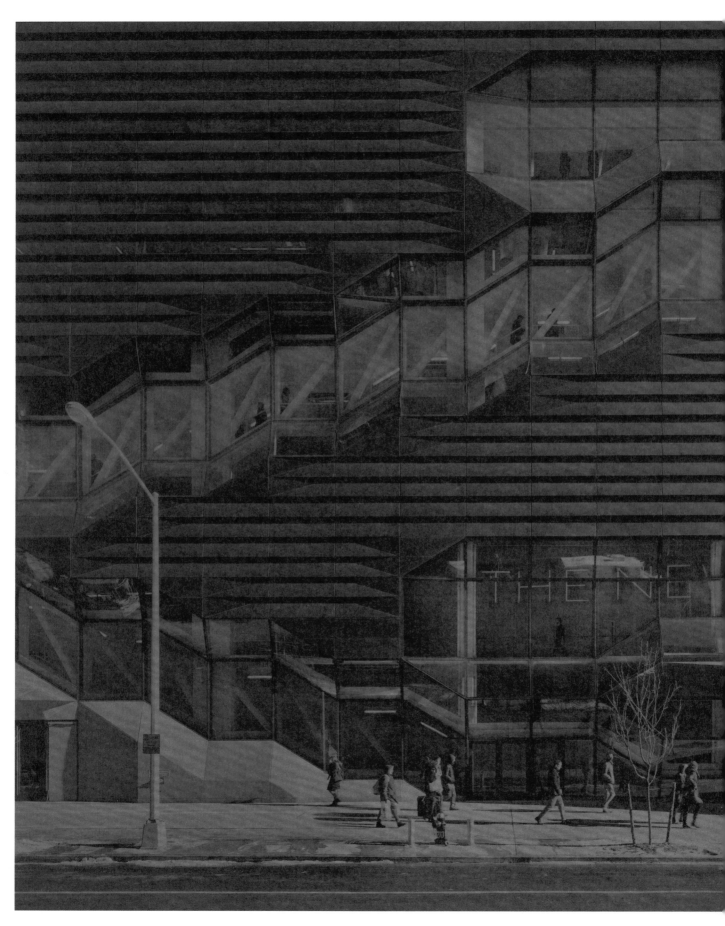

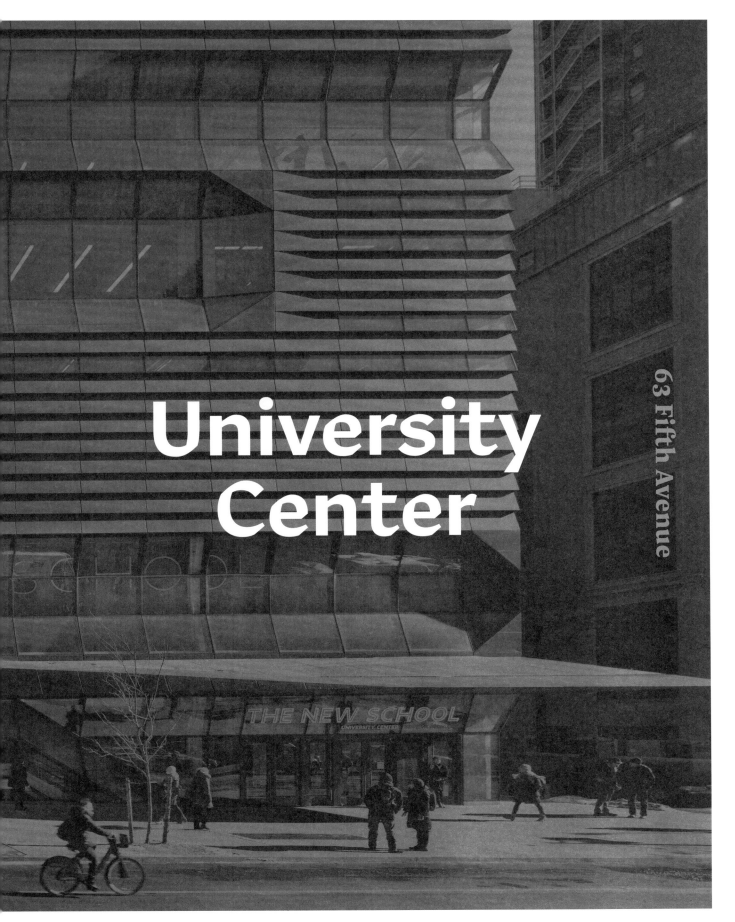

University
Center

THE NEW SCHOOL
UNIVERSITY CENTER

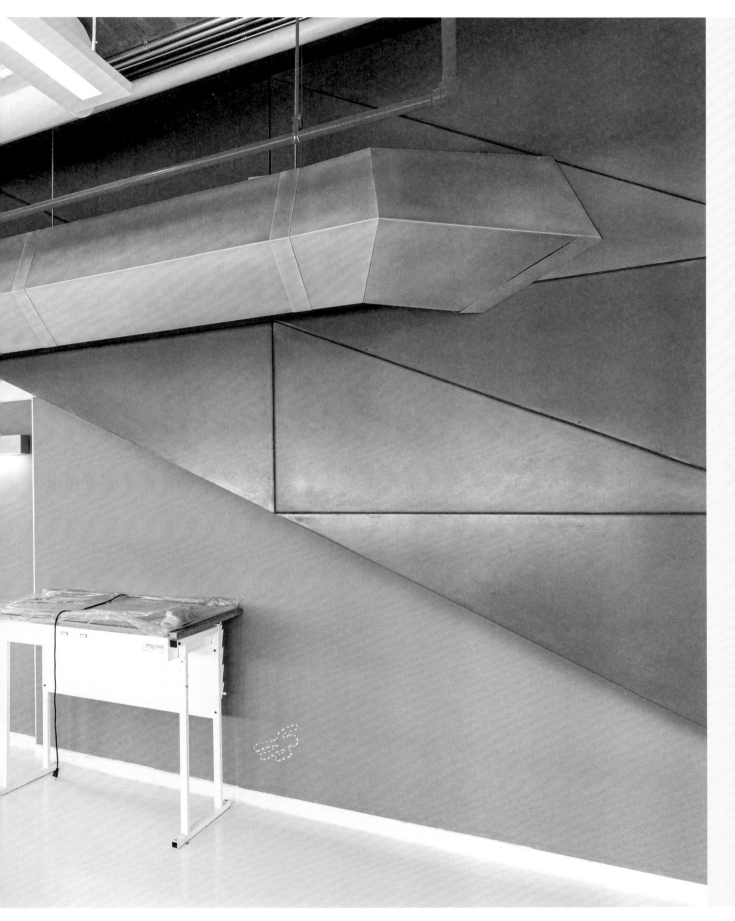

Rita McBride

Bells and Whistles
2009–14
Brass

Mnemonics and Pneumatics

Robert Kirkbride

CAN INFRASTRUCTURE BE ORNAMENTAL? As with city water mains and the bones in our bodies, infrastructure tends to "do its job" unobtrusively, if not invisibly, below the surface and behind the scenes. In fact, infrastructure rarely captures our attention until it fails, disrupting everyday life. Consequently, it tends to elicit curses more than praise. Yet, perhaps infrastructure might serve *and* inspire, by deliberately drawing attention to itself.

"Is sculpture a form of decoration in architecture?" Rita McBride asked rhetorically in recent correspondence about her project *Bells and Whistles* (2009–14).[1] I'd inquired about the pentagonal geometry of her 530-foot-long site-specific installation, an apparently (but not literally) continuous bespoke brass sleeve that encases the egress-stair pressurization ducts in The New School's University Center.[2] At once decorative and enmeshed with the building's life-saving infrastructure, *Bells and Whistles* extends McBride's ongoing exploration of relationships between *servant* mechanical systems and the spaces they *serve*. "When I started imagining a systemic work of sculpture that could incorporate itself throughout the building, I immediately thought of the arterial system of the body. A sculpture that would distribute nutrients and carry away toxins throughout the organism."[3]

Bells and Whistles highlights "the essential but hidden mechanical life of the building," presenting occupants with a scavenger hunt hiding in plain sight.[4] Dodging and weaving, the sculpture draws the eye through classrooms, over alcoves, and along hallways to the emergency stairwells. Therefore, *Bells and Whistles* is well-suited for The New School's

PAGES 186–89: Rita McBride, *Bells and Whistles*, 2009–14 (detail).

1 Email correspondence with the author, April 29, 2017.
2 Distinct from the ductwork (or HVAC) that circulates air throughout a building, egress-stair pressurization ducts use positive pressure to supply fresh air to emergency stairs during an evacuation, which prevents smoke from following occupants into the stairwell.

3 Email correspondence with the author, April 29, 2017.
4 Rita McBride in collaboration with Skidmore, Owings & Merrill, *Bells and Whistles* project summary (2014).

Art Collection, which is distributed throughout the university's public and private spaces; it is kindred in spirit to the university's mission to engage the inner workings of things, including the frameworks of justice and injustice, and the systemic flows that influence how *stuff* is made, distributed, and used in our world.

Why, one might ask, couldn't *Bells and Whistles* be the pressurization duct itself, rather than its sleeve? According to the University Center's architects, Skidmore, Owings & Merrill (SOM), with whom McBride collaborated closely, the pentagonal sleeve *was* conceived as the pressurization duct. However, the numerous seams in the multifaceted ductwork

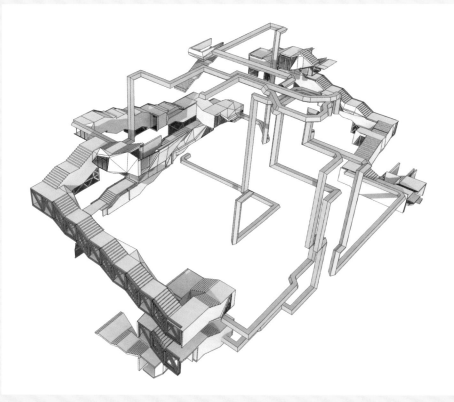

Skidmore, Owings & Merrill (SOM), diagram of Rita McBride's *Bells and Whistles*, 2014.

could not guarantee the perfect seal required by the pneumatic system. Moreover, pressurization ducts require fire-protective insulation. As a result, *Bells and Whistles* encases both the circular pressurization duct and its two-hour fire-rated wrapping. Although the sheath might have been fabricated using circular tubing, thereby reducing the number of seams, McBride's pleated hydra evokes the University Center's brass facade, bringing the outside inward, while its faceted bends and joints mirror the gray glass-fiber-reinforced concrete panels of the building's interior skin. Through its materiality and formal expression, then, *Bells and Whistles* is simultaneously integrated with the building and supplementary to its life-saving system.

Why is *Bells and Whistles* pentagonal in section? "The associations of the pentagonal shape are so rich and varied as to be almost kitsch," McBride notes, emphasizing her underlying aesthetic aim. "To distinguish this system as sculpture rather than engineering," she writes, "an added level of complexity was needed, [and] the pentagon shape offered this quality. For a pentagonal duct to maneuver in and out of the floors and ceilings requires a level of artifice far beyond the building's normal construction standard, one that only recently is possible with the help of computer-assisted fabrication."[5] Presented to a building inhabitant's upward view, the faceted geometry of a downward-pointing pentagonal section is also far more visually dynamic than a flat-bottomed rectangular duct. Meanwhile, a profile more faceted than a pentagon, for example a hexagon or heptagon, would have been inordinately difficult to fabricate. A pentagonal section is symbolically evocative, experientially provocative, complex and yet achievable.

"Decoration," McBride observes, "is essentially an additive and superficial complexity."[6] Yet ornament hasn't always been perceived as superficial. "In modern English," as Mary Carruthers observes in *The Craft of Thought: Meditation, Rhetoric, and the Making of Images, 400–1200* (2005), "we insist on conceptually separating decoration from function. In Latin, these verbs encompassed both."[7] For millennia, ornament (from *ornare*: to equip, to adorn) has conducted the mind's eye along edges, seams, and folds in the constructed environment, providing perches for the birds of thought.

5 Email correspondence with the author, April 29, 2017.
6 Ibid.

7 Mary Carruthers, *The Craft of Thought: Meditation, Rhetoric, and the Making of Images, 400–1200* (Cambridge and New York: Cambridge University Press, 2005), 205.

Ornament is integral to wayfinding in cities as in buildings, not merely as a matter of functional expediency but also as a conscious and subconscious identity-building endeavor for individuals and for communities. Intrinsic to the arts of memory and rhetoric, the decorum of our habitats informs the decorum of our habits, framing how we think and interact—verbally, materially, and spatially. Minimal or maximal, the construction lines of buildings, furnishings, and clothing draw the eye through space and time, revealing how human relationships manifest themselves as fabricated artifacts and habitations. As we make our constructed environment, it makes us.

Ringing Bells, Blowing Whistles

Daniel A. Barber

RITA MCBRIDE'S *BELLS AND WHISTLES* establishes an ingenious sculptural presence in the SOM-designed University Center at The New School. In brushed, faceted brass, the piece wraps around the egress-stair pressurization duct—a crucial piece of any contemporary public building, which allows fire escape routes to remain safe havens during an emergency. The duct system winds through the building like a stylized snake; not actually indicating where those fire exits might be, it presents itself as a conduit connecting the present to possible futures.

It is possible, even likely, that the biggest challenge of the twenty-first century is rendering visible the systems-conditions of the built environment. This contention is based on two simple facts: First, buildings produce forty to sixty percent of carbon emissions in the United States,

much of which come from operating and maintenance systems related to heating, ventilation, and air-conditioning; second, the so-called comfort standards that determine how a building's interior is experienced, in terms of temperature, humidity, and movement of air, have risen dramatically over the past half-century, as a combination of medical knowledge and industry practice have colluded to establish an ever more isolated, filtered, and circulated interior-air condition—a condition that is itself dependent upon fossil fuels and carbon emissions. The result: Comfort in interior climates is leading inexorably to the degradation of the global climate. Building systems—unlike, say, cars or coal plants or even oil pipelines—are relatively invisible (though certainly audible), making affective experience of an HVAC system difficult to draw on as a means for stimulating a more engaged relationship between social patterns and ecological conditions.

Yet this indeed is what is at stake. How do we as a species develop a new cultural relationship to conditions of the natural world that allow human life to persist? How can we render visible this interdependence of built and biotic systems—and will such a visibility encourage ways of living in the world that reduce our reliance on the burning of fossil fuels? All the technological fixes—solar panels, wind farms, geothermal pumps, etc.—will certainly help to close the gap between energy needs and nonfossil energy supplies. But the biggest change will, eventually, come from habits, practices, evolving forms of awareness—adjustments to a cultural sense of comfort.

Bells and Whistles makes mechanical systems more starkly visible to the building's users, inviting investigation even for those who might not realize that the sculpture is revealing an aspect of the building's mechanical system. The gleaming brass cladding on the egress-stair pressurization duct, faceted in a way that reflects the architectural treatment of both interior and exterior walls, does not offer to change social behaviors directly. What it does suggest, however, is that the forms of affect at work in the art and media of the carbon-choked present are simultaneously surprising and mundane. And that environmental crises, as Rob Nixon has pointed out, are also crises of representation: "[C]limate change,

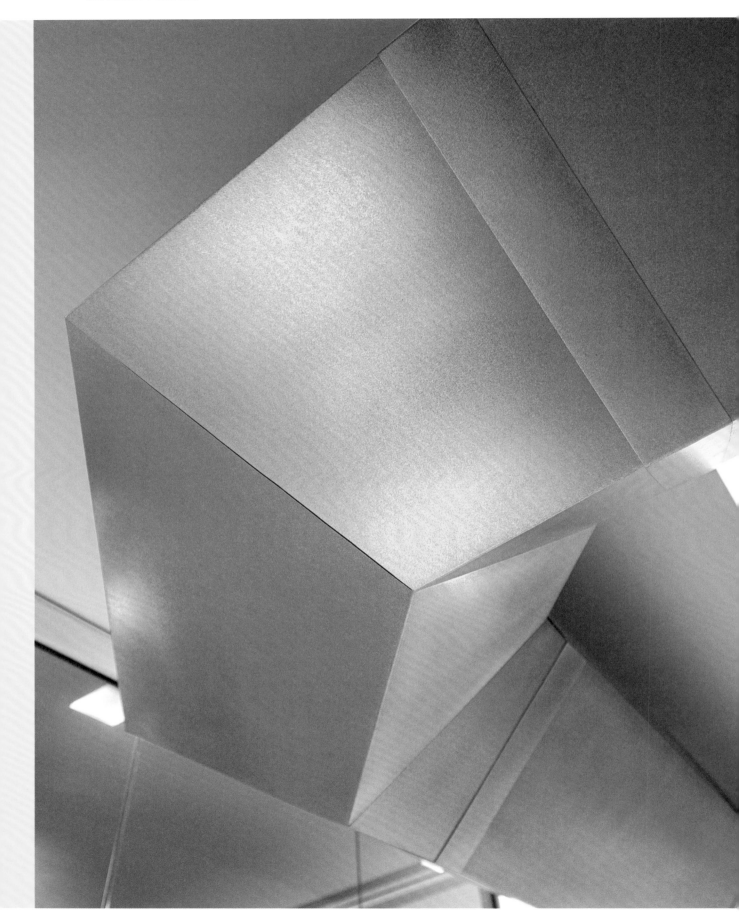

the thawing cryosphere, toxic drift, biomagnification, and a host of other slowly unfolding environmental catastrophes," Nixon writes, "present formidable representational obstacles that can hinder our efforts to mobilize and act decisively."[1] They are hard to see. McBride's piece considers how to re-present the mechanical system—to present it *as such*, as a material and affective system, inflecting cultural habits and their consequences.

So, another set of stakes: What is the position of the arts relative to professions, such as architecture, that are less willing to explore their complicity in the slow accumulations—of pollutants, of habits, of buildings and their systems—that are intensifying climatic instability? The rendering visible of mechanical systems requires a delicate engagement with systems of production. *Bells and Whistles* emphasizes the difficulty of responding effectively to climate change. First, because our lives are organized around fossil-fuel use to such an extent that most people in so-called developed nations can't survive without oil; it is in our food systems, our transportation systems, in the air we breathe. Second, because professions such as architecture that, in effect, manage social relationships to climate still struggle to recognize the threats that buildings' mechanical systems present to "life as we know it." Until recently, the general line was that architectural approaches to energy efficiency would change when government regulations required them to, rather than transforming in a proactive way from within the field. Transdisciplinary projects such as McBride's productively complicate these causal parameters, and their epochal effects.

Bells and Whistles is an elegant piece, then, not only because of its shimmering brass, but because it cunningly recapitulates the conditions of contemporary life—quasi-subversively valorizing the mere presence of the mechanical air-transfer system; rendering visible, however coyly, oil as the life blood of late capitalism; and marking out a circuitous path that is leading us deeper into planetary and social instability. The ducts in question are, remember, used to maintain pressure in the egress stairways in the event of fire, chemical, or atmospheric emergency. *Bells and Whistles* celebrates the possibility of escape and aestheticizes the

Rita McBride, *Bells and Whistles,* 2009–14 (detail).

1 Rob Nixon, *Slow Violence and the Environmentalism of the Poor* (Cambridge, MA: Harvard University Press, 2011), 2.

systems that allow for the preservation of life, while also making visible the inverted logic by which the maintenance of our social system becomes the harbinger of its potential collapse.

Breaking Out of School

Elizabeth Ellsworth

MCBRIDE'S *BELLS AND WHISTLES* knows that *emergencies* happen—in multiple senses of the word. Emergencies as in immediate, often dangerous events: fires, smoke, rescues, migrations, evacuations, escapes, quarantines, stagnations.

And, perhaps (but not necessarily) less apocalyptic emergencies, as in outbreaks of *emergences*: intense, rapid, and consequential deconfigurings of the "what has been" into the "not quite yet"; emergent, incipient gatherings and assemblings that can be felt and sensed but not yet named or known. Nevertheless, they press in on us urgently to announce the future.

Of emergencies *Bells and Whistles* knows quite a bit. It is married (in ways however queer) to one of the University Center building's essential infrastructural systems: the egress-stair pressurization duct. The pentagonal brass tubes that comprise *Bells and Whistles* encircle and adorn this duct. They make known the presence and pathway of an infrastructure designed with emergencies in mind.

Charged with protecting life in case of smoke, fire, and other occasions for evacuation or rescue, the egress-stair pressurization duct delivers air to the center's stairwells, elevator shafts, and areas of refuge, at a pressure that inhibits smoke from entering. Not only does this allow inhabitants and firefighters to breathe in the event of fire, it also makes it

Rita McBride, *Bells and Whistles*, 2009–14.

possible to see well enough in an otherwise obscured situation to generate theories and make decisions about what directions those involved in the crisis should go and what actions they should take.

When emergences compound, compose, speed up, and scale up into emergencies, we must think differently if we are to go on thinking at all. Habits of thought and pre-produced knowledge turn dangerous when they are unresponsive to a current situation and moment. When an outbreak of emergences is in the making, it requires urgent and focused ex-pressings of novel ideas and actions—the putting forth, at usefully pressurized levels, of tools that can redirect habitual ways of doing things.

The designers of the University Center were charged with just such a task: to invent a "sustainable," "green" building capable of responding to the emergency of the Anthropocene, to the stifling fire and air of global warming, the suffocating accumulations of pollution and waste, the limits of earth resources.

Enter *Bells and Whistles*, rendering an outbreak of emergences in a place of learning.

Its serpentine thread of gold makes its appearances playfully and boldly, ex-pressing itself in and out of view, through ceilings and walls, classrooms and concourses. The glittering stretches of brassy add-ons to humble ductwork sound an aesthetic appeal and summon our attention. They entice us to look up and elsewhere from our classroom desks and hurried beelines across the concourses. But we never see it all. It can't all be taken in at once.

Bells and Whistles delivers an aesthetic address. It calls us to learn what art knows so well about emergences; namely, that before new becomings are identified and known, they are lived as embodied sensations for which we have no words, no curricula.

As an egress-stair pressurization duct, *Bells and Whistles* makes a vital connection to breathable air in the event that the inside of the center turns stifling. As an aesthetic experience, *Bells and Whistles* makes a vital connection between what unfolds in the center's classrooms

and what is right now emerging, coagulating, compounding, composing outside thought. The work extends the meanings and functions of emergency egress infrastructure by exerting a continuous *aesthetic* pressure on those habits of perception and ignorance that we as teachers and students tend to cling to as cherished aspects of our identities. As a sustained extrusion (intrusion?) of the aesthetic into the academic, *Bells and Whistles* holds open pathways for imaginations and thoughts to find egress as emergent sensations that are without cultural precedent.

In a review of McBride's work, Daniel Kurjakovic suggests that, through her sculptures, she often gestures toward a lurking reality "that is difficult to acknowledge and therefore only latently palpable."[1] A great description, I'd say, of the emerging realities that are the Anthropocene.

The Anthropocene's emergencies are the emergent, not-fully-knowable material conditions of contemporary life. They are fast becoming the conditions of contemporary learning. Unprecedented events and material conditions are breaking out all around us. There is no emergency infrastructure capable of ventilating the planet. There is no egress stairway out of human existence on earth, nor from its consequences.

Works of art, however, hold open to us paths of egress of a different sort. They seek out and render palpable emergent sensations and conditions. In the emergency that is the Anthropocene, artworks ex-press us only deeper into the human accident, into the emergences that are us. Let's see what we might learn here.

1 Daniel Kurjakovic, "The Echo of a Burlesque Realism in the Work of Rita McBride," in Kurjakovic, Dieter Schwarz, and Iris Wein, *Rita McBride: Previously* (Düsseldorf: Richter Fey Verlag, 2010), 35.

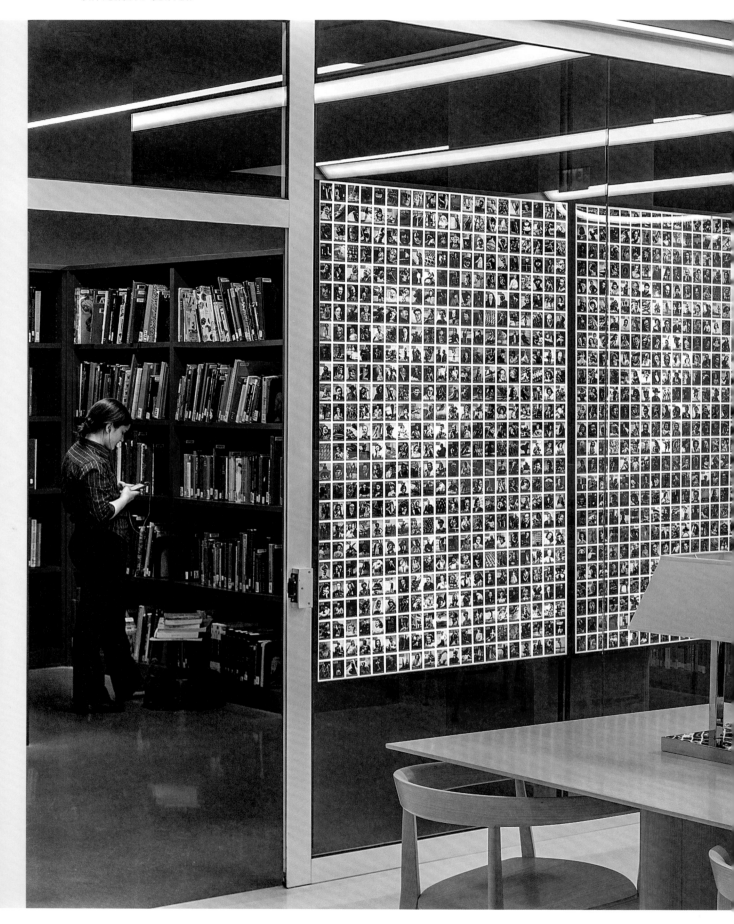

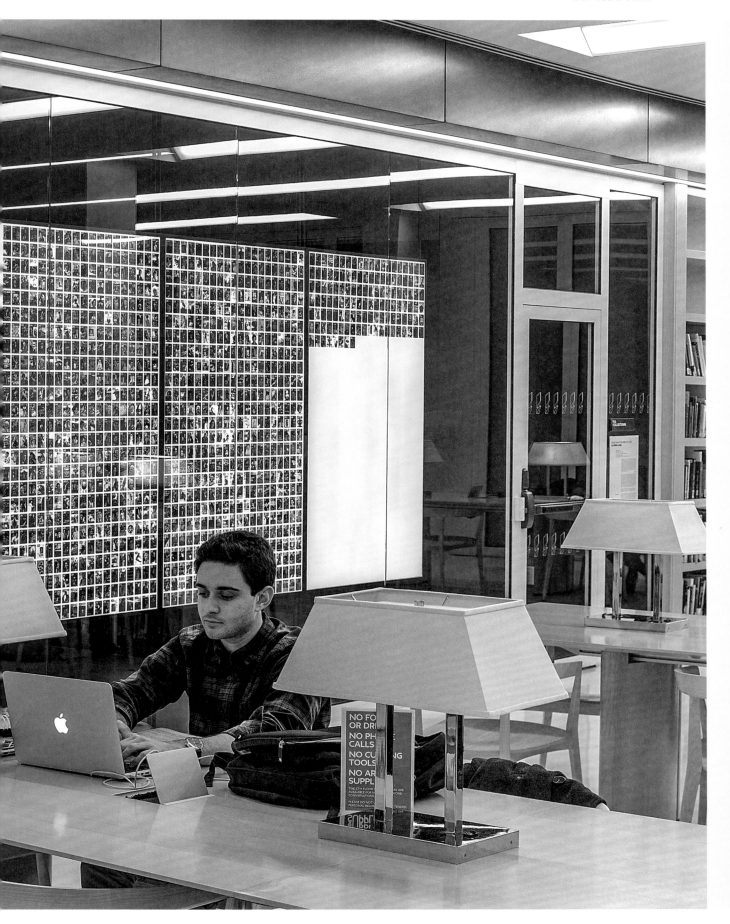

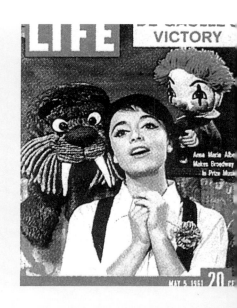

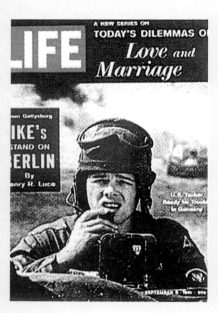

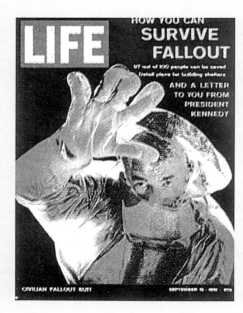

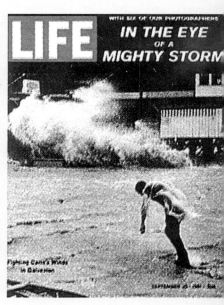

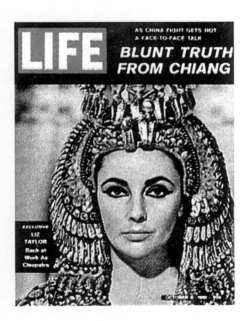

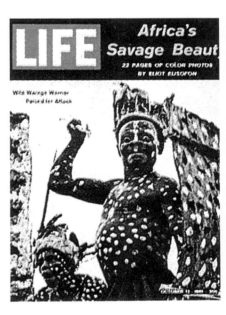

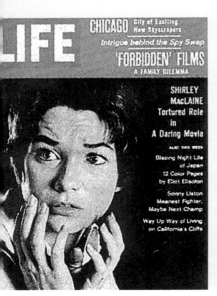

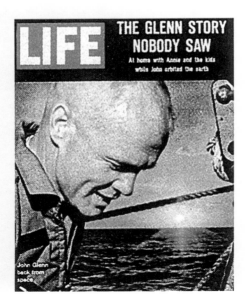

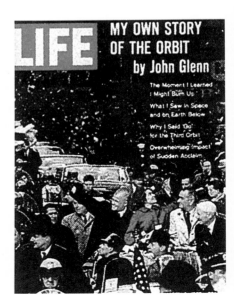

Alfredo Jaar

**Searching for
Africa in *LIFE***
1996/2014
Duratrans color
transparency
and LED lightboxes

Searching Blindly

Radhika Subramaniam

SEARCHING FOR THE ORIGINS OF HUMAN LIFE, we find it in Africa. At Laetoli, near the Olduvai Gorge in Tanzania, lie our earliest-known imprints: footprints stamped indelibly into volcanic ash. While made with far less fanfare than Neil Armstrong's giant step on the moon, that determined foray by our African ancestors heralded our rapid and rampant journey across the planet. When we recognize ourselves in those footsteps, the time intervening between then and now is immediately eclipsed. The geographical space of our journey, on the other hand, doesn't collapse so easily. Few vantage points, it seems, extend their lines of sight to Africa.

Searching for representations of African subjects in *LIFE* magazine, Alfredo Jaar doesn't find much of an impression. In the sixty-year span of a magazine that prided itself on the global reach and caliber of its photojournalism, Africa steps onto its covers a scant five or six times. In the library of The New School, Jaar stages his quest across the magazine's history from 1936 to 1996 as a set of five lightboxes on which are displayed its complete run of 2,128 covers. As sentinels, these images watch over the spirits active in the site itself, a place that invites in people who are thirsty for knowledge and information. But Jaar's survey is equally an indictment of repositories whose very practices of collection, classification, and access channel thirst down specific courses that determine what seekers may find.

If you're searching for faces in the crowd of *LIFE*'s cover reproductions, peer closely because they aren't much more than an inch high. You would have to squint hard at the serried rows to spy those few African covers. Does this optical failure in the face of a multitude of miniature pictures mirror the artist's findings in the archive? The masses of images that suffuse everyday life in the West are selective. The profusion

PAGES 202–03: Alfredo Jaar, *Searching for Africa in* LIFE, 1996/2014.
PAGES 204–05: Alfredo Jaar, *Searching for Africa in* LIFE, 1996/2014 (detail).

so effectively overwhelms people's vision that often they are rendered unaware of what they overlook. The sixty-year barrage of photographs from the likes of *LIFE* has produced, in many eyes, a continental blind spot.

LIFE's iconic covers run the gamut from astronauts to bombs, steelworkers to marines, kisses to frogs, the Beatles to politicians, movie stars to dancers, divers to ships at sea. They feature faces of the times, from Mahatma Gandhi to Mother Teresa, Alfred Hitchcock to Charles Manson, Winston Churchill to Greta Garbo, FDR to JFK, Richard Nixon to Jackie Robinson, Mountbatten to Tito, the Kings (Elvis and Dr. Martin Luther) and the Queen (Elizabeth). As extensive as they are, they remain opaque to decades of events on the African continent.

Having seen all this, it is now that you might notice that the fifth lightbox in Jaar's installation is largely empty. Only six and a quarter rows appear in its upper portion, with a large expanse of empty space below. Blank space, light space, white space.

Step back and see where you are. Search for your own location.

What light does this shed on dark matters? Image making is intimately wrought with matters of life and death. Even as time is killed at the moment the photograph is taken, it is taken alive in the space of the image. Resurrection through the image is at the heart of the process. So if you're searching for the reasons why *LIFE*'s covers raised some and not others into the light, you know whose lives matter. In the library, you could get caught in the cross fire of light's reflections: The day's white light slants in; overhead electric lights bounce off windowpanes that refract the night lights of the city; Jaar's installation radiates implacably behind glass; and throughout, the glow of phone and computer screens on the features of students deep in their searches—seeking contact, poring through faces and feeds, searching for meaning amid the relentless ricochet of word and image. Where once the likes of *LIFE* directed our sight, it is algorithms that now ensure you will seek what you find.

Searching to make sense of the blank expanse on the fifth lightbox, I thought at first it was an invitation to project onto it the faces and

places that were absent from the rest. Yet, all I face is the exhaustion of my eyes. But isn't this limit of sight the very experience that propels Jaar's illumination, demonstrating how the poverty of representation makes people and places invisible? His long-standing excavation of the limits of representation—what images cannot show, words cannot say, eyes cannot see—has focused on the genocide in Rwanda, itself only about a day's journey from the footprints of Laetoli. Where do these limits leave us? Do we step anew out of this sightlessness, toward others, searching blindly for the simple clarity of those footsteps made over three million years ago in the ash of Africa?

An Absence That Conjures a Presence

Omar Berrada

HERE IS A WALL OF IMAGES, a large picture made of smaller pictures juxtaposed into a grid of homogeneous discontinuity: the covers of *LIFE* magazine (1936–96), all 2,128 of them, distributed over five backlit panels. *LIFE* was a wildly popular publication, with up to thirteen million weekly readers. It had the power to shape perception. Here is a vertical, open-faced visual encyclopedia of the twentieth century as understood by North Americans.

Searching for Africa in LIFE offers a direct confrontation with media-constructed reality. You have to come close to distinguish specific images and captions. But then you lose sight of the larger picture. Either way, one thing you will not find is Africa. It is virtually absent, except for a handful of wild animals or hungry children waiting to be saved—a classic case of humanistic dehumanization.

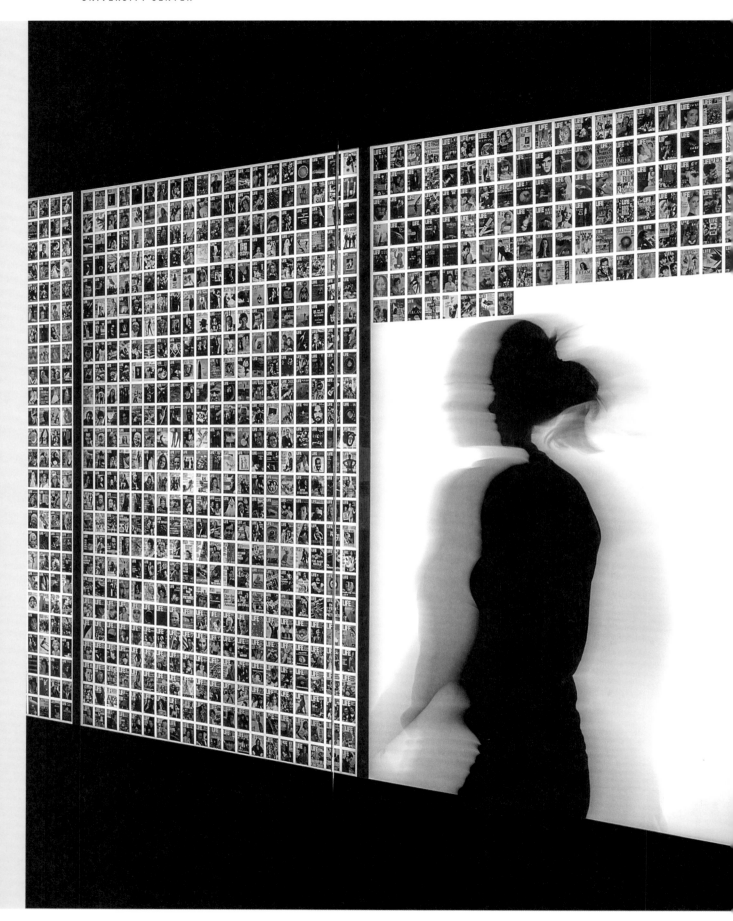

In his book *Blank Darkness*, Christopher Miller lists various historical definitions of and etymologies for "Africa." A nineteenth-century American encyclopedia states that "its name is a mystery; it is supposed to be derived from Afrigah, which word, in the ancient Phoenician, is said to have meant colony."[1] Africa is presented as *ontologically* colonial, so to speak, an entity meant to be conquered and kept in the dark. Some have also linked Africa to the Arabic root *fa-ra-qa*, which means "to separate." Stripped of agency, the continent is exposed to lazy projections of the Western imagination. Always already separated, Africa cannot possibly be found on the covers of *LIFE*. It dwells in the interstices between them.

Alfredo Jaar has long been interested in repressions of representation. He spent his early twenties in Pinochet's totalitarian Chile, where opinions were silenced and people "disappeared." Making use of what seemed like naive, innocuous language ("Are you happy?"), he devised performative frameworks that eschewed censorship while offering ordinary people a space of appearance,[2] an opportunity for their images and opinions to be publicly displayed on billboards, in videos, in interview transcripts.[3] Thus gathered together, "they could see themselves. They could see others. They felt complicity."[4] In media-saturated twentieth-century America, it is the African other who has been disappeared. This is not dictatorial repression; it is imperial indifference. To the extent that it is represented at all in *LIFE*, "Africa" is reduced to clichés endlessly repeating.

The visual economy of American spectatorship is one of anesthetized half-consciousness. But false representations produce real effects. As the journalist Fergal Keane observes in regard to his work covering the Rwandan genocide, "In our world of instant televised horror it can become easy to see a black body in almost abstract terms, as part of the huge smudge of eternally miserable blackness that has loomed in and out of the public mind through the decades."[5] *Searching for Africa* is part of an extended series of "African" works that Jaar made following his visit to Rwanda in the summer of 1994. He wanted to see the aftermath of atrocities to which the Western world had turned a blind eye. The Rwandan

Alfredo Jaar, *Searching for Africa in LIFE*, 1996/2014 (detail).

1 *New American Cyclopaedia* (New York: Appleton, 1858), 1:169, quoted in Christopher Miller, *Blank Darkness: Africanist Discourse in French* (Chicago: University of Chicago Press, 1985), 10.

2 According to Hannah Arendt, "the space of appearance comes into being wherever men are together in the manner of speech and action," where the space of appearance is "the space where I appear to others as others appear to me, where men exist not merely like other living or inanimate things but make their appearance explicitly." See Arendt, *The Human Condition* (Chicago: University of Chicago Press, [1958] 1998), 198–99.

3 See Alfredo Jaar, *Studies on Happiness 1979–1981* (Barcelona: Actar, 1999).

4 Alfredo Jaar quoted by Caille Millner in "Alfredo Jaar and the Happiness of Chile," *Los Angeles Review of Books*, December 8, 2013, https://lareviewofbooks.org/article/alfredo-jaar-and-the-happiness-of-chile (accessed November 12, 2017).

5 Fergal Keane, *Season of Blood: A Rwandan Journey* (New York: Viking Press, 1995), 29–30.

genocide is a central subtext of *Searching for Africa*, for decades of media-made invisibility are precisely what makes indifference possible.

One of Jaar's best-known Rwanda-related works, *Real Pictures* (1995), centers on photographs he took in Rwanda, which are concealed inside closed black linen boxes, each bearing a verbal description of the image it contains. "Images are buried in order that history might again be made visible and legible,"[6] as David Levi Strauss observes. Another well-known work by Jaar, *The Eyes of Gutete Emerita* (1996), comes in multiple versions. One of them sets up a cinematic device (a darkened room in which sequenced text panels are projected) that slows down perception before the viewer is made to encounter a single image appearing in a brief, intense flash: a close-up of the eyes of a woman who has witnessed the massacre of her own family. If this work eschews direct violence, it displays a gaze that conveys unspeakable, unpicturable horror. As Levi Strauss suggests, the moment we meet the eyes of Gutete Emerita, the distance imposed by media representations of Rwanda collapses. *Searching for Africa* seeks not to collapse the media gaze, but to expose it. In a way, it is a preliminary to *The Eyes of Gutete Emerita*, or perhaps its reverse shot. Imagine Emerita's eyes watching you looking at *Searching for Africa* in LIFE.

Jaar's work has long relied on a sense of geometric clarity, of strong emotion contained by form. *Chile 1981, Before Leaving* (1981) presents a line of small Chilean flags planted in the sand, extending into the ocean. *Telecomunicación* (1981) is an alignment of six bin lids on the floor, referencing Northern Irish women's ritual of clashing lids together in order to announce the death of IRA hunger strikers. In *Searching for Africa*, Jaar could have fit the magazine covers into a set of four rectangular panels. Instead, they spill over into a fifth panel that remains largely blank. The blank oblong redoubles the absence of African representation, but it also provides the viewer with the potential for alternative inscription, a surface on which a face for Africa might be drawn—a surface for apparition rather than a space of drowning.[7] In this glowing space is an absence that conjures a presence.[8]

6 David Levi Strauss, *Between the Eyes: Essays on Photography and Politics* (New York: Aperture, 2003), 93.

7 Jaar's *Emergency* (1998) consists of a sculpted map of Africa that continually sinks into and reemerges from a pool of dark water, much as the "African" covers of LIFE seem lost in a sea of indifferent images.

8 As Jaar has said in the context of *Real Pictures*, "[I]f the media and their images fill us with an illusion of presence, which later leaves us with a sense of absence, why not try the opposite? That is, offer an absence that could perhaps provoke a presence." Quoted in Rubén Gallo, "Representations of Violence: The Limits of Representation," *Trans*, nos. 3/4 (1997): 59.

Alfredo Jaar: Dialectic of Sight

Jennifer A. González

IMAGE SATURATION IS THE CONTEMPORARY condition of humans who live in close proximity to computers and phones, to the software and hardware of pixels and screens. Saturation implies a limit, a fullness, a completeness. Our daily sensation of an overflowing abundance of visual culture has clearly surpassed that discussed in Guy Debord's *Society of the Spectacle* (1967); it articulates yet also exceeds the imposition of capital as a mediation between people and things; it has become the very breath we take, the vertebrae in the spine of our lives, the pulse and the rhythm of our thoughts. Image after image scintillates and accumulates; informational documents and eroticized residues of Instagram and the Internet shape every corner of our consciousness, our knowledge of the world and of ourselves. As an artist, Alfredo Jaar deploys this visibility and its corollary invisibilities in equal measures. Occlusion of spectacle undergirds his photographic installations as frequently as the economical revelation of the image does. His works interrogate how it is that, despite our image-saturated state, we cannot see.

Founded in 1883, *LIFE* magazine was originally a humor and entertainment weekly. The motto of the first issue was "While there's Life, there's hope."[1] "We wish to have some fun in this paper," wrote the editors. "We shall try to domesticate as much as possible of the casual cheerfulness that is drifting about in an unfriendly world."[2] When *TIME* owner Henry Luce bought the name rights in 1936, he transformed the weekly into an important source for current events and information. *LIFE* magazine was the first all-photographic American news magazine, and effectively invented modern photojournalism, bringing the international world to the

1 "Life: Dead & Alive," *TIME* magazine, October 19, 1936. 2 Ibid.

United States and American popular culture back to the world. Dominating the market for more than forty years, with millions of subscribers, *LIFE* under Luce had a goal distinct from the earlier editors' wish to have fun: "To see life; to see the world; to eyewitness great events; to watch the faces of the poor and the gestures of the proud; to see strange things—machines, armies, multitudes, shadows in the jungle and on the moon; to see man's work—his paintings, towers and discoveries; to see things thousands of miles away, things hidden behind walls and within rooms, things dangerous to come to; the women that men love and many children; to see and take pleasure in seeing; to see and be amazed; to see and be instructed."[3]

Alfredo Jaar's lightbox installation *Searching for Africa in* LIFE (1996/2014) invites us to contemplate the degree to which "taking pleasure in seeing" is anything but an innocent enterprise. Backlit and hung in five vertical panels, the dense photographic grid of miniature *LIFE* covers, chronologically spanning the magazine's production from 1936 to 1996, has a nearly painterly, Color Field aspect. Black-and-white covers from the early years, on the left side, give way to warm skin tones and technicolor blues that flicker across the surface of the remaining panels with a nearly pointillist effect. As one approaches the work more closely, each cover can be seen in detail, yet these details are not the primary focus of the piece. Instead, the title leads the viewer to become aware of two things: First, there are no more than a handful of covers, perhaps five, that relate to the African continent, and the majority of these focus on African animals; second, the last of the five panels is largely composed of blank white space.

Searching is a visual act. Where is "Africa" in *LIFE* magazine? Virtually nowhere. Given the massive political and anticolonial upheavals the continent experienced in the twentieth century, it is all the more stunning to consider how little it appears in *LIFE*'s pages. The conceptual and formal elegance of Jaar's work motivates us to contemplate other possible searches and other obvious omissions, while simultaneously compelling us to look at the blank space, the emptiness where stories remain untold. *Searching for Africa in* LIFE follows an earlier work by Jaar, *Untitled (Newsweek)* (1994), in

3 Liz Ronk, "LIFE in 2012: The Year in 12 Galleries," *TIME* magazine, December 2, 2012, http://time. com/3875143/life-in-2012-the-year-in-12-galleries (accessed May 22, 2018).

which a week-by-week chronology of the massacre of hundreds of thousands of Rwandan people is recounted through short summaries paired with the concurrent cover of *Newsweek* magazine. For fourteen weeks, the periodical entirely ignored the massacre, though the body count jumped by the hundreds and thousands between issues. What can account for this radical silence? A decade later, the artist's search through twenty-five years of *TIME* magazine covers revealed only nine related to Africa. Of the nine, three depicted animals, and the other six depicted poverty or disease. These nine images appear as a grid of photographs in *From Time to Time* (2006). "According to these covers," says Jaar, "it appears that there is no 'life' in Africa, there is no architecture in Africa, there is no science, there is no music. It is only death that they are interested in."[4] The embedded racism in these publications echoes the overt white supremacy now on the horizon of the American and European scene, but it also reminds us that systemic visual censorship may operate at the origin of such social formations. Jaar's works, with their emphasis on relations of excess and lack in the visual imaginary, invite us to contemplate the paradoxical likelihood that contemporary image saturation may be just the latest form taken by an endemic Western censorship of sight.

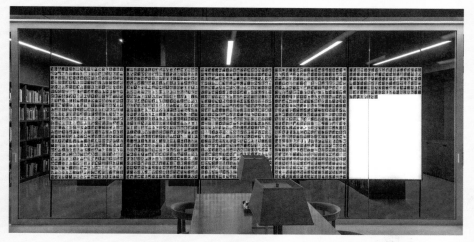

Alfredo Jaar, *Searching for Africa in* LIFE, 1996/2014.

4 *Vogue Italia, Focus on: Alfredo Jaar* (interview
 by Alessia Glaviano, 2013), https://www.youtube.com/
 watch?v=EjvRtNPVzgs (accessed November 30, 2017).

The Blink of Failure: Imagining Life in Africa

Tisa Bryant

> I want people to walk in that space and to feel they have entered into a model of thinking, of looking at the world.
> —Alfredo Jaar

FROM A DISTANCE, Alfredo Jaar's installation *Searching for Africa in* LIFE could be mistaken for a room divider of mosaic tiles, an abstract assemblage across five panels. The left side begins in whitish grounds with smudges of gray black, a small red flag listing repeatedly to the left, bleeding into the grid. Panning right, color intensifies on a diagonal grade, ending in a jagged edge above an empty white glow. Once face-to-face with the work, we find that the emergence of color denotes *LIFE* magazine's progression through photographic innovations—while consistently misrepresenting the lives of this world. The magazine's covers chronicle Olympiads, starlets, dictators, monarchs, fashion models, and war heroes, scientific discoveries and natural disasters, all to the near total exclusion of African people.

Each cover is a blink of denial and a failure of imagination. Over *LIFE*'s six-decade run, readers were encouraged to ignore the lives of Africans outside a stereotypical shared imaginary propagated by colonialism, condescension, and fetish. At the same time, they were invited to imagine African Americans as uniquely American, cyphers for entertainment, brawn, occasional revolutionary acts, and dreams impoverished and bloodied by white supremacy. A snapshot from the magazine's 1960s-era tables of contents gives an idea:

South African massacre of Negro demonstrators at Sharpeville
Terrorism in South Africa—blacks revolt and assassinate Hendrik Verwoerd
First black cardinal of Roman Catholic Church, Laurian Cardinal Rugambwa

Kenneth Kaunda, head of a new Nationalist party in Northern Rhodesia
Belgian Congo becomes independent
Congo king Lukengu Bope Mabinshe loses 750 wives

Still, it's the weekly marquee that insists on the most specific stories—not only about who and what warrants magnification in the public eye, but how and to what effect. The tropes as expressed in the covers' headlines are predictable:

Africa: A Continent in Ferment [Masai in close-up, staring beyond the frame]
Ghana's Leap from Stone Age to Eager New Statehood [Ghana's speaker
 of the house]
Carroll Baker [holding a spear, flanked by two Masai]
Africa's Savage Beauty [photo caption: "Wild Warega warrior poised for attack"]
Starving Children of Biafra War
Billy Graham in Africa

By representing the entire run of *LIFE,* from 1936 to 1996, set inside his signature lightboxes, Jaar marks out the labor implicit in his title. This "searching," of course—the quest for a counternarrative that would upend clichés of "darkest Africa"—is aided by the viewer. We must stand and scan, read and compare, to suss out how and what *LIFE* (and Jaar) think about Africa. Or, more importantly, what we think about Africa, what we think about the role that photographic images, and deliberate over-, mis- and under-representation in images, have played in Black people's oppression. Answers to such questions require a diligent accumulation of evidence—a fact as galling as it is unavoidable.

Consider these juxtaposed comments by Jaar:

My imagination starts working based on research, based on a real-life event, most of the time a tragedy, that I am just starting to analyze, to reflect on[1]

—and by scholar Christina Sharpe:

The methods most readily available to us sometimes, oftentimes, force us into positions that run counter to what we know. That is, our knowledge, of slavery and Black being in slavery, is gained from our studies, yes, but also

1 Jaar interviewed on *Art21: Art in the Twenty-First
Century*, "Protest," season 4, November 4, 2007.

in excess of those studies; it is gained through the kinds of knowledge from and of the everyday, from what Dionne Brand calls "sitting in the room with history."[2]

Jaar sits in the room with history, positioning research as a form of attention. He is clear about the impossibility of closing the gaps between reality and representation, between what poet Erica Hunt calls our historic and our authentic selves. His ways of seeing are, by his own account, influenced by his formative years in Martinique. Given his assertion that he is incapable of creating a work of art wholly from his imagination, it's tempting to speculate about how the artist's living in relation to African-descended people has not only developed his consciousness of racism and violence, but reconfigured his imaginary beyond programmatic "inclusivity," yielding an interventionist practice.

For African and African diasporic artists, scholars, and everyday people, research is likewise a method of attention. Sitting in the room with history, with eyes on present cultural phenomena, is part of living in a world that excludes you at every level. As Jaar suggests, such research via attention entails constant acts of intervention and assemblage.

Consider "The Dangers of a Single Book Cover," an article that appeared in 2014 on the online platform Africa is a Country.[3] In a riff on novelist Chimamanda Ngozi Adichie's oft-cited TED Talk, "The Danger of a Single Story" (2009), the listicle gathered dozens of cover designs for books by African authors; a whole category of these are emblazoned with stock photographs of an acacia tree, often at sunset (another subset presented one or another image of a sub-Saharan African woman, artfully blurred, never making eye contact). The treatment of the marquee space, the cover, in these examples seems intended to thwart readers' ability to enter the space of discourse. This is a deliberate working against the potential of relations between people as facilitated by art. The "acacia tree" meme, then, is protest. It is social practice, malleable, ripe for appropriation.

But what do such interventions, such accumulations, ultimately succeed in doing? While the critical acacia-tree meme can't be proven

2 Christina Sharpe, *In the Wake: On Blackness and Being* (Durham, NC: Duke University Press, 2016), 12. Sharpe is in dialogue here with Dionne Brand's *A Map to the Door of No Return: Notes to Belonging* (Toronto: Vintage Canada, 2002).

3 Elliot Ross, "The Dangers of a Single Book Cover: The Acacia Tree Meme and 'African' Literature" (May 7, 2014), https://web.archive.org/web/20180704225820/https://africasacountry.com/2014/05/the-dangers-of-a-single-book-cover-the-acacia-tree-meme-and-african-literature (accessed July 4, 2018).

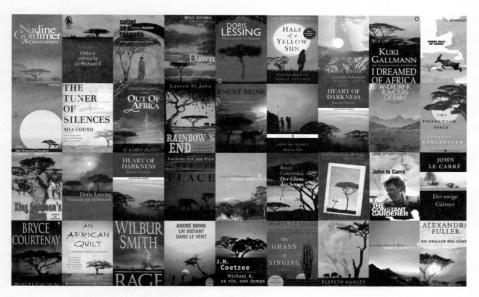

Simon Stevens, book covers with "Acacia tree sunset treatment" (Twitter post), 2014.

to have chastened the designers of African books, such archival examination affirms the experience of sitting in the room with history crowded by the white imaginary. Jaar's installation, by assembling magazine covers, calls the eye to hover over sixty years of editorial failure to see life in Africa. Residually, Jaar's work chronicles the reality and the inequity of this everyday labor of attention in nonwhite peoples' lives. *Searching for Africa in* LIFE sits doubly in the room with history, within itself and in a well-appointed library, beckoning viewers to enter into this mode of thinking and awareness. People sit at desks, headphones on, or walk past what appears to be a brightly lit decorative wall. Some don't notice it; others glance and look away. A few stop and study. Perhaps here, in this literally standing invitation to recalibrate the imaginary represented by *Searching for Africa in* LIFE, we find the nexus at which the blink of failure opens its eyes or expands its blind spot.

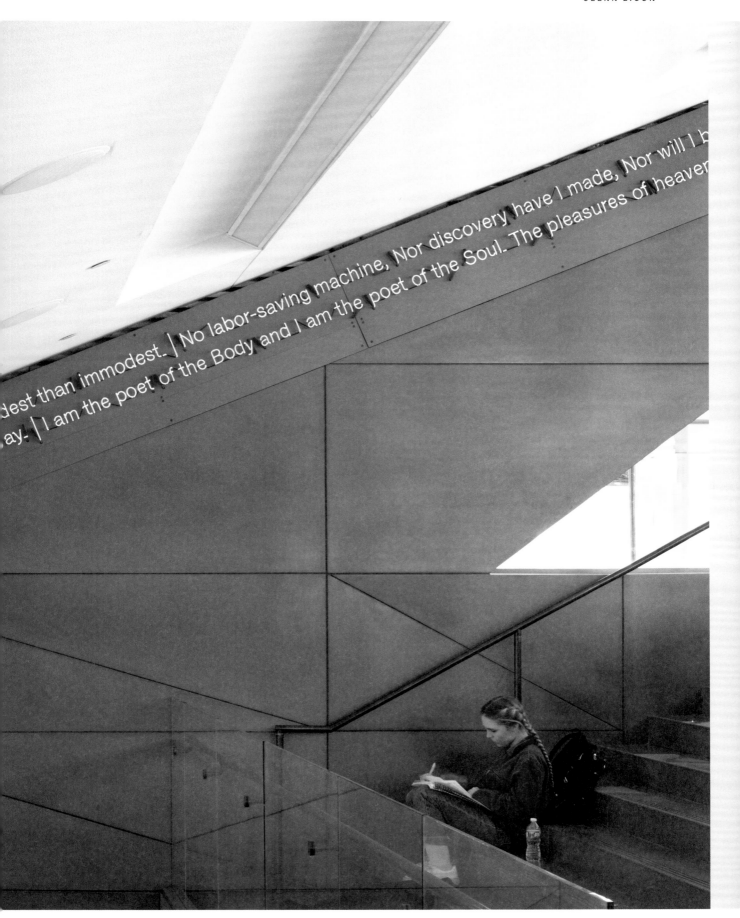

Glenn Ligon

**For Comrades
and Lovers**
2015
Neon

Democratic Vistas of Space

Carl Hancock Rux

TODAY, AHEAD, THOUGH DIMLY YET, we see, through light, through space, through rooms, through halls in which we gather. A copious, sane, gigantic, lasting power becomes us in our gathering. A harmony of eyes and minds and language gives us a right to things. Here the body and the life are to be considered in diatonic notes—little shreds of fabric to make the whole of a continuum. We spend our lives inside buildings, our thoughts shaped by walls. Walls and space influence cognition, inspire thinking, ignite variables of imagination, trigger associations with sky and ocean in expansive horizons and diffuse light. Daydream here. Think in terms of tangential associations. Focus on and become aware of the possibilities, simmering interests. Ponder creative solutions and abstract speculations of principle, and theory. Develop perfection.

Comprehenders, contradict one another, question democracy, realize your convictions and present them in oneness, tempered by wandering. The triumphant futures of business, of play, of republic, are afforded us here. Value your occupancy, inhabit your intellect. Look up and read the words illumed above. They are authored by someone who willed, *This is what you shall do: Love the earth and sun and the animals, despise riches, give alms to every one that asks, stand up for the stupid and crazy, devote your income and labor to others, hate tyrants, argue not concerning God, have patience and indulgence toward the people, take off your hat to nothing known or unknown or to any man or number of men, go freely with powerful uneducated persons and with the young and with the mothers of families, read these leaves in the open air every season of every year of your life, re-examine all you have been told at school or church or in any book, dismiss whatever insults your own soul, and your very flesh shall be a great poem and have the richest fluency not only in its words but in the silent lines of its lips and face and between the lashes of your*

PAGES 220–23: Glenn Ligon,
For Comrades and Lovers, 2015
(detail).

eyes and in every motion and joint of your body.[1] These words are authored by someone who was before you and who believed himself to be among you eternally in the city that he loved. They are words as art, art as light, light as implementation of solution, making vision a reality concerned with the aesthetics of thought. Light as words become our interaction with life, become thought, become wave and particle. Waves of light, cursive, electromagnetic. Photon. Index of refraction from material to material. Lines become relationships between angles of incidence and refraction, passing through boundaries, between two different isotropic media, between water, between glass, between air. Words as light bent backward, curled to refractive index, made open as a mirrored lens to the soul's equivalent, to the ratio of phase velocities, to the reciprocal of the ratio of the indices of refraction. This is an integration of gas emitting color, color as atoms of inert gas, chemically bonding with atoms; a distribution of transmuted thought. The glare luminance of surfaces, shadows reflecting a system of nation vigorous in its literature, transcendental in the expression of its design, inviting your expression. Look up. See yourself here. Ask someone—Who are you? Where are you now? What do you think? What shall we change? Where is our congress? Who is curious? What are our proposition and remedy? Where shall we place our attention and how shall we give it decision? How can we redefine the chivalry of the feudal, ecclesiastical, dynastic world in the conscious and unconscious blood of belief? Welcome a poet. A visual artist. An architect. A maker of things. Embrace the magnitude of a moment in the aggregation of heroes and sufferers of misfortune. This is your place. It is a constant puzzle and an affront to the merely educated cosmical artist-mind lit with infinite thirst. Turn to the essential dualism here, of nature's co-existence, of waves at the level of quanta. Welcome a poet. Welcome an architect. Welcome a maker of things. Welcome an artist (and all lovers of art). Speak to someone of what you know. Know words to be light.

1 Walt Whitman, preface to *Leaves of Grass* (1855 ed.) (New York: Penguin Classics, 1961), 11.

Among the Throng: Glenn Ligon Situates Whitman

Wendy S. Walters

ALL THE WORDS IN GLENN LIGON'S nearly two-hundred-foot frieze in violet neon, *For Comrades and Lovers*, appear to be touching. This work follows in the tradition of spareness found in Ligon's previous neon pieces: Each wall features two rows of lines collaged from passages of Walt Whitman's *Leaves of Grass*, as the lighted letters hover with a fizzy intensity that stretches from corner to corner. The illuminated words contrast with the angular patterns of the gray cast-concrete panels on the walls of the Event Café in The New School's University Center, and they give the public, multipurpose meeting place a sense of gravitas.

A wide staircase cuts from the entrance level of the building to the lower level of the café. At the stair's midpoint, at the west wall, one can stand close enough to the work to see the charged particles of argon gas through the bent glass tubes outlining each word while the enclosed coronas intimate a pulse more hurried than a heartbeat. As students and visitors mill about on their way to class, studio, public talks, and the library, so the glimmering text invites audiences to find a Whitmanic solitude among the throng. The text emphasizes the idea of placelessness as utopian, a world where there is no prerequisite for belonging:

> Martyrs, artists, inventors, governments long since,
> Language-shapers on other shores,
> Nations once powerful, now reduced, withdrawn, or desolate,

> or

> Ah, lover and perfect equal, I meant that you should discover me so by
> my faint indirections.

The manner in which Ligon gives primacy to language in his prints and neon compositions provokes a rereading of key texts that speak with authority about the explicit ways one is connected to others—as in, for example, James Baldwin's "Stranger in the Village" from *Notes of a Native Son,* published in 1955; or Muhammad Ali's two-word poem "Me/We," delivered during a lecture at Harvard University in 1975; and Zora Neale Hurston's 1928 essay "How It Feels to Be Colored Me," each of which Ligon has quoted in his works. *For Comrades and Lovers* amplifies the urgency of Whitman's demands for a more equitable society interlinked across the boundaries of race, gender, and even species. Because this kind of "touching" can also be hard for some to see, Ligon demonstrates it through the repetition of key phrases, which serves as emphasis rather than redundancy; and the reflections cast by his light works, which illuminate the many ways in which a word might be read. Ligon's literary influences share an interest in the individual's struggle to achieve full participation in the citizenry through announcements of purposeful connection.

Ligon uses words and letters as a means of expressive embellishment and conceptual emphasis. Text-based images are central to his practice, as often they invoke a point of view that implies the artist is speaking. Lauren DeLand notes that this borrowed "I" functions paradoxically as an announcement of self, as presence: "In Ligon's work, identificatory declarations come from other lips, and the artist's body represents not a unitary self, but a dialogic, citational, and wholly subjective being for others."[1] Tension arises between the historical position of a given text and what it might evoke as it points toward the future—emphasized by the visual space the linguistic signs take up in Ligon's art.

If one thinks of alphabetic characters as symbolic representations of sound rather than two-dimensional images, then the use of words seems an obvious choice for an artist who approaches human connection as an implicit consequence of language, a kind of comportment of knowledge. Just as Whitman writes of "language-shapers on other shores," Ligon reminds us that words are both aural and visual as they point to and

1 Lauren DeLand, "Black Skin, Black Masks: The Citational Self in the Work of Glenn Ligon," *Criticism* 54, no. 4 (Fall 2012): 509.

deflect from the things they name. Whitman writes in the poem "Manna-hatta," also in *Leaves of Grass*:

> Now I see what there is in a name, a word, liquid, sane, unruly, musical, self-sufficient.

For Whitman, to be a citizen means to be one more person almost indistinguishable from the rest, yet he celebrates expressions of intimacy and affection—of life unbounded by institutions that emphasize disparity, deference, and separation through social codes. One might say that, for Ligon, citizenship is a call to this world that has not yet arrived; an inscription of the hope that, through such insistence on selfhood, one might be in that world, thriving.

Incantations

Luis Jaramillo

IN THE ESSAY "A BACKWARD GLANCE O'ER TRAVEL'D ROADS," included as an epilogue to his collected works in 1889, Walt Whitman uses the word "buoyancy" to describe the defining quality of his life's work, *Leaves of Grass*. Over the incantatory arc of his poem, Whitman's narrator addresses his words "towards himself and towards his fellow-humanity," noting, "It is certainly time for America, above all, to begin this readjustment in the scope and basic point of view of verse; for everything else has changed."

The "everything else" he refers to, needless to say, includes the Civil War and the industrial revolution. But Whitman's aspirational conviction is that "the crowning growth of the United States is to be spiritual and heroic."[1] Not so fast, Glenn Ligon's work seems to say; things are a bit more complicated than that.

1 Walt Whitman, *Leaves of Grass: The 1892 Edition* (New York: Bantam Classic Editions, 1983), 444, 455.

I teach a class at The New School called Illuminated Manuscripts: Story in Word and Image. The title captures much of what we do, but not everything. I tell my students that what we're really trying to learn is how to be brave.

To get to our classroom, students walk below—that is, through—Ligon's installation *For Comrades and Lovers*. Whitman's words hover along the edges of the ceiling in a broad and shallow stairwell, the letters formed in violet neon that glows against a frieze of dark cast concrete. Warriors and poets have always taken time to pause before battle, before writing, to invoke the ancestors and the gods. For me, Whitman is something between god and ancestor, a grandfather poet and gay man, a voice from the other side. So when I walk down the stairs, I give him a nod, invoking him through my quotidian movement through this space where I teach.

On the level below *For Comrades and Lovers* hangs Ligon's untitled suite of four black-and-white etchings (1992). One panel of the quartet repeats the lines "I feel most colored when I am thrown against a sharp white background," and another, "I do not always feel colored." These texts are taken from Zora Neale Hurston's essay "How It Feels to Be Colored Me" (1928). The word "colored" in the essay and in the etchings refers to blackness, but the other meaning of "colored" is present also in the work. To move through the two-story space connecting the lobby of the University Center building and the lower level is to cross through contrasts between light and darkness, weight and weightlessness, violetness and brownness and blackness, a calling of attention to the difference between the above and the below.

"We live in a white-supremacist-capitalist-patriarchy," bell hooks has written often. With repetition comes the imperative to look—look here, look at what's true right in front of you. In the other two etchings in the suite, Ligon borrows from the first lines of Ralph Ellison's novel *Invisible Man* (1952). The letters are glossy black on a matte black background, hard to read; and, like Hurston's sentences, Ellison's repeating lines become congested—invisible—at the bottom of Ligon's frame, a literal representation of the failure of language and art.

Glenn Ligon, *For Comrades and Lovers*, 2015 (detail).

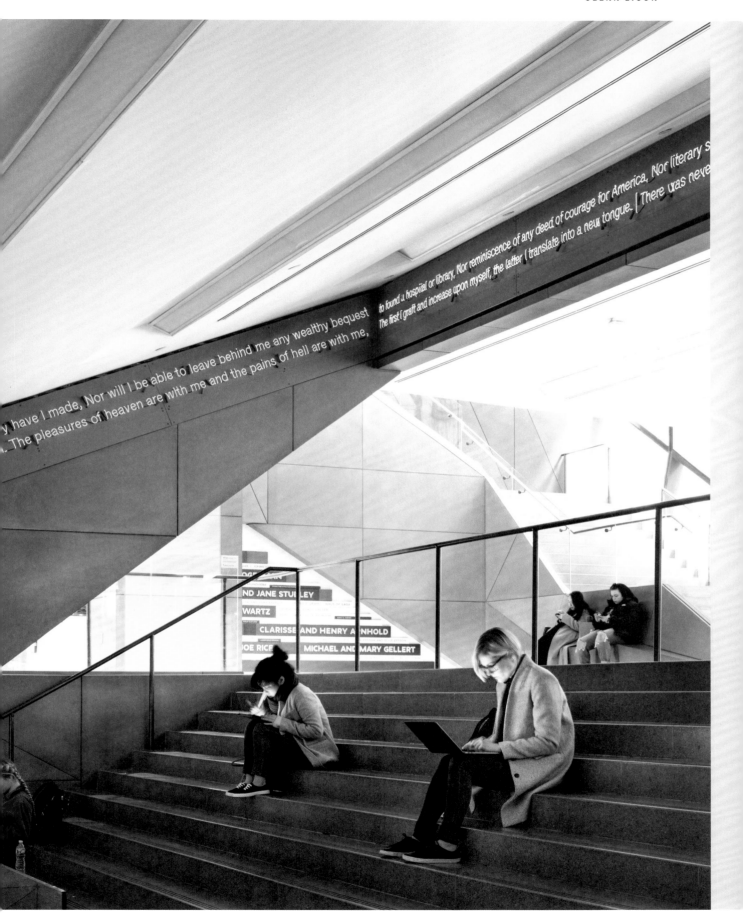

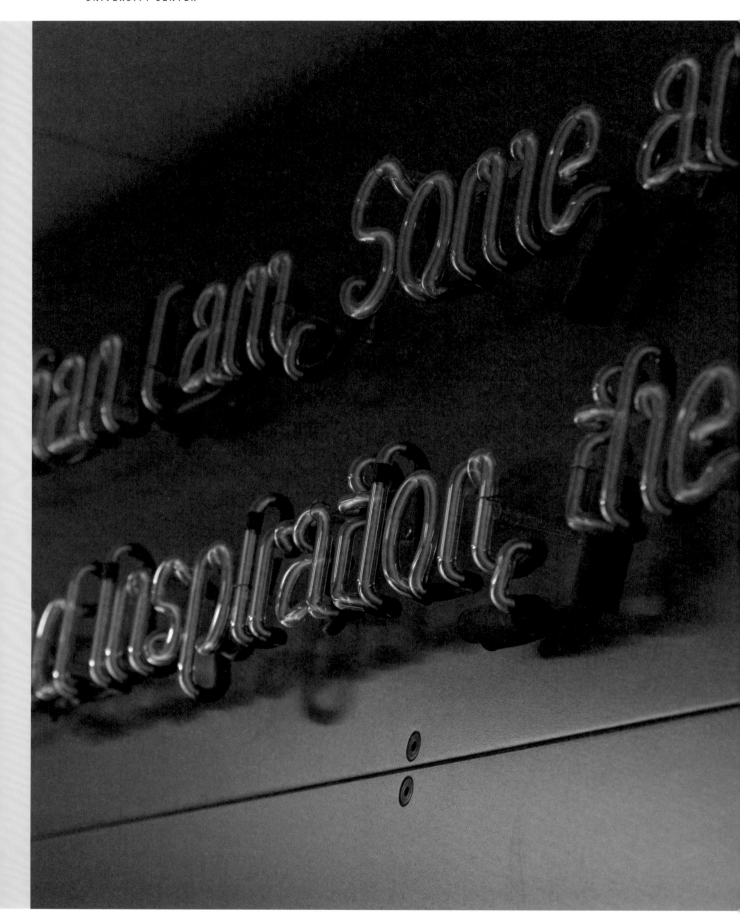

When I tell my students that I want them to be brave, this is what we need to be brave for: to be willing to stick with our art until the moment of its failure. That's the only way to the other side. Whitman writes, "The actual living light is always curiously from elsewhere—follows unaccountable sources and is lunar and relative at the best." In "How It Feels to Be Colored Me," Hurston observes that sometimes "[t]he cosmic Zora emerges," belonging "to no race nor time…the eternal feminine with its string of beads."[1]

In *For Comrades and Lovers*, this string of beads is a lovely pale purple.

For Comrades and Lovers: a dialogue

Claudia Rankine

dare not proceed till I respectfully credit what you have left wafted hither, I have perused it, own it is admirable, (moving awhile among it). **I think Walt Whitman,** ah, lover and perfect equal, I meant that you should discover me so by my faint indirections, **was an interesting choice for The New School,** dead poets, philosophs, priests, martyrs, artists, inventors, governments long since, language-shapers, on other shores, **because I think Whitman,** no sentimentalist, no stander above men and women or apart from them, **is so much about the joys and the problems,** think nothing can ever be greater, nothing can ever deserve more than it deserves, **and the promise of democracy,** nations once powerful, now reduced, withdrawn, or desolate, **and The New School's history,** I see through the broadcloth and gingham whether or no, and am around, tenacious, acquisitive, tireless, and cannot be shaken away, **seems to speak to that.**

Glenn Ligon, *For Comrades and Lovers*, 2015 (detail).

1 Zora Neale Hurston, *How It Feels to Be Colored Me* (Carlisle, MA: Applewood Books, 2015).

The smoke of my own breath, echoes, ripples, buzz'd whispers, love-root, **black, the absence of light,** silk-thread, crotch and vine, **light as words becomes our interaction with life, becomes thought, becomes wave and particle,** my respiration and inspiration, the beating of my heart, the passing of blood and air through my lungs. **It's this sense of America as a shining beacon** through me forbidden voices, **and dark star at the same time. Whitman was the poet I could actually read.** I am the poet of the Body and I am the poet of the Soul. **I was very interested in his poetry style,** and I, when I meet you, mean to discover you by the like in you, **that was very plain spoken in some ways—**Undrape! you are not guilty to me, nor stale nor discarded—**also the subject matter,** turbulent, fleshy, sensual, eating, drinking and breeding, **Whitman's continual fascination with democracy and America.** Regarding it all intently a long while, then dismissing it. **So much of my work has been interested in America as a subject matter both celebratory and critical.** I stand in my place with my own day here. **The word America blinks on and off in an annoying fashion.** But a few carols vibrating through the air I leave, For comrades and lovers. **Whitman's words really resonated with me.** There was never any more inception than there is now, nor any more youth or age than there is now, and will never be any more perfection than there is now, nor any more heaven or hell than there is now. **He's interested in the common person. He's not writing about kings and queens, he's writing about the people he meets on the street,** among the men and women, the multitude, **taking the ferry from Brooklyn to Manhattan, walking the streets of Manhattan, walking the streets of Brooklyn,** I perceive one picking me out by secret and divine signs, **and observing, imagining that this is a giant community that he's a part of.** Acknowledging none else, not parent, wife, husband, brother, child, any nearer than I am. **I am interested in what happens when a text is difficult to read or frustrates legibility—what that says about our ability to think about each other, know each other, process each other,** the pleasures of heaven are with me, and the pains of hell are with me. **Whitman is a rebel,** Walt

Whitman, a kosmos, of Manhattan the son, **so that's attractive too. It's very clear in his poetry,** the first I graft and increase upon myself, **and it's very clear in his life** the latter I translate into a new tongue. **When Whitman was first publishing *Leaves of Grass*, it was considered by many blasphemous, sacrilegious, obscene even,** voice of sexes and lusts, voices veil'd and I remove the veil, voices indecent by me clarified and transfigur'd, **and now it's a classic of American literature, so I'm interested in that process, how the society seems to catch up to Whitman. But I'm also interested that Whitman wasn't bound by the prejudices of his day,** no more modest than immodest. No labor-saving machine, nor discovery have I made, **that he extended himself beyond his class, his race, his gender, and that he really embraced the totality of humanity. He's sort of a poet of fragments.** Some are baffled, but that one is not—that one knows me. **I think one encounters the text in my piece in the same way you encounter the text in Whitman. Nobody reads *Leaves of Grass* from the front to the back, you sort of dive in at different points.** Nor reminiscence of any deed of courage for America, nor literary success nor intellect, nor book for the book-shelf, **and in a place like [this], where people meet and greet and hang out, I think it's fitting to have these words hovering in the air.**

Above are fragments from Walt Whitman's *Leaves of Grass* (as selected by Glenn Ligon for inclusion in his site-specific neon installation *For Comrades and Lovers*) interspersed with quotations from interviews with Ligon.

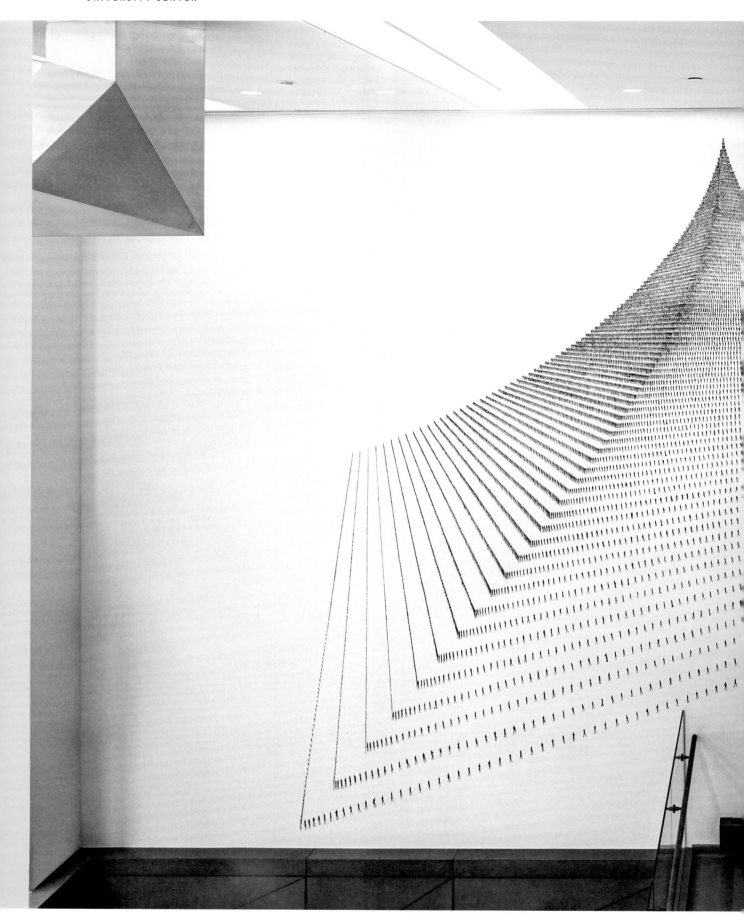

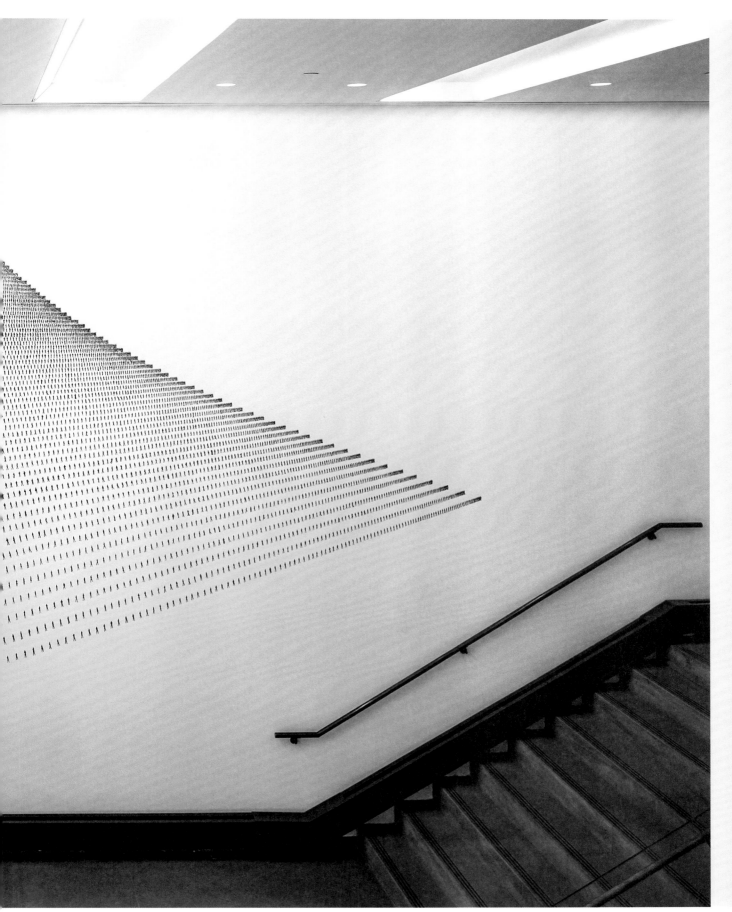

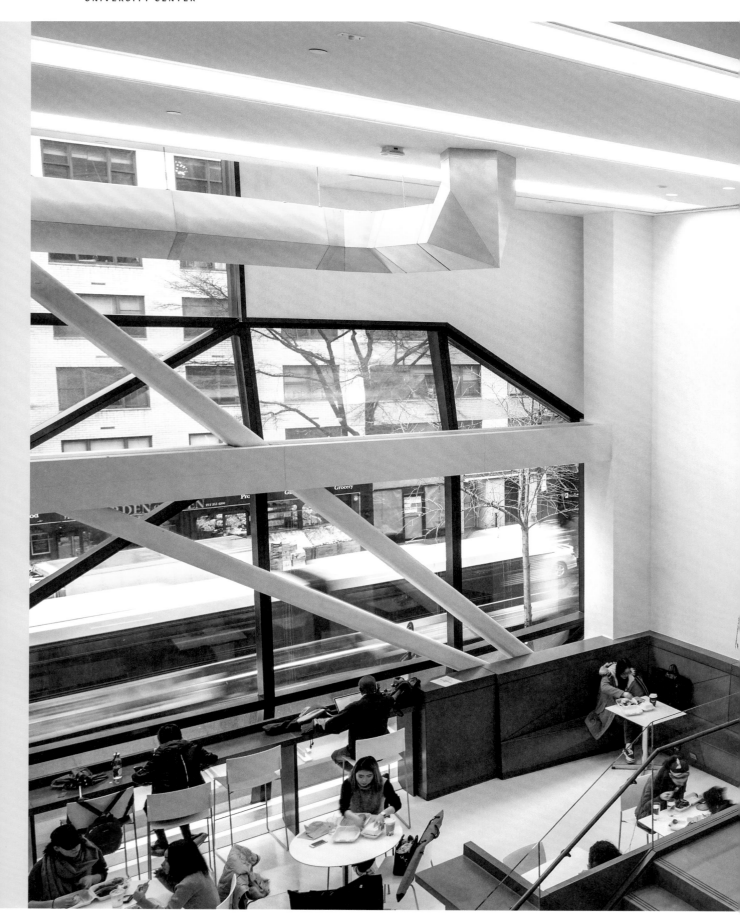

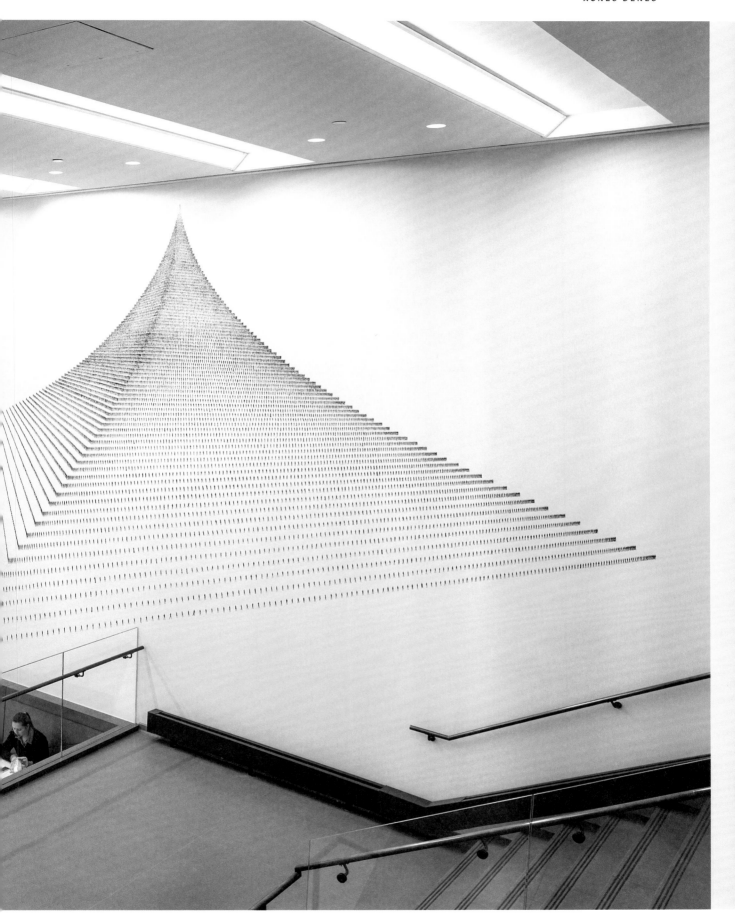

Agnes Denes

**Pascal's Perfect
Probability
Pyramid & the
People Paradox—
The Predicament
(PPPPPPP)**
1980/2016
Vinyl

In Formation

Aruna D'Souza

THE THOUSANDS OF FIGURES that make up Agnes Denes's *PPPPPPP* are a human murmuration. The word signifies a flock of starlings, and more specifically the way that flock dances and careens across the sky in complex patterns, changing direction, adopting new formations, and modulating speed in ways that defy scientific understanding. It is as if a mass of a thousand or more creatures think with the same brain, share the same nervous system, hold deep in their DNA an imperative not only to evolve or survive but—simply, or not so—to create. To draw pictures in the sky, to model three-dimensional forms marked out in space by individual bodies. To make pyramids.

Up close, each of the humans that make up *PPPPPPP* is distinct; poses, features, and dress are all uncannily precise despite the relatively simple means of the figures' rendering, and their size. (None measuring much more than three inches tall, they evolved from drawings, a few deft gestures of ink on vellum, expressing a liveliness that reminds me a bit of Monet's ability to capture personality with a few strokes of paint.) Seen at a distance, however, the figures become something else: locked into an invisible grid, a mathematical schema—Pascal's pyramid—they are parts of a whole. Necessary, yes, but also trapped in place by a formula of which they are ignorant.

The effect is dystopian and utopian at once. What could be more demoralizing than having to face the fact that our sense of uniqueness, our conviction that we, in our political beliefs, our ethics, our ways of being in the world—our attempts to *resist* being co-opted by an overwhelming and stultifying status quo—are nonetheless stuck in lockstep, motivated by an innate drive to fly in formation with our species? How can we possibly conceive of ourselves as political beings when, as Denes points

PAGES 236–39: Agnes Denes, *Pascal's Perfect Probability Pyramid & the People Paradox—The Predicament (PPPPPPP)*, 1980/2016. Rita McBride's *Bells and Whistles* is visible in the upper-left corner of the images on pages 236 and 238.

out in her rendering, our sense of individual will is only an illusion—a matter of the quirks of our comportment (our ways of holding ourselves, the tilt of our heads when we speak, the bow of an arm held akimbo) that we execute only from our node in a grid that we cannot see? When we, even in our individuality, conform, speaking only from our predetermined spot?

What makes one starling different from any other in a murmuration?

On the other hand, what could be more liberating than the notion that we—who are living in a political moment where the fetishization of "individualism" is simply a means of obfuscating and making palatable (even heroic!) the sad fact that we have been torn apart, that the strength of "the people" has been rendered impotent by our atomization, and that capital has thoroughly bypassed democratic structures in the liberal state— remain part of a collective, whether or not we have the capacity to know it?

This, to my eye, is the choice that Denes offers us in *PPPPPPP*: Will we allow ourselves to see our existence as part of a human murmuration? Will we take the opportunity, that is, to reimagine the political realm

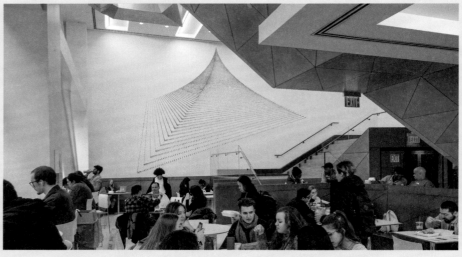

University Center cafeteria (Denes mural on rear wall and McBride artwork visible at top left).

as distinct from individual ego, as separate from individual notions of freedom, and instead in terms of collective notions of being—and even of creating? Perhaps this is the lesson of the starlings, of Denes's *PPPPPPP*: that our political will cannot be that of the individual, cannot be based on a liberal subject, but must, in fact, be understood as a matter of radical collectivity. Many bodies moving as one. Many minds imagining new forms of being in the world.

For what could be more beautiful than all those figures, those abstract-at-a-distance bodies that Denes depicts, soaring in unison in a different direction—a better one—guided by a sense of common will?

The one who is the one who who is the one who is not many. Thoughts called forth by Agnes Denes's *Pascal's Perfect Probability Pyramid & the People Paradox— The Predicament* (PPPPPPP)

Andrea Geyer

WHAT IS THE STATE OF SINGULARITY, of subjectivity, of oneness? What is the state of community, of collectivity, of togetherness? Who can be recognized as one? Who recognizes that one? Who is seen as many? Who can feel a We? A We in space? A We in time? Who becomes a We by necessity? By experience? Through trauma? Who is rendered They? Yesterday? Today?

Who is pictured? Photographed? Drawn? Rendered? Who is shared as such? Who is recognized? Who can be recognized and who does that recognizing? What necessitates an "I"? The count of one. Taking account of one-self. My-self. Embodied. Felt. Experienced. An agent of self. An agent for self. A selfie. The determined investment. A commodity. Traded. Liked. Connected to each other intangibly. From one space. Across space. In no space. An entropy. Technologically. Systematically. Alien and liberated. Utilized. Self-less. Minus. Many. The count of many. Body counts. Connected to each other tangibly. Together.

The blurring of lines, outlines of bodies into a mass. Into a surface. Into a lack of recognizability. Flat. Flatness. Finding themselves tight spaces of refuge. Finding ourselves tight spaces of shelter. Dense fringe. Frightened. Bodies on line. Marking a drawing. Building a structure. Representing shadows. Representing light. Offering the in-between. Demarking an image of self. An image of uniqueness hand-drawn. Multiplying multitudes. Collected on the margin. Felt at the border. Delineated. Shielded. Metal. Mesh. Wires. Crossed. A mirror-shield reflecting. Held up in resistance. Others. Otherness projected back. Face to face. Separation into existence. Into the inevitable difference.

The beauty of being one, other than another. Close. Closest. Lingering together in necessity. Breathing the same air. Breathing quietly. Breathing across divergence. Recognizing fear, fearless. Allowing discomfort. Understanding inadequacy. Committed proximities. Disruptions of the self into another. Mis-possession. Disbelieving. Celebrating thieves of beliefs. Cooks of desire. Being students together. Loitering in the not-knowing. Letting go of words. Re-thinking. Re-speaking. New.

Interrupting language into the skin of another. Halting reason. Feeling affinities. Seeing in-between-ness moving. Moving more slowly. Enduring alongside. Inside-outside the scheme. Able to hear. Able to see. In touch. With touch. Deep urge. Touch each other at the edge drawn by perspective. Sweeping clean-cut. Sweat. Smell. Sound. Noise. Louder. Love. Lust. Lines lost. Disrupting each other in order to listen. Offering visions.

Agnes Denes, *Pascal's Perfect Probability Pyramid & the People Paradox—The Predicament (PPPPPPP)*, 1980/2016 (detail).

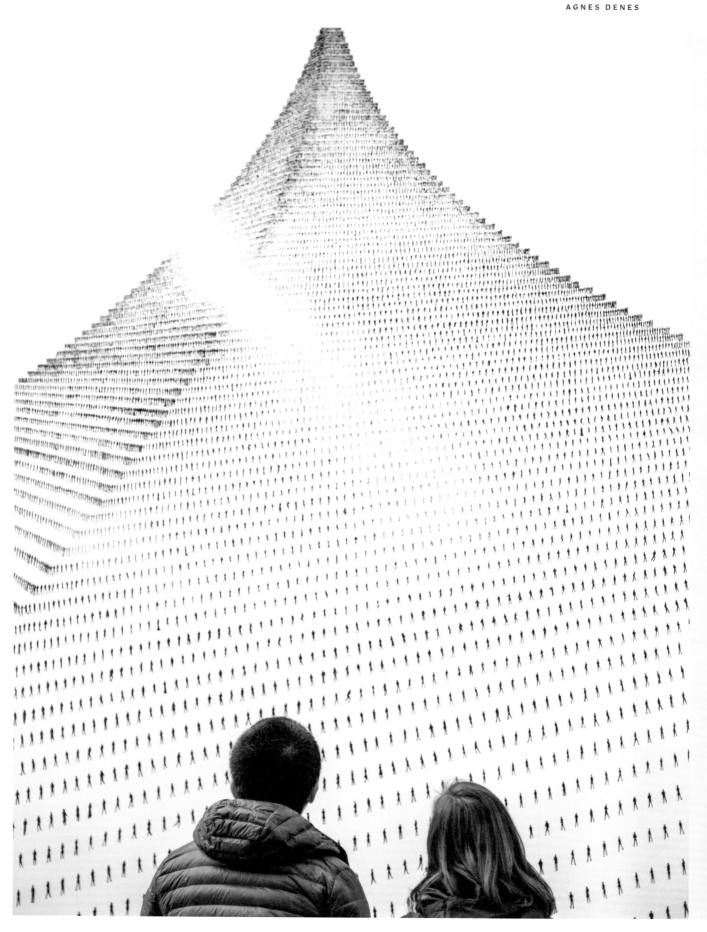

Offering returns moving forward. Again. Huddled in. Yearning in. Losing the line. Losing the outline. Desynchronize the structure. Walking against. Leading upward into four, three, two.

A rhythm. A rhythm of sounds supported from below. Holding on. Holding onto the density of bodies. Interconnected into a line, into fields. Thick. Thicker. Thickets causing blackout among bodies. Activating darkness as refuge. A sensatory presence undetermined. Let loose. Unframed. Deconditioned. Freed from signification. Possibility of experience. Lift your head. Deface bright singularities. Retool resistance into the un-unified body.

Agnes Denes: Promethea of Paradox

Lucy R. Lippard

I MUST HAVE FIRST MET AGNES DENES around 1970 in meetings of the Ad Hoc Women Artists Committee. Her work impressed and befuddled me, as mathematics and philosophy are not my strong points. However, her vast and original embrace of human thought and endeavor, the beauty of her fusions of nature and intellect, and her unapologetic confidence were compelling, and have become more so over the decades.

Denes's brilliance was recognized early on, but she has been endlessly frustrated by the broader success of male colleagues, many of whom are neither as smart nor as innovative as she is. Though her vita attests to a sterling exhibition and lecturing record beyond conventional art/science boundaries, the complex density of her work means she doesn't fit easily into the shallower drawers of the commercial art world—which is,

of course, a good thing. ("Complexity" is a word consistently used to describe her work.) The beauty of her isometric drawings, map projections, charts, and triangular graphs can stop a viewer in her tracks, leaving full comprehension of the underlying philosophy elusive. Denes has often been called a conceptualist, but that label does not do her justice. She is a driven visionary, concerned less with current facts than with future possibilities. Her art has been called timeless, but time—more than space—seems its primary medium; her projects include a number of time capsules. "Change," she says, "is the fourth dimension, time is but a measuring device."[1] Lawrence Alloway once said that "Denes' art is like a textual criticism of the universe,"[2] and she has been compared to Leonardo da Vinci.

Because of my own preoccupations, I have been most attracted to Denes's work in and about the natural world (and what part of the world is not natural?). There is a reason that her most popular work, *Wheatfield—A Confrontation* (1982), is also her simplest—not in concept or execution, but in its clarity of purpose. With the late World Trade Center looming behind the pastoral pre-harvest scene, the micropolitics of the working landscape informs the macropolitics of nearby Wall Street, as well as silently protesting the impending upscale development that would soon replace fecundity with finance.

The thirty-foot-high *Living Pyramid*, created for the Socrates Sculpture Park in 2015, is the outdoor, three-dimensional sister of the graceful, soaring interior mural at The New School. Its concave sides and sharp apex recall Denes's other best-known living land art, *Tree Mountain—A Living Time Capsule* (1982–96), in which 11,000 trees were planted by volunteers in Finland, spiraling up a curved pyramidal mountain and slated to survive for 300 or 400 years as a symbolic antidote to global ecological stress. In her earliest land art proposal—*Rice/Tree/Burial* (1968–79)—burial and rebirth coexisted. Like *Wheatfield*, these projects can be seen as what she has called "planting the paradox."[3] The astounding breadth of her work includes natural forces and isolated sites—endangered species, boundaries, portals, glaciers, undersea, outer space, Antarctica…

1 Agnes Denes, *Agnes Denes: Perspectives* (Washington DC: Corcoran Gallery of Art, 1974), n.p.

2 Lawrence Alloway, "A Note on Macro-Esthetics," in ibid., n.p.

3 "Planting the paradox" is a phrase Denes often uses, especially concerning *Wheatfield*.

The pyramid that has been the vehicle for some of Denes's most ambitious ideas can be (mis)perceived as a hierarchical form—its pinnacle occupied by an elite, informed by historical associations with Egyptian pharaohs and Mesoamerican sacrifices. But her rhythmic, weightless, and iridescent *Crystal Pyramid* (1976), for instance, is the antithesis of the heavy, grounded monuments to which her sculptures are inevitably compared. On perusal of Denes's proposals from the 1960s on, it becomes clear that the pyramid stands for aspiration. Her definition of "dialectic" (in her analytically fertile *Dialectic Triangulation: Visual Philosophy*, 1967–69) as "a forever rising knowledge, a deepening awareness or consciousness through which the trinities are argued and regrouped," is a pyramidal concept.[4]

In Denes's hands, the pyramid becomes a shape-shifter, a knowledge carrier, as well as a monument to an unresolved future. The *Restless Pyramids* (1983–), conceived in 1980 as "awakened" organic forms (one is in the shape of a flying bird), are no longer rigid or static: "They begin to stretch and sway, as they break loose from the tyranny of being built,"[5] she says, offering models and metaphors for a drastically "new urbanism." One of their incarnations is the *Self-Supporting City Dwelling* (1984)—a prescient suggestion, given today's attempts to create sustainable urban environments. Noting that our civilization "attempts to interfere with its own evolution," she has conceived a *New City* (that is also a *City of Fools*). It is divided by a river called *You Can't Step Into Me Twice* (because unstoppable time interferes, as Herodotus pointed out, sweeping both life and death before it), and eventually, inevitably, it becomes a *Flawless Ruin*. The *New City*'s place names are both prescriptive and predictive: *Moral High Ground*, *Pillars of Assumptions*, *Square of New Roots*, *Temple of Narcissism*, *Power Drive*, and *Error Lane*.

Denes embraces extremes and scorns mediocrity. (Her *University of Mediocritus* "teaches tolerance toward a lack of extremes"—an engrossing statement in itself.) Her *Perfect Pyramids* (1986) display "freshness and vulnerability," like the new era they herald.[6] Underlying everything Denes creates and writes is a passionate desire for humanity to succeed, despite its constant failures.

4 Agnes Denes, "Dialectical Triangulation: A Visual Philosophy, 1967–69," in *Agnes Denes: Perspectives*, n.p.

5 Agnes Denes, *The Human Argument: The Writings of Agnes Denes*, ed. Klaus Ottmann (Putnam, CT: Spring Publications, 2008), 119.

6 Ibid.

Agnes Denes, *Pascal's Perfect Probability Pyramid & the People Paradox—The Predicament (PPPPPPP)*, 1980/2016 (detail).

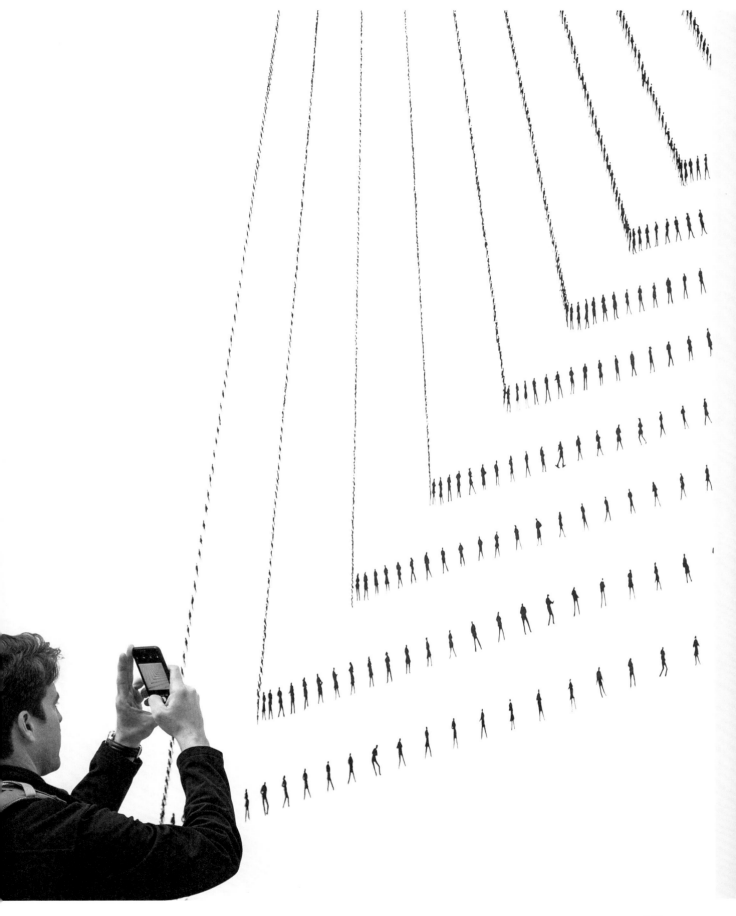

"Organized by Fascination"

A Roundtable Conversation on Art, Institutions, and Pedagogy

In March 2017, four contributors met at The New School to discuss institutional structures, public service, public space, historical awareness, teaching, and curatorial practice. We wanted to host an open-ended conversation that would provide a rhythmic counterpoint to the more topical texts in this book. Taking part were **Carol Becker**, Dean of Faculty at the School of the Arts and Professor of the Arts at Columbia University; **Gregg Bordowitz**, artist, activist, and Program Director of the Low-Residency MFA at the School of the Art Institute in Chicago; **Pablo Helguera**, artist, writer, and Director of Adult and Academic Programs at The Museum of Modern Art in New York; and **Lydia Matthews**, writer, curator, and Director of the Curatorial Design Research Lab at Parsons at The New School. **Frances Richard** was the moderator.

Frances Richard

So, thank you all—

Carol Becker

But we haven't done anything yet. [*laughter*]

Lydia Matthews

It was no small matter to get everybody in one room! To further clarify our starting point: The New School Art Collection is omnipresent across the campus, and yet I would go so far as to say that people often don't realize it's there. These site-specific works become so much a part of daily life that their cultural and pedagogical value barely registers. As members of the Curatorial Design Research Lab, we feel strongly, though, that these works speak to the core mission of our university. They are, after all, not only treasures to be lived with for students, faculty, and staff, but also links to New York City and beyond. We want to explore the histories of these commissions— why particular artists were invited at particular historical moments to produce works for our public spaces; what it means to exhibit images and objects like these; how a single work might change its meanings depending on the interests of individuals who engage it.

Frances Richard

I came into the book project as editor thinking about The New School as an entity with its own tradition of "the new." But also thinking more broadly about what it means to give art a prominent place in a pedagogical context. Just before we convened, I stopped by the Agnes Denes mural in the cafeteria, and a pair of students were looking at it, talking about what it would be like if the figures in the wall drawing were animated. You could say that, without being quite aware of it, they were engaging not only Denes's ideas about the role of the individual inside

a larger social form—that each individual "animates" the social—but also they were thinking, in effect, about the medium of the mural. What if it were in motion?

In other words, the background assumption for a collection like this is that if you put these works in front of students, a pedagogical mission will be furthered. At the same time, an institution that displays art for audiences' benefit is in basic ways more like a museum than a university. So in addition to thinking about The New School as a particular place, I've been thinking about schools and museums and public space and about tropes of pedagogy and school-based structures as central to the last few decades' developments in art making—in social practice, or new institutionalism, or relational aesthetics. These questions are central to your practice, all four of you, as artists, curators, writers, teachers, and program organizers.

Gregg Bordowitz

When I went around to look at the collection in preparation for today, I got a strong feeling of lived relation to the objects. That, I appreciated. It felt different from even a well-trafficked museum. In a school setting, one can become familiar with objects, return to them, use them as landmarks, get up close to them. They're not as intimidating as objects in museums can unfortunately be.

This suggests something important to pedagogy, which is a trust on the part of the institution that the student body and people who pass through the buildings will live with these works and honor their presence, in a way that doesn't have to be constantly surveilled or restricted by stanchions or guards—even though I'm sure there are guards around.

Pablo Helguera

When I think about a school with artworks on view, I think about José Vasconcelos, who as minister of education in Mexico in the 1920s offered the national high school, the Escuela Nacional Preparatoria, to muralists to paint. That inaugurated the muralist movement, and the murals are still there. These artworks are national symbols; they trigger a whole form of thinking about what should be given to the public and how art should engage the public in educational dialogue about its own history and culture.

At the same time, in the case of those who study in these buildings, I think that **the experience must be like living with relatives. You see them every day; you don't think of them necessarily as pretty or ugly, or young or old. Familiarity, in this sense, might breed contempt.** So the question in my mind would be, How does an educational mission remain alive in the face of such stasis?

Carol Becker

Thinking about which "relatives" are arrayed around an institution: at Columbia, we have portraits of trustees and former presidents—white men mostly, very few women. That's what surrounds us.

Frances Richard

In each of these cases, there's an authority built into the imagery that seems unchanging.

Pablo Helguera

Or think about museums that are, let's say, the house of an artist or an artist's collection—like Clyfford Still, who specified that his work could be shown only in that one museum and nothing other than his work would ever be exhibited.

Lydia Matthews

Or Joseph Beuys's works in the Darmstadt Museum, which are never supposed to leave their particular spots because they were placed in the galleries by the hand of the artist.

Carol Becker

Or the Isabella Stewart Gardner Museum, where there are rules even about the flower arrangements.

Pablo Helguera

Exactly. In these kinds of institutions, educational departments or curators have to be creative as to how they approach the subject. All of which is to say that this problem of overfamiliarity or static relationship is not new.

Lydia Matthews

Is the primary goal of a curator, then, to develop strategies for defamiliarizing?

Pablo Helguera

Or finding new approaches to something that feels monothematic, where you might feel that everything has already been said.

Carol Becker

I'm sensitive to what people see in which context. Why that piece there? Maybe a site made sense at one moment for a given work, but it can be awkward when it gets caught in history. At Columbia, there was a fight—well, not a fight, but a public discussion—over a Henry Moore sculpture. A commitment had been made to donors years ago that their gift of a Henry Moore—a large nude—would be placed on the Morningside campus. It was supposed to be installed to line up with *Alma Mater* (1903–04) by Daniel Chester French, the seated bronze Athena in robes with her laurel crown that is sited at the heart of campus. Students went ballistic. They didn't want this huge naked woman lying on her back in front of Butler Library. They didn't see the piece as something to be revered; they saw it as something to be criticized. Finally, the piece was placed at another campus location. But it did cause a real debate, and it was a good one. Many of the university's art people, those who were paying attention to the discussion, were quite happy that the students cared so passionately about their interpretation of the sculpture and its placement.

Lydia Matthews

So often, the way art history is taught suggests a fixed timeline, which obfuscates the reality that if works are famous in one moment, they may still become controversial in another. Take that fabulously bizarre George Washington sculpture by Horatio Greenough, with Washington dressed as Zeus in a toga and sandals. It was the first official sculpture commissioned for the centennial of his birth, and it was meant to be permanently sited in the U.S. Capitol Rotunda. In 1841, some people didn't blink when that massive marble was unveiled, because Neoclassicist forms were considered normal. Others hated it, because seeing Washington half-naked incensed puritanical viewers so much that it had to be moved. It ended up in the basement of the Smithsonian until postmodernism made it seem interesting again. When they recently opened their new wings in the National Museum of American History, it was designated one of four so-called Landmark Objects!

The cultural and monetary—not to mention peda- gogical—value of art objects is constantly shifting. But that complexity gets repressed by the so-called timeless- ness of art.

Carol Becker

I don't really believe that any public sculpture should be placed in one location forever.

Gregg Bordowitz

Thinking about inheriting something you don't want: I love to teach, and even though I was on sabbatical in New York—this is in the early 2000s, maybe the late nineties—I taught a class at Cooper Union. I took the students on a walking tour to see some suffering works of art that are permanently installed in SoHo. There's a Picasso sculpture on West Broadway at Houston, behind these three apartment buildings. It's not a great Picasso; it's concrete, a series of perpendicular planes, angled, with a line drawing of a face. But it does what a Picasso does. I had the class walk around it, and even though it's not well sited, you can see that the face changes in depth and scale, that you yourself activate the piece. Even moments when you're inheriting what might be an awkward context—those are good teaching moments.

Pablo Helguera

We as art educators are trained to find ways to help people love artworks, even those we don't like.

Frances Richard

All these examples speak to changing definitions of site specificity. There's the way in which institutional site implies the monumental—rain or shine, year in and year out, here's the Picasso or the Moore. Or site specificity might more properly imply an understanding that a given work should exist only in an environment the artist desig- nates. Or it can be a proposition about context: "We'll put this here for a while to activate this space and then, as the site changes, the work will change."

Gregg Bordowitz

There's geographic site; there's architectural site. There's the discursive site.

Lydia Matthews

And the social space.

Gregg Bordowitz

And the social space and the historical site. I'm thinking of examples where objects or museums have been pre- served precisely as teaching tools. For example, under apartheid in South Africa—in Cape Town, I believe—the

Museum of Natural History was horrible and racist. When apartheid was defeated and the African National Congress came to power, they decided to leave this racist museum intact but to change—

Carol Becker

—the narratives surrounding it.

Gregg Bordowitz

And the objects in it. They showed how all the figures in various dioramas came from a single cast of one person, and alongside the dioramas were explanations of the logic of anthropology as it meets trajectories of racism. That was one of the most interesting pedagogical or almost epiphanic experiences I have had regarding ways in which something meant to last was overturned and then mobi- lized to remain instructive.

Carol Becker

It's courageous to do that, because it means that everyone involved understood the implications. Everybody knew what had been before, so what was the point of pretending it hadn't existed? There was value in keeping it available.

Lydia Matthews

Another example is the taking down of Soviet architecture and heroic sculptures in the post-Soviet world. There are many who want to forget or symbolically annihilate that ideological inheritance, and there are others who oppose this deliberate historical amnesia. They believe it's worth being reminded about their Marxist-oriented past, especially given the complete embrace of neoliberal capitalism that is radically transforming their countries. I'm thinking of Tbilisi-based collectives like Urban Reactor, which are working to preserve Soviet material culture and rekindling debates about now-fading leftist ideologies and what they can mean today.

But I was also thinking how what you're describing, Gregg, pushes up against what Pablo was saying about the job of the educator to help the viewer love the work. I'm not sure that's my role. When I think about what art can do, **it seems less a matter of trying to get people to adore the work than it is to ask questions. What kind of work is this art doing now in the world and for whom? What kind of work did it do when it was made?**

Pablo Helguera

It can be very difficult for a museum to—

Carol Becker

—tell the story it wants to tell.

Pablo Helguera

To position itself to say, "We're showing these things because we think that they're important to see, but we don't agree with them ideologically."

Frances Richard

It sounds like what succeeded in the South African example is that the institution was able to contradict its role as a natural history museum and take up a role as a social history museum. Or, apropos the Columbia students' response: To hate a work of art or to critique it passionately *is* to love it in the sense that one invests in it strongly. One feels that the world is changed, for better or for worse, if that thing is sitting there.

Gregg Bordowitz

This is where critical consciousness comes in. **I think about what it means to pose questions that students or audiences can mobilize around, to organize by fascination. Instead of talking about loving or hating a work of art, then, we talk about stimulating fascination, getting students or viewers to look again and to defamiliarize the work.** Now that we have Trump and his fascistic appointments and policies in the White House, the function of critical consciousness is all the more urgent, I think—to establish criteria by which students can ask their own questions about what's in front of them.

Lydia Matthews

And developing historical consciousness helps to encourage critical consciousness. When I thought about this publication originally, I was interested in teasing out the intersection of the artists' histories in their own moments, and the history of The New School as an institution. It's precisely *not* about learning to love the trophy in the courtyard. It's a constant challenge to think about how progressive attitudes can manifest through the arts at different points in history, and where students stand today in relation to those belief systems and previous aesthetic strategies.

Carol Becker

Part of my challenge at Columbia has been to make the production of culture in the art school valuable to an institution that incorporates sixteen professional schools and focuses strongly on brain science and Big Data. It is very important to say about the arts, "We are also about ideas and research, and we are also asking difficult questions." I'm constantly translating what we do as an art school for an academy that understands research and critical con-

sciousness in one form—not because they devalue art, but because they are not in the habit of thinking about it as an important locus for ideas. Giving value to art as research and explaining how that works is part of my role as dean.

Pablo Helguera

Unfortunately, it's something we see at the national level: that the arts are dispensable.

Carol Becker

The United States, on a fundamental level, has always been predominantly anti-intellectual and has never understood the importance of art precisely because art is complex and requires intellection as part of the response. For an American society trying to carve out its own identity, art has historically been understood as "European."

Frances Richard

There's a flip side to that, too, which is that an outsized importance is given to the arts through that very lack of understanding. The arts are made to seem outrageous, ridiculous.

Carol Becker

It is because the arts are associated with progressive ideas.

Frances Richard

Exactly. The symbolic gesture of cutting budgets is like an iconoclasm, smashing the statuary of the regime you want to overturn. It's weirdly out of proportion to the importance—or lack thereof—ascribed to art itself.

Carol Becker

Because **art scares many people. They are frightened by the images artists can produce and how powerful those images can be.** But who wants to fight the NEA now? I don't, anymore. I've said this before: Everyone who files taxes as an artist should donate a dollar. That would give us twenty million dollars a year, or whatever it might be, and we could set up an organization to give the money away. We could create a board and make our own grants. I know this would end up being problematic as well, but the gesture is just to make the point that artists should take control of the problem of funding themselves. We really cannot rely on this society to understand why art is essential to democracy.

Pablo Helguera

But still, those public funding fights illustrate how we think about what art does and doesn't do, how important it is, or is not, in the larger society.

Carol Becker

We don't agree as a society that it is important. Most people would accept that art making is good for children. After that, it gets too complicated—and, I might add, too meaningful.

Gregg Bordowitz

We are in a peculiar position now of needing to defend what we perhaps used to criticize as liberal institutions. It's more important now than ever to make a distinction between being anti-institutional and being critical of institutions. Because what is threatened now is the very existence of our institutions.

Carol Becker

I agree with that.

Gregg Bordowitz

So we are in the position—I feel like I am in the position of defending the institutions I engage with. Being critical, but nonetheless defending them against this vicious attack on their existence. Questions around the NEA and many other questions that I first engaged in the late eighties and early nineties as an artist and activist are being revivified. I probably answer those questions differently now that I'm fifty-two instead of twenty-seven. But we're under profound attack. All the institutions, democracy itself. Of course, it has not ever been, for many, an open and democratic society. But now we're facing an even greater challenge.

Frances Richard

Can you say more about how strategies might have been different in the eighties as compared to now?

Gregg Bordowitz

Well, now there's a great deal of thinking about connections between patrons, board members, and so forth—people within the administration of art institutions and their ties to Trump or to a repressive agenda. I'm trying to think about where I fit in as a lifelong activist. Thinking about what it means to work with inflated tuitions, a corrupt loan system, institutions economically enforcing all kinds of prejudices and segregations. Relations among art institutions and banks and PACs and prisons.

Lydia Matthews

But don't you think these connections already existed in many people's minds?

Frances Richard

Artists and activists of the 1970s certainly made connections between institutions, trustees, corporate profits, and, say, the war machine in Vietnam.

Gregg Bordowitz

We're not reinventing the wheel. But we are talking about a shift in scale that involves a greater number of people, more money, and a global system in a networked age.

Frances Richard

This feels like a crux to me: defending institutions while being critical of institutions, or defending institutions *by* being critical of them. At the same time, I can't help wondering if there isn't a romanticized investment in what we are saying, regarding the role of the avant-garde artist. The artist as cultural watchdog and naysayer.

Gregg Bordowitz

I want to answer very quickly that I'm for Romanticism with a capital *R*. Romanticism bequeathed modern artists a choice—to change the existing world or invent one's own.

Pablo Helguera

We will always romanticize movements and such. But I think **if there's anything to be said about the present moment, it's that it is fiercely pragmatic. My generation, and younger generations, are looking at the agency art can have in the present. They're willing to abandon art completely if that's necessary because what matters is to change the world.** Obviously, there are many artists who try to keep the two things happening at once. But I feel that Occupy Museums and other movements that have emerged in recent years are very serious about politics. There's not so much concern about how this or that gesture might make you look or whether you will eventually be rewarded.

Frances Richard

Or if it's aesthetic, the artifact that the engagement yields.

Pablo Helguera

And so in terms of critical consciousness, **we need to make a distinction between teaching art as connoisseurship or appreciation—which I agree is a passive and neoliberal approach—and using educational tools. Making art *as* education.** Of course, we should all learn to appreciate art, and students should really look at the artists on display here at your school and learn about them. But there's much more to do.

Lydia Matthews

This may indeed sound romantic, but I do see this actualized pretty often. **Artists can set an example by the ways they go about their research**

and understand materiality. Or an imagery can be produced that really does put something new on the table, that's different from what normative ideology would have you believe. In that sense I do think there can be a pragmatism to art practice. It's not necessarily romantic in the sense of being escapist.

Carol Becker

I always say, "I am not an art educator. I educate artists." I believe in the pedagogy of art making, and I defend being Romantic with a big *R* too. I mean, why not? Our students struggle, really struggle, to figure out how to be relevant in the world. They are working on it from the inside out. I defend that work because that is the interface between the individual and the society. Every generation is different, and our job in educating artists is to figure out how to help them do their particular job even better.

I spend a good deal of time with the World Economic Forum, and it's not just innovation they're looking for. They're interested in representing the world, and in art-related pedagogy, we work on the problems of representation. So they need the kind of thinking artists are good at.

You are always caught between the institution and what you would like to be able to give your students. You can't throw your students to the wolves, and you can't throw the institution to the wolves. You're trying to broker balance all the time. I really believe in building institutions, or I wouldn't have been doing this work all these years.

Frances Richard

I appreciate the battle cry of Romanticism with a capital *R*. Although I'm mindful, too, that the Romantic persona of the artist has historically meant a white man enfranchised to criticize the very structures that enfranchise him. And I'm relating all this, somewhat backhandedly, to reserving the right to criticize an institution while defending it, trying to push or cajole the institution into adapting to its circumstances—as distinguished from deriding or trying to undermine or flee from the institution.

I'm wondering if we can talk about how that sits with projects that are itinerant, temporary. Say, a project like Pablo's migrating used bookstore, *Librería Donceles* (2013–17), which was an institution of a sort, but also explicitly not. Open to the public, actually selling Spanish-language used books to whoever happens to walk in. But also an artwork.

Pablo Helguera

I have this dual identity, right? Half my life I spend doing politics in a context that is supposedly about permanence and history.

Carol Becker

The curatorial, the archival.

Pablo Helguera

And my other identity is somebody who is romantic, I suppose.

Carol Becker

You definitely are.

Pablo Helguera

So romantic! Well, no—but it is about engaging with experimental ideas and projects, inventing models that sometimes are ephemeral. I want to believe that those ephemeral things are actually the most permanent, while the day-to-day politics is in fact ephemeral. I mean, I don't want to say it's meaningless; I work hard to make educational programming in the museum mean something. But, honestly, in the long view, when I work as an individual to imagine possibilities like the bookstore—which, over time, traveled to eight cities in the U.S.—I feel it can have a life beyond its life.

Frances Richard

In terms of how it filters into its users' consciousness?

Pablo Helguera

Yes. The socially engaged art I produce is about experience. It's like performance; it was only possible in this or that location, and if you weren't there, you weren't there, period. You can see the archive. But I think this work is paradoxically enduring, because these ideas can find new value in the future.

Carol Becker

Don't you think that, if the institution approaches education only in one particular way, then we lose people? One is always trying to wedge into this monolithic thing, to infiltrate it with different ways of thinking about production—a wider way of thinking about why the institution is there.

Pablo Helguera

To be honest, I feel that education is a colonialized practice. It has to be decolonialized. It's understood that being an artist can mean many, many things. But that is not true of education. Education, culturally, is so monothematic, so much about very specific approaches.

Carol Becker

You are changing that. At MoMA, you function more like an artist in the institution.

Pablo Helguera

But the discipline tends to be rigid.

Lydia Matthews

Increasingly, and maybe because of this dangerous political moment, I've shifted some goals in my pedagogy. I try not to make it only about studying works that exemplify some particular subject matter. I'm more focused on encouraging students to develop their own sense of agency, no matter what the topic, and to revalue and strengthen skills that we as a culture have been losing.

For example, I'm teaching classes now like Walking as a Research Practice, where we slow down and tune into sensory perception, explore territories of the city outside students' current comfort zones—because I think it's important to revalue embodied knowledge rather than to rely exclusively on book- or lecture-derived knowledge. Or, as another example, I teach Socially Engaged Art Practice, where it's about getting people in different disciplines across the university to interact. I'm concentrating on how to get students who are stuck with one another for fifteen weeks to understand that they embody the materials and topic of the class. They become a de facto community, a self-critical laboratory to work within.

We've all read the research about millennials; you know—there is an expectation that as a student, you're going to replicate a formula, that you're going to be told exactly how to go from step one to step ten. Even in art schools, a lot of young students expect that. But there are spaces, still, that allow a teacher who is willing to experiment to produce different ends, to encourage agency.

Pablo Helguera

So, then—going back to The New School's collection. With these goals of agency and self-activation, why would a collection like this be treated as a museum collection, with all the limitations, the guards—

Lydia Matthews

Well, the guards at school are not about protecting the works of art. The guards are about safeguarding the bodies of the individuals—

Carol Becker

It's about the street.

Frances Richard

That means it's also about the distinction between the street as public space and the institution, with its tuition and ID cards and cultural capital, and a guard at the door.

Pablo Helguera

But, but, but. The thing is: How do you make the learning process, access to the collection, operate in similar ways to your teaching approaches? What are the social elements or communication access elements that should

be in place for those dynamics to come to life and engage the public, even if only within the school? Do you just want to have a work with a label next to it? Because that label still implies authoritative interpretation.

Frances, in advance you asked us a question about a meaningful artistic-educational experience. That's a question we at MoMA ask all the time. And almost inevitably, we hear anecdotes that illustrate how social experiences in our lives are key to developing aesthetic awareness. A typical comment might be, "My mother used to take me to the museum," or, "My father was a lover of the opera, and he would take me to the opera and tell me the stories, and I became an opera lover because of that." **The operative factor is emotional connection to the work and sometimes a strong affective relationship with someone who brought you into the world of the work.** Museums tend to facilitate contact with the work but in an official, serious manner—it's not a process that in itself provides agency in the way you describe it, Lydia. It's a transaction. You pay and walk in and stand in front of the thing.

Lydia Matthews

Right.

Pablo Helguera

When it changes is if there's somebody who brings you in, who is able to elicit response from you or encourage you to make those connections emotionally.

Carol Becker

So much of my own experience in education was like that. It was coming through the body, almost. An embodied—

Lydia Matthews

—contagious enthusiasm.

Frances Richard

Pedagogically, I ask myself constantly: How can I be that person? How can I, through the classroom or a teaching conversation, offer that contact high of fascination with the object?

At the same time, this connects to the issue we started with, regarding what it's like to have art on the walls in that familiar yet institutional way. What's at stake is access. You had a father who loved opera and passed that on. You go to The New School, so you have the privilege seeing a work every day and taking it for granted as wallpaper. The family-member theory of installation is in some senses emotional and warm, because it presupposes sustained contact. But privilege is embedded in that contact, too, because to come in off the street and be

waived in by the guard is its precondition. No contact with the art if you haven't been ushered in.

Gregg Bordowitz

Even in my twenty-year teaching career, though, **the walls of the classroom have become more permeable—not only literally, because of communication technologies, but also through interconnection between disciplines**, either at a material level in terms of, say, people making art using their knowledge of biology or just through different epistemological models. You see this in the art education field as well, because in museums there's been a striking increase in speakers from different disciplines talking about works of art or ideas that are adjacent to the works of art. In some ways, I see the reverse of what Carol was talking about, regarding the difficulty of explaining art's value to other humanities or the sciences.

Carol Becker

Scientists understand it best, because they understand experimentation.

Lydia Matthews

But are you suggesting, Gregg, that it's more a case of other disciplines coming in to re-inform the art community?

Gregg Bordowitz

I never see teaching as apart from what I do as an artist; it's one long sentence connected by conjunctions. So in a classroom, there are fashions for this or that theory, and people still use the term "critical theory," but actually I think critical theory is historically bound and refers mainly to the Frankfurt School. It's not really the guidepost anymore, the central spine around which we should be organizing art education. Instead, in the classroom, there's been an increase in the relevance of scientific understandings coming out of neurobiology, for example, or artificial intelligence or science fiction. Various literatures become more relevant, as well as new art-historical projects that include people historically excluded from canons—people of color and women and queer people who made work with content that was visibly queer in some way. People excluded for reasons of geography and colonialism.

It's been important for me to shift my notion of what constitutes the avant-garde. Prompted by other people—certainly Fred Moten's work is enormously influential. His book *In the Break: The Aesthetics of the Black Radical Tradition* (2003) shows that if you look, for example, at the history of downtown New York and

include in your survey both Judson Memorial Church and the Five Spot, there's a connection. Because actually, Cecil Taylor played at both. I've been thinking about the Village in the sixties. "Downtown" was constituted of artists, musicians, dancers, and the queer theater, Charles Ludlam and the Theater of the Ridiculous, for example.

I've talked to my friends who are older and who were there. So, **as a scholar and as a teacher, I've had to re-educate myself, expand my notion of the avant-garde.** I don't know if I'm a Romantic. I'm a romantic, modern, postmodern, anti-aesthetic sensualist. That's how I would conjugate and identify; that's the formulation.

Lydia Matthews

What you're saying, Gregg, reminds me of a conversation I had with William Warmus, who has been writing about the history of glass for many years. He was talking about an epiphany he had regarding his own aesthetic and historical blind spots, having come of age amidst the dogma of Clement Greenberg's formalist tradition. I know this might sound like a stretch, but he said he had this "aha" moment after he started scuba diving and recognized the aesthetics of the underwater world. His art-historical training, which was hierarchical and "purist" in orientation, was useless to him as he tried to make sense of the diversity of aquatic species and their innerconnectivity. This embodied experience required a totally different logic, so he coined the term "reticulate analysis," which addresses how species and their material forms interbreed and recombine, how they can be simultaneously similar, unique, and permeable.

The job of the reticulate writer or scholar or artist, then, is to tease out what those connective tissues have been in the past or are today. To extend Warmus's metaphor, **we unlearn and relearn how to describe the ecosystem of the arts. It's a horizontal, networked approach that recognizes how a field evolves organically, in response to environmental conditions.** I've been mulling over these metaphors a lot lately.

Frances Richard

When you were talking about wall labels, Pablo, I was thinking, "Nothing is self-explanatory." The idea of an autonomous object that stands alone and can be defined and explained to anyone and everyone in a hundred-word blurb is fantastical. Yet art also requires the making of form and therefore the establishment of boundaries, coherences, contexts.

Gregg Bordowitz

Somehow, where education meets the market, the MFA becomes (or became; it might not be anymore) the necessary terminal degree, the credential. Which is a recent development; very few of my teachers had MFAs. Here I'm being critical but not anti-institutional, and I'm implicated, because I train MFA candidates. And I'm going to be a teacher for as long as I'm around. What emerged, though, in the institutionalization of art education is a debate around, say, social practice versus craft that is inflected with market concerns. Some programs advertise themselves as social practice, to the exclusion of craft. That, in turn, creates a niche for the school that says, "We're all about craft. Come to us and touch things." Right? I try to defeat that false opposition. Social practice involves craft, and every craft has a social history. It's the same thing with false distinctions between beauty and the idea, which arose during the Conceptual period—an anti-aesthetic anti-Romanticism.

Pablo Helguera

I would say this opposition is a misunderstanding of the history of Romanticism, although it took me twenty years to actually read Romanticism and see that. Anyway, a lot of false oppositions arose that I think need to be dismantled, and some of them have to be parsed in relationship to the need, the imperative, to define oneself within a marketplace.

Lydia Matthews

It comes down to how you build a curriculum. Even if you have a social practice territory in your institution, where does it fit relative to a greater set of skills and histories? Do you develop it as its own major? Is it a minor that complements training in other areas? Do you understand it as a set of critical questions about the artist's role in society that inflect a multitude of practices? I think it's exciting when somebody not from a fine arts background comes in the door. Maybe they've been in a neuroscience lab and they've become fascinated by something they now want to explore as an artist.

Pablo Helguera

When you are given the opportunity to explore the diversity of your own experience, then you can rebel against that experience.

Lydia Matthews

Maybe their rebellion is against the neuroscience lab's rules. And perhaps rebellion will come around again once they absorb their MFA and recognize its own limitations.

Frances Richard

How does this relate to what you were saying before,

Pablo, about the pragmatism of our current students' generation, their willingness to say, "If it's not art, fine. But I want to address this situation"?

Pablo Helguera

The artists who I think are doing this successfully are not ignorant about art. But they know this is not the moment to sit down and make a painting. This is a moment to act in other ways. They'll figure out later how to define that action; what is most important now is what art does, not what it's called. Maybe twenty years from now we'll look at a group of people who don't at present see themselves as being in the art field and say, "This was an amazing group of artists."

Carol Becker

Part of the strength of a great curriculum or great environment for art making is not to define production rigidly, categorically, but to allow people to experiment with ideas and allow the forms to follow from that experimentation.

Gregg Bordowitz

I agree. I'm just thinking that I still very much believe in rigor. And actually, I still believe in disciplines. But I think we're at a moment where older categories of discipline have been undone or pressures have been brought to bear such that older disciplines have to change.

At the same time, in order to structure a curriculum, I had to create categories. I'm not saying these are the best categories, but I thought it would be interesting to focus on poetics—not poetry specifically, but poetics as defined by Aristotle: how we put things together. This is an interesting way to create bridges between increasingly atomized students. Students arrive at school looking at many different screens. They learn their histories through entertainment, largely. There are multiple literacies any student will be juggling, and they'll see it all out of chronology. If you're working with film students, say, they've been looking at Amazon or Netflix; they aren't going in order from Lumière to Godard, which was how I learned cinema. No students I know of are reading Gombrich's *The Story of Art* (1950)—which is actually a great book, if very flawed. I mean, no one's sitting in that auditorium anymore with slides, learning that art history goes from the Venus of Willendorf to Jackson Pollock, and then whatever extra chapter was tacked on.

Lydia Matthews

I'm afraid there are still a lot of places that teach like that. It's hard to believe, but from my travels, I can tell you that it's true.

Gregg Bordowitz

I'm saying that there's still a need for rigor. I believe in what's been said regarding this open architecture where you encourage; you say yes. **It's a dynamic, a dialectic between permission, encouraging through your own enthusiasm, and, at the same time, demanding rigor and discipline. And those terms are now in need of new translations.**

Lydia Matthews

Right.

Frances Richard

Now I want to ask, what is rigor?

Carol Becker

Maybe rigor is asking the hard questions regarding the work's ability to communicate as one wants it to.

Frances Richard

It's also testing the poetics, as you were describing it, Gregg, against its own evolution. Testing a process of making against that process's own histories.

Lydia Matthews

That sounds like it's primarily located in the critique, no? Critique becomes the site of exchange, of learning.

Carol Becker

That's within the institution. But the minute students are out, which is pretty fast, the work is also out in the world, and people are either responding to it or they are not.

Lydia Matthews

That's true, but I think there are ways to extend the institutional support network. What we do in the Parsons curriculum, for example, is to emphasize collaboration over competition. **It's what Brian Eno calls "scenius" instead of "genius"—we challenge students to think about how they can create a "scene" together, help one another sustain a practice beyond the walls of the institution. If we're doing our job, their colleagues become their ongoing community.** They get to know one another and have to grapple with one another's differences, know what resources each brings to the table, with an emphasis on carrying on after they graduate. Especially since so many of them are part of globally diverse communities that offer a range of opportunities.

Carol Becker

I totally agree with that. I just meant that if we haven't helped them to internalize ways of being good editors of their own work, asking themselves the hard questions, then they are going to put something out into the world that is not going to succeed.

Lydia Matthews

The internal critic is essential. That's partly our pedagogical challenge: How can an art program insist to students that they not wait for a teacher to tell them whether something is good or not? And, as teachers, how do we frame research modes that might give students a bigger multidisciplinary tool kit as well as deepened social relations and networks that continue beyond school?

Frances Richard

This takes us again to critical consciousness, or what bell hooks calls "education for critical consciousness"—which nurtures not only artists and audiences but also citizens, a population that can engage critique and call out a lack of rigor or ignorance of history while still fostering community.

Gregg Bordowitz

The other piece is genealogy because there are so many literacies. To foster a ground where students can place themselves in their own constellations, which may or may not include fine art, but that extend to other traditions or forms of production. Methodologies and genealogies are largely what I try to foster as a ground from which students can develop.

Me, personally, I come out of the early eighties, late seventies. The last student standing in a crit was the one who would go on, endure—a dynamic I never want to reproduce. It was a cruel sectarian model that developed out of art culture's encounter with political movements—and that kind of cross-pollination is not inherently bad. But what happened to destroy activist movements in the counterculture was repeated in the context of art critiques. So I want to teach with a kind of pressure in the room toward the aims of the artist and also the aims of anyone participating in the critique; to facilitate the group's understanding at the moment. It's more like relational psychoanalysis than relational aesthetics.

I ask myself constantly, How does the world enter the classroom? The state-sanctioned murders of African Americans by the police are an urgent topic of conversation in the classroom. So when we're having discussions about opposing the rule of white supremacy and racism in this country and we're discussing work by African American artists—in that context, what burdens are we placing on those artists, on that work, or on faculty and students of color?

African Americans and other people of color are disproportionately burdened in contexts where they remain in the minority in the classroom. What demands are we placing on each other? This happens in other ways too. How are people who are visibly queer or trans—or self-identified as such—asked to carry the conversation about homophobia or transphobia? There are forty people in the room. Construct a conversation that allows for people from vastly different geographic places; with age diversity; with racial, ethnic, gender, and sexuality diversity. How do I facilitate these conversations? It requires all the skills I developed as an activist-organizer to protect people from horizontal violence and allow others to make mistakes or voice contradictory opinions. But at the same time to think aloud together. To truly foster a space for analysis structured by theories of intersectionality. To create a place for conscious-raising—I still use that term.

I think every teacher should be familiar with alternative notions of the vanguard; should recognize new scholarship about avant-garde history, remembering that art history itself has been structured by exclusions along a number of different lines. We can't make presumptions about people based on how they appear to us or expect people occupying various oppressed or stigmatized subject positions—

Lydia Matthews
—to be the spokespeople for a particular group.

Gregg Bordowitz
To be, solely, the bearers of that historical knowledge.

Carol Becker
You are a deep thinker about these things, and many faculty are not. It comes up all the time. Students are put on the spot by faculty who haven't thought this through.

Lydia Matthews
Part of the ability to do that thinking is to understand that you are facilitating with all your knowledge, from activism, from years of experience—but at the same time you're there to learn. This is Paulo Freire's radical-pedagogy position, and I so strongly believe in it. It makes me want to listen very deeply to what students are saying, what their experiences are now, coming up at a moment so profoundly different from my own history.

Gregg Bordowitz
Museum education takes this job on too, right?

Pablo Helguera
Yes. There's a debate now in schools and museums—going back to the question about rigor and what it means. To an extent we are coming back from a battle that started in the art world a decade or so ago around books like Jacques Rancière's *The Ignorant Schoolmaster* (1987) and Ivan Illich's *Deschooling Society* (1971). As the "pedagogical turn" in curating emerged, there were many discussions about how education could be employed. Unfortunately, I feel this was often about co-opting education for curatorial purposes. It kind of backfired on the ideas of thinkers like Rancière and Illich. The idea that you can teach somebody something without knowing it yourself and the idea that the educational system is a dictatorship that oppresses people, so we have to dismantle it: These propositions have, I think, served a neoliberal attitude that says, Let's dismantle everything. Because people don't really need to know anything. Or they can find out on their own.

Lydia Matthews
And here we are.

Pablo Helguera
And here we are. You come into the institution like a sponge, absorb the grandiosity of the arts, and that's the end of it.

Carol Becker
Right.

Pablo Helguera
No context necessary. We are grappling with attitudes about art as this floaty thing you can inhale like a spore and become illuminated by. Yet we want to provide context without being prescriptive or didactic or academic, without creating formulas for socially engaged art, activism, or politics. **The question is what structures we create as educators to allow for critical thinking, for independence—but a type of freedom that is informed, a thinking freedom.**

Frances Richard
Pablo, I want to read from your "Transpedagogy" essay (2011):

> The transpedagogic Feast of the Ass is not only a reversion of social roles, but of meanings and interpretations of disciplines, including art in pedagogy, conflating them together, at times canceling one another and at times joining them in progressive ways, constructing models of interactions that other disciplines are too shy or reluctant to try. What art making has to offer today is not to represent accurately, but rather to misrepresent so that we can discover new questions.

We've talked about many of these things in different ways. But we haven't discussed the foolish rushing-in of

art, the willingness to turn things on their heads, which is what the Feast of the Ass accomplishes.

Pablo Helguera

I was writing about a medieval celebration called the Feast of the Ass, celebrated after Christmas, where all roles of the townspeople would be reversed.

Lydia Matthews

Like Mikhail Bakhtin's description of carnival?

Pablo Helguera

Exactly. It's a Bakhtinian, carnivalesque idea. If you were young, you would act old. If you were old, you would act young. You were a man, you would act like a woman. The donkey was the Pope; it would be dressed in robes and brought into the church. It was a crazy, extravagant celebration, eventually forbidden by the church. My point was that art can produce such moments, create these environments where suddenly roles can be suspended.

Lydia Matthews

The optimistic belief is that after inhabiting an otherwise forbidden role, you return to the social order somehow transformed. But the darker view is that you let off steam and then return obediently to the social order and look forward to the next carnival.

Pablo Helguera

I did the Feast of the Ass in Mexico City a few years ago in a museum. I convinced the director to bring a donkey into the museum. I gave a series of workshops for about a week to different kinds of audiences: curating for artists, performance for curators, criticism for the general public, and so on. People who fit these categories took the corresponding workshops, and on the day of the final event, members of the general public read reviews they had written; artists presented curatorial projects, etc.

Some curators were really angry about what they thought was my disrespect for their discipline. One came to me and said, "I don't agree with this." You don't agree with a performance? The project was about reversing identities, changing identities, with the hope that participants might better understand the complexity of these various roles that are played in the art world.

Frances Richard

Again, I think we've been talking about it already—but I'll throw out another quote. Gregg wrote in the 1990s, "I like to think that I'm a civil servant." So are we proposing that the inversion brought about by the Feast of the Ass is a civil service, an artist's civil service?

Carol Becker

In service to the civil or to civilization.

Frances Richard

The service of overturning proprieties. Of convening a constituency that tries not to commit horizontal violence—and can imagine what that term might mean and can believe that it is a leader's role to protect a community's members and to marshal such a constituency in an improvisatory way?

Pablo Helguera

I confess that I have a discomfort with the civil servant analogy. Perhaps because I've worked in museum education departments for so many years, which are often treated as service departments, not as areas of the museum that use their expertise to stimulate new thinking.

Carol Becker

You are like me, not wanting to be called an art educator.

Pablo Helguera

I object to the treatment of the educator as a waiter who serves you some knowledge. This is a consumerist attitude: "I am paying you, so you're going to give me what I want. Just tell me what it is." [*laughter*]

Carol Becker

"Tell me what it means."

Pablo Helguera

"How much does it cost? When was it made and who made it?" As if that's what art is, downloaded information that you forget in three seconds. I see my job instead as inserting debate. My success lies in being able to make a person feel fulfilled in the conversation but at the same time slightly uncomfortable.

Carol Becker

It's the uncomfortable part that confuses people. It is not the expectation that art should be uncomfortable; the avant-garde is not internalized as a definition of what art should be, especially in this society. **When a work causes discomfort, often people think, "Why are you doing this to me? I didn't come here for this." The work is experienced as hostile, and the response to it becomes hostile as well.**

Lydia Matthews

So on one hand, you can provoke through context, encouraging people to realize that they're confronting something uncomfortable. On the other hand, a public work—like our Agnes Denes mural, for example—is an opportunity for people to realize that if they take time to engage, they actually do have quite a lot of information and relevant experience.

Pablo Helguera

Right.

Carol Becker

Of course. Yes.

Lydia Matthews

How do you make people realize they have a license to exercise agency when they have typically been taught that only an expert could do that or only certain kinds of things matter? To really engage it from one's subjective position: This can be the translation that makes a work meaningful. For me, that is where the mural, say, retains its importance as a prototypical kind of public art—having multiple people come to the reading of that mural and trying to orchestrate a conversation that makes each person realize it's not a singular narrative but a meeting point of multiple narratives.

Gregg Bordowitz

I think that underlying a lot of what we're saying are very deep and somewhat preconscious or unconscious theological assumptions. They extend way back to the secularization of art—because there is a presumption, which I also make, about art as a medium for understanding or revelation. I too have this core belief that, because I am fascinated by and devoted to art, everyone else will be too. [*laughter*]

I was a public school kid in Queens when art programs were valued and funded. Every year they took us to museums. I was one of a few kids who went queer for art. It represented different horizons, actually, art did. When I first got to the art world or got to Manhattan from the boroughs and was living downtown—

Carol Becker

The way you say "the boroughs." I grew up in Brooklyn. Of course, Queens is a borough and so is Brooklyn, but we say it as if Manhattan were something other.

Gregg Bordowitz

My grandmother lived in Queens for thirty, thirty-five years. She went to Manhattan twice.

Carol Becker

I know people who never went. I know exactly what you mean.

Gregg Bordowitz

When you went into Manhattan, you dressed up. It was more expensive.

Carol Becker

It seemed like a huge thing to do, to go to this other world. People who didn't come from where we came from got

to do that. And when we did, it was as if the whole large world of culture opened to us.

Frances Richard

That's what I was talking about regarding the boundary. The kiosk at the door. And before that, the subway ride.

Gregg Bordowitz

Manhattan might as well have been Hollywood as far as I was concerned. Even though it was a subway away. Anyway, I want to go back to the theological assumption underlying this—which I'm not necessarily against. But this idea is exactly why kids like me were bused to museums in Manhattan. Art would have a civilizing impact on the working class. Entering the art world required traversing class boundaries.

Carol Becker

Right. Absolutely. And it takes a while to internalize this fact.

Gregg Bordowitz

This theological thing—I think it arises now in an interesting way. Maybe we at this table don't have the same taste in art but we do share similar commitments. I don't have to remind you all that these commitments are not shared by everybody. **What's interesting to me is how one makes the argument that art is a necessary part of culture.**

Or let me put it this way: What's interesting about the theological analogy is that I'm concerned at the moment with issues of sanctuary. And one response to the need for sanctuary for undocumented people in this country has been to place the demand on museums and schools. Which is surprising because traditionally, the place of sanctuary is the church. Why do we think museums are places where people should seek sanctuary? Practically speaking, they're not the best places to house people or to feed them. But there is this notion—and I'm not negating it—a notion about the sacred nature of spaces where art or study happens.

Frances Richard

This is why I brought up Romanticism, and romantic myths of artistic passion. I feel as if we've been ratifying something close to that. Maybe "sacred" isn't the word we would choose to describe the function of art in a pedagogical context. But I don't think it's an inappropriate word, given that we've been talking about engagement with art—both vis-à-vis the object and interpersonally, with one's fellows in a situation structured by art—about those confrontations as beneficial. Beyond beneficial—instructive, revelatory, liberating. Encouraging a turning away from tendencies that we see as dangerous or narrow.

Gregg Bordowitz

There is symbolic importance in saying, "This is a space where we reject the violent xenophobia in our midst. Where we protect those subjected to that violence." But underneath **there is a presumption—at least for me, if I'm honest with myself—that I hold these places to be dear, if not sacred. Places of sanctuary.**

Pablo Helguera

The sociologist John Falk, who has written about museums for decades, has a typology of the museum visitor. Not everyone agrees with him, but it is worth thinking about. He proposes that we should not classify museum visitors in terms of age or economic background but in terms of interest. So, for example, there is the companion, like a relative who you convince to go with you to the museum. There is the professional, like those of us who go because it's part of our jobs and besides, we want to. There is the explorer, the person who is open to adventure. And so forth.

Carol Becker

Like a pilgrimage to see a particular object.

Pablo Helguera

Or the spiritual wanderer—those who we imagine will sit in front of the Rothko and go "ahh." It's precisely these types of experiences that museums grapple with. On one hand, you want to deal with real life and contemporary issues; you want to be at the center of dialogue about what's happening in the world and show that what you do is relevant. At the same time, a museum's function can be similar to that of a church. You have to have that Rothko, and it has to be beautiful, and nobody can touch it, and you have to facilitate that spiritual experience. Museums are caught in an identity crisis around their function.

Carol Becker

It's interesting to me that this would be a crisis. The museum reflects parts of our humanness, what people want and need. Can't a museum be all those things? Does it have to choose?

Pablo Helguera

The question revolves around desires or needs for inclusiveness and, or versus, the benefits of exclusivity. How do you reach out to audiences to make them feel involved in a conversation? To what extent do you preserve and defend a type of art or a kind of atmosphere?

Carol Becker

But is that exclusivity when—to Gregg's point—there *is* a spiritual dimension to people's experiences with art?

They do come to museums to have those kinds of experiences, to see something beautiful and feel all that goes with that. Then maybe you capture those same people to see something else, something more confrontational.

Pablo Helguera

It can be as simple as, "Are you're coming to see Monet, or are you coming to see Kara Walker?"

Carol Becker

MoMA has both.

Frances Richard

And in a sense, so does The New School. Not Monet—but Sol LeWitt, bright bars of hot color, and Kara Walker, figures in a tableau of hellish violence. And they're side by side.

Pablo Helguera

But the question for the museum is different from the problem for the school because the museum has to have a certain number of visitors. Large museums feel the pressure to do blockbuster exhibitions because they attract large audiences. On the other hand, if they exhibit obscure contemporary artists, even if the curators think it's the most interesting art in the world—

Gregg Bordowitz

That's why **museums are not the only places we go to see art. That's why it's relevant to see art in school.** Of course, there are many battles to be fought around what is included and excluded and what kind of spaces schools can be, and for whom. But institutions are not monolithic. I wanted to say this before: Institutions are made up of the people who work in them. You learn this as an organizer. You go into the most conservative institutions and find that people who work in them have vastly different opinions from one another. You search for allies.

Which gets me back to that quote about civil service. That statement goes on to say that art performs a service much like crime, which is a claim for transgression.

Lydia Matthews

Where I imagined you might be going with the theological idea was not toward literal sanctuary for X number of bodies. I was imagining an argument to be made for cultural institutions as sanctuary for ideas and practices. I don't mean to lump together different kinds of institutions, but there are so few spaces left where critical consciousness is encouraged—and I do understand this encouragement, this consciousness, as sacred. I want to insist on there being spaces where multiple voices, different perspectives, and debates can thrive.

Spaces that will queer or otherwise counter oppressive norms, and this includes not only **arts institutions but educational spaces as well. These are two of the last bastions—of psychic space, physical space, community space, critical space—that actually invest in notions of "resistance" or "transgression."** I feel passionately about that. And you can call it a romantic position if you want to.

Pablo Helguera

It's very difficult to work in a theological institution, however. The last thing I want is to impose on an audience, "This is God and you have to adore it." To me, in doing that, I have failed as an educator. We function better when we are closer—as you suggested, Gregg—to an anthropology or archaeology museum, where we are looking at an object to understand it, not venerate it. You may say, "Oh, this is horrible," or "This is very beautiful," but it doesn't matter. It's about understanding what it means.

Gregg Bordowitz

We might have fallen into a polarization or polemic that I think should be undone. Just because we mentioned the word *theology*, we're not necessarily talking about fundamentalism, or indoctrination in terms of a particular dogma. **We have to recognize that the history of aesthetics is bound up with ideas of the sacred.** There is this idea in modernity that we, whoever we were, separated art from religion. In fact, that was a fiction maintained by a very narrow group of people. I'm not talking about observance when I say "theological." I'm talking about what produces certain effects or aporias. We're not talking, necessarily, about loving the beautiful object or hating the ugly object—and besides, we know that psychoanalytically there's pleasure in unpleasure, right?

But **art is all about belief. If a work doesn't seem credible, doesn't feel like it should be on the wall, that's "game-over."**

And, for me, it's about building what D. W. Winnicott called a "holding environment." For Winnicott, this is the transitional space between caretaker and child where objects first come into existence for the child; and those transitional spaces continue to emerge for individuals and groups throughout adulthood. I think that teaching—making art, even—is about producing holding environments. In other words, that these practices are able to hold any number of contradictions and pushes and pulls. I don't mean in a Hans Hofmann kind of way.

But maybe I do. We are having to think ethically about the ways in which we produce holding environments, patterns of recognition where differences that once seemed incommensurate are now the differences we encounter in the world.

Pablo Helguera

What I think is exciting about having work in a school like this is that you don't have the limitations a museum has. You are living with these relatives. You're not in church; they're in your house. They're here, surprisingly. In that sense, these works become living documents.

Histories of the Commissions

Thomas Hart Benton

America Today
1930–31

66 West 12th Street
(Now in the collection
of The Metropolitan
Museum of Art, New York)
Mural cycle in ten parts;
egg tempera with oil glazing
over Permalba, on a gesso
ground on linen mounted
on wood panels with honey-
comb interiors

1. *Instruments of Power*
92 × 160 in.

2. *City Activities with
Dance Hall*
92 × 134½ in.

3. *City Activities with
Subway*
92 × 134½ in.

4. *Deep South*
92 × 117 in.

5. *Midwest*
92 × 117 in.

6. *Changing West*
92 × 117 in.

7. *Coal*
92 × 117 in.

8. *Steel*
92 × 117 in.

9. *City Building*
92 × 117 in.

10. *Outreaching Hands*
17 ⅛ × 97 in.

Thomas Hart Benton (American, 1889–1975) was the scion of a Midwestern political family; his father, Colonel Maecenas Benton, served four terms in the U.S. House of Representatives as a Democrat from Missouri. Encouraged by his mother, Benton followed the bohemian path taken by many aspiring American artists, studying in Paris from 1909 to 1912. He returned to serve in the U.S. Navy during World War I and then moved to New York, where he taught at the Art Students League, honed his own style, and mentored a young Jackson Pollock. In counterpoint to the Post-Impressionist and Cubist abstraction

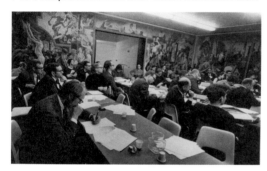

that were in the ascendant following the Armory Show in 1913, Benton began to develop a mannerist figurative idiom later associated with American Scene Painting or Regionalism.

Toward the end of the 1920s, Benton let it be known among Manhattan art aficionados that he wanted to paint a major mural. His opportunity came in 1930. The energetic first president of the New School for Social Research, Alvin Johnson, had engaged the New York–based, Austrian-born architect Joseph Urban to design a modern building befitting the experimental character of the fledgling institution and had commissioned José Clemente Orozco to paint a mural cycle.[1] Orozco's invitation was finessed by writer and gallerist Alma Reed, a member of the literary salon known as the Delphic Circle, to which Benton and his wife, Rita Piacenza Benton, also belonged. Johnson was happy to incorporate the participation of another artist into his vision for 66 West

12th Street, and he and Rita Benton reportedly worked out the arrangements at a party in Greenwich Village: Benton would produce a mural in egg tempera for the boardroom in the new building, and the school would rent a studio for the artist and pay for his materials, including the eggs.[2] Benton also delivered a series of New School lectures titled Craftsman and Art. These talks, as his biographer observes,

> likely emphasized the artisanal methods of art production rather than its more romantic myths. One reason that Benton favored working with egg tempera, for instance, was its association with the Italian Renaissance, a period he admired as much for its system of training, apprenticeship, and craftsmanship as for its grand manner. Painting, Benton believed, was a manual labor as much as it was an intellectual exercise.[3]

According to Johnson, who visited the work-in-progress daily, Benton would assemble sketches, then sculpt a "little garden of the needed solids in clay and study it painfully" before rendering a distemper underpainting on linen-covered panels.[4] Despite this laborious process, *America Today* was completed in less than a year. Influenced by sketching trips across the rural South and by contemporary cinema, as well as Renaissance models and the work of Mexican muralists such as Orozco, Benton's ten-panel suite presents a sweeping narrative of the national experience, juxtaposing scenes of labor, industry, and leisure in settings ranging from Eastern cities to Midwestern farmland, coalfield to prairie, steel mill to movie house.

As The New School's student body expanded during the postwar boom, the boardroom was repurposed as a classroom, with a concomitant increase in traffic that endangered the fragile murals. Benton

OPPOSITE: Peter Moore. Thomas Hart Benton, *America Today*, 1930–31, installed in a boardroom repurposed as a classroom at 66 West 12th Street. 1950s.
RIGHT: Peter Moore. Thomas Hart Benton restoring *America Today*, 1930–31. 1968.

returned twice (in 1956 and 1968) to clean and repair them. But by 1982, the ongoing need for conservation—coupled with the work's potential as a source of needed revenue—prompted the school to sell the mural cycle to the Maurice Segoura Gallery. No secondary buyer was forthcoming for the entire suite, and it seemed that the gallery might separate the panels for sale at auction; this attracted the attention of Mayor Ed Koch, who campaigned to keep *America Today* in New York City. In 1984, the Equitable Life Assurance Society of the United States (now AXA) bought the complete cycle and installed it in the lobby of its midtown headquarters; the firm brought the cycle along to a second site when the headquarters moved in 1996.[5] In 2012, AXA donated *America Today* to The Metropolitan Museum of Art, where it is installed in a dedicated gallery that re-creates the original room at 66 West 12th Street. The work was celebrated in the 2014 exhibition *Thomas Hart Benton's America Today Mural Rediscovered* and remains on view in the American Modern wing.[6] Critical consensus now ranks *America Today* among the most significant accomplishments in American art of the interwar period.

1 Johnson had initially been named director, but became president in 1930.
2 Justin Wolff, *Thomas Hart Benton: A Life* (New York: Farrar, Straus and Giroux, 2012), 202.
3 Ibid., 203.
4 Ibid., 202.
5 The two headquarters were at 787 Seventh Avenue and 1290 Avenue of the Americas.
6 The exhibition was organized by Elizabeth Mankin Kornhauser, Alice Pratt Brown Curator of American Paintings and Sculpture, and Randall Griffey, associate curator of Modern and Contemporary Art (September 30, 2014–April 19, 2015). See https://www.metmuseum.org/press/exhibitions/2014/thomas-hart-benton-america-today (accessed June 4, 2018).

José Clemente Orozco

**Call to Revolution
and Table of Universal
Brotherhood
(The New School
Mural Cycle)**
1930–31

66 West 12th Street
Mural cycle in five parts;
fresco

1. *Science, Labor and Art*
Hallway: 78 × 174 in.

2. *Struggle in the Orient*
East wall: 78 × 368 ⅜ in.

3. *Table of Universal
Brotherhood*
South wall: 78 × 174 in.

4. *Homecoming of the
Worker of the New Day*
North wall: 78 × 384 in.

5. *Struggle in the Occident*
West wall: 78 × 368 ⅜ in.

José Clemente Orozco (Mexican, 1883–1949), along with his peers Diego Rivera and David Alfaro Siqueiros—*los tres grandes*—came to prominence in the 1920s in postrevolutionary Mexico, when the influential secretary of education, José Vasconcelos, instituted a national literacy program supported by the commissioning of murals for public buildings. The American press began to discuss the muralist's work, which also influenced the development of the Works Progress Administration's mural program, and Orozco lived for several years in the United States. During this time, he executed three commissions in the context of higher education: *Prometheus* at Pomona College in 1930; his five-panel suite at The New School, completed in 1931; and *Epic of American Civilization*, installed in 1934 at Dartmouth College and recently designated a National Historic Landmark.

Breaking ground for new construction was risky in the aftermath of the stock market crash of 1929. Undaunted, university president Alvin Johnson sought to make 66 West 12th Street into a center for modernism, "broadly defined as artistic creativity, social research and democratic reform"; architect Joseph Urban promised a building that could "house an idea."[1] Into this mix stepped Alma Reed, a journalist who had established the Delphic Studios gallery on 57th Street. A dedicated supporter of Orozco's art, Reed urged Johnson to commission a work from the artist, who proposed to donate his labor for the cost of expenses alone. Johnson was easily persuaded. "What could have been my feeling," he wrote, "when

Orozco, the greatest mural painter of our time, proposed to contribute a mural to the New School. All I could say was, 'God bless you. Paint me the picture. Paint as you must. I assure you freedom.'"[2] Delays in the building's construction meant that Orozco and his assistant Lois Wilcox had just forty-seven days to complete the cycle, which was designed for the dining room and adjoining student lounge.[3]

Call to Revolution and Table of Universal Brotherhood centers on revolutionary figures, from Gandhi to Lenin to Stalin to the assassinated governor of Yucatán, Felipe Carrillo Puerto (who had been Reed's fiancé). The central panel, *Table of Universal Brotherhood*, presents figures representing ethnicities—two Asians, an African, a Sikh, a Tartar, an indigenous Mexican, and an African American—along with recognizable individuals, including an American art critic, a Dutch American poet, a Zionist painter, and a French philosopher.[4] Seated around a table, they call to mind the League of Nations (founded in 1920), not to mention the New School community who would have gathered in the room to eat. The confraternity of the Delphic Circle might be invoked as well, since several of those depicted were members, as were Reed, Thomas Hart Benton, his wife, Rita Piacenza Benton, and Orozco himself.

The murals, unveiled at the building's inauguration, initially met with skeptical reviews. Yet a groundswell of publicity, stimulated by excitement about Urban's modern structure, brought some twenty thousand visitors to the school in the first few months. The positioning of an African American at the head of the *Table of Universal Brotherhood* and generalized curiosity about Orozco and his fellow muralists no doubt contributed to this public attention as well.[5] After Rivera's unfinished mural cycle at Rockefeller Center was destroyed in 1934—Rivera,

like Orozco, had made Lenin's portrait prominent—*Call to Revolution and Table of Universal Brotherhood* became the only surviving example of a site-specific Mexican fresco in New York. At the height of the McCarthyist Red Scare, the cycle's explicit politics occasioned further controversy, and school administrators covered the panel depicting Lenin and Stalin with a yellow curtain. Protest by students and faculty eventually convinced them to remove this fig leaf.

Political quarrels were not the only adversity faced by the Orozco murals. Wear and tear took a toll as well, despite the fact that, in the 1980s, constituents both within and beyond The New School campaigned for their preservation—including, once again, Mayor Ed Koch, who "personally intervened to stop the sale of the mural cycle to the Mexican government."[6] A comprehensive restoration was undertaken (funded partly by the sale of the Benton murals), and by 1995, the Orozco Room had become a showplace of The New School, dedicated to hosting special events.

Orozco's achievement has been celebrated in several recent exhibitions. In 2010, El Museo del Barrio presented *Nexus New York: Latin/American Artists in the Modern Metropolis*, dedicating a gallery to The New School for Social Research and the influence of Orozco and Egas.[7] The same year, New School Art Collection curators Silvia Rocciolo and Eric Stark organized the exhibition *Re-Imagining Orozco* at the Sheila C. Johnson Design Center at Parsons School of Design (then called Parsons The New School for Design). Featuring large-scale drawings by Enrique Chagoya commissioned for the occasion, along with a selection of mixed-media works by students and faculty, *Re-Imagining Orozco* presented a "collective, community-wide response to the murals as a platform for contemporary exploration of sociopolitical art practices."[8]

Berenice Abbott, *José Clemente Orozco*, 1936. The New School Art Collection.

1 Peter M. Rutkoff and William B. Scott, *New School: A History of the New School for Social Research* (London: Collier Macmillan, 1986), 38. Joseph Urban quoted in Wolff, *Thomas Hart Benton: A Life*, 200.
2 Alvin Johnson, *Pioneer's Progress: An Autobiography* (New York: Viking Press, 1952), 328.
3 A renovation in the 1950s relocated the library and reconfigured the building's layout, with the result that the Orozco murals are now on the building's seventh floor instead of its fifth. See Reinhold Martin's essay in this volume.
4 The critic was Lloyd Goodrich, the poet was Leonard Charles Noppen, the Zionist artist was Reuven Rubin, and the philosopher was Paul Richard. See Diane Miliotes, "The Murals at the New School for Social Research (1930–31)" in *José Clemente Orozco in the United States, 1927–1934*, ed. Renato González Mello and Diane Miliotes (Hanover, NH: Hood Museum of Art/Dartmouth College, 2002), 121.
5 Miliotes, "The Murals at the New School for Social Research," 128.
6 Wall text accompanying the exhibition *(re) collection*, organized by Silvia Rocciolo, Eric Stark, and John Wanzel for the Anna-Maria and Stephen Kellen Gallery at the Sheila C. Johnson Design Center at Parsons, 2011. See https://www.newschool.edu/university-art-collection/re-collection (accessed June 4, 2018).
7 The exhibition was organized by Deborah Cullen, El Museo del Barrio, 2010. See http://www.elmuseo.org/wp-content/uploads/2014/03/Nexus-NY-Press-Release.pdf (accessed June 4, 2018).
8 The exhibition was held at the Anna-Maria and Stephen Kellen Gallery, 2010. See https://www.newschool.edu/university-art-collection/re-imagining-orozco/ (accessed June 4, 2018).

Camilo Egas

**Ecuadorian
Festival**
1932

66 West 12th Street
Oil on canvas
96 × 199 in.

Camilo Egas (Ecuadorian, 1889–1962) was
born in Quito and as a young man studied
art in Rome and Madrid. After returning
from Europe in 1926, he played a pivotal
role in founding the Indigenist movement
in Ecuador, launching the country's first
art periodical, *Hélice,* and connecting his
interest in Andean themes and the struggles
of indigenous people to Marxist politics.
The very next year, however, he moved to
New York, where from 1932 until his death
he taught at The New School for Social
Research. Egas became director of the
Art Workshops in 1935 and later served as
director of the Art Department. Faculty
hired during his tenure included Stuart
Davis, Yasuo Kuniyoshi, and Lisette Model
in a period that helped to shape the school
into a home for emergent modernisms. In
1939, Egas painted a mural for the Ecuador-
ian Pavilion at the New York World's Fair,
and in 1943, at the federal government's
request, he taught a tuition-free New School
class titled The Plastic Arts and the War.

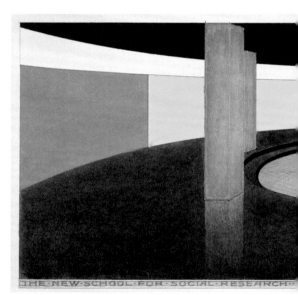

In the early 1930s, in the flurry of commissions for 66 West 12th Street, Alvin Johnson invited Egas to produce a painting for the anteroom of the dance studio, an unusual circular space on the lower level for which Joseph Urban had devised a color scheme of orange, royal blue, emerald green, and yellow. Martha Graham and Doris Humphrey would each work there, but Egas took Ecuadorian folk dance as his theme. Unveiled to considerable acclaim in a period when Latin American artists were lionized—if not fetishized—in progressive American circles, *Ecuadorian Festival* was reviewed in the *American Magazine of Art*, *Art News*, the *New York Evening Post*, the *New York Sun*, and the *New York Times*. Nevertheless, this view of muralism as uplifting, educational, and/or an art of popular resistance led to a corollary neglect of Egas's work in the later twentieth century, as conceptualist, performative, and multimedia art practices took hold. Following Egas's

death in 1962, his painting languished; in the early 2000s, it was concealed behind a protective temporary wall.

In recent years, conditions have again changed. A reappraisal of Latin American modernisms has been furthered by a new generation of scholars, and the landmark exhibition *Nexus New York: Latin/American Artists in the Modern Metropolis*, organized in 2010 by Deborah Cullen at El Museo del Barrio, looked closely at both *Ecuadorian Festival* and José Clemente Orozco's *Call to Revolution and Table of Universal Brotherhood*. In 2011, curators Silvia Rocciolo and Eric Stark oversaw the painting's restoration and, the same year, included it in the exhibition *(re) collection*, organized by Rocciolo, Stark, and John Wanzel at the Anna-Maria and Stephen Kellen Gallery in the Sheila C. Johnson Design Center at Parsons. Following *(re) collection*, Egas's commission was installed in the lobby of Alvin Johnson/ J. M. Kaplan Hall, where it remains.

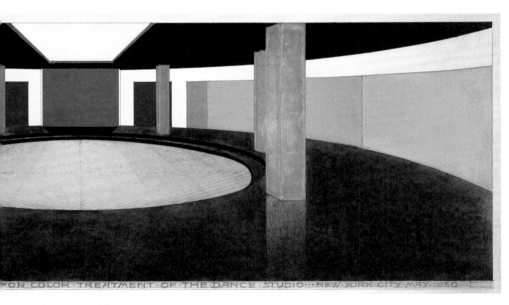

Color treatment of dance studio at 66 West 12th Street. Watercolor by Joseph Urban, c. 1929–31.

Gonzalo Fonseca

Untitled
1961

66 West 12th Street
217 × 136 in.
Glass mosaic

Gonzalo Fonseca (Uruguayan, 1922–1997) studied architecture but soon became involved in El Taller Torres-García, the influential transdisciplinary workshop founded in Montevideo by artist and educator Joaquín Torres-García. Inspired by Torres-García's interest in universal symbols, Fonseca explored archaeological sites in Bolivia, Peru, and Syria and worked for a time with Gerald Lankester Harding, the British archaeologist who helped preserve the recently discovered Dead Sea Scrolls. In 1957, Fonseca received a Guggenheim Fellowship and settled in New York with his wife, Elizabeth Kaplan Fonseca, daughter of the philanthropist Jacob M. Kaplan. The elder Kaplan supported causes across the city, from the New York Botanical Garden and NAACP Legal Defense and Education Fund to the campaign to save Carnegie Hall from demolition; his gift to the school allowed for the razing of a brownstone adjacent to the original Urban building and the construction of a new entryway and annex on 12th Street. A midblock courtyard linked to yet another new structure, the Albert List Building at 65 West 11th Street (now housing Eugene Lang College of Liberal Arts), designed by the firm of Mayer, Whittlesey & Glass and completed in 1959. The lobby of the 12th Street building, now known as Alvin Johnson/J. M. Kaplan Hall, became the site for Fonseca's work.

Untitled is the sole site-specific work in The New School Art Collection that was commissioned in the 1960s.[1] Yet the mosaic belongs to a particularly fertile period in the history of the institution and of the downtown Manhattan art scene in general.[2] The only courses ever taught

by the poet Frank O'Hara were taking place at The New School in these years, along with John Cage's Experimental Composing classes. The Art Center and Collector's Circle, endowed by Albert and Vera List and directed by Paul Mocsanyi, began to host lectures and exhibitions and to acquire works—first for the Collector's Circle, then occasionally for The New School Art Center, which in turn gave rise to The New School Art Collection.

Fonseca's mosaic was commissioned—with the support of the new lobby's architect, Albert Mayer—by Dr. Hans Simons, a political scientist who had arrived at the University in Exile as a refugee from Germany in 1935 and served as New School president for a decade (1950–60).[3] As the only large-scale mosaic that Fonseca produced, the work is anomalous in his oeuvre, which centers on stone sculptures evocative of pueblos, temples, ritual objects, and/or children's toys. Yet the installation kept alive the school's interest in place making through art and, as one of Fonseca's first public projects in New York, paved the way for his other grandly scaled endeavors, including a forty-foot cast-concrete monument, *La Torre de los Vientos* (*The Tower of the Winds*), commissioned for the 1968 Olympic games in Mexico City, and an exhibition for the Uruguayan Pavilion at the 1990 Venice Biennale.

Gonzalo Fonseca, *Untitled*, 1961.
Photographer unknown, 1960s.

1 In 1959, a pair of murals by the French artist Michel Cadoret (1912–1985)—who later taught at The New School for a short period—was commissioned by the French-American Scholarship Committee to commemorate the school's provision of safe haven to French scholars fleeing totalitarianism. *Welcome* and *Cooperation* were located for several decades on the second and third floors of 65 West 11th Street but were later lost. See Announcement of committee to celebrate twenty years of French-American scholarship, October 12, 1959, *New School press release collection*, The New School Archives and Special Collections Digital Archive http://digitalarchives. library.newschool.edu/ index.php/Detail/objects/ NS030107_000406 (accessed May 2, 2018).
2 Visual art acquisitions had not been a priority under Alvin Johnson's successor as president, Bryn Hovde, though other arts flourished: Erwin Piscator's Dramatic Workshop found a new home at The New School; the first-ever college class devoted to jazz was offered; and Sterling Brown, W.E.B. Du Bois, and Alain Locke taught courses in African American culture and history.
3 The period following Simons' retirement saw two episodes (in 1960 and 1963–64) during which acting presidents served the institution, as well as a short term filled by labor historian Henry David (1961–62). John Everett, founding chancellor of the City University of New York, became New School president in 1964 and served until 1982.

Martin Puryear + Michael Van Valkenburgh

Vera List Courtyard, 1997

66 West 12th Street Courtyard and atrium design; benches in granite, stainless steel, and maple

Martin Puryear (American, b. 1941) was born in Washington, DC. In his youth, he learned to build furniture, canoes, and guitars; his interests also included falconry and archery. Puryear served in the Peace Corps in Sierra Leone in the 1960s, and in 1971, he received an MFA from Yale University. Incorporating influences from West African sculpture, Scandinavian design, Minimalist sculpture, and woodcraft such as boatbuilding and cooperage, Puryear's work has garnered numerous honors, including a John D. and Catherine T. MacArthur Foundation Award and the National Medal of Arts.

Michael Van Valkenburgh (American, b. 1951) founded his architectural landscaping firm, MVVA, in 1982, with offices in Brooklyn and Cambridge, Massachusetts. From early commissions for gardens, plazas, and other smaller institutional spaces, MVVA's projects have expanded in scale to urban interventions making use of existing landforms, as in the design for the eighty-five-acre Brooklyn Bridge Park (begun in 2003 and ongoing).

Puryear and Van Valkenburgh had occasion to join forces in 1989, nearly thirty years after the expansion that established Alvin Johnson/J. M. Kaplan Hall and Eugene Lang College (now Eugene Lang College of Liberal Arts) on West 12th and West 11th Streets, respectively. Puryear signed on at the invitation of Kathleen Goncharov, curator of The New School Art Collection from 1987 to 2000, to refurbish the midblock courtyard; Van Valkenburgh was the artist's choice as collaborator. The outdoor space as it existed was a conventional paved sculpture court, with limited greenery and restricted seating, overhung by the double-height skybridge connecting 66 West 12th and 65 West 11th Streets. The courtyard's centerpiece was *Garden Elements* (1959), a two-part stone

sculpture by Isamu Noguchi. Other works were rotated in and out as temporary placements, among them Chaim Gross's *Family of Five Acrobats* (1951), now installed in the interior atrium.

Puryear and Van Valkenburgh's interventions reconceptualized the space entirely, integrating it into a simple yet multifaceted indoor/outdoor program. The indoor portion of the commission responded in part to the stipulations of the federal Americans with Disabilities Act (1990), which mandated accommodations such as access ramps. Unfortunately, in the limited space of the Joseph Urban Lobby, the interior ramp partially obscures the mosaic by Gonzalo Fonseca. Such compromises notwithstanding, in 1989, *Vera List Courtyard* won a Design Award from the American Society for Landscape Architects. The work was also the occasion for a historic lawsuit arguing for freedom of expression in public art practice and protesting anti-obscenity restrictions on federal arts funding, which was initiated by New School President Jonathan Fanton and brought by The New School against the National Endowment for the Arts and its chairman, John E. Frohnmayer in *The New School v. Frohnmayer*, No. 90-3510 (S.D.N.Y. 1990).

Martin Puryear + Michael Van Valkenburgh, *Vera List Courtyard*, 1997 (interior). Photo by Joseph Schuyler, 1990s.

Dave Muller

Interpolations and Extrapolations
2002–03

66 West 12th Street
Acrylic on paper,
in fifteen parts
Dimensions variable

Extensions (Interpolations and Extrapolations)
2008

66 West 12th Street
Acrylic on paper,
in four parts
Dimensions variable

Dave Muller (American, b. 1964) was born in San Francisco and has worked as a DJ and curator as well as an artist. His particular interests lie in the in-group image systems through which pop music and the art world establish a presence in the marketplace; he examines processes of definition, categorization, and the construction of individual identity through mass-cultural references, from album covers and top-ten lists to exhibition announcements.

The first portion of Muller's two-part work for The New School, *Interpolations and Extrapolations*, was commissioned by Stefano Basilico, curator of The New School Art Collection from 2000 to 2004. Inaugurating the first sustained series of new commissions for the university's public spaces since the 1930s, Basilico and the Committee for the University Art Collection in effect championed a twenty-first-century muralism. In this regard, the selection of Muller represented both a continuation and a departure. Like Benton, Orozco, and Egas, Muller catalogs the visual discourses through which a nation or a generation asserts its visual identity. But where the older artists' reference points were labor, politics, and indigeneity, Muller's are advertising, ephemera, and fandom. Rather than consisting

of a single, unified picture plane, Muller's "mural" is composed of multiple framed works, parts of a fragmented whole that can be reconfigured.

For his slyly modest installation in the Vera List Atrium, Muller culled from New School archives of promotional materials and course bulletins, tracking changes in graphic design and logotypes—and hence, projections of identity—since the school's inception in 1919. The resulting fifteen-part series incorporates three of the school's founders, Alvin Johnson, Charles Beard, and James Harvey Robinson, as portrait heads embossed on a medallion—its design drawn from a New School seal dating to the 1960s—which anchors the array of individually framed images. Another drawing depicts bamboo branches from Van Valkenburgh's plantings and a glimpse of Puryear's steel-latticework bench, centerpieces of *Vera List Courtyard*; yet another drawing shows *Garden Elements* (1959), the carving by Isamu Noguchi that once stood in the adjacent sculpture court (the sale of which partially funded the Puryear commission).

In 2008, Muller was invited by Basilico's successors, Silvia Rocciolo and Eric Stark, to update his commission for inclusion in the exhibition *OURS: Democracy in the Age of Branding*, organized for the Anna-Maria and Stephen Kellen Gallery at the Sheila C. Johnson Design Center by Carin Kuoni of the Vera List Center for Art and Politics.[1] The result, titled *Extensions*, is a four-part work centered on yet another New School logo, this one featuring the twice-repeated word *NEW* in graffiti-like letters overlaid by clean sans serif type. The doubled touchstone term is set out on a banner in a particular shade of orange that was at the time an element of The New School's brand identity. Surrounding the banner, wispy clouds waft through a bright blue sky.

1 The exhibition ran from October 15, 2008, through February 1, 2009. See http://www.veralistcenter.org/engage/exhibitions/131/ours-democracy-in-the-age-of-branding/ (accessed June 4, 2018).

Seal of The New School for Social Research depicting founders Charles Beard, Alvin Johnson, and James Harvey Robinson. Photo by Gin Briggs, 1960s.

Sol LeWitt

Wall Drawing #1073, Bars of Color (New School)

2003
Acrylic paint

55 West 13th Street

Part A (first floor)
Outer lobby: 193 × 272 in.
Inner lobby: 102½ × 252½ in.

Part B (second floor)
Left: 115 × 141 in.
Right: 173 × 335 in.

Drawn by John Hogan, Emily Ripley, and Jason Rulnick in February and March 2003.

Part A rescaled by Anthony Sansotta and redrawn in August 2015 by Krysten Koehn, Mario Moore, Karen Tepaz, and Christopher Watts.

Sol LeWitt (American, 1928–2007) studied at the Cartoonists and Illustrators School—now the School of Visual Arts— and worked in publishing until 1956, when he joined the architecture studio of I. M. Pei as a graphic designer. In 1960, he took a job at the bookshop of The Museum of Modern Art, where he worked alongside Lucy R. Lippard; later, with Dan Flavin and Robert Ryman, he became a museum guard. Known as a staunch supporter of other artists' work, LeWitt published the seminal texts "Paragraphs on Conceptual Art" (1967) and "Sentences on Conceptual Art" (1969). He partici- pated in exhibitions heralding the emer- gence of Minimalism and Conceptualism, including *Primary Structures*, orga- nized by Kynaston McShine at the Jewish Museum in 1966, and *When Attitude Becomes Form*, curated by Harald Szeemann at the Kunsthalle Bern in 1969.

In 1984, the Stedelijk van Abbe- museum in Amsterdam hosted a complete retrospective of LeWitt's wall drawings. Executed on-site and understood to be temporary, these geometric, mathematics- driven projects take form, of course, as fully realized murals. Yet, in a funda- mental way, the core of each piece is not the realized drawing itself but rather the Conceptualist document from which each drawing emerges: a written contract between the artist and the purchaser, accompanied by measurements and instructions that are executed (and hence to some degree interpreted) by assistants. The wall drawings thus respond to their settings in both physical and concep- tual terms. In the later part of LeWitt's career, such drawings largely became the medium of his art.

This responsiveness has been fundamental to the site-specificity of *Wall Drawing #1073, Bars of Color (New School)*. The work was secured as a gift from the artist by the curator Gabriella De Ferrari, LeWitt's close friend, who was the founding chair of the Vera List

Center for Art and Politics and, at the time, chair of the Committee for the University Art Collection. The drawing, the first such commission for Arnhold Hall on West 13th Street, was installed in 2003.[1] Continuing the pattern of accelerated change that characterized the school in the 2000s, the lobby of Arnhold Hall was subsequently reconfigured twice, including a redesign in 2015 to accommodate the consolidation of the university's performing arts division on the premises.

This alteration, which occurred after LeWitt's death, changed the proportions of the first-floor west wall. In response, *Part A* of the installation was rescaled by Anthony Sansotta of the LeWitt Studio, who had been authorized by the artist to oversee the posthumous rescaling and resizing of realized works as needed in order to allow those works to be reimagined for new spaces and configurations in the future. *Part A* was then redrawn for the altered space.

1 The nine-story brick building had been built by R. H. Macy & Co. in 1891, and had more recently housed a Bon Marché department store.

CERTIFICATE

This is to certify that the Sol LeWitt wall drawing
number _____ evidenced by this certificate is authentic.

Wall Drawing #1073
Bars of color (New School)

Acrylic paint
A - Top: green background; blue front plane;
yellow side plane; orange side plane
Bottom: red background; blue front plane;
purple top plane; yellow side plane;
orange side plane
B Left: purple background, blue front plane,
orange top plane, red side plane; right:
yellow background; red front plane;
blue top plane; green side plane
First Drawn by: John Hogan, Emily Ripley,
Jason Rulnick
First Installation: New School University,
New York, NY
February 2003

This certification is the signature for the wall drawing and must
accompany the wall drawing if it is sold or otherwise transferred.

Certified by

Sol LeWitt

Copyright Sol LeWitt Date

Certificate of Authenticity for
Sol LeWitt, *Wall Drawing #1073,
Bars of Color (New School)*, 2003.
The New School Art Collection.

DIAGRAM

This is a diagram for the Sol LeWitt wall drawing number _____. It should accompany the certificate if the wall drawing is sold or otherwise transferred but is not a certificate or a drawing.

DIAGRAM

This is a diagram for the Sol LeWitt wall drawing number _____. It should accompany the certificate if the wall drawing is sold or otherwise transferred but is not a certificate or a drawing.

Kara Walker (American, b. 1969) was born in Stockton, California, and raised in Atlanta. She began to develop her idiom of brutally satirical large-scale cut-paper silhouettes laid out against white walls while still a graduate student at the Rhode Island School of Design and first showed this work in New York City in 1994. In 1997, she became one of the youngest artists ever to receive a John D. and Catherine T. MacArthur Foundation Award. Staging nightmarish scenes from the American cultural imaginary of slavery and making inventive use of proto-cinematic technologies such as silhouettes, shadow puppetry, and the panorama, her explorations of violent abjection and racist caricature have made Walker one of the most celebrated—and, at times, controversial—artists of her generation. She has gone on to work in media as varied as monumental installation, text, video, and drawing.

Event Horizon was commissioned by Stefano Basilico and the Committee for the University Art Collection in 2003, though it was not completed until two years later. This was Walker's first permanent public commission and The New School's first permanent public acquisition to be commissioned from a woman

Kara Walker

Event Horizon

2005

55 West 13th Street
Latex paint
West wall: 432 × 179 in.
East wall: 432 × 154 ½ in.

artist in more than seventy years of collecting such site-specific works—although numerous other works by women, including pieces by Adrian Piper, Dorothea Rockburne, Lorna Simpson, Nancy Spero, and Carrie Mae Weems, had been added to the Art Collection, notably during the tenure of Kathleen Goncharov as curator.

Walker's installations consistently mix delicate detail with disturbing subject matter and epic historical sweep. Her art is always responsive to the power relations at play in its institutional settings, from museums to white-cube galleries to unusual locations like the former Domino Sugar warehouse on the Williamsburg waterfront, home to her monumental sculpture *A Subtlety, or the Marvelous Sugar Baby* (2014). This temporary installation, like many of Walker's works, foregrounded the suffering and mother wit of women and children, presenting a gigantic carved "mammy" figure, surfaced in white sugar, crouching in the posture of the Sphinx and surround-

ed by life-size figures of child laborers cast in resin and coated in unrefined—and slowly melting—brown molasses candy.

At Arnhold Hall, a similarly fraught tableau of women and children caught in postures of victimization and resistance occupies the main stairwell leading from the ground-floor lobby to the Theresa Lang Community and Student Center on the second floor. Accentuating the narrowness of the sharply turning stairs, Walker in effect compresses her signature panoramic arrays into a precipitous plunge to the underworld—which, since the stairwell is partially enclosed by glass, nevertheless remains suggestively open.

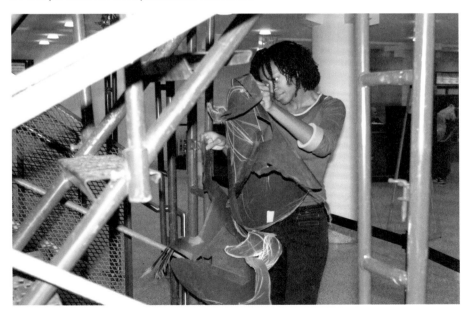

ABOVE AND OPPOSITE: Kara Walker at work on *Event Horizon*, 2005.

Brian Tolle

Threshold
2006

55 West 13th Street
Fiberglass and acrylic
paint
Each panel 63½ × 106½ ×
16 in.

Brian Tolle (American, b. 1964) is fasci-
nated by the imaginative resonances
of built space and interested in overlaps
between fictional and factual histories—
perhaps reflecting the fact that, before
earning a BFA at Parsons School of Design
and an MFA at Yale University, the New
York native received a BA in Political
Science from the University of Albany.
Tolle embarked on his commission for
The New School soon after completing the
Irish Hunger Memorial (2002) in lower
Manhattan's Battery Park City. For this
public art installation on the Hudson
River waterfront, the artist transported
and reconstructed a stone cottage from
County Mayo, Ireland, creating a theatri-
cal environment that memorializes the
potato famine of the 1840s—a disaster
during in which an estimated one million
people died and more than two million
emigrated, many of them to New York.

In 2004, Tolle was invited to produce
a site-specific work for the Dorothy H.
Hirshon Suite, a trustee boardroom on
the second floor of Arnhold Hall that
has since been redesignated as a seminar
room and special events reception
space.[1] The idea for *Threshold* grew out of
Tolle's *Eureka* project in Ghent, Belgium
(2000). In this installation, the facade
of a seventeenth-century canal house was

overlaid with a digitally modeled ten-panel surface registering a "reflection" of the building, rippled as if by boats cruising the canal, that seemed to physically deform the architecture. As Tolle explains, "I wanted to express something that technology enabled me to bring into

not the movement of wavelets on an urban waterway but that of HVAC systems and indoor drafts; *Threshold* models the passage of air currents across deceptively solid scrimlike panels. Appearing white on white at first glance but gradually revealing a faint blush of pink, the paired reliefs model the building's studs, ventilation system, and interstitial spaces, seeming to offer a glimpse beyond the finished skin of the room—yet literally revealing only another, more complex surface.

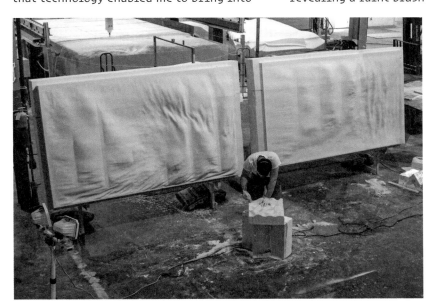

real time, real space, and integrate it into a landscape rather than onto a picture plane."[2]

In *Threshold*, the "landscape" into which technology imports its ripples is a modest institutional interior. The work consists of two fiberglass panels set into the upper portion of the Hirshon Suite's west wall. Using a blueprint of the room's structural supports and the most advanced digital-mapping software available at the time, Tolle simulated

Assistant to Brian Tolle at work on *Threshold*, 2006.

1 Dorothy Hart Hirshon (1908–1998) was a New School trustee as well as a trustee of Carnegie Hall, a board member at Lincoln Center, and a member of the New York City Human Rights Commission. She was a member of the glittering Algonquin Hotel set in the 1920s; Matisse made her portrait, as did Cecil Beaton and Horst P. Horst. Like Vera List and J. M. Kaplan, Hirshon was a philanthropist whose engagements helped shape the cultural fabric of contemporary New York.
2 "Brian Tolle by William R. Kaizen," *BOMB* 76 (summer 2001), https://bomb-magazine.org/articles/brian-tolle/ (accessed June 4, 2018).

Rita McBride

Bells and Whistles

2009–14

63 Fifth Avenue
Brass
Spanning six floors
(approximately 530 ft.)

Rita McBride (American, b. 1960) lives and works in Los Angeles and Düsseldorf. Her art explores architectural infrastructure as sculptural form; in parallel to the interests of many postmodern architects, she is interested in making operational apparatus like vents, ducts, and scaffolding not only visible but central, putting pressure on the distinction between aesthetic display and practical use in the built environment.

The title of McBride's New School installation, *Bells and Whistles*, emphasizes this tension, boldly labeling the work with a phrase implying fancy but unnecessary add-ons. The brushed-brass form winds from the second through the seventh floor at University Center, following the egress-stair pressurization duct upon which its pentagonal cladding is, in certain segments, parasitic. Appearing to weave in and out of classrooms and communal areas—the structure is actually discontinuous—*Bells and Whistles* dramatizes not only the interconnection of areas within the building but the relationship of physical substrate to decorative overlay.

In *Bells and Whistles*, McBride adapts an interest in ductwork that she had explored in *Servants and Slaves* (2002–03), another duct-based site-specific sculpture, whose title plays on Louis Kahn's idea of "servant" spaces—the shaftways, storage closets, and technical rooms that support a building's habitable square footage. Deploying terms likewise applicable to the New School project, *Servants and Slaves* has been described

as an assembly of "custom-modeled ducts and conduits, transformed by trophy-like metals...built to inhabit peculiar architectures as visible material objects."[1] Such works emphasize McBride's interest in zones of transit, function, and exchange—zones that one critic describes as "the public domain, public spaces, public activities, public symbols."[2]

When the University Center opened in January 2014, it was just the second stand-alone building commissioned by the school since Alvin Johnson hired Joseph Urban more than sixty years before, and this unique construction project allowed McBride to work in a way that was distinct from any of the artists commis-

sioned by The New School before or after her.[3] Benton, Orozco, and Egas had worked closely with Urban, and Puryear and Van Valkenburgh created a comprehensive design for *Vera List Courtyard*, just as Glenn Ligon later would for the Event Café at the University Center. Muller's series engages intimately with the graphic-design history of the school as a whole, and the rescaling of LeWitt's wall drawing in response to the secondary renovations at Arnhold Hall was not insignificant. Nevertheless, for the most part, the artists commissioned since the 1930s—including, in their very different ways, Fonseca, Jaar, Walker, Tolle, and Denes—had responded or would soon respond to New School spaces as given rather than made. McBride, in contrast, worked closely with Roger Duffy of Skidmore, Owings & Merrill, conceptualizing her work in tandem with the development of the building that would house it; indeed, McBride's commission was advanced at the recommendation of the architect and functions in dialogue with the architecture.

1 "Servants and Slaves, 2002–2003," in *Rita McBride: Public Works* (Museum Abteiberg Mönchengladbach, 2008), 52.
2 Susanne Titz, "Public Works," in *Rita McBride: Public Works*, 9.
3 In the 1880s, Thomas Alva Edison's electrical company was headquartered in a brownstone on this site, which became one of the first buildings in New York exclusively lit by electricity. In 1951, a Lane's department store was built on the parcel, and when this store failed in 1967, The New School for Social Research bought the building to house its Graduate Faculty, which had been founded in 1933 as the University in Exile.

Rita McBride, *Bells and Whistles*, 2009–14 (detail).

ON SPACE

VICTORY

Alfredo Jaar

Searching for Africa in *LIFE*
1996/2014

63 Fifth Avenue
Duratrans color
transparency and
LED lightboxes
Five panels, 70 × 220 × 3 in.

Alfredo Jaar (Chilean, b. 1956) is an artist, architect, and filmmaker whose art takes form as installation, photography, film, and community-based projects, exploring the limits of representation in catastrophic human-induced events. With subjects ranging from the holocaust in Rwanda to gold mining in Brazil, toxic pollution in Nigeria, and Mexican-U.S. border crossings, his work bears witness to military conflicts, political corruption, and the imbalance of power between industrialized and developing nations while also interrogating the relationship between photography and the language with which photographs are captioned and contextualized. Jaar emigrated to the United States from Chile in 1982, at the height of the military dictatorship of General Augusto Pinochet, and has since been based in New York City. He has participated in biennials around the world, including Venice (1986, 2007, 2009, 2013) and São Paulo (1987, 1989, 2010), as well as Documenta in Kassel (1987, 2002). In 2000, he won a John D. and Catherine T. MacArthur Foundation Award.

In 2010, Jaar was invited by The New School Art Collection Advisory Group and the curators Silvia Rocciolo and Eric Stark to propose a project for The New School's newest building, the University Center. His initial proposal—a multilevel, data-driven interactive installation—proved to be beyond the school's resources. The artist then proposed a site-specific version of his 1996 piece *Searching for Africa in* LIFE, which in its original form comprises five C-prints mounted on Plexiglas. For The New School, Jaar reframed this work as a lightbox installation for the seventh-floor reading room in the University Center's Arnhold Forum Library.

The resulting five-panel work includes all 2,128 covers from the complete run of *LIFE* magazine, which was founded as a photojournalistic weekly by Henry Luce in 1936 (prior to that, it had been a humor magazine) and continued publication until 2000. Jaar's project centers of the lightboxes' Plexiglas screens with the glass enclosure of the reading room, all bathed in the ambient wash of the building's artificial lighting and the daylight admitted on three sides by windows, subtly implies an accumulation of framing devices, an accumulation of distance.

Alfredo Jaar with *Searching for Africa in* LIFE, 1996/2014. Photo by Jee Eun Esther Jang, 2019.

on his long-standing interest in light as the sine qua non of photography, as likely to disorient as to reveal or to dazzle, while interrogating distinctions between the popular press, advertisements, and systems of knowledge relay such as libraries and archives. The fifth panel of the lightbox contains images of the magazine from the final years of the its run, laid out in seven rows, with the rest of the panel projecting a blank glow. Installed behind the reading room's glass partition and facing a wall of windows overlooking Fifth Avenue, the work is saturated by ambient light as well as light emerging from within its own form. This glow, along with the small yet highly detailed images of the covers—each measures 2½ by 1⅞ inches—draws the viewer in close, encouraging attentive reading. Yet the "incomplete" final panel signals a refusal to ratify ideas of comprehensiveness, while the layering

Glenn Ligon

For Comrades and Lovers
2015

63 Fifth Avenue
Neon
193 ft. 10 in.

Glenn Ligon (American, b. 1960) was born in the Bronx and studied in the Whitney Museum Independent Study Program. He was included in the much-debated "identity politics" iteration of the Whitney Biennial in 1993, as well as the watershed exhibition *Black Male: Representations of Masculinity in Contemporary American Art*, organized by Thelma Golden at the Whitney Museum of American Art in 1994.

The early phase of his career established Ligon as a conceptual artist engaged with the dynamics of race, gender, power, subjectivity, and American history. The legacies of painting as a medium are also activated and contested in Ligon's monochromatic text-based works in oil-stick, which foreground resonant phrases from the works of writers such as James Baldwin, Ralph Ellison, Jean Genet, Zora Neale Hurston, and Mary Shelley.

Ligon's Brooklyn studio was upstairs from Lite-Brite Neon (a neon-fabrication collective founded by Matt Dilling) and it was there that the artist produced his first neon work. *Warm Broad Glow* (2005) consists of the words "negro sunshine"—from Gertrude Stein's novella *Melanctha* (1909)—rendered in three-foot-high neon letters totaling sixteen feet in length. The face of each gigantic letter is painted black, so that the phrase is lit only from the back, casting a coronal glow on the wall in front of which the words seem to float. For his New School installation, commissioned by the curators Silvia Rocciolo and Eric Stark along with The New School Art Collection Advisory Group, Ligon turned to another ancestor in queer

American letters, Walt Whitman, and to another suggestive though subtle use of tinted light. The resulting work, *For Comrades and Lovers*, was Ligon's first permanent large-scale site-specific commission in New York.

 For Comrades and Lovers comprises a frieze of phrases rendered in violet neon, framing the Event Café in the New School University Center with lines from Whitman's *Leaves of Grass* (originally published in 1855). The café centers on a wide, shallow stairway that doubles as seating for performances and talks and was conceived as a multipurpose space where community members and visitors could gather with students, faculty, and staff. Considering the conjunction of this informal assembly spot with the larger site of learning that is the university, as well as the greater downtown Manhattan location, Ligon observes, "Whitman created a new space in which to consider the American experiment…. The quotes in this piece are reflective of a space of encounter and transience, a restless space

that in Whitman's poems is characteristic of the space of the city."[1] Indeed, Whitman's poem "Starting from Paumanok" (included in *Leaves of Grass*) begins with an invocation of the poet's birthplace on Long Island, called Paumanok in the local *Renneiu* dialect of the Algonquin people.[2] It is from this poem that Ligon selected the passage that, in turn, provides the title for the present volume:

> Dead poets, philosophs, priests,
> Martyrs, artists, inventors, governments
> long since,
> Language-shapers on other shores,
> Nations once powerful, now reduced,
> withdrawn, or desolate,
> I dare not proceed till I respectfully credit
> what you have left wafted hither,
> I have perused it, own it is admirable,
> (moving awhile among it,)
> Think nothing can ever be greater,
> nothing can ever deserve more than
> it deserves,
> Regarding it all intently a long while,
> then dismissing it,
> I stand in my place with my own day here.

1 The New School Art Collection pamphlet printed to mark the inauguration of Glenn Ligon's *For Comrades and Lovers* on April 29, 2015.
2 Evan T. Pritchard, *Native New Yorkers: The Legacy of the Algonquin People in New York* (San Francisco: Council Oak Books, 2002), 305.

OPPOSITE: Matt Dilling of Lite-Brite Neon and Glenn Ligon, 2013.
ABOVE: Glenn Ligon at work on *For Comrades and Lovers*, 2015.

Agnes Denes

Agnes Denes (American, b. Budapest, 1931) is the author of six books and since the 1960s has participated in more than 450 exhibitions worldwide. Investigating philosophy, linguistics, mathematics, geography, psychology, history, poetry, and music, she is a pioneering figure in environmental art, earthworks, and Conceptualism. Her ritualistic *Rice/Tree/Burial* was installed in Sullivan County, New York, in 1968, and over a four-month period in 1982, she produced *Wheatfield— A Confrontation*, a field of wheat planted and harvested on two acres of rubble-strewn landfill in Manhattan, at what is now the site of the World Financial Center. Denes continues to produce such monumental interventions. In 1996, for *Tree Mountain—A Living Time Capsule*, a bio-reclamation project in western Finland, Denes enrolled volunteers to plant more than ten thousand pine trees in a pattern derived in part from the golden section; the site will remain legally protected for four centuries.

**Pascal's Perfect
Probability Pyramid
& the People Paradox—
The Predicament
(PPPPPPP)**
1980/2016

63 Fifth Avenue
Vinyl
216 × 288 in.

ABOVE: Agnes Denes with *Pascal's Perfect Probability Pyramid & the People Paradox—The Predicament (PPPPPPP)*, 1980/2016.
OPPOSITE: John McGrail, *Wheatfield—A Confrontation: Battery Park Landfill, Downtown Manhattan—with Agnes Denes Standing in the Field*, 1982.

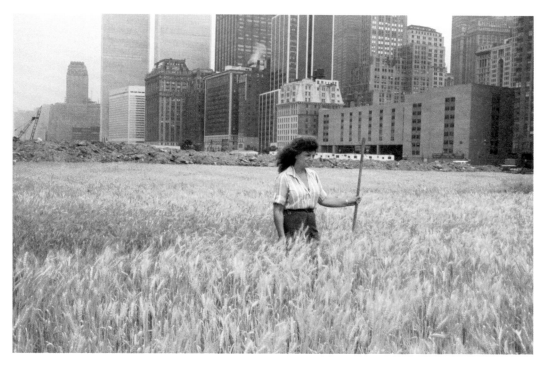

In 2015, a twelve-acre version of *Wheat-field* was planted in Milan.

Invited by the curators Silvia Rocciolo and Eric Stark and members of The New School Art Collection Advisory Group to propose a site-specific work for the University Center dining room, Denes chose to re-envision a work titled *Pascal's Perfect Probability Pyramid & the People Paradox—The Predicament (PPPPPPP)*, a drawing made in 1980. The original work, on silk vellum, measured just 32 by 43 inches yet had taken nearly two years to execute, depicting thousands of unique figures—some of which are portraits of the artist's friends and acquaintances—each rendered with the finest-gauge silver-tip pen. Scaled up electronically in a process closely monitored by Denes and transferred to the wall as vinyl cutouts, the figures in the mural remain individually legible.

The pyramid form has been consistent in Denes's art since the 1960s.

In 2000, contemplating this sustained engagement, she wrote:

> There are real pyramids and exotic ones, imaginary and philosophical. They represent logical structures, architectural innovations, and society building.... They can be stone, etched glass, plantings, and even silk. They can be invisible as thought processes, logic and mathematics; trees when they form a forest; conceptual, shaped like a nautilus when a future city; in motion when they seem to awaken; birds when they fly; history when they probe the ancients.[1]

In 2017, Denes added a dedication and exhortation to the wall text for the dining-hall site at The New School:

> I dedicate this work to the refugees of the world, the homeless, misplaced and unwanted whose wellbeing depends on human kindness and compassion.

> It is also a gift to the students. Read the figures, they are you.

1 Agnes Denes, "A Short History of the Pyramids" (2000), in *The Living Pyramid* (New York: Socrates Sculpture Park/ Socrates Publishing, 2015). See https://socrates sculpturepark.org/digital/ catalogue-agnesdenes/ (accessed June 4, 2018).

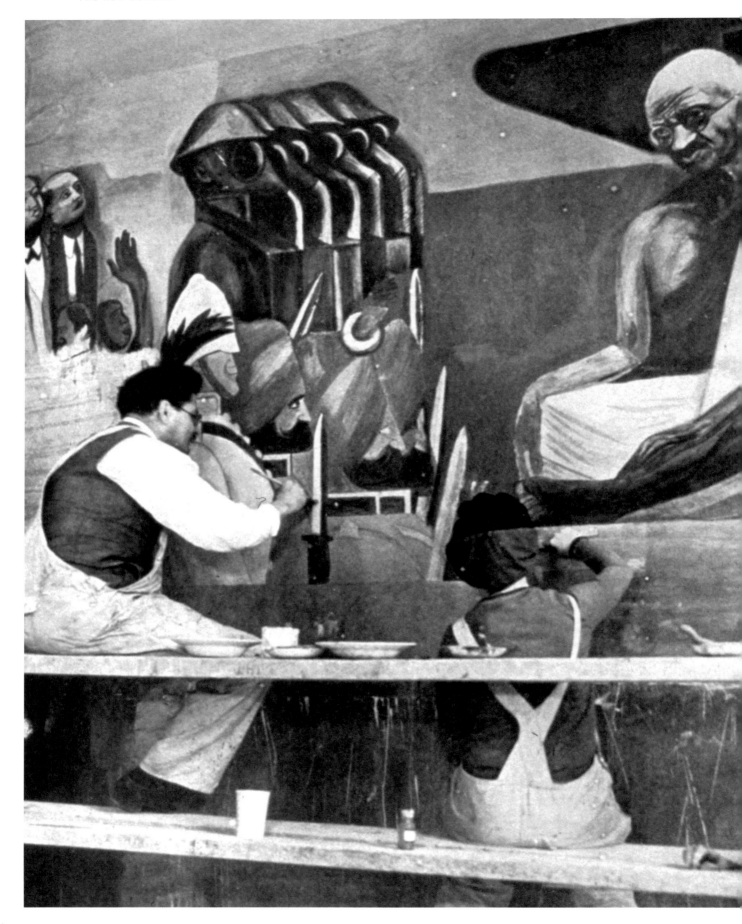

Contributors

Saul Anton is a writer, scholar, and editor whose essays on contemporary art and culture have been published in magazines such as *Frieze*, *Afterall*, and *Artforum*. He is the author of *Lee Friedlander: The Little Screens* (MIT Press, 2015) and *Warhol's Dream* (JRP Ringier, 2007); he is also the translator of Jean-Luc Nancy's *Discourse of the Syncope: Logodaedalus* (Stanford University Press, 2007). Anton has served as senior editor at *BOMB* magazine and editor-at-large at *Cabinet* magazine. He teaches in the department of Humanities and Media Studies at Pratt Institute.

Daniel A. Barber is an architectural historian. He is the author of *Climatic Effects: Architecture, Media, and the Planetary Interior* (Princeton University Press, 2018) and *A House in the Sun: Modern Architecture and Solar Energy in the Cold War* (Oxford University Press, 2016). His essays have been published in periodicals such as *Grey Room*, *Technology and Culture*, and *Public Culture*. Barber is the recipient of fellowships from the Rachel Carson Center for Environment and Society, the Princeton Environmental Institute, and the Harvard University Center for the Environment. He is an associate professor of architecture at the University of Pennsylvania School of Design.

Stefano Basilico is a curator, writer, and advisor. He is the principal of Stefano Basilico Art Advisory and has been owner-director of Basilico Fine Arts, co-director at Sonnabend Gallery, adjunct curator of contemporary art at the Milwaukee Art Museum, and curator of The New School Art Collection. His articles on contemporary art have been published in a range of periodicals, including *BOMB* magazine, *Documents* magazine, and *Time Out New York*. He has been an associate professor at Parsons School of Design and continues to lecture in the education departments of Sotheby's and Christie's.

Carol Becker is a writer and scholar. She has published multiple books of cultural criticism, including *Thinking in Place: Art,*

Action, and Cultural Production (Paradigm Publishers, 2009), *Zones of Contention: Essays on Art, Institutions, Gender, and Anxiety* (SUNY, 1996), and *The Invisible Drama: Women and the Anxiety of Change* (Fulcrum Publishing, 1990), as well as a memoir, *Losing Helen: An Essay* (Red Hen Press, 2016). Becker works closely with the Cultural Leaders of the World Economic Forum and its Global Leadership Fellows Program. She is the dean of faculty and a professor of the arts at Columbia University School of the Arts.

Naomi Beckwith is the Marilyn and Larry Fields Curator at the Museum of Contemporary Art Chicago (MCA). Central to her curatorial practice are themes of identity and conceptual practices in contemporary art, the work of artists of African descent, and artists' professional development. Prior to joining the MCA, she was a fellow at the Institute of Contemporary Art in Philadelphia and associate curator at The Studio Museum in Harlem. She has curated numerous exhibitions, including *The Freedom Principle: Experiments in Art and Music, 1965 to Now* at the MCA (2015) and *30 Seconds off an Inch* at The Studio Museum in Harlem (2009). Beckwith is the recipient of a VIA Art Fund Curatorial Fellowship, multiple Andy Warhol Foundation Grants, and a Whitney Museum Independent Study Program Critical Studies Fellowship.

Omar Berrada is a writer, translator, and curator. He is the editor of *The Africans* (Kulte Editions, 2016) and co-editor of *Album—Cinémathèque de Tanger* (Librairie des Colonnes, 2012) and *Expanded Translation—A Treason Treatise* (Sharjah Art Foundation, 2010). He has curated various exhibitions, including *Memory Games*, a group show within the Marrakech Biennale (2016); *Black Hands*, a solo M'barek Bouhchichi show at Kulte Gallery (2016); and *I want to possess in this world . . .*, a presentation of Ahmed Bouanani's archive at Witte de With Center for Contemporary Art (2016). Berrada has served as curator of public programs at the Centre Pompidou, director of the Tangier International Book Salon, and co-director of Dubai's Global Art Forum. He is the director of Dar al-Ma'mûn in Marrakech.

Gregg Bordowitz is an artist and writer and the director of the Low-Residency Master of Fine Arts program at the School of the Art Institute of Chicago. A recipient of the Frank Jewett Mather Award for art journalism from the College Art Association in 2006, he is the author of *Glenn Ligon: Untitled (I Am a Man)* (Afterall Books, 2018), *General Idea: Imagevirus* (Afterall Books, 2010), and *The AIDS Crisis Is Ridiculous and Other Writings, 1985–2003* (MIT Press, 2004). Bordowitz was a member of the groundbreaking AIDS activist group ACT UP and is on the faculty of the Whitney Museum Independent Study Program at the Whitney Museum of American Art in New York.

Tisa Bryant's mixed-genre writing has been presented in a range of publications, including *Lana Turner*, *Flesh*, *LitHub*, and *Letters to the Future: Black WOMEN/Radical WRITING*. She is the author of *Residual* (Nightboat Books, 2019), a nonfiction work on grief and archival research; and *Unexplained Presence* (Leon Works, 2007), a collection of hybrid essays. She is also the co-editor of *The Encyclopedia Project*, a cross-referenced literary/arts series. She is the program director of the MFA in Creative Writing at the California Institute of the Arts.

Holland Cotter is a senior writer and co-chief art critic of the *New York Times*. Cotter has been the recipient of a Pulitzer Prize for Criticism and an American Academy of Arts and Sciences Fellowship. Currently, he is working on a study of contemporary Indian art.

Mónica de la Torre is the author of five poetry collections, including *The Happy End/All Welcome* (Ugly Duckling Presse, 2017), *Public Domain* (Roof Books, 2008), and *Talk Shows* (Switchback, 2007). She writes about visual art; has translated an array of Latin American poets, including, most recently, the Chilean modernist Omar Cáceres; and has co-edited several multilingual anthologies, most notably *Reversible Monuments: Contemporary Mexican Poetry* (Copper Canyon Press, 2002). She was the senior editor at *BOMB* magazine for nearly ten years and is now an assistant professor of the practice of literary arts at Brown University.

Aruna D'Souza is a writer whose work focuses on art, race, feminism, and museums. She is the author, most recently, of *Whitewalling: Art, Race & Protest in 3 Acts* (Badlands Unlimited, 2018). She has co-edited several volumes, including *Making It Modern*, a volume of Linda Nochlin's collected essays on modernism (Thames & Hudson, 2019), and *Art History in the Wake of the Global Turn* (Clark Art Institute, 2014). D'Souza's writing on contemporary art has appeared in publications including the *Wall Street Journal*, *ArtNews*, *Momus*, *Art in America*, and *Garage*. She is a member of the editorial advisory board at *4Columns*, to which she is also a regular contributor.

Elizabeth Ellsworth is a scholar and media artist. She co-founded Smudge Studio, a nonprofit media arts organization, and is the author of *Making the Geologic Now: Responses to Material Conditions of Contemporary Life* (Punctum Books, 2012), *Places of Learning: Media, Architecture, Pedagogy* (Routledge Publishing, 2004), and *Teaching Positions: Difference, Pedagogy and the Power of Address* (Teachers College Press, 1997). Ellsworth is the recipient of a Research Council of Norway Grant, two Provost Faculty Development Grants from The New School, and a Distinguished Lecturer Award from Columbia University's Teachers College. She is a professor of media studies at the Schools of Public Engagement at The New School.

Julia L. Foulkes is the author of *A Place for Us: West Side Story and New York* (University of Chicago Press, 2016), *To the City: Urban Photographs of the New Deal* (Temple University Press, 2010), and *Modern Bodies: Dance and American Modernism from Martha Graham to Alvin Ailey* (The University of North Carolina Press, 2002). Foulkes also curated the exhibition *Voice of My City: Jerome Robbins and New York*, held at the New York Public Library/Lincoln Center (September 2018–March 2019). She is a professor of history at The New School.

Andrea Geyer is a multidisciplinary artist. Recent exhibitions of her work include *If I Told Her* at Hales Gallery, London (2018), *To Those Who Have Eyes to See* at the San Francisco Museum of Modern Art (2017), *Revolt, They Said* at The Museum of Modern Art, New York (2015), and *Time Tenderness* at the Whitney Museum of American Art (2015). Geyer is the recipient of a MoMA

Research Fellowship, a New York Foundation for the Arts Artist Fellowship, a Creative Time Global Residency, and other awards and honors. She is an associate professor of new genres at Parsons School of Design.

Kathleen Goncharov is senior curator at the Boca Raton Museum of Art. She has served as curator of The New School Art Collection, public art curator at the MIT List Visual Arts Center, and adjunct curator of contemporary art at the Duke University Nasher Museum of Art. Her honors include being appointed commissioner of the U.S. Pavilion at the 50th Venice Biennale (2003).

Jennifer A. González is a writer. Her essays appear in various scholarly journals and art magazines, including *Diacritics*, *Art Journal*, and *BOMB* magazine. She is the author of *Pepón Osorio* (University of Minnesota Press, 2013) and *Subject to Display: Reframing Race in Contemporary Installation Art* (MIT Press, 2008). González is the recipient of fellowships from the Ford Foundation, the American Association of University Women, and the American Council of Learned Societies. She is a professor in the History of Art and Visual Culture Department at the University of California, Santa Cruz, and a faculty member of the Whitney Museum Independent Study Program.

Michele Greet is associate professor of art history at George Mason University. She is the author of *Transatlantic Encounters: Latin American Artists in Paris Between the Wars* (Yale University Press, 2018) and *Beyond National Identity: Pictorial Indigenism as a Modernist Strategy in Andean Art, 1920–1960* (Penn State University Press, 2009). Greet is the recipient of fellowships from the Phillips Collection and the National Endowment for the Humanities. She is currently curating a major traveling exhibition on Latin American artists in Paris between the wars with the American Federation of Arts. Her next research project will focus on the emergence of abstraction in the Andes.

Randall Griffey is curator of modern and contemporary art at The Metropolitan Museum of Art, New York. At The Met, he has co-curated *Marsden Hartley's Maine* (2017), *Thomas Hart Benton's America Today Mural Rediscovered* (2014), and other exhibitions. His essays have appeared in periodicals and exhibition catalogs; they include "Reconsidering 'The Soil': The Stieglitz Circle,

Regionalism, and Cultural Eugenics in the 1920s" (Brooklyn Museum, 2011) and "Marsden Hartley's Aryanism: Eugenics in a *Finnish-Yankee Sauna*" (*American Art*, 2008). Griffey's honors include two publication awards from the Association of Art Museum Curators.

Victoria Hattam is a political scientist working on questions of inequality and politics in the United States and the global economy. She is the author of *Political Creativity: Reconfiguring Institutional Order and Change* (University of Pennsylvania Press, 2013); *In the Shadow of Race: Jews, Latinos, and Immigrant Politics in the United States* (University of Chicago Press, 2007), which won the Ralph Bunche Award from the American Political Science Association; and *Labor Visions and State Power: The Origins of Business Unionism in the United States* (Princeton University Press, 1993). Hattam has been named a fellow at the Institute for Advanced Study at Princeton University and a visiting scholar by the Russell Sage Foundation. She is co-director of the Mellon Foundation–funded "Sawyer Seminar on Imagined Mobilities," which bridges art and design with social research. She is a professor of politics at The New School for Social Research.

Pablo Helguera is an artist and educator. His artwork has been presented at a range of international venues, including the Museo Nacional Centro de Arte Reina Sofía, MoMA PS1, and the Royal College of Art in London. He is the author of *Education for Socially Engaged Art: A Materials and Techniques Handbook* (Jorge Pinto Books, 2011). Helguera is the recipient of grants from the Creative Capital Foundation and the Franklin Furnace Fund, as well as a John Simon Guggenheim Fellowship. He is the director of Adult and Education Programs at The Museum of Modern Art in New York.

Jamer Hunt is the founding director of the MFA Transdisciplinary Design program at Parsons School of Design and co-curator, with Paola Antonelli, of an online curatorial experiment, *Design and Violence* (Museum of Modern Art, 2013–15). Hunt and Antonelli also collaborated on "Headspace: On Scent as Design" (2010) and "MIND08: The Design and Elastic Mind Symposium" (2008). Hunt is the co-author, with Meredith Davis, of *Visual Communication Design* (Bloomsbury Visual Arts, 2017); he is a design blogger for *Fast Company*; and his writing

has been featured in the *Huffington Post*. He is vice provost for Transdisciplinary Initiatives at The New School.

Anna Indych-López is an art historian. She is the author of *Judith F. Baca* (UCLA Chicano Studies Research Center and University of Minnesota Press, 2018) and *Muralism without Walls: Rivera, Orozco, and Siqueiros in the United States, 1927–1940* (University of Pittsburgh Press, 2009), and co-author of *Diego Rivera: Murals for The Museum of Modern Art* (Museum of Modern Art, 2011). She is the recipient of a Wyeth Foundation for American Art Grant and is an associate professor of art history at The City College of New York and at The Graduate Center, CUNY.

Luis Jaramillo is the author of *The Doctor's Wife* (Dzanc Books, 2012), which received the Dzanc Books Short Story Collection Prize and was included on NPR's Best Books of 2012 List; he has published in literary journals including *Literary Hub, Tin House* magazine, and *H.O.W. Journal*. He is the director of the School of Writing at the Schools of Public Engagement at The New School.

Jeffrey Kastner is a writer and critic and the senior editor of *Cabinet* magazine. He is the editor of *Nature* (MIT Press, 2012) and *Land and Environmental Art* (Phaidon Press, 1998), and co-author, with Claire Lehmann, of *Artists Who Make Books* (Phaidon Press, 2017). His writing on contemporary art has appeared in publications including *Artforum, The Economist*, and the *New York Times*, and he has published monographic essays in exhibition catalogs on artists including Doug Aitken, David Altmejd, Michaël Borremans, Ragnar Kjartansson, Tomás Saraceno, and Sarah Sze.

Robert Kirkbride is an architectural scholar-practitioner. He is the co-designer, with Anthony Cohn, of the Morbid Anatomy Museum, and author-designer of *Architecture and Memory* (Columbia University Press, 2008), an award-winning multimedia online book. His design and research projects have been featured in a range of periodicals, including the *Financial Times*, the National Academy of Sciences, Engineering, and Medicine's *Issues in Science and Technology* magazine, and the *New York Times*. Dr. Kirkbride is a founding trustee and spokesperson of PreservationWorks and the director of studio 'patafisico. He is the dean of the School of Constructed

Environments and associate professor of architecture and product design at Parsons School of Design.

Lynda Klich is an art historian and curator. She is the author of *The Noisemakers: Estridentismo, Vanguardism, and Social Action in Postrevolutionary Mexico* (University of California Press, 2018), which received the University of Maryland/Phillips Collection Book Prize. Klich is assistant professor of art history at Hunter College, CUNY, and curator of the Leonard A. Lauder Postcard Collection.

Carin Kuoni is a curator and writer and a founding member of the artist collective REPOhistory. She has edited and co-edited several anthologies, including *Assuming Boycott: Resistance, Agency, and Cultural Production* (OR Books, 2017), *Entry Points: The Vera List Center Field Guide to Art and Social Justice* (Duke University Press, 2015), *Take Care: A Curator's Vademecum* (ICI, 2001), and *Energy Plan for the Western Man: Joseph Beuys in America* (Four Walls Eight Windows, 1990). She has curated numerous transdisciplinary exhibitions, including *OURS: Democracy in the Age of Branding* at Parsons School of Design (2008), *The Puppet Show* at the Institute of Contemporary Art, Philadelphia (2008), and *Red River Crossings* at the Swiss Institute (1996). Kuoni is the director and chief curator of the Vera List Center for Art and Politics at The New School.

Sarah E. Lawrence is an art historian and curator. She has curated multiple exhibitions, including *Crafting a Jewish Style: The Art of Bezalel, 1906–1996* at the Jewish Museum in New York and *Piranesi as Designer* at the Cooper-Hewitt, National Design Museum (now Cooper Hewitt, Smithsonian Design Museum), in collaboration with the Rijksmuseum in Amsterdam. Her scholarship has received funding from the Getty, Kress, and other foundations. She is the dean of the School of Art and Design History and Theory and an associate professor of art history at Parsons School of Design.

Tan Lin is a writer and artist. He is the author of thirteen books, including *Insomnia and the Aunt* (Kenning Editions, 2011) and *Seven Controlled Vocabularies and Obituary 2004. The Joy of Cooking* (Wesleyan University Press, 2010). His video, theater, and LCD

work has been exhibited at Artists Space, the Yale University Art Gallery, and the Ontological-Hysteric Theater; his work was the subject of a solo show at Treize Gallery in Paris in 2017. His writing has appeared in *Artforum*, the *New York Times Book Review*, and *Triple Canopy*. Lin is the recipient of grants from the Foundation for Contemporary Arts, the Getty Foundation, and the Andy Warhol Foundation. He is a professor of creative writing at New Jersey City University.

Lucy R. Lippard is a writer, activist, and sometime curator. She is the author of twenty-four books, including *Undermining: A Wild Ride Through Land Use, Politics, and Art in the Changing West* (The New Press, 2014), *Mixed Blessings: New Art in a Multicultural America* (The New Press, 2000), and *Six Years: The Dematerialization of the Art Object* (University of California Press, 1997). She co-founded a number of pathbreaking organizations and publications, including the Art Workers Coalition, Printed Matter, and *Heresies* journal. Lippard has received numerous honors and awards, including a Guggenheim Fellowship, the Frank Jewett Mather Award for Criticism from the College Art Association, and a Creative Capital Grant. She lives in Galisteo, New Mexico, where she is active in her community.

Laura Y. Liu is an associate professor of global studies and geography at The New School. Her research focuses on community organizing, labor, migration, urban development, and design. Her essays have appeared in a range of academic journals, including *Anthropology Now*; *Women's Studies Quarterly (WSQ)*; *Urban Geography*; *Gender, Place, and Culture*; and *Social and Cultural Geography*. She has contributed to the Situated Technologies Pamphlets Series with *From Mobile Playgrounds to Sweatshop City* (Architectural League of NY, 2010), and to the edited volumes *Anne Wilson: Wind/Rewind/Weave* (Knoxville Museum of Art, 2011) and *Indefensible Space: The Architecture of the National Insecurity State* (Routledge Publishing, 2008). She is writing a book, *Sweatshop City*, that looks at the continuing relevance of the sweatshop in New York City and other post-Fordist, globalized contexts.

Reinhold Martin is an architectural historian and theorist. He is the author of *The Urban Apparatus: Mediapolitics and the City* (University of Minnesota Press, 2016),

Utopia's Ghost: Architecture and Post-modernism, Again (University of Minnesota Press, 2010), and *The Organizational Complex: Architecture, Media, and Corporate Space* (MIT Press, 2003). Martin is a professor of architecture at the Columbia University Graduate School of Architecture, Planning, and Preservation, where he directs the Temple Hoyne Buell Center for the Study of American Architecture.

Shannon Mattern is an associate professor of media studies at the Schools of Public Engagement at The New School. She is the author of *Code and Clay, Data and Dirt: Five Thousand Years of Urban Media* (University of Minnesota Press, 2017), *Deep Mapping the Media City* (University of Minnesota Press, 2015), and *The New Downtown Library: Designing with Communities* (University of Minnesota Press, 2007). She contributes a regular long-form column about urban data and mediated infrastructures to *Places* journal. Mattern is the recipient of fellowships from the Finnish Cultural Institute, the Bauhaus-Universität Weimar, and the Graduate Institute for Design, Ethnography, and Social Thought (GIDEST) at The New School.

Lydia Matthews is a writer, curator, and educator. She has curated multiple exhibitions, including the U.S. contribution to Artisterium International Art Exhibition (2017, 2014, 2012, 2010, and 2008) and the Batumi Backyards Stories Project (2013 and 2012). She is the recipient of grants from the U.S. Embassy, the Lower Manhattan Cultural Council, CEC Artslink, the Fulbright Foundation, and the Open Society Foundation. She is a professor of visual culture and the founding director of the Curatorial Design Research Lab at Parsons School of Design.

Maggie Nelson is a writer and scholar. She has written five nonfiction books, including *The Argonauts* (Graywolf Press, 2015), winner of the National Book Critics Circle Award; *The Art of Cruelty: A Reckoning* (Norton, 2011), named a Notable Book of the Year by the *New York Times*; and *Bluets* (Wave, 2009), named one of the ten best books of the past twenty years by *Bookforum*. She is also the author of four poetry collections, including *Something Bright, Then Holes* (2007), and *Jane: A Murder* (2005). Nelson is the recipient of fellowships and grants from the MacArthur Foundation, the Guggenheim Foundation, Creative

Capital, and the National Endowment for the Arts. She is a professor of English at the University of Southern California.

Olu Oguibe is an artist, writer, and curator.

G. E. Patterson is a poet, critic, and translator. His recent work includes two public art commissions, *CREATE: The Community Meal* (on food access and food justice) and *The Plume Project* (on energy awareness and sustainability). He is the author of two poetry collections, *To and From* (Ahsahta Press, 2008) and *Tug* (Graywolf Press, 1999), which won the Minnesota Book Award. Patterson has been a featured poet-performer in New York's Panasonic Village Jazz Festival and is the recipient of awards and honors including fellowships from Cave Canem, the Djerassi Foundation, the MacDowell Colony, and New York City's Fund for Poetry.

Hugh Raffles is a writer and anthropologist. His essays appear in a range of periodicals, including *Granta*, *Cultural Anthropology*, and the *New York Times*. He is the author of *Insectopedia* (Pantheon Books, 2010) and *In Amazonia: A Natural History* (Princeton University Press, 2002). Raffles is the recipient of a Whiting Writers Award and a Victor Turner Prize for Ethnographic Writing. He is a professor of anthropology and director of the Graduate Institute for Design, Ethnography, and Social Thought (GIDEST) at The New School.

Claudia Rankine is a poet, playwright, and essayist. She is the author of five collections of poetry, including *Citizen: An American Lyric* (Graywolf Press, 2014), winner of the PEN Open Book Award, the PEN Literary Award, the NAACP Award, and the National Book Critics Circle Award for Poetry. She has also written two plays, scripted numerous video collaborations, and edited several anthologies. Rankine is the recipient of fellowships from the MacArthur Foundation, the Academy of American Poets, United States Artists, and the Guggenheim Foundation. She is the Frederick Iseman Professor of Poetry at Yale University. In 2016, she co-founded The Racial Imaginary Institute (TRII).

Jasmine Rault is an assistant professor of cultural studies at the University of Toronto. Their research focuses on mediations of gender, race, and sexuality in architecture and design, digital cultures and economies, and arts and social movements. They is

the author of *Eileen Gray and the Design of Sapphic Modernity: Staying In* (Ashgate Publishing, 2011). Currently Rault is at work on the Digital Research Ethics Collaboratory (DREC) and a book provisionally titled *Open Secrets: Technologies of Opacity for Queerly Surviving the Transparency Epoch*.

Heather Reyes is a writer and curator. Her master's thesis, *Camilo Egas in New York: 1927–1962*, was completed in 2018, and she was co-organizer of *Bronx Calling: The Fourth AIM Biennial* (Bronx Museum of the Arts, 2017). Reyes has served as executive projects manager at Friends of the High Line and as assistant to the executive director at Art21. She was recently the exhibitions and collection manager at the Bronx Museum of the Arts.

Frances Richard is the author of *Gordon Matta-Clark: Physical Poetics* (University of California Press, 2019) and co-author, with Jeffrey Kastner and Sina Najafi, of *Odd Lots: Revisiting Gordon Matta-Clark's "Fake Estates"* (Cabinet Books, 2005). She is the editor of *Joan Jonas is on our mind*, a volume of essays on the artist (Wattis Institute, 2017). Her books of poems include *Anarch.* (Futurepoem, 2012), *The Phonemes* (Les Figues Press, 2012), and *See Through* (Four Way Books, 2003). Richard is the recipient of a Creative Capital/Warhol Foundation Arts Writers Grant. She is associate editor of *Places* journal and teaches at the California College of the Arts in San Francisco.

Silvia Rocciolo is director and chief curator of The New School Art Collection. Previously she served as a specialist in American art at Phillips, de Pury & Luxembourg; an art advisor curating modern American and European works of art for private and corporate collections with Guggenheim Asher Associates; and director of Von Lintel and Nusser Gallery, a Munich-based gallery for midcareer and emerging artists.

Carl Hancock Rux is a writer, performer, recording artist, and theater director. He is the author of three novels, including *Asphalt* (Simon & Schuster, 2004); nineteen plays, including the Obie Award–winning *Talk* (TCG, 2003); two collections of poetry, including *Pagan Operetta* (Fly by Night Press, 1998); and the librettos for four operas, including *Makandal* (performed at the Harlem Stage, in the Guggenheim Museum Opera Series, and at Art Basel). His plays and performance works for theater

have been produced at the Joseph Papp Public Theater, the Penumbra Theatre, Lincoln Center Theater, and the BAM Harvey Theater. Rux is the recipient of numerous awards, including the New York Foundation for the Arts Prize, the CINE Golden Eagle Film and Video Award, the Village Voice Literary Prize, and the Herb Alpert Prize in the Arts.

Luc Sante is a writer. He is a frequent contributor to the *New York Review of Books*, and his books include *The Other Paris* (Farrar, Straus and Giroux, 2015), *Kill All Your Darlings: Pieces 1990–2005* (Yeti Publishing, 2007), and *Low Life: Lures and Snares of Old New York* (Farrar, Straus and Giroux, 2003). Sante is the recipient of awards from the Whiting Foundation, the American Academy of Arts and Letters, and the GRAMMY Foundation (for album notes).

Mira Schor is a painter and writer. Recent exhibitions of her work include *Mira Schor: Unseen Dick Paintings (1988–1993)* at Frieze, New York (2018), with Lyles & King Gallery; *Mira Schor: The Red Tie Paintings* at Lyles & King gallery (2016); and *War Frieze (1991–1994) and 'Power' Frieze (2016)* at CB1 Gallery (2016). She is the author of *A Decade of Negative Thinking: Essays on Art, Politics, and Daily Life* (Duke University Press, 2009) and *Wet: On Painting, Feminism, and Art Culture* (Duke University Press, 1997). Schor is the recipient of awards from the Guggenheim Foundation, the Rockefeller Foundation, and the Pollock-Krasner Foundation. She is an associate teaching professor in the MFA Fine Arts program at Parsons School of Design.

Eric Stark was curator of The New School Art Collection from 2004 to 2018. From 1989 to 2005, he owned and directed Stark Gallery; in 1995, he founded Crosby Street Project, a nonprofit exhibition space dedicated to international installation-based projects. Throughout his curatorial career, he has managed Eric Stark Design Associates, specializing in interior design and art advisory services.

Radhika Subramaniam is a curator, editor, and writer. She is the recipient of an international visiting curatorship at Artspace, Sydney; a SEED Foundation Teaching Fellowship in Urban Studies at the San Francisco Art Institute; and artist/writer residencies at Banff Centre for Arts and Creativity in Canada and the Hambidge

Center for the Creative Arts & Sciences. She is an assistant professor of visual culture at Parsons School of Design, where from 2009 to 2017 she also served as the first director and chief curator of the Sheila C. Johnson Design Center.

Edward J. Sullivan is the Helen Gould Sheppard Professor at the Institute of Fine Arts of New York University, where he is also deputy director. His recent publications include *Making the Americas Modern: Hemispheric Art, 1910–1960* (Laurence King Publishing, 2018), *The Americas Observed: Collecting Colonial and Modern Latin American Art in the United States* (Pennsylvania State University Press, 2018), *From San Juan to Paris and Back: Francisco Oller and Caribbean Art in the Era of Impressionism* (Yale University Press, 2014), and *The Language of Objects in the Art of the Americas* (Yale University Press, 2007). Exhibitions he has recently organized include *Roberto Juarez: Processing: Paintings & Prints, 2008–2018* at the Boulder Museum of Contemporary Art in Colorado (2018); *Impressionism and the Caribbean: Francisco Oller and His Transatlantic World* at the Brooklyn Museum (2015–16), and *Observed: Milagros de la Torre* at the Museo de Arte de Lima (2012). Sullivan is the recipient of a Guggenheim Fellowship and an American Society for Hispanic Art Historical Studies Award.

Roberto Tejada is a writer and art historian. He is the author of the poetry collections *Full Foreground* (University of Arizona Press, 2012), *Exposition Park* (Wesleyan University Press, 2010), and *Mirrors for Gold* (Krupskaya, 2006), as well as the critical studies *National Camera: Photography and Mexico's Image Environment* (University of Minnesota Press, 2009) and *Celia Alvarez Muñoz* (Chicano Studies Research Center, UCLA, 2009). Tejada founded and co-edited the journal *Mandorla: New Writing from the Americas* (1991–2013). He is the Hugh Roy and Lillie Cranz Cullen Distinguished Professor at the University of Houston.

Otto von Busch is a designer and critic. He is the co-founder of roomservices and founder of Selfpassage, two research institutions for design research and practice. His essays have been published in a range of academic journals, including *Critical Studies in Fashion and Beauty*, *Organizational Aesthetics*, and *Creative Industries Journal*; he has also contributed chapters

to edited volumes, among them *Fashion Studies: Research Methods, Sites and Practices* (Bloomsbury Publishing, 2016), *The Routledge Companion to Design Research* (Routledge Publishing, 2015), and *Design as Future-Making* (Bloomsbury Publishing, 2014). Von Busch is an associate professor of integrated design at Parsons School of Design.

Wendy S. Walters is the author of the essay collection *Multiply/Divide: On the American Real and Surreal* (Sarabande Books, 2015) and two poetry collections, *Troy, Michigan* (Futurepoem, 2014) and *Longer I Wait, More You Love Me* (Palm Press, 2009). Walters is the recipient of awards and honors including fellowships from New York Foundation for the Arts, the Ford Foundation, and the Smithsonian Institution. She is associate dean of the School of Art and Design History and Theory at Parsons School of Design and an associate professor at Eugene Lang College of Liberal Arts.

Jennifer Wilson is a mathematician. Her research has been published in a range of scholarly journals, including *Mathematical Social Sciences*, *College Math Journal*, and *Art, Design and Communication in Higher Education*. Wilson is the recipient of awards and honors including a Provost Professional Development Grant. She is an associate professor of mathematics at Eugene Lang College of Liberal Arts and a member of the Visualizing Finance Lab at Parsons School of Design

Mabel O. Wilson is an architectural designer and scholar. She is the founder of Studio &, a collaborative transdisciplinary practice, and a founding member of Who Builds Your Architecture? (WBYA?), an advocacy project. Her projects and design research have been exhibited at the Art Institute of Chicago, Istanbul Design Biennial, and the Cooper Hewitt Design Triennial. She is the author of *Negro Building: Black Americans in the World of Fairs and Museums* (University of California Press, 2012). Wilson is the recipient of awards and fellowships from the Getty Research Institute, the New York State Council for the Arts, and the Center for Advanced Study in the Visual Arts (CASVA) at the National Gallery of Art. She is a professor in Columbia University's Graduate School of Architecture, Planning and Preservation.

Index

Numbers in bold refer to illustrations.

This book is a collaboration between
The New School Art Collection and
Parsons Curatorial Design Research Lab,
published on the occasion of
The New School Centennial.
thenewschoolartcollection.org

The publication of this book is possible
in part through the generous support of
Joshua Sapan and Ann Foley, Beth
Rudin DeWoody and the Mary and Samuel
Rudin Family Foundation, Inc., and
William B. Havemeyer. The New School
Art Collection, The New School's Provost
Mutual Mentoring Grants, and Parsons
Deans Council Cross-School Grants have
provided additional support.

**I Stand in My Place with My
Own Day Here: Site-Specific Art
at The New School**
Conceived and produced by Silvia Rocciolo,
Lydia Matthews, and Eric Stark
Edited by Frances Richard

ISBN: 978-1-4780-0808-8 (print)
ISBN: 978-1-4780-0911-5 (e-book)

Copy editor: John Haffner Layden
Editorial assistant: Elisa Taber
Design: Barbara Glauber, Kellie Konapelsky,
Asad Pervaiz, Taylor Woods / Heavy Meta
Printed and bound in Italy by Conti Tipocolor
Typeset in Newzald, Operator, and Robinson

Published by The New School.
Distributed worldwide by
Duke University Press.

The New School
66 West 12th Street, 8th Floor
New York, NY 10011
newschool.edu

Duke University Press
905 West Main Street
Durham, NC 27701
dukeupress.edu

Cover: Glenn Ligon, *For Comrades and
Lovers*, 2015 (detail).

Endpapers: Agnes Denes, *Pascal's Perfect
Probability Pyramid & the People
Paradox—The Predicament (PPPPPPP)*,
1980/2016 (detail).

"Art Shack," rooftop offices of The New School
Art Collection, 66 Fifth Avenue, 2018.

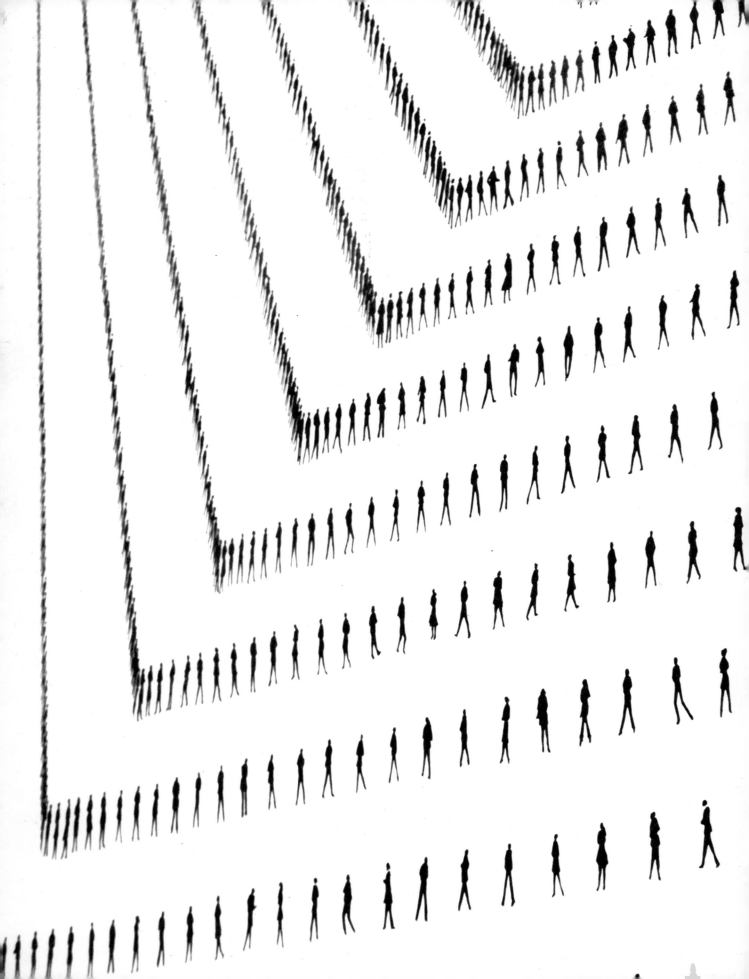